1000 SYMBOLS

# 1000 SYMBOLS

## ROWENA & RUPERT SHEPHERD

*With 1,157 illustrations*

Thames & Hudson

*Dedicated to the memory of*
*Michael Beechey*
*1950–2001*
*Scholar - Teacher - Friend*

First published in the United Kingdom in 2002 by THAMES & HUDSON LTD
181A High Holborn, London WC1V 7QX

First published in paperback in the United State of America in 2002 by
THAMES & HUDSON INC.
500 Fifth Avenue, New York
New York 10110

© 2002 The Ivy Press Limited

This book was created by
THE IVY PRESS LTD
The Old Candlemakers,
Lewes, East Sussex BN7 2NZ

British Library Cataloguing-in-Publication Data

A catalogue record for this book is available from the British Library

Library of Congress Catalog Card No.
2001095717

ISBN 0-500-28351-6

Printed and bound in Italy

## Contributors

**Michael Beechey** (gemstones) was a lifelong scholar of the Western Mystery Tradition, and taught astrology and tarot for over twenty-five years.

**Linda Carter** (Masonic symbols) has been a member of the Order of International Co-Freemasonry for twenty years.

**Patricia Friedman** (Judaic symbols) runs an ecumenical study centre in south-west Wales.

**Rachel Kennedy** (Aboriginal, Maori and Oceanic symbols) has worked as a researcher, writer and museum curator for several museums and heritage organizations.

**Rebecca Naylor** (Ancient Middle eastern, Greek and Roman, and Islamic symbols) works as a curator in the Asian Department of the Victoria & Albert Museum.

**Julie North** (Native American, South American, Aboriginal and Oceanic symbols) has worked intensively with Native American and Australian Aboriginal teachers and elders over the past twelve years.

**Kate Newnham** (Chinese and Japanese symbols) is Curator of Eastern Art and Culture at Bristol City Museum and Art Gallery.

**Shashi Sen** (Indian and Islamic symbols) is currently a curator at the Victoria & Albert Museum.

**Rowena Shepherd** (editor, Norse and African symbols) has a long-standing interest in the history of symbolism in art and religion, and has published on the symbolism and history of tarot cards.

**Rupert Shepherd** (editor) is currently a Research Fellow at the University of Sussex.

**Andrew Spira** (Eastern and Western Christian symbols) works at the Victoria & Albert Museum and lectures widely.

**Russell Stephenson** (letters, numbers, editor of ch. 8) is involved with research into the more esoteric aspects of Freemasonry, Sacred Geometry, and Gematria, the 'numerological' aspect of the Kabbalah.

**Kate Warren** (Central and South American symbols) currently works for the National Trust as Collections Manager at Kingston Lacy, Dorset.

**Helene Watson** (Egyptian, Celtic, astrological and alchemical symbols) has studied and practised the Western Mystery tradition for over twenty-five years. She is also published and teaches on the subject.

# CONTENTS

## ❶
## HEAVEN AND EARTH

## ❷
## CHARACTERS AND PEOPLE

## ❸ THE BODY AND ACTIONS

## ❹ LIVING CREATURES

## ❺ MYTHICAL BEASTS

## ❻ FLOWERS, PLANTS AND TREES

## ❼ OBJECTS AND ARTEFACTS

## ❽ ABSTRACTS

# A-Z SYMBOL FINDER

A – Z SYMBOL FINDER

7

# PREFACE

## Aims

We have edited this book with the increasing importance of multiculturalism, and more general interest in religions and cultures throughout the world, in mind. We have aimed to include as many cultures as possible in order to give a wider vision of the way symbols have been interpreted. Of course, it is not possible in a book of this scale and format to be comprehensive, especially in the case of cultures that are organized into many distinct groups (for instance 'clans' or 'tribes'), each with their own, self-defining mythologies and customs, particularly the peoples of Africa, North, Central and South America, Australia, and the Pacific. Similarly, as cultures change through time, so do the meanings attached to their symbols. Thus, in many cases it has only proved possible to include some indications of the infinitely wider and more complex whole that makes up the cultures we discuss as they have developed around the world and across time. In the limited space available, we have tried to give an idea of the range of meanings a symbol might carry, and provide a few of the more telling (or striking) examples with which to illustrate these meanings; but we have not tried to be comprehensive. If you wish to discover more about the meanings symbols carry in particular cultures, we have provided a brief guide to further reading at the end of the book. Although we hope that specialists will find new angles of interest, this book is aimed at the general reader.

Symbols are used extensively in literature, legend and myth, as well as the purely visual arts. Many cultures also consider actual things – be they living creatures, plants or inanimate objects – to carry symbolic meanings. We have not restricted the book to visual symbols because some symbols may have little or no tradition of visual representation. Indeed, in some cultures, a symbol may be so powerful that its actual representation in visible form is circumscribed or taboo.

## What is a symbol?

This question has resulted in intense, detailed and erudite discussions for centuries. Rather than recap them, we offer the relatively simple, working definition of a symbol which we adopted when compiling the book.

A symbol is something that a particular culture considers to mean something else. Thus, a coloured shape (a red circle) means a celestial body (the sun) in Japan. This example suggests that a symbol may seem to be the same as a sign; but the difference lies in their roles. A sign exists only to convey meaning; nothing more. A symbol, on the other hand, exists in its own right, not just as a conveyor of meaning. In Jung's words, 'What we call a symbol is a term, a name, or even a picture that may be familiar in daily life, yet that

possesses specific connotations in addition to its conventional and obvious meaning. ... Thus a word or an image is symbolic when it implies something more than its obvious and immediate meaning.' (C.G. Jung, *Man and His Symbols*, New York: Dell Publishing Co. (1968), pp. 3–4).

Thus, the images of men and women that appear on the doors of public toilets are signs: they indicate which facilities are to be used by men, which by women. Women, however, are very complex symbols: they exist in their own right as living, breathing entities; yet they also, in certain contexts, convey any number of different meanings – perhaps 'the moon', 'mutability', or 'nurture'. Unlike signs, the meanings carried by symbols are 'loose': that is, often capable of more than one interpretation, and beyond really precise definition. The world of symbols is a world of inference and suggestion, rather than of concrete facts and definite statements.

### Using *1000 Symbols*

In order to create an affordable and readable book, which still contains a reasonable number of symbols, the majority of entries are quite brief. This means that in any particular entry we will often refer to other symbols, with little accompanying explanation. These other symbols will be indicated in CAPITALS, and we would encourage you to cross-refer to them as much as possible. As the book is arranged thematically, the easiest way to do this is to use the A–Z Symbol Finder at the front of the book to find the number of the symbol referred to. In several cases, the capitalized cross-reference will refer to a symbol by a different name from that under which it is found in the book (for example, we sometimes refer to St Bridget, a specifically Christian manifestation of the Celtic BRIGID – in whose entry she is discussed); but the heading to look for will also be indicated in the A–Z Symbol Finder.

We don't expect you to read the book from cover to cover. Instead, you should dip into it: look up a particular symbol, and follow the cross-references you come to – follow the THREAD through the LABYRINTH. In addition to the information that you were originally searching for, we are sure that you will find something new or striking!

*Rowena & Rupert Shepherd*

*December 2001*

# HEAVEN
# AND EARTH

A          B          C

## Heaven ✳ Overworld

Usually found in the cosmos or SKY; the home of the gods, or – for Jews, Christians and Muslims – the home of God. In the belief systems of most world religions, the dead are thought to have to pass through a GATE or doorway before they are sent to Heaven or HELL (and sometimes Purgatory or Limbo). The image above (A) emphasizes this transitional aspect. It refers to the Christian vision of the gates of Heaven, which are guarded by ST PETER.

The Field of REEDS (B), so named by the Ancient Egyptians, was the area of the sky around the NORTH Pole, where the circumpolar STARS always remain visible at night. The Egyptians believed it to be a place in which nothing perished. The Greek word 'Elysium', as in 'Elysian Fields' (the place to which heroes were conveyed after death), was derived from the Egyptian word for 'reeds'.

For the Ancient Greeks and Romans, heaven was envisaged as a DOME that sat over the earth, an idea that is alluded to in religious architecture.

The Celtic heaven was divided between a world inhabited by gods and heroes, and an Otherworld inhabited by the FAIRY beings of the *Sidhe*. The Nordic heaven, Asgard, housed ODIN, THOR, the heroes and a host of lesser deities who engaged in feasting and battles until the last struggles against the GIANTS; it was represented as a stronghold that included Odin's hall, Valhalla. In the *Kojiki*, an early Japanese chronicle (AD 712), heaven is the dwelling place of deities, the chief of whom is AMATERASU OMIKAMI, the SUN goddess. Daoists believe that the world of the immortals exists in the celestial heavens.

For the Ancient Greeks, heaven was the home of the heroic dead; from the second century BC, Jews have believed that it also contains the SOULS of the good, resurrected to live with God; this belief is echoed by the Christians. Islamic heaven is conceived as a GARDEN or paradise. Muhammad ascended to heaven from the Dome of the Rock (C). Later Chinese beliefs, influenced by Daoism, Confucianism and

Buddhism, held that the souls of the dead might reach heaven after being purged in the underworld.

The relationship between heaven, perfection and immortality is embodied in many beliefs. In Buddhism, humans can attain release (Nirvana) from the cycle of birth and rebirth through enlightenment. For Christians, heaven is a state of divine enlightenment and freedom from sin; ascension is used as a symbol of spiritual quest (for example, the spires on Gothic churches). In Western alchemy, heaven is the end result of the Work, symbolizing the evolved spirit of the alchemist. Likewise, in Chinese alchemy a journey to the land of the immortals is part of the process.

In traditional Chinese culture, heaven represents the active MALE principle of YANG; EARTH the passive FEMALE essence of YIN. Interaction between heaven and earth produces all things. Heaven is thus the ultimate power. The emperor, or 'son of heaven', interceded between heaven and earth in special rituals.

## Star

Stars (A) are often associated with deities: one of the earliest representations of a star was the eight-rayed star (the planet VENUS) of the Sumerian goddess INANNA. The same device as the *Stella Maris* (star of the SEA) was associated with the VIRGIN MARY.

Stars played a significant part in Ancient Egyptian religious belief. Temples were aligned so that particular stars shone through tiny apertures, illuminating inner chambers and statues on specific festivals. Sirius was connected with the goddess ISIS and the inundation of the Nile, and Orion was associated with her partner OSIRIS. The Ancient Greeks venerated the Pleiades because their rising heralded the beginning of SUMMER, while their setting heralded the advent of WINTER.

In Aboriginal culture the Morning Star (VENUS) is associated with the story of night and day, life and death, symbolizing the passage of the SPIRIT from one state to another. Many Native American tribes think of the stars as the campfires of the ANCESTORS. In Nordic cultures, it was believed that stars were glowing embers that had been placed in the sky by the god ODIN and by his brothers Vili and Ve.

Astrologers believe that stars can be used to predict the future; the sudden appearances of some stars are believed to be omens. Christians associate stars with auspicious births (CHRIST, ST DOMINIC). The Chinese believe that the stars directly affect events on earth. The Japanese traditionally believe that shooting stars were the SPIRITS of the dead, and sighting them was unlucky – whereas in Europe they are seen as lucky, and one should wish upon a falling star.

The traditional Chinese belief is that everything in the heavens revolves around the Pole Star, where the Celestial Emperor sits surrounded by his courtiers. The Great BEAR or PLOUGH was believed to control the balance of YIN and YANG in the universe, and, represented as THREE stars, it was one of the 'TWELVE Ornaments' embroidered on imperial robes. In Britain this constellation is also known as ARTHUR's Wain (wagon); this may relate to the Welsh word for BEAR, *arth,* and to Celtic and Nordic depictions of various gods standing in wagons. The Maori and South Pacific islanders have always revered the Southern CROSS, which points to the celestial SOUTH Pole.

To the Native American Mohawk and Delaware tribes of the Northeast USA, the visible stars of the Pleiades (B) represent SEVEN boys who, while DANCING in the forest at night, danced right up into the sky.

Masonic symbols include the Blazing Star (C). Found in the centre of the lodge (which represents the physical universe), it symbolizes the glory of God. Polynesians believe that 'stars are the EYES of heaven', secretly observing everything.

Stars may be represented with any number of points: the Ancient Egyptians usually had FIVE (A), while a six-pointed star relates to the Jewish STAR OF DAVID.

## Milky Way

The Milky Way has long been considered to be a RIVER in the SKY or BELT of STARS (A), and has served as a celestial counterpart of the Nile, the Ganges and the Yangtze. In Ancient Chinese belief, the PEACHES of immortality could be found on its banks. The Sumerians called it the SNAKE River, and its sinuous form means that the Milky Way has also been associated with SERPENTS by some Native American tribes. It marked the seam where the two hemispheres of the HEAVENS were fastened together, according to the Babylonians and, much later, the Mongols; for the former, it was a gap in the join.

The Sumerians believed that ghosts followed the Milky Way to the Otherworld, a belief echoed by many other cultures, whether it be as the Straw ROAD of the Near East, the Road of the WHITE ELEPHANT of the Siamese, or the road that many Native Americans (such as the Lakota Sioux of the American Plains) believe is taken after death by human SPIRITS. The Norse believed it was a path for dead WARRIOR heroes, and the Ancient Greeks thought it was the main street of HEAVEN. For Christians, it symbolizes the pilgrim's path; Inuit and African San (Bushmen) both see it as a track of ASHES that glows faintly for the traveller to follow. In Welsh myth it was said to have been used by GWYDION as a track by which he could search for the soul of BLODEUWEDD's murdered husband, his nephew Llew.

The Native American Zuni of New Mexico (B) believe that it was created by the WARRIOR TWINS as they searched for the CORN MAIDENS.

The scattered appearance of the stars in the Milky Way means that it is associated with various spilled substances: the cloud of dust raised by a HORSE and BUFFALO who raced across the SKY, according to the Pawnee, who originally lived in Nebraska; the STARS released from a sealed container by the impatient or mischievous TRICKSTER COYOTE for the Hopi of Arizona, and the Navajo of Mexico, Arizona and Utah (C).

For the Ancient Greeks and Romans it was the MILK that spilled from Ops's BREAST when she hid her child JUPITER from her husband SATURN, who was devouring his children, or the milk that spurted from HERA's breast as she tore the nursing HERAKLES away. In the Celtic church, ST BRIDGET, as CHRIST's wet nurse, was believed to have fed him the Milky Way.

For Mongols and Tibetans, the Milky Way is the BREATH of an ELEPHANT, which is to be found swimming in the great SEA that encircles the earth. The Seminole (a Native American tribe from the Southeast of the USA) believe that it was created by their hero, BREATH Maker.

## Chaos

Chaos is the original formless mass, from which order and the universe are created.

Chaos has been envisaged in various forms by various cultures: a watery void (Ancient Egyptian 'NUN', Jewish 'Tehom'); a jellyfish or an EGG-like substance, which later splits into HEAVEN and EARTH like the separation of the yolk and white of an egg (early Japanese chronicles); a frozen formless wasteland (Nordic 'Ginnungagap'); or a swirling, formless mass (European), as indicated above.

Chaos is usually considered to be the initial state out of which order arises. Thus, the Western alchemical process starts with chaos, echoed by a chaotic state of mind – sometimes caused by the fumes of the external chemical process – encountered when first making physical contact with the *prima materia*. In some cultures (for example, Maori), the present day is the time of chaos, through which we are guided by myths, while traditions create order.

## Light

Light is generally related to spiritual purity and the gods.

In Ancient Greek mythology, Phoebus APOLLO was the god of light as well as reason, harmony and morality, all of which are positive attributes associated with illumination. Likewise, Buddhists associate it with spiritual enlightenment.

Light is often considered to be the fundamental source of all matter: in Judaism it is the first creation of God, while bishop and theologian Robert Grosseteste (c. 1175–1253) proposed that the matter of the universe was composed of light. For the Maori, light is inextricably linked to their story of the world's creation; the Maori symbol for life, Te Ao Marama, symbolizes the realm of being or the light of day.

In Christian symbolism, light is the love and wisdom radiating from God; invisible in itself, it enables all other things to be seen. The supreme vision for Orthodox mystics is of the Uncreated Light, as witnessed at the transfiguration of CHRIST.

## Comet

In many cultures, the appearance of a comet in the SKY represents a dramatic change in the HEAVENS, which in turn prefigures dramatic changes on earth.

Comets are often thought of as being portents of war: a comet (probably Halley's Comet) is depicted in the Bayeux Tapestry. They are also believed to precede general misfortune: sightings of Halley's Comet in China in 1910–11 caused widespread fear and unrest.

Conversely, comets have also been interpreted as signs of hope. The comet that appeared after Julius Caesar's murder was believed to signal his apotheosis in heaven, and so comets came to symbolize optimism and new beginnings.

They also foretold the deaths or births of important men, such as KING ARTHUR, whose birth was reputed to have been heralded by a comet, or CHRIST (the STAR of Bethlehem is sometimes depicted as a comet, which some evidence suggests may be Halley's Comet).

A

B

C

## Sun

One of the most prevalent and important cultural symbols, often seen as MALE and associated with kingship and major male deities.

In traditional Chinese culture the sun embodies the male active principle, YANG. It is the greatest source of power in the heavens, and a symbol of the emperor, who wore a sun design (a CIRCLE containing a THREE-legged CROW) among the 'TWELVE Ornaments' on his robes. The Japanese Imperial family are said to be direct descendants of their sun goddess AMATERASU OMIKAMI. The Japanese word *nihon* means 'origin of the sun' and, as a RED sun symbol, appears on the national flag. In the Kubu kingdom (Kongo), a sun motif is used on royal regalia such as the THRONE, and part of the Ashanti regalia is a GOLD sun disc representing the king's *kra*, or SOUL.

Sun deities were also central to the pre-Hispanic civilizations of Latin America. For the Maya, the rising sun affirmed the divine right of the ruler, and sacred rituals centred around SACRIFICES, which guaranteed that the sun would rise. Other cultures, too, encourage the sun to rise. To the Native American Cherokee tribe of the South-east USA, the sun is FEMALE. When her daughter dies from a SNAKE-bite, the sun covers her face in grief and the world becomes dark. The people DANCE and sing to the sun to console her, upon which she uncovers her face. The Plains tribes' Sun Dance is still a significant annual religious festival.

The sun is often seen as a deity being transported across the sky on a CHARIOT: examples are seen in Norse mythology, the Ancient Greek sun god HELIOS (APOLLO), MITHRAS, the Ancient Egyptian RA, and the Ancient Indian Surya. In Ancient Egypt, the sun disc was worn by many deities. A spoked WHEEL was the Celtic symbol of the sun, associated with TARANIS. The deities Mabon, LUGH ('Light') and BRIGID were also linked to the sun.

According to the Vedic beliefs of the Ancient Indians, the sun god Surya was one element of the trinity of AIR (*vayu*), FIRE (*agni*) and sun (*surya*). Such beliefs probably lie behind the depiction of the sun containing a face in the standard Western image (A). The Native American Hopi of Arizona's Sun Kachina also wears a 'human' face (B).

In Western alchemy, the sun represents the ego of the alchemist, to be worked on and transformed by union with the MOON. It represents MALE energy (*animus*) and can be depicted as a KING. It is associated with SULPHUR, the spirit, while GOLD is called 'the sun of the earth'.

Astrology links the sun to individuality, the will, ego and personality, the father, health and vitality; it influences the circulation of the BLOOD and physical growth. The sun rules the sign of LEO, and is associated with those in authority, and those working with money and GOLD. It is usually represented as a POINT WITHIN A CIRCLE (C).

## Pluto

The furthest planet from the sun, in the deepest darkness of the solar system, Pluto was not observed until its discovery in 1930 by the Lowell Observatory. Its glyph (above) combines the initials of its original name, 'Pluto-Lowell' – the former being the Ancient Roman ruler of the UNDERWORLD and the dead. Pluto is related to the plants associated with HADES, such as the NARCISSUS and CYPRESS TREE, and to the colour BLACK.

Astrology relates the planet to the deep psyche, and how people cope with fundamental change; its influence leads to an urge to refocus and reformulate values and ideals. It is associated with obsession, power, the desire to control others, the sexual instincts and powers of attraction and repulsion. Anatomically, it governs the excretory system, the reproductive organs, the body's metabolism and deep regenerative processes at and below cellular level. Associated occupations are mining, crime, politics, detection, research, healing, terrorism, armaments and power generation.

## Neptune

This distant, BLUE-GREEN planet, discovered in 1846, takes its name from the Greco-Roman SEA god Neptune (POSEIDON in Greek), who was given dominion over all the WATERS (and so its glyph – above – resembles the God's TRIDENT). Astrologically, the planet relates to the mobile, fluid worlds of dreams, invention, imagination, psychism and mysticism, while its influence can be related to the effects of alcohol and narcotics. It is associated with occupations in perfumery, cosmetics, all professions involving OILS, the arts, film and professions relating to glamour, anaesthetics, the legal and illegal drugs trades, psychology, chemistry, psychism, healing, philosophy, and magic and the occult. Together with JUPITER, it rules PISCES. It is thought to govern the pineal gland and the parts of the nervous system that involve dreaming and psychism, as well as the aura and psychic centres such as the CHAKRAS. Neptune's colours are sea-GREEN, aquamarine and lavender.

## Uranus

Discovered in 1781 by William Herschel, who named it the Georgian Planet after the reigning king of the United Kingdom, Uranus took its eventual name from the Ancient Greek god who was the original manifestation of the heavens, produced out of the Ancient Greek earth god Gaia, with whom he created the first immortals, the Titans. Later overthrown and castrated by Saturn, his spilt semen and BLOOD generated VENUS and the FURIES/ERINYES.

Astrologically, Uranus is associated with disruption, revolution and sudden change, and represents the powers of revolutionary transformation and the urge to break through restrictive boundaries. Its glyph (above) is based upon Herschel's initial. With SATURN, Uranus rules AQUARIUS; it governs the nervous system. Uranus is associated with invention, science, technology, electricity, computing, aviation, space exploration, social science and astrology. It is thus linked with bright hues, multicolours, light BLUES and silvery WHITES.

## Saturn

The slowest-moving planet visible with the naked eye, named in the West after the Greco-Roman Titan SATURN, the son of URANUS and the EARTH god Gaia. In its glyph (above), the CROSS of matter presses on the CRESCENT of the SOUL. In astrological terms it is related to old age, the father, structure, restriction, hardship, discipline and learning; it also represents the parts of the personality one avoids examining. It governs the bones, skin, TEETH, ligaments, joints, spleen and hearing. Associated occupations are to do with land, building, banking and undertaking. It is associated with muted colours and BLACK stones including JET and OBSIDIAN (although Indians relate it to SAPPHIRE), and LEAD. Herbalists connect it to poisonous, purgative, dark and WINTER-growing plants. Saturn rules CAPRICORN and AQUARIUS.

In traditional Chinese culture Saturn is known as the Regulator or EARTH Planet, and is associated with late SUMMER. It represents the YELLOW Emperor.

## Jupiter

The largest planet in the Solar System, taking its Western name from JUPITER, the ruler of the Ancient Roman pantheon. Its glyph (above) shows the SOUL (CRESCENT) crossed by matter (the CROSS).

Astrologically, it is associated with growth and expansion, and so with the LIVER and pituitary gland. Associated occupations are higher education, languages and the law. In alchemy it is represented as a THUNDERBOLT, and rules over *solutio*, the second stage of the Lesser Work. It is related to tin, and to the SAPPHIRE (or, for people of India, the TOPAZ). Jupiter rules SAGITTARIUS and (with NEPTUNE) PISCES.

In traditional Chinese culture it is called the Wood Planet; it is FEMALE and associated with the element of WOOD, and thus with SPRING, growth and birth. It is also known as the Year Star, because its TWELVE-yearly cycle through the heavens marks the years of the Chinese ZODIAC.

## Mars

The RED planet is named after MARS, the god of war. Its glyph (above – originally a CROSS over a CIRCLE, the opposite of VENUS's) represents direction and desire over the circle of SPIRIT. Astrologically it is linked with masculinity, and the expression of individuality, energy, aggression and desire – and so with BLOOD, the excretory organs, the adrenal system, muscles, the NOSE and the external reproductive organs. Associated occupations include the military, work with sharp instruments, metallurgy, engineering and sport.

Because of its colour, Mars is associated with various shades of RED, with RUBIES and GARNETS (or CORAL, for people of India), and with hot, stinging or thorny plants. Mars rules ARIES and SCORPIO.

Its traditional Chinese name is FIRE Planet. It corresponds to the SOUTH and rules over the SUMMER months. Its attributes are similar to those in the West, especially those relating to war.

## Venus

The brightest planet takes its name from VENUS, the classical goddess of love. Its glyph (above) depicts the CIRCLE of SPIRIT over the cross of matter. Astrologically, it represents the FEMALE, allurement, beauty, harmony, refinement, attraction, affection and relationships. It governs the HAIR, skin, facial features, kidneys, thymus gland, circulatory system and female reproductive organs. It is related to those working with beauty, fashion, plants and flowers, and to sweet-tasting and sweet-smelling plants. Venus is associated with GREEN and hence with EMERALDS, or, as the goddess born from the sea, with CORAL (in India, DIAMONDS). Venus rules LIBRA and TAURUS.

In traditional Chinese culture, Venus is called the Great WHITE or METAL Planet, and is linked with metal, particularly GOLD. It corresponds to the WEST and AUTUMN. Although generally auguring peace, Venus may also foretell disturbances and the outcomes of battles.

## Mercury

The fastest planet takes its name from MERCURY, the classical messenger of the gods. Its glyph (above) – the MOON's CRESCENT (the SOUL) over the CIRCLE (SPIRIT) over the CROSS (matter) – encompasses all the other planetary glyphs and may be derived from the CADUCEUS. It affects communication, the intellect, thought and adaptability. It governs the nervous system, hearing, speaking, respiration, the thyroid, the limbs, the bowels, the FEET and the gall bladder. Associated occupations are communication, education, trade, accountancy and engineering. Its colours are metallic BLUES and lilacs, and YELLOW; it is associated with AMETHYSTS (or EMERALDS in India). Its plants are herbs, HAZELS and WALNUTS. Mercury rules VIRGO and GEMINI.

In traditional Chinese culture, Mercury is called the WATER Planet, and corresponds with the NORTH. Its appearance in different parts of the sky is related to the FOUR SEASONS, while its non-appearance may cause discord.

## Solar Eclipse

Solar eclipses are significant portents, generally bad: one occurred during the crucifixion of CHRIST, while in traditional Chinese culture it represents the emperor (SUN, YANG) being overshadowed by the empress (MOON, YIN).

Many stories explain the sun's disappearance. In Japan, the sun goddess, AMATERASU OMIKAMI, hides in a cave. In China, a DOG attempts to devour the sun. The Ancient Egyptians said that HORUS, the falcon-headed SKY god, had lost one of his EYES (the sun and moon) in combat with SET. Native Northern Californian tribes believed that sky monsters devoured the sun; other stories tell of the trapping or theft of the sun until a TRICKSTER-hero releases it. Whatever explanation is given, attempts are usually made to bring the sun back.

In alchemy, the final transformative conjunction reveals the spirit either to be the corona of the sun, or the hidden lapis or STONE in the darkness of the moon.

A

B

C

## Moon

The moon is often perceived to be FEMALE (B), as in China, where it embodies YIN. Frequently partnered with the SUN as husband and wife, or sister and brother, it is often related to goddesses such as ARTEMIS, Selene, and to Celtic goddesses such as RHIANNON. In Egypt, ISIS and the god KHONSU were also linked to the moon in Hellenic times. In Constantinople, the CRESCENT moon represented the VIRGIN's purity; when the city fell to the Ottomans, it became a symbol of Muslim conquest over Christians; the CRESCENT moon (A), used by Arab armies, thus evoked militant Islam.

Because of the moon's changing phases, it has been used as a calendar by: Celts; Native Americans (see the Pueblo image at C); Jews, who consider the New Moon a sacred time; Muslims, who use a lunar calendar to time religious events such as the Hajj or Ramadan; and the Japanese and Chinese, who only adopted a solar calendar in 1873 and 1911 respectively, and still use the lunar calendar to determine their astrological years. The 14 pieces into which the Ancient Egyptian god OSIRIS was dismembered correspond to the 14 days of the waning moon. In Africa, the duality of the new and full moons symbolize darkness and ignorance, and LIGHT and wisdom. The moon's changing influence has also led to an association with intermittent lunacy and with inconstancy.

The moon's control over tides and liquids (especially menstruation) is recognized in many cultures. Native American women gather in the Moon Lodge during their menstrual time. Alchemists relate the BLOOD RED moon of a lunar eclipse to menstruation.

Many stories account for the patterns seen on the face of the moon. A Polynesian creation myth involves RU and Hina, a brother and sister. After travelling around the world, Hina's passion for discovery did not cease, and when the moon caught her eye, she sailed there and stayed forever, becoming the 'man' that we can see today.

Freemasons work during the day, and so consider the moon to be one of the lesser lights towards truth compared to the SUN; but both are represented in the lodge, and derive their light from the great Master of Heaven and Earth.

In Western alchemy the moon represents the soul of the alchemist, to be worked on and transformed by its union with the sun. It symbolizes feminine energy (*anima*) and is depicted as a QUEEN. Astrologically it is associated with the persona, the feelings, FEMININITY, the MOTHER and CHILDREN, protection, nourishment, emotions, instincts and the ability to adapt. It rules the female reproductive organs, BREASTS, STOMACH, TEAR ducts, lymphatic system and sympathetic nervous system, and is associated with menstruation and conception. Associated occupations are childcare, midwifery, nursing, seafaring, dealing in liquids and purveying food. It rules the sign of CANCER.

## Zodiac

The word 'zodiac' derives from *zodiakos*, the Greek expression for 'CIRCLE of living things', and in the West it describes the TWELVE constellations through which the SUN passes every year. The sun's position in the zodiac influences life and events on earth.

Derived from Mesopotamian constellations, the signs employed by classical and late Egyptian astrology are still used today in the West. Christianity mediated and moralized the classical zodiac through the LABOURS OF THE MONTHS, while its division into twelve reflected the TWELVE APOSTLES.

In alchemy, the zodiac represents the timing and ordering of the various stages of the Work, starting with the sign of ARIES.

In the Chinese zodiac, the twelve dimensions are represented by the RAT, OX, TIGER, HARE, DRAGON, SNAKE, HORSE, GOAT, MONKEY, COCK, DOG and BOAR.

## Aries

*21 March–20 April*. Astronomers still begin the year at the SPRING equinox, when the SUN first enters Aries according to the tropical ZODIAC. Aries is the RAM, sometimes shown running forwards but looking backwards, suggesting its impetuous movement into the New Year while still looking backwards towards the old year. Its glyph, ♈, represents a ram's HORNS or the up-welling force of a SPRING. Arians are impetuous, enthusiastic, sporting, independent, easily bored and ambitious. Anatomically, it is linked with the HEAD. Ruled by MARS, its element is cardinal FIRE, and its gemstone DIAMOND. It is associated with the Ancient Egyptian gods OSIRIS, AMUN and KHNUM, with the Greek MINERVA and with ST PETER.

Alchemically, Aries often indicates the beginning of the Work: the spring equinox, when nature's creativity is at its greatest, is considered the best time to open the Work, begin preparations and seek the *prima materia*.

## Taurus

*21 April–21 May*. Taurus is depicted as a BULL, and so its glyph, ♉, is said to symbolize a bull's head; it also represents the full and crescent MOON, which is exalted in Taurus. Appropriately, therefore, the sign is ruled by VENUS, and its gemstone is EMERALD. Taureans are steadfast, loyal, practical, sensitive, understanding, calm, generous, stubborn, sometimes aloof and rigid, lovers of luxury, and materialistic. Taurus governs the throat and ears. It is associated with the Ancient Egyptian HATHOR (who has a COW's head), and with the Greco-Roman myth of JUPITER's rape of Europa while he was disguised as a BULL. Its element is fixed EARTH.

The Wesak festival celebrating BUDDHA's birth occurs on the first full moon after the sun enters Taurus; DRUIDS may have worshipped the bull at the festival of Beltane, when the Pleiades (within Taurus) rose with the SUN.

## Gemini

*22 May–21 June.* Gemini represents the TWINS, as shown above; its glyph, ♊, could depict the number TWO in Roman numerals, or a GATE – the sun enters the gateway of the SUMMER solstice at the end of Gemini. Those who are born in Gemini are dualistic, as well as communicative, intellectual and changeable; thus, Gemini is ruled by MERCURY, while its element is mutable AIR; its gemstone is AGATE. It is related to the arms, HANDS and LUNGS. Gemini is connected with the Elder and Younger HORUS, Shu and TEFNUT, and Castor and Pollux.

In China, the twin stars of Gemini are associated with the dualism of life, and the symbol of the *tai-ji*. In India, the constellation was linked with the Vedic MOTHER-goddess Aditi, who supported the SKY – so it is connected with the dawn and the light of the EASTERN SKY.

## Cancer

*22 June–23 July.* The CRAB, although earlier depictions also show a crayfish. Cancer begins with the SUMMER solstice, when, after rising and setting further north on the horizon each day, the sun changes direction like a crab. Its glyph, ♋, may be based upon a crab's claws, or symbolize the waxing and waning MOON. Cancerians are moody, changeable, imaginative, romantic, shrewd, nurturing and possessive. Ruled by the moon, its element is cardinal WATER, and its gemstone MOONSTONE. It is related to the chest, BREAST and STOMACH. Alchemically, Cancer relates to the primal waters and MOTHERHOOD; protective of its emotions within its shell, the crab's moods change like the waxing and waning of the moon and tides. It represents dreaming, intuition and memory. Associated with the Ancient Egyptian Khepri and NEPTHYS, it is the crab sent by HERA to bite HERAKLES when he fought the HYDRA; he inadvertently crushed it.

## Leo

*24 July–23 August.* The LION, whose tail is sometimes said to be reflected in its glyph, ♌. Like the lion, Leos are magnanimous, egotistical, generous, proud, courageous and loyal; they dislike sudden change. Ruled by the SUN, its element is fixed FIRE – an appropriate description for the hottest part of SUMMER in the Northern hemisphere; in alchemy, a lion represents a controlled fire. Its gemstone is RUBY, and it governs the HEART. The constellation honours the courage and ferocity of HERAKLES and the Nemean lion in their battle; Ancient Egyptians associated it with Ra Herakhty – RA and HORUS combined as the god of the morning sun. In China it is known as the HORSE, or (with extra stars) the YELLOW DRAGON, while a section was also called the PALACE of the FIVE Emperors. Christians associate Leo with ST MARK.

## Virgo

*24 August–23 September*. The VIRGIN, whose glyph, ♍, may represent her VAGINA, ovaries and uterus. Arabian astrology depicted the constellation as a SHEAF of corn – related to the STAR Spica, the brightest in Virgo, who is therefore often represented holding corn and a SICKLE.

Virgo has been associated with most major Western female deities, including ISHTAR, GEB, HATHOR, ISIS, DEMETER, PERSEPHONE, Rhea, APHRODITE, Astraea, Dike (Roman goddess of justice) and the VIRGIN MARY. Virgoans are practical, discriminating, critical, quick-witted, sensitive and communicative; they enjoy serving others and are sometimes aloof. Related to the intestines, spleen and solar plexus, and ruled by MERCURY, its element is mutable EARTH, and its gemstone CARNELIAN.

The Chinese year begins when the full moon lies within Virgo, part of which is considered to be part of a vast DRAGON, which runs as far as SAGITTARIUS.

## Libra

*24 September–23 October*. The SCALES, also represented in its glyph, ♎ (which may also show the SUN on the horizon). In Greco-Roman astrology, Libra represented the CHARIOT that carried PERSEPHONE (VIRGO) into the UNDERWORLD: it marked the AUTUMN equinox, when WINTER came and Persephone withdrew from the world.

Many civilizations have associated Libra with scales and balance, as the days and nights are of equal length at the equinox: the Egyptians; the Chinese, who call it *Tien Jing* ('Heavenly Balance'); and the Indians, who call it *Tula* ('the Balance'). The scales of Libra are also associated with the scales of justice.

Librans are artistic, refined, sociable, graceful, attractive, manipulative and impartial; finding it hard to make decisions, they tend to rely on others. Related to the kidneys and the LIVER and ruled by VENUS, its element is cardinal AIR, its gemstone SAPPHIRE.

## Scorpio

*24 October–22 November*. The SCORPION, represented by the glyph ♏, often associated with death, marks the AUTUMN, the time of dying back before WINTER; for the Maya, it was the sign of the Death God, while the Ancient Egyptians linked it with ANUBIS, the guardian of the necropolis. It was believed to be the scorpion sent to kill the Ancient Greek HUNTER Orion (whom the Ancient Egyptians associated with OSIRIS), whose constellation is nearby. A COMET in Scorpio signalled forthcoming plague. Scorpios are independent, inquisitive, egotistical, loyal, seductive and passionate to the point of jealousy, with hidden depths of emotion. The constellation governs the THIGHS, excretory organs and pelvic region. Ruled by MARS and PLUTO, its element is fixed WATER and its gemstone is OPAL.

In New Zealand, the constellation is the FISH-HOOK with which Maui, chief of the gods, caught the ISLAND now known as the North Island of New Zealand.

Z O D I A C

## Sagittarius

*23 November–21 December.*
Sagittarius is the archer, and so its glyph, ♐, represents an ARROW. It is usually depicted as a CENTAUR firing an arrow; the Ancient Greeks believed the centaur Chiron was the first to trace images (including his own) in the constellations, thus making it possible for people to read the stars.

Sagittarians are philosophical, idealistic, academic, optimistic, expansive, independent, sporting and enjoy travelling. Ruled by JUPITER, Sagittarius's element is mutable FIRE, and its gemstone is TOPAZ; it governs the THIGHS and pelvic region. It has been associated with NEITH, one of the most ancient Egyptian goddesses, and with ST JAMES the APOSTLE.

Parts of Sagittarius have been associated with OSTRICHES going to drink from the MILKY WAY by Arabian astrologers.

## Capricorn

*22 December–20 January.*
Capricorn is the GOAT, but it is always represented with a FISH'S tail, and this is symbolized by its glyph, ♑. There is said to be a reference to a 'goat fish' in early Chinese records, and the fish's tail relates to the Babylonian god Ea, to whom the constellation has been related. The Ancient Egyptians linked it to SET, the god of chaos and misfortune who was sometimes depicted as a goat. The sign has also been associated with the Ancient Greek Arcadian god PAN and, for the Romans, Priapus, who was pictured with a man's head, a goat's torso and a fish's tail (alluding to his PHALLUS). Capricorns are practical, reliable, ambitious, hard working and cautious. The sign governs the SKELETON and knees.

Appropriately for the sign that begins with the WINTER solstice, Capricorn is ruled by SATURN. Its element is cardinal EARTH, and its gemstone is GARNET.

## Aquarius

*21 January– 19 February.*
The water-bearer Aquarius's glyph, ♒, represents WATER and communication. It has been associated with HAPY, the Ancient Egyptian god of inundation and the Nile, who dipped his bucket into the RIVER of STARS as he set in the West. Associated by the Ancient Greeks with ZEUS – who, pouring water onto the earth, brought back abundance and fertility – Aquarius was later connected with the gods' cup-bearers Ganymede and Hebe, and with the sole survivors of the FLOOD, Deucalion and Pyrrha.

Aquarians are eccentric, humanitarian, distant, opinionated, forward-thinking and freedom-loving. Related to the ankles and lower legs, and ruled by SATURN and URANUS, its element is fixed AIR, and its gemstone AMETHYST.

The Chinese zodiac begins with this constellation, the RAT (a water animal), as does the Indian zodiac, in which it is associated with Varuna, an all-powerful SKY god who became a water god.

## Pisces

*20 February–20 March*. The FISH, attached to each other yet swimming in opposite directions. Its glyph represents this contradictory aspect: ♓. Pisceans often feel pulled in two directions; they are artistic, intuitive, imaginative and impressionable. They tend to be martyrs and are emotionally manipulative. Related to the lymphatic system, ruled by NEPTUNE and JUPITER, its element is mutable WATER, its gemstone BLOODSTONE.

The last sign of the zodiac, in alchemy Pisces represents the moment of death and rebirth, the final conjunction of SUN and MOON, the final process before the alchemist dies to be reborn.

The Ancient Chinese believed that the Piscean fish had power over the fate of SHIPS and sailors, bringing shipwrecks and storms. The Chinese also depicted this area of the sky as a SWASTIKA known as the Ba Gui, the EIGHT Chiefs, which is believed to be a malevolent influence.

## Air

One of the FOUR elements of Ancient Greek philosophy, air was considered to be hot and wet. Astrologically, it is linked with GEMINI, LIBRA and AQUARIUS and with the realm of the mind. This is true also for the hermetic and alchemical traditions, in which air is also the realm of SPIRITS associated with the creative life-BREATH; and in which it is represented as a TRIANGLE pointing upwards with a horizontal line through it. In traditional Chinese cosmology it represents the 'BREATH of universal life'; Chinese and Hindus represent it with a BLUE CIRCLE.

Air is associated with the EAST in the hermetic tradition. It is thus associated with dawn, and with the SEASON of spring. It was associated with Greco-Roman nature spirits called Sylphs, with the Ancient Egyptian god SHU, with the Vedic god Vayu and with the ARCHANGEL Raphael. Air is the major spirit for most Inuit people; its force is felt through the WIND and the weather.

## Sky

The sky is often perceived to be the MALE partner of a FEMALE EARTH, likened in shape to a DOME, and said to contain the home of the gods.

In China the dome of the sky represents YANG, while EARTH embodies YIN. Likewise, the African Batammaliba of Togo and Benin have a sky god called Kuiye whose wife, Butan, is goddess of the EARTH. In Maori culture RANGI inhabits the sky and the world of daylight after being forcibly parted from his wife PAPATUANUKU, the earth goddess, by his son TANE-MAHUTA, with whom he lived in the darkness of night.

However, in Ancient Egypt the sky was the goddess Nut, whose body arched over that of her husband, the earth deity GEB. Nut and Geb were separated by their father SHU, the atmosphere.

In Christianity, the sky is related to the mantle of the VIRGIN MARY, decked with STARS.

A

B

C

## Wind

The different winds are each represented by individual deities in many cultural traditions. The deities are usually considered to blow the winds (A). As the weather brought by winds from different DIRECTIONS varies according to the local climate, so each wind carries different meanings for different cultures.

The Ancient Egyptians believed in FOUR winds, ruled by SHU, god of AIR. The North wind brought refreshment to the DESERT and 'came from the throat of AMUN', while SET was connected with the destructive hot DESERT wind. To the Ancient Greeks and Romans, the North wind was Boreas (B) (Aquilo in Rome); the South wind Notus (in Rome, Auster); the East, Eurus; and the West, Zephyris (in Rome, Favonius). Each had their own characteristics. To the Native American Tsimshian of the North-west Coast, the Four Great Winds (South, East, West and North) were the great chiefs of the four corners of the world who, after contention as to how their powers should be balanced in the world, established the four SEASONS.

In the traditional Chinese system of feng shui ('wind and water'), wind direction is one of the elements studied by geomancers in the siting of buildings, graves and other features. The Chinese identified EIGHT different winds, venerated as deities. The Chinese compilation of divinatory texts, *Yi jing* (*I Ching*) – the earliest traceable part of which, the *Zhouyi*, perhaps originated as long ago as the Chinese Bronze Age – states that 'wind follows the TIGER': using the system whereby animals embodied the four directions, wind was thought to be created by the WHITE TIGER of the WEST (C). Later, the deity Fei Lian was believed to create winds by letting them out of a SACK, just as the Japanese god Fujin kept the wind in a sack. In the Shinto religion of Japan, the wind (in common with other natural phenomena) was seen as a *kami* or deity, while folk beliefs referred to it as a *bakemono*, a type of monster.

The Celts believed that different types of wind foretold the weather that would come. They were often named after the colours of the prevailing light and became an effective way of passing on weather lore, especially for sailors. There was also a land 'at the back of the North Wind' in which Mother Carie lived, another form of the ancient crone of winter.

In Maori culture, strong winds and storms are symbolized by the god of wind TAWIRI-MATEA: they are his revenge upon his disobedient brother TANE-MAHUTA (god of mankind and forests), who separated their parents to create light.

According to some Native American tribes, the wind can talk: Wind's Child whispers to the heroes of Navajo stories, while the Ojibwe recall when all the winds had voices, although now they can only make a noise through other objects.

## Cloud

Clouds are associated with RAIN, and thus fertility; in traditional Chinese culture, by extension, they denote plenty and happiness. Clouds shown with RAIN or a DRAGON are a symbol of SEXUAL UNION, while coloured clouds are particularly good omens; a RED cloud is said to have accompanied LAOZI, the founder of Daoism.

The FIVE Chinese elements are said to have been handed down from five sacred MOUNTAINS upon wispy dawn clouds, and clouds are the vehicles of many Chinese deities. They also conceal the divine: Christians often depict God as a hand emerging from a cloud, and in Ancient Roman myth JUPITER seduced the nymph Io under cover of thick cloud in order to escape JUNO's notice. Therefore clouds can symbolize mystery, leading either to confusion or to rapturous surrender to the divine will.

The Maori call New Zealand Aotearoa, 'Land of the Long WHITE Cloud'.

## Rainbow

Rainbows appeared after the FLOODS of the Mesopotamian *Epic of Gilgamesh* (mid-7th century BC) and the Bible (Genesis), symbolizing, respectively, ISHTAR's many-jewelled necklace and God's promise not to destroy humankind again.

Freemasons associate the different colours of the rainbow with the different degrees and orders; combined, they represent the unity of all life to be found in Freemasonry. For some Native American tribes, the rainbow symbolizes the coming together of all tribes, the 'rainbow people' – a term now used in South Africa with the same meaning.

In Nordic traditions, a rainbow BRIDGE led to the realm of the gods. The Navajo believe that the rainbow is a BRIDGE between the human and SPIRIT worlds. The Ancient Greeks personified the rainbow as IRIS, a messenger of the gods. In Dahomey, the rainbow SERPENT represents the kingdom and its prosperity; in Aboriginal Australia it created land; in Southern Asia and tropical Africa it holds back rain.

## Aurora Borealis

The Northern Lights are named after the Ancient Roman dawn goddess AURORA and her son Boreas, the NORTH WIND. The Celts believed it was the goddess ARIANRHOD's revolving castle behind the North Wind, where WARRIORS, bards and DRUIDS resided after death, awaiting rebirth.

Native Americans of the North believed that the aurora were shining PATHWAYS lit by the torches of their dead ANCESTORS, which led to a hole in the DOME of the SKY through which the SPIRITS of the dead could escape into HEAVEN. The Algonquin tribes tell how Nanabozho, a TRICKSTER and creator figure, left for his abode in the North after completing his task of teaching the plants, animals and humans how to live. He promised to watch over the humans and, as a sign of his protection, sent the aurora borealis for all to see.

A

B

C

# Fire

Fire's vital warmth enables mankind to survive in cold and harsh climates. It also transforms everything it touches, from food to ceramics to METAL, making it a powerful symbol in all cultures. In Chinese and Hindu cosmology fire is represented by a RED TRIANGLE; in Western alchemy and hermeticism, it is represented by an upward-pointing triangle (A).

Fire comes from the HEAVENS, and was often stolen: by Prometheus in classical mythology, or by a TRICKSTER figure for some Native American tribes (for others, fire was given to humankind by a celestial being). The Dogon of Mali believe that a piece of the SUN was stolen in defiance of God.

Native American fire medicine is concerned with passion for life, spontaneity, vitality and sexuality, and fire protects many practitioners when in a magical trance. The Hindu fire god AGNI represents the practical use of fire for light and heat, and to purify and consume the dead. Fire is

fundamental to Hindu and Zoroastrian rituals, and the maintenance of a perpetually burning fire was central to the rituals associated with the Aztec god of fire, Xiuhtecuhtli. Fire also plays a part in many Japanese ceremonies such as the Bon festival, where fires guide the SPIRITS of the ANCESTORS back to earth and send them on their way again. In China, where the words for 'fire' and 'living' (*huo*) are phonetically identical, bonfires are lit at New Year to honour the god of wealth. Bone fires (hence bonfires) symbolized the SUN at Celtic solar festivals, while the Bale fire was lit at Beltane or May Eve.

Fire was one of the FOUR elements found in Ancient Greek philosophy, and was held to be hot and dry. Linked in astrology with ARIES, LEO and SAGITTARIUS, its characteristics are vitality, action, intuition and enthusiasm. Alchemically, it fuels the Work. Alchemical symbols show it encircled in a triangle (B) or as a sign similar to the letter M (C); hermetically, it represents the SOUTH, the ARCHANGEL Michael,

SUMMER and noon. Similarly, it is related to the South and summer in traditional Chinese cosmology: it is one of the FIVE elements, and is related to the number TWO and FEATHERED creatures. A design of flames is one of the 'TWELVE Ornaments' found on the Chinese imperial robes, symbolizing zeal.

Fire is dangerous: the Ancient Egyptian god SEKHMET scorched the earth and tried to destroy humanity when RA wished to remove its corrupting influence. In the Christian tradition, HELL is full of flames that consume sinners for all eternity.

However, fire can symbolize regeneration too: hence the PHOENIX, born from flames, and the lizard-like elemental SALAMANDER, which feeds on fire in classical mythology. Setting fire to the ground is an established way of reviving it in Aboriginal Australia: the 'fire dreaming' at Warlukurlangu was created by the BLUE-TONGUED LIZARD Man to punish his selfish sons; it was followed by a torrential RAINFALL that brought new plants and flowers to the area.

## Flame

The silent and steady glow of a CANDLE flame in a Christian church symbolizes silent prayer and attentiveness to God, while an intense flame in the HEART is associated with passionate love of the divine, mysteriously able to consume the ego without destroying the self (as the burning bush burned but was not consumed before MOSES).

Faces on Celtic statuary occasionally sported a mark showing a triple flame in the form of three lines converging at the bridge of the NOSE from the forehead; this was said to indicate *Arwen*, or divine inspiration. The imprint of a triple flame also marks the places where BRIGID's feet touch the LAND as she crossed it in SPRINGTIME.

In Ancient Rome the flame of Vesta, the goddess of the HEARTH, was considered to be so important that it was kept constantly alight by the Vestal VIRGINS.

## Smoke

As it rises into the sky, the smoke from sticks of incense and burnt offerings is a medium through which the prayers of the devout can ascend to the gods.

The Jews used smoke to create a VEIL; it was thought that this would protect the faithful from seeing the Holy of Holies (the inner sanctum of the Temple) directly when it was opened on the Day of Atonement. It also symbolized the arrival of visions (in the form of the Vision SERPENT) in Maya kingship rituals performed by the ruler and his wife, in which strips of paper stained with the ruler's BLOOD were burnt to initiate the visionary phase of the ceremony.

Smoke can sometimes be used as a means of communication, as in Native American smoke signals. When Catholic cardinals are in conclave in the Vatican to elect a new pope, WHITE smoke indicates that an election has led to a final decision, while BLACK smoke indicates that the process has been inconclusive.

## Thunderbolt

Thunderbolts (or lightning bolts) often symbolize angry intervention or retribution by the gods. They are a primary attribute of many SKY gods, such as JUPITER. Thunderbolts are represented by an S-shaped motif on the clothes of Romano-Celtic SUN or SKY deities, and by HAMMERS (above) such as the hammer held by THOR. A hammer or AXE also symbolizes thunder in some African cultures, such as the cult of SHANGO. In Benin, where thunderbolts are important symbols of kingship, they are shown as brass PYTHONS zig-zagging down from the turrets of the ancient city of Benin.

The Ancient Chinese told how the first thunderstorms of SPRING were caused by DRAGONS flying into the SKY after hibernating on the earth. In Hinduism and Buddhism, a thunderbolt (*vajra*) is of DIAMOND hardness, able to shatter wickedness; it embodies the divine strength of the BUDDHA's doctrine. It is double-ended, symbolizing its destructive and creative powers.

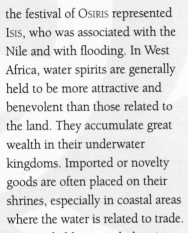

## Water

Water is widely associated with fertility and renewal; sometimes shown flowing from a vessel (A), it is a constant source of refreshment.

Water was one of the FOUR elements of Ancient Greek philosophy; unsurprisingly, it was considered to be cold and wet. Some Ancient Greeks believed that the world was given form out of water, and in various Near Eastern myths the CHAOS out of which everything was created takes the form of water.

Water is also one of the FIVE elements of traditional Chinese culture, and is associated with the number ONE, depth, WINTER and the NORTH, and represented by an upturned SILVER CRESCENT (as it is in Hinduism, C). It embodies the YIN or FEMALE principle, and so in Chinese paintings, flowing water (yin) is frequently contrasted with the changeless nature of ROCKS (YANG). It is fundamental to the geomantic system feng shui, 'the WIND and the water'.

In the hermetic tradition water is placed in the WEST, and is connected with the ARCHANGEL Gabriel, AUTUMN and twilight. Astrologically, it is linked with CANCER, SCORPIO and PISCES, which are imaginative, emotional and intuitive. Alchemical water (symbolized as an inverted TRIANGLE, B) is considered to be the 'universal solvent', but it is not ordinary water, and has unusual properties, such as not wetting the hands. It is also known as alchemical MERCURY.

Many water deities are associated with fecundity and life-giving properties, such as the Norse Vanir deities. Japanese water deities, *suijin*, were invoked to help with RICE-growing. In Greco-Roman myth nymphs were associated with land-locked water, whereas in traditional Chinese culture DRAGONS are associated with all bodies of water. Nile-water was considered to be sacred by the Ancient Egyptians: it was essential to life and agriculture, and many Egyptian rituals aimed to propitiate the RIVER's seasonal rise and fall. The vase of water carried at the head of the procession on the festival of OSIRIS represented ISIS, who was associated with the Nile and with flooding. In West Africa, water spirits are generally held to be more attractive and benevolent than those related to the land. They accumulate great wealth in their underwater kingdoms. Imported or novelty goods are often placed on their shrines, especially in coastal areas where the water is related to trade.

Water held a special place in the Celtic tradition, reflecting images from the Otherworld. RIVERS were associated with goddesses, while LAKES had underwater kingdoms.

Water is used in many cultures for ritual purification, whether poured on to an object or used to wash the body. Christianity emphasizes its powers of spiritual transformation: specially blessed 'holy water' is used in BAPTISM, in imitation of ST JOHN THE BAPTIST's baptism of CHRIST. In Islam, water is the most blessed of substances, used for ritual ablutions, and, in the WELL of Zamzam, symbolizing Allah's unceasing compassion and benevolence.

A

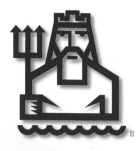

B

C

## Sea

A primeval sea (A) was the source of all creation for the Ancient Egyptians and Jews, and in the first Japanese chronicles the sea was the primeval mass from which the deities IZANAGI AND IZANAMI, standing on the BRIDGE of HEAVEN, made the first land.

The Sumerians, Babylonians and the earliest Greeks believed that an ocean encircled the world, and flowed into the SKY; it was embodied in the Greek deity Oceanus, who eventually retired as the sea god to make way for his nephew POSEIDON (B).

The sea can appear to be another world or kingdom: the Celts believed that their shores were beaten by waves emanating from a mysterious place. The NINTH wave was said to mark the boundary between the kingdoms of the sea and the land; to hear it call you portended your death. In coastal areas of Japan, the SPIRITS of the ancestors are symbolically returned at the end of the Buddhist festival of Bon by floating LANTERNS representing their SOULS out to sea;

historically, fishermen would not sail on this 'tide of the returning ghosts', when the sea joined this world to the next.

Mysterious kingdoms may lie beneath the waves, such as the kingdom of the Irish sea god MANNANAN (whose Welsh counterpart is Llyr). This was where the *silkie* (beautiful FAIRY seal WOMEN) lived, shedding their coats from time to time to lure unsuspecting men to their deaths, like MERMAIDS.

The mythical Chinese and Japanese sea gods or DRAGON KINGS, whose wrath was responsible for storms (C), had PALACES at the bottom of the sea, described as beautiful magical places where lost TREASURE could sometimes be found. In one story, the Kusanagi SWORD – one of the THREE Japanese imperial regalia – was retrieved from the sea god.

The mythical Chinese EASTERN Sea or the Sea of Happiness contained the fabled ISLANDS of the Blessed, home to the EIGHT IMMORTALS. The sea was therefore linked with immortality.

In Hawaiian folklore the sea is called Kai Holo-o-ka-I'a (Ocean Where the FISH Run); there are countless Hawaiian proverbs and sayings to do with things relating to the sea, sailing and fishing.

In some alchemical pictures, the sea symbolizes the MERCURIAL sea, which concerns the transformative and subconscious function of the FEMALE energies. Some illustrations show a sea of MERCURY created from the MILK (WHITE) and BLOOD (RED) of a VIRGIN; this is linked with the amniotic fluid. A drowning KING depicted within this implies the stage before a state of rebirth, death and the first gasp of BREATH. For Christians, the sea (Latin *mare*) is the BLUE mantle of the VIRGIN MARY, the accommodating form of the regenerative MOTHER.

### Flood

Floods are seen as divinely ordained events. They can bring life: the annual flooding of the land by the Nile, believed by the Ancient Egyptians to be directed by the god HAPY, fills ditches and brings fertile silt. Or they may bring death and be signs of divine wrath: the Judeo-Christian Flood destroyed all humanity save Noah and his family, and symbolized God's retribution. (The story probably derives from the Babylonian *Epic of Gilgamesh*; both are similar to the Ancient Greek myth of the destruction of Atlantis.) Some Native American tribes believed that the great flood was sent by the Great SPIRIT because humans had broken the sacred laws, and the Ancient Chinese believed that floods signified divine displeasure with the country's rulers.

The Celts saw floods as the Otherworld encroaching onto the LAND, relating to the myths of the inundation of sacred places such as Lyoness (Cornwall), Ys (Britanny) or the land beneath Cardigan Bay in Wales.

### Lake

In Greco-Roman mythology lakes represented entrances to the UNDERWORLD: Aeneas descended into Hades from Lake Avernus (near Naples).

The Celts believed lakes to be inhabited by FAIRY WOMEN or otherworldly KINGS. The SWORD given to ARTHUR by the Lady of the Lake may have been related to the Bronze Age swords that have been found in lakes, apparently thrown in as offerings or upon the death of their owners.

Many Ancient Egyptian temples had a rectangular sacred lake in the outer precincts, representing the primeval ocean of NUN, and these were used to purify those visiting and working in the temple. A famous stele of the 'internal body map' in the Daoist WHITE CLOUD Temple in China depicts the human body as a landscape and foetus. In the head, a lake – representing the 'sea of marrow', the brain – reflects the night SKY, symbolizing the mind's ability to receive or reflect the HEAVENLY realms like a MIRROR.

### River

Because river-WATER sustains life, many river gods represent fertility and prosperity. The Nile was central to Ancient Egyptian religion, while the African Ashanti culture's most important gods are river gods. Hindus consider the Ganges, Jamna and Saraswati rivers to be the veins and channels of the body of Mother EARTH, promoting fecundity and life; the Ganges, descending from the abode of SHIVA in the Himalayas, is thought to be the most sacred. In parts of Africa, riverbanks are considered liminal zones where the river gods can be contacted.

Rivers are also associated with the UNDERWORLD: in classical mythology Hades had FIVE rivers which represented hate, woe, FIRE, wailing and forgetfulness. The Norse underworld contained a river called 'Fearful' or 'Resounding'. In Christian allegory, a river flows from the EAST of Eden, splitting into FOUR rivers which represent the gospels of the four evangelists, Matthew, Mark, Luke and John.

## Spring

Springs are a vital source of life-giving WATER for small communities. Long ago, they were seen as the homes of local deities, and the sites for offerings and petitions in Europe (where the deities became SAINTS), suggesting that spring-water flowed from the Otherworld. The Nile was believed to originate in a spring rising from the Ancient Egyptian UNDERWORLD. In the Cameroon, underworld deities and royal ancestors travel along underwater springs.

Springs, particularly hot ones, are often associated with healing. The Japanese believed that the first water drawn from a WELL or spring on New Year's morning would repel illness and bring good fortune. In China, the springs on the mythical MOUNT Kunlun and the ISLANDS of the Blessed brought immortality.

Christians associate the action of MOSES, in striking a ROCK to create a spring for the Israelites, with ST PETER, 'the rock'; a spring symbolizes prayer, which refreshes the SOUL.

## Well

Japanese legends link wells with unusual happenings and encounters with monsters or deities, while Japanese and Chinese legends also connect them with the capture of supernatural beings, and death.

Wells are frequently connected with WOMEN, who usually bear the brunt of fetching WATER and as indicated later are also a symbol of birth. The Chinese use 'well' as a term for the VAGINA, and in Western alchemy wells represent the birth canal. The depiction of the SUN falling into a well may thus indicate the duality of birth, when one also falls back into the earth.

For Christians, a well can symbolize the depths of prayer required to savour the fresh water of the divine. In Islam, the well of Zamzam (a few metres from the KA'BAH) was created by the ANGEL Jibril to sustain Hajira (Hagar) and Ishmael; its waters bestow blessing and symbolize Allah's infinite mercy.

## Rain

As WATER that falls and irrigates the crops, rain is strongly associated with fertility. ZEUS, the Greek god of SKY and weather, transformed himself into a shower of GOLD to seduce Danaë, imprisoned under ground by her jealous father; she gave birth to the hero Perseus as a result of their union.

Although Native American tribes DANCE for many reasons, in the south-western deserts where rain is rare and precious, Pueblo people often say 'we dance for rain' as, without rain, the 'THREE sisters' – corn, squash and BEANS – will die and the people will not be fed. According to the Zuni people of New Mexico, different rain priests are associated with each of the FOUR DIRECTIONS. For other tribes a prayer from the south-west calls to Father SKY and Mother EARTH to weave a garment of brightness for the people, with fringes of falling rain.

WATER

## Cracked Ice

The motif of cracked ice and flowering prunus was popular on Chinese porcelain of the Kangxi period (AD 1660–1722); together they represented the end of WINTER cold and the first signs of SPRING and renewal. A Chinese marriage broker was said to 'crack the ice' between a prospective couple.

## Dew

In Ancient China, dew, when drunk, was believed to help those who drank it obtain longevity. In both China and the West it was believed that the MOON created dew, which can be depicted as drops of WATER falling from the moon in alchemical illustrations and on Tarot cards.

## Ford

For the Celts, fords represented the boundaries between worlds. The WASHER by the Ford was a mysterious ghostly FEMALE figure awaiting the dead, washing their shrouds. In the medieval Welsh *Mabinogion*, the 'Tale of Pwyll' recounts how the eponymous hero, the Prince of Dyfed, met Arrawan, lord of the UNDERWORLD, by a ford, and they swapped each other's kingdoms for a year and a day. Many Celtic tales tell of battles by fords, which may symbolize the battles between forces of LIGHT and darkness. Alchemically, fords could symbolize the division between two forms of consciousness.

## Earth ∗ Clay

Earth was one of the FOUR elements of Ancient Greek philosophy, considered to be cold, dry and MELANCHOLIC.

Astrologically (B) it is linked with TAURUS, VIRGO and CAPRICORN, to which it gives the characteristics of practicality, pragmatism, cautiousness, materialism and deep emotional understanding, but also a lack of empathy. In the hermetic and alchemical traditions earth represents the first material (*prima materia*); it is described as BLACK earth, believed by some to be Nile silt. BLACK earth has been called the 'ground of the SOUL'. Represented as a downward-pointing TRIANGLE divided in two by a horizontal line (A), earth was also related to the ARCHANGEL Uriel, WINTER and midnight.

Earth is one of the five elements of Chinese tradition, corresponding with the number FIVE and the centre of the world, and depicted by a YELLOW SQUARE, as it also is by Hindus. Earth also embodies the passive FEMALE essence of YIN.

Earth is often related to fertility: it was associated in Norse myth with the cult of the Vanir, who represented those powers. One of the most important duties of the Chinese emperor was the ritual ploughing of a furrow at the beginning of the lunar year to ensure good harvests. There is, therefore, a frequent correspondence between the earth and MOTHER deities (C). The Greco-Roman Gaia/Tellus personified mother earth; she was the successor to CHAOS and mother to Antaeus, who was vanquished by HERAKLES when the hero held him aloft, breaking his physical connection to the maternal life force. Christian allegory associates earth with mother, matter and matrix (which share a common etymology), the fundamental material from which man was made. Similarly, the Ancient Egyptian fertility god KHNUM made humans from clay as if potting them on a WHEEL; Osanobua (the father of OLOKUN, WATER deity of the Edo kingdom of Benin) formed the first humans from riverbank clay; the Ancient

Chinese creator goddess Nü Gua formed the first humans out of earth; and Yahweh made ADAM from dust. Even the mortally (but magically) created GOLEM was made of clay. Gods, too, can be created from the earth: the earth mother PAPATUANUKU or Papa ('ROCK') symbolizes the earth for the Maori, who tell how Papa lived in the darkness with her husband RANGI, the SKY father. They came out of nothing and when they embraced in the night, seventy male children were born, and became the gods from whom all Maori are descended. The Norse earth goddess, Jord, was said to be the mother of THOR, the SKY god.

## Rock

Certain rocks have long been considered sacred, as the centuries of paintings on rocks such as Uluru (Ayers Rock) in Australia testify; this tradition continues today in Africa and Australia. Churches and temples have been cut into rocks in many countries, such as Ethiopia, Turkey (Cappadocia) or Jordan (Petra). The Dome of the Rock is one of the holiest places in Jerusalem: it is built over the rock on which ABRAHAM prepared to SACRIFICE his son, SOLOMON built his Temple, and from which Muhammad ascended to HEAVEN.

A rock symbolizes stability, permanence and security for Daoists and Christians: it is a symbol of ST PETER (Petrus), the first pope, the rock upon which CHRIST founded the Church.

In Greco-Roman mythology, Sisyphus perpetually pushed a rock up a hill in Hades, only to see it roll down once near the top. His punishment was interpreted as man's endless struggle to overcome his material desires.

EARTH • GEMSTONES

## Stone

The Celts believed that megalithic stone CIRCLES and standing stones were sacred: round stones with holes in their centre (above) were used for healing and fertility rituals. Some stones contained an animate presence; others were created from transformed animals or humans, like Niobe, turned into a perpetually WEEPING stone after her children's slaughter. In China and Japan beautiful stones from RIVER-beds might hatch into DRAGONS, while special stones were used to invoke RAIN and to bring (male) CHILDREN to women.

Meteorites, falling from the sky, are especially venerated: the Black Stone, the focus of Islamic pilgrimages to the KA'BAH, is thought by some to be a meteorite. The Greco-Roman mother goddess Cybele was worshipped in the form of a meteorite. The priests of SHANGO, the Yoruba god of thunder, carry sacred stones thought to be created by LIGHTNING; stones in the Roman Temple of Capitoline JUPITER were believed to be petrified thunderbolts.

## Ashlar

Early Jewish sacrificial altars were made from an ashlar (large square-cut building stone) carved in the form of a CUBE, with FOUR pinnacles or HORNS placed at the corners.

The Ancient Egyptian hieroglyph for 'ashlar' means 'that which is being worked upon', while in Freemasonry a rough ashlar (shown as a roughly shaped and square CUBE of freestone, still in the quarry) represents the rude and natural state of people before education has worked upon them. Applying the tools of education will make them polished – disciplined, knowledgeable and cultured so that they become like the perfect, cubed and smoothed ashlar, and are fit to take their place in the building and fulfil their part in the plan. The contrast between rough and smooth therefore represents the Mason's education. An ashlar also symbolizes a TOMB, the SOUL entrapped in matter. After purification, glorification and transmutation, it becomes a temple fit for the KING.

## Diamond

The diamond is the hardest of all stones, and it is also the most highly prized. A clear stone, it is traditionally worn cut throughout Europe, where the rough or uncut stone is a metaphor for hidden riches; in India, it is valued more when uncut, and is associated with the planet VENUS on the NINE-gem JEWELS (which are called *navratnas*). More generally associated with eternity and everlasting love, it is the traditional stone of wedding RINGS.

Buddhist symbolism frequently plays upon the pure, hard qualities of the diamond: one of the SEVEN auspicious signs on the FEET of the BUDDHA was the diamond MACE (*vajra*), a THUNDERBOLT that had hardened to diamond toughness falling from the SKY. It had the power to destroy all delusions. In Japanese esoteric Buddhism, the wisdom of the Buddha is revealed in the diamond or thunderbolt realm.

## Ruby

A precious stone, ruby takes its name from its colour (Latin *ruber*, RED), which has long linked it with FIRE and the planet MARS: it was thought to be capable of boiling or melting wax. Hindus know the ruby as the LOTUS passion, considering it to be a particularly significant stone; it represents the SUN on the NINE-gem JEWELS (*navratnas*) of India. In Ceylon, rubies are called the TEARS of BUDDHA. Chinese alchemists associate rubies with the HEART; for Christians, they symbolize glory.

Rubies, like sapphires, can contain 'STARS'. These are foreign micro-crystals, which appear as delicate shimmers of silvery light that form six-pointed stars. Such stones are highly valued and are considered to be especially lucky; as SIX is the number of VENUS, they are also believed to be powerful love charms.

## Sapphire

The clear BLUE sapphire, a precious stone, has often been related to the HEAVENS and enlightenment. Jews tell how the throne of God is made of sapphire, as were the tablets on which the Ten Commandments were carved. Kabbalists believe that the ANGEL Raziel revealed the divine mysteries to ADAM from the mythical *Book of Sapphire*. For Christians, the sapphire symbolizes wisdom and chastity, and it is used in cardinals' RINGS. Indians associate sapphires with SATURN, the planet of wisdom, on the NINE-gem JEWELS (*navratnas*).

Like the RUBY, the sapphire can contain a six-pointed STAR. The most famous of these sapphires was the Star of India, also known as the Stone of Destiny. As with rubies, such sapphires are considered lucky, while the association of the number SIX with VENUS renders them powerful as love charms.

## Emerald

Emerald, a precious stone, is clear and GREEN like the sea, and so is associated with the love goddess APHRODITE in Greco-Roman mythology, but with MERCURY on the Indian NINE-gem JEWELS (*navratnas*). It is thought to have been worshipped by the Inca, while Indians and Ancient Egyptians used it to form the EYES of gods and goddesses in images.

Egyptian emerald amulets engraved with the papyrus SCEPTRE were emblematic of eternal youth. To the Romans, emerald RINGS symbolized resurrection when placed on the fingers of dead VIRGINAL girls, a meaning retained in Christianity; the papal ring of office contains an emerald.

Hermeticists believe that the Holy GRAIL was cut from an emerald that fell from SATAN's crown during his battle with the ARCHANGEL Michael, while the sacred texts said to have been written by HERMES TRISMEGISTUS were called the *Emerald Tablet*. Emeralds could heal EYES – Nero used an emerald eye-glass.

## Topaz

Topaz means 'FIRE' or 'heat' in Sanskrit, which may be the origin of this polished YELLOW stone's name. For Ancient Egyptians topaz represented the SUN god RA; it was used as a life and fertility symbol. In the Western hermetic tradition it also represents the power of the sun and priests.

## Amethyst

Amethyst is a clear PURPLE precious stone. The Ancient Greeks believed that it enhanced its wearer's sobriety, but when used in Christian bishops' RINGS it symbolizes communion WINE. Jewish priests wore it to denote spiritual power. It is associated with the planet MERCURY because mercury gives off a purple vapour at high temperatures. It also protects against sorcery and poison.

## Crystal

Quartz crystal (or rock crystal, the clearest form) ranges from clear to milky-WHITE, and is faceted. The Ancient Greeks named it *krystallos*, 'ice', because they thought that it was WATER forever hardened into ice by the gods – a belief shared with the Ancient Chinese, for whom it formed one slope of the MOUNTAIN home of the mythological RULERS OF HEAVEN.

In Japan small rock crystals were traditionally believed to be the congealed breath of the WHITE DRAGON; larger and more brilliant crystals were the saliva of the VIOLET Dragon.

In Renaissance paintings, orbs of crystal that are held by CHRIST represent the world. Rock-crystal balls are also traditionally used for seeing into the future. The rock from which many British Bronze Age standing stones are hewn contains a large element of quartz-bearing rock, suggesting that it was chosen for sacred reasons.

## Bloodstone

Bloodstone, an opaque GREEN quartz with RED spots, symbolizes the BLOOD of CHRIST; from which it was said to have formed as blood dripped from his wounds. In Ancient Greece it was known as heliotrope ('turning to the SUN'), as it was believed that the red spots reflected the sun within the earth. Gladiators wore bloodstone talismans (above) for protection.

## Carnelian

Carnelian is an opaque, rich REDDISH-BROWN semi-precious quartz. The Ancient Egyptians associated it with death and the BLOOD of ISIS; they reputedly engraved the *Book of the Dead* onto carnelian, and placed carnelian AMULETS engraved with the TET around the necks of the dead to secure Isis's protection.

## Jade

Jade is a hard, opaque, light-GREEN stone, highly prized in Ancient China and Mesoamerica. The Chinese associate it with immortality, sewing it onto burial garments and placing it in the MOUTHS of the dead to prevent decomposition. A wide range of admirable qualities were also attributed to jade, such as excellence, purity, charity, wisdom and courage, and it embodies the YANG principle today.

Mesoamericans prized jade above GOLD or SILVER, and it was reserved for important ceremonial objects. It symbolized vegetation, WATER and RAIN due to its green transparent colour, but it also represented BLOOD.

Greenstone jade is common to New Zealand, where it is used to make traditional weapons and carvings invested with spiritual prestige, such as the neck pendants made in the shape of a man called *hei-tiki*. These are said to contain the wisdom of the ANCESTORS, and are handed down through the generations.

## Garnet

Garnets may be any colour from RUBY RED to YELLOW, and are usually polished. Their name comes from the Latin for POMEGRANATE, as they resemble pomegranate seeds; they are also called carbuncles (from the Latin for 'little coal'). The colour of red garnets connects them to BLOOD and the planet MARS; they may be confused with rubies.

## Jacinth

A form of the mineral zircon that varies in colour from RED to YELLOW, jacinth is also called hyacinth, and so is related to the flower of the same name. This flower sprang from the BLOOD of the Ancient Greek youth Hyacinthos after he was accidentally killed by his lover APOLLO.

## Agate

Agate, a form of quartz, is usually polished. Agates may have multi-coloured bands, spots and markings, each with its own meaning. Moss agate, clear with a GREEN moss-like colouring, is universally considered to be the most powerful, giving strength, health and riches. In the first stage of alchemy (the NEGRIDO), the *prima materia* is traditionally pulverized in an agate mortar.

## Jasper

Jasper, a form of quartz, occurs as an opaque RED, BROWN or GREEN stone. Medieval Europeans and some Native American tribes believed it could be used to bring RAIN; Native Americans also use it as a divining stone. It was said to have been used to build the walls of the celestial CITY of Jerusalem.

G E M S T O N E S

## Opal

The opal is a multi-coloured gem whose colours can range from milky-WHITE to GREENS, BLUES and roses. Its composition – it comprises up to 30 per cent WATER – gives it some unusual qualities: it will become translucent if held in water, it becomes more colourful in the warmth of the HAND, and it is also very brittle and can only be polished, not cut. Its changeability has led to it being seen as a mystical stone. It also has the reputation of being unlucky. In Sir Walter Scott's novel *Anne of Geierstein* (1829), an opal worn by Anne's grandmother, Hermione, lost all its colour and life when splashed with holy WATER; soon afterwards, Hermione became ill and was found later as just a pile of ASH.

In Australian Aboriginal lore, a creator spirit is believed to have come down to earth on a RAINBOW. Where the sacred rainbow touched the ground, the rocks and pebbles became the first opals.

## Lapis Lazuli

Lapis lazuli is a deep BLUE metamorphic stone, speckled with flecks of GOLD or pyrites, which link it to the STARRY HEAVENS. The Ancient Egyptians believed that its origins were sacred and heavenly; it was mainly used by royalty and priests. It was often used in jewelry carved into the shape of a SCARAB beetle in order to invoke the protection of the SUN and the heavens for the wearer. It was also carved into the shape of an EYE, ornamented with GOLD: this was related to the sun god RA, and symbolized the ability to see the truth.

Lapis lazuli has, for a very long time, been associated with FEMALE divinities. The Sumerian mother-goddess INANNA, for example, wore a CROWN of lapis lazuli. Ground up and processed into ultramarine pigment, it was often used in Renaissance paintings to depict the blue of the VIRGIN MARY's cloak.

## Turquoise

Turquoise is an opaque, polished, semi-precious stone found in every colour between greenish-BLUE and deep GREEN. It was sacred to the Mesoamericans from Toltec times (AD 10th century onwards); they used it to decorate religious statues and in grave goods. The Aztec's war and SUN god was Huitzilopochtli, the Turquoise Prince, whose weapon was a turquoise SNAKE; their fire god Xiuhtecuhtli, the Turquoise Lord, was dressed in turquoise.

Turquoise is respected as a stone of protection by many Native Americans. For the Pueblo Indians of New Mexico, it symbolizes the SKY, the BREATH of life and the SPIRIT. It is particularly valued by the Navajo people, who are well known for their beautiful BELTS and jewelry of SILVER-work and turquoise. It is sacred to them because it is the precious stone associated with Mount Taylor in New Mexico, which, as the MOUNTAIN of the SOUTH, is one of four mountains that are sacred to the Navajo. It is also associated with the BLACK GOD.

## Amber

Amber – clear, ORANGE-BROWN, polished fossilized resin – often contains trapped BUBBLES. Its colour allies it with the SUN: the Ancient Greeks believed it was the TEARS of the SUN-charioteer Phaeton's sisters. It is warm to the touch and produces static electricity when rubbed, so they also believed it to have healing qualities. The Chinese believe that when a TIGER dies, its SPIRIT becomes amber, which symbolizes bravery.

## Peridot

Peridot is a transparent, olive-GREEN, semi-precious stone. It also exists in a YELLOW form, in which it was used by the Ancient Egyptians, who believed that it was a TOPAZ because of its colour, and therefore linked peridot to the SUN.

## Moonstone

A milky semi-precious stone with a pearly sheen. The Ancient Romans believed that it was sacred to DIANA, the MOON goddess. According to the elder Pliny (AD 23–79), it was believed to contain an image of the moon, which waxed and waned with its heavenly counterpart.

## Jet

Jet, actually a compressed form of coal, is shiny and BLACK; its colour connects it astrologically with the planet SATURN. The Ancient Greeks dedicated it to Cybele, goddess of the EARTH. It was worn by Ancient Romans and during the Middle Ages to ward off evil: Italian craftsmen carved it into prophylactic beetles, CROSSES or HEARTS. Its colour links it to death: Victorians used it extensively for mourning jewelry.

## Metal

In traditional Chinese beliefs metal is associated with the AUTUMN and with sorrow. In Daoism it is also linked to the QUEEN MOTHER of the WEST (XI-WANG-MU), who – among other things – is the guardian of immortality and rules over life and death; it is thus revered by Chinese alchemists.

Metal is sacred in many African religions; the shinier it is, the more power it is thought to contain. It is used to create the most sacred statuary, such as the heads of KINGS and QUEEN MOTHERS, ALTARS such as the altars of the HAND (Benin), and magical STAFFS (Mali). Metalworking is traditionally considered to be a MALE profession linked with death and sterility, as opposed to potting, which is both FEMALE and fertile.

In Greco-Roman mythology metal and metalworking were particularly associated with the SMITH god HEPHAESTUS, who was the first to forge metal.

A

B

C

METALS

## Gold

Gold is associated with divinity as it is incorruptible, neither rusting (like IRON) nor tarnishing (like SILVER), and it is also purified by FIRE. Ancient Egyptian texts described the flesh of the gods as being made of gold and their bones of SILVER (hence the gold masks of mummified royalty, B). For Christians, it is the purest and most valuable substance, associated with majesty, God and the SUN , and symbolizing all that is best.

Its incorruptibility means that gold often symbolizes immortality. The Ancient Chinese, therefore, put gold into the MOUTHS of the dead at burial, while the rich diluted it and drank it in the hope of prolonging their lives. Related to this is the way in which the fruit of immortality was often believed to be golden: the tree of life on Horaizan, the Japanese island of immortality, was supposed to have a gold trunk and branches, while the golden APPLES of the Nordic heaven, Asgard, prevented the gods from growing old.

Gold is also associated with the SUN and majesty, and is sometimes represented by the glyph for the sun (A). It features prominently in the regalia of monarchs. The gold on the golden STOOL of the Ashanti state symbolized the essence of the sun and life's vital force, making it essential to the king's power and wellbeing. As the sun never dies – unlike the MOON – gold symbolizes immortality to the Ashanti, too. In Ancient Egypt the sun god RA was particularly associated with gold, and was called the 'MOUNTAIN of gold that radiates to the whole world'. Hence the tips of OBELISKS and PYRAMIDS, which received the SUN's rays, were often gilded. The sarcophagi of the pharaohs were also gilded to signify their status as divine beings.

Gold is also linked to the highest aspirations of the spirit. In Buddhism, gold represents enlightenment: images of the BUDDHA (C) are gilded and the colours gold and YELLOW are sacred. The Ancient Jews used it to create the BREASTPLATE of Aaron the High Priest, the ARK OF THE COVENANT and the Menorah CANDELABRA. For alchemists, gold symbolizes spiritual enlightenment, and turning base metal into gold is a metaphor for the ultimate aim of the Great Work. In antiquity, the first race of pure and blessed mortals were believed to have lived in the GOLDEN AGE. In Greek legend, Jason, leader of the Argonauts, sought the Golden FLEECE in an arduous journey of spiritual purification.

Gold is also symbolic of wealth: for example, the BOAT-shaped ingots of gold depicted on Chinese New Year cards represent riches. Despite their spiritual aims, both Chinese and Western alchemists also maintained that they could achieve the physical transmutation of common substances into gold. Gold has been used extensively by Andean metalworkers since 2000 BC, and formed a significant part of the grave goods of Inca nobility.

## Silver

Although less effective than GOLD, silver was also considered to be related to the gods and to confer immortality. The Ancient Egyptian gods had silver bones. The legendary Japanese tree of life had silver roots, while Ancient Chinese alchemists used elixirs containing silver to help the drinker achieve immortality.

Used as currency and given in tribute, silver was a sign of wealth. However, it was also associated with treachery because of the thirty pieces of silver given to JUDAS for betraying CHRIST.

In the Western Classical tradition, the SILVER AGE was the second age of mortals created by the greatest god, JUPITER. The metal was associated with purity, FEMININITY and the MOON, to which it was linked because of its colour, and so it is sometimes represented by the moon's glyph. In alchemy, too, silver relates to the lunar, FEMALE energies. Its production was the goal of the first, transformative stages of the Work, known as the 'Lesser Work'.

## Copper

Copper is ORANGE-BROWN in its polished form and corrodes to form verdigris, which is GREEN. Both colours led to it being associated with the leaves of AUTUMN in the classical world, while its capacity to decay visibly links it with autumnal fruition and decay. The colour green was thought sacred to VENUS, so copper is linked to both the goddess and her planet and is sometimes represented using Venus's glyph (above).

The Chinese word for copper (*tong*) sounds the same as that for 'together', so in Northern China people often placed copper BOWLS and shoes in bridal beds in the hope that couples would grow old together. Chinese COINS were made of copper, and so it was believed that sinners in the eighth HELL were punished for making money in evil ways by being made to drink molten copper.

## Bronze

When bronze objects are first made they have a bright golden colour, and so can take on the symbolism of GOLD. Thus it has long been used for the creation of images of the deities, related symbols and ritual objects by Buddhists, Hindus and the Chinese; the latter, who consider it one of the most valuable materials along with JADE, also used it for weapons, musical instruments and MIRRORS. In Japan a bronze mirror is one of the THREE items of imperial regalia believed to have been presented by the gods of HEAVEN to AMATERASU OMIKAMI, the SUN goddess, who passed them down to the imperial family. The Chinese and Japanese both placed bronze items in burials.

In classical antiquity, the BRONZE AGE was the third generation of mortal men; terrible and warlike, they were the first to forge SWORDS and ploughs.

Bronze is an alloy of COPPER and tin and so it may be represented by the glyphs of VENUS and JUPITER.

M E T A L S

## Iron

Iron is strong and needs intense work to forge; this, and its RED rust, led the Greco-Romans to link it to the war god ARES; and so it is sometimes represented by Mars's glyph. They believed that the fourth generation of mortals, debased and brutal, constituted the IRON AGE, and associated iron with the UNDERWORLD.

In China, iron was represented by the colour BLACK and was considered to be a symbol of strength, determination and justice. As the 'iron tree' of South China was said to flower once every sixty years, iron symbolized longevity.

Some African tribes consider it to be sacred, having life force and the power to make things happen. In some Benin BRASS portrait heads it is used specifically for the EYES and inlaid in parallel strips on the forehead.

In folklore, iron has magical qualities: WITCHES, FAIRIES and vampires dislike it, while Chinese DRAGONS were said to hate it. 'Found' iron, for example a horseshoe, is considered lucky.

## Brass

Brass combines COPPER and zinc; it can be represented by the glyphs of VENUS and JUPITER, considered by alchemists to rule zinc as well as tin. Its colour allies it to GOLD. Alchemists considered it to be a fool's GOLD, because it gave off BLACKNESS, thereby revealing that it was not a true state of purity.

Brass is strong and never corrodes or rusts, and so symbolizes CHRIST's divinity. As a symbol of permanence in Africa, it represents the continuity of kingship in Benin, where it is used only for royalty. The Nigerian Edo describe it as 'RED', and consider it to be threatening; therefore they use it to drive away evil forces.

Brass was used for sacred implements in early Jewish culture: the brazen SEA, a brass basin on the porch of King SOLOMON's Temple, embodied the heavenly ocean; in the desert, God commanded Moses to make a brazen SERPENT and set it on a T-shaped pole to heal people who had been bitten by SNAKES.

## Mercury

Mercury is unusual in being a liquid METAL, hence it has also been called 'quick-SILVER'. It is represented either as WATER or the SEA. Its mobility relates it to the planet and deity MERCURY (the Ancient Roman messenger god), and it is sometimes represented by the planetary glyph, which resembles the god's CADUCEUS. In alchemy it is the metal of transformation, released from the *prima materia* and perfected throughout the Work.

In Ancient Chinese alchemy mercury was associated with the QUEEN MOTHER of the WEST (XI-WANG-MU). The Chinese believed that it gave immortality, so small amounts were imbibed with herbs and fungi. Mercury is highly toxic, causing insanity and even death. Thus, people who worked with it – for example alchemists and hatters (who used mercuric nitrate to lay the felt used in hats) – were often associated with madness.

## Lead

As one of the denser, heavier metals, lead often symbolizes a burden. Thus astrologers have associated it with the oppressive influences of the planet SATURN, whose glyph sometimes identifies it. For Christians it symbolizes the burden of sin.

In alchemy, its poisonous properties, density and dirty BLACK residue symbolize the lowest material state and the sinner's soul. However, it was also depicted as containing a DOVE, symbolizing its ability to release the SPIRIT and the 'WHITE STONE' after the dark state of the NEGRIDO and the white purifying state of the 'albedo' had taken place.

The heaviness and dull surface colour of lead has meant that it has often been associated with dullness of the mind, ignorance and stubbornness, while its poisonous nature led to the belief that it causes cold, damp, sickness and MELANCHOLY.

## Sulphur

Sulphur is a combustible element that typically occurs as yellow crystals. Alchemically, sulphur represented MALE energy. Its glyph combines the CROSS of EARTH with the TRIANGLE of FIRE. Compounds of sulphur can smell foul; in Greco-Roman antiquity sulphur was said to issue from the UNDERWORLD, while Christians associate its smell with Hell and the DEVIL. It causes imperfections – BLACKNESS and impurity – in metals. Cleansed and purified, it is identified with the power of the SUN and GOLD.

## Cinnabar

Cinnabar, a RED mineral, was the raw material from which MERCURY was obtained by Chinese alchemists; it, too, was capable of transmutation. The image above is an alchemical symbol; cinnabar may also be represented by Mercury's glyph. As an elixir (called DRAGON'S BLOOD in Japan), it was believed to prolong life. It was linked with the SOUTH.

## Lodestone

Lodestone, which is a naturally magnetized material, moves towards IRON; it symbolizes attraction and the power of love. Its name in Sanskrit means 'the KISSER'; in Chinese it is 'the loving stone'. A Greco-Roman tale told of how a lodestone statue of VENUS was seen to move towards an IRON statue of MARS.

METALS · MINERALS

M
I
N
E
R
A
L
S

## Salt

Salt is essential to health. Found in SEAWATER, and in ROCK salt on land, it is associated with the SEA and EARTH and thus with FEMALE energy. Alchemically, it was one of the philosophical elements, representing the corporeal. The alchemical symbol for salt is shown.

Salt's role in food preservation gives it cleansing and purifying powers; hence it is strewn on THRESHOLDS and floors after funeral services in Japan. In European folklore, salt is thrown over one's left shoulder if it is spilt or something unpleasant is experienced – 'throwing salt in the EYE of the DEVIL'. Likewise, Ancient Jews insisted on all SACRIFICES and meal offerings being salted before they were placed on the ALTAR. After the destruction of the Temple in Jerusalem, the Jewish home symbolized the altar, so salt is placed upon the table for all meals.

After the Ancient Romans demolished Carthage, they ploughed salt into nearby fields, poisoning the ground and symbolically obliterating the city.

## Oil

OLIVE oil was used in the Ancient Mediterranean to improve the body, cleaning it, preparing it for athletic contests and as a cosmetic: thus, it imbues youth and health. Similarly, in the Cameroon, women are ritually painted with PALM-TREE oil and powdered RED camwood to symbolize youth and fertility. An association with life, health and wealth led to palm-wood oil being rubbed onto portrait sculptures in the Kubu Kingdom of Kongo.

Used in lights, olive oil became synonymous with illumination; used in the eternal lights of synagogues, it became a symbol of spiritual power and illumination, and – from the more fragrant oils – of a life of sweetness and devotion. It is therefore used to ANOINT priests, KINGS and holy objects, and for consecrations, invoking God or CHRIST to empower the anointed, purify their SOUL and help them to resist evil SPIRITS.

## Ash

Ash remains after something is destroyed or purified by FIRE. Early Jews mixed the ashes of burnt offerings with WATER to create the water of purification (used after touching the dead), as the ashes contained the life force of the slaughtered animal; Buddhists believe that the ashes of cremated holy people retain special powers. In Ancient Chinese folklore, ashes were believed to ward off evil SPIRITS and ghosts.

Hindus believe elements of original, cosmic matter are present in all things, and can be extracted by purifying them in a fire; ash is therefore a residue of primal matter, and so *sadhus* (Indian ascetics or holy people) smear themselves with it as a symbol of this.

For early Christians, ashes represented penance; this survives today in the rituals of Ash Wednesday.

Some alchemists believe that the MERCURY of the wise develops from the ashes left after the process of NEGRIDO.

## Obsidian

A BLACK volcanically-created glass, astrologically linked to SATURN, obsidian was used to make images of the Aztec god Tezcatlipoca ('Smoking Mirror'), and for divination MIRRORS. Some Native American tribes believe small obsidian nodules are 'Apache tears', cried by women when an Apache WARRIOR dies.

## Mysterious Pass

Before the Daoist philosopher LAOZI left the material world for MOUNTAINS, he was asked to leave behind his words of wisdom by the keeper of the Mysterious Pass; this became the site of the creation of the *Dao de jing*. Laozi went to the mountains and was never seen again; so the pass symbolizes the GATEWAY to immortality.

## Negrido

The Negrido is usually represented as the first stage of the alchemical Work, and is classically depicted by showing the KING (MALE, SUN) and QUEEN (FEMALE, MOON) lying together, dead, in a glass coffin (the alembic). It is the BLACKENING and putrefying process that occurs after the dissolution that follows the finding of the *prima materia*. It is a state of depression and death, falling under the energies of SATURN; the dark side, or SHADOW, reveals itself at this point and so it is sometimes symbolized by the moon ECLIPSING the sun. Other images of the Negrido are the SKELETON, the RAVEN (the black BIRD that portends death), the GREEN LION (symbolizing the force of nature) consuming the sun (or ego), the black sun illuminating a wasteland and the *caput mortum* (the dead HEAD).

## Mountain

Mountains are the meeting place between HEAVEN and EARTH, where the gods can be encountered: Mount Olympus, Mount Sinai, the Himalayas and the FOUR sacred mountains of the Navajo are examples. They are favoured sites for temples and churches.

Mountains also represent the power within the landscape. To the Hindus, the mythical mountains Meru and Mandara represent the centre of the universe; in traditional New Zealand culture, mountains possess spiritual power, symbolizing their peoples' strength. Daoists venerate FIVE mountains in China, which relate to the five DIRECTIONS of the Chinese elements.

Pre-Hispanic Mesoamerican cultures associated mountains with fertility and mother deities. Tepeyac (Mexico City) housed a temple dedicated to the MOTHER GODDESS Tonantzin; later, this was the site of the appearance of the VIRGIN of Guadalupe, whose image became TRIANGULAR, echoing the shape of the mountain.

MINERALS · NATURAL FORMS

NATURAL FORMS

### Hill

Christians associate hills with
the Hill of Golgotha (place
of a SKULL), where CHRIST was
crucified. Churches built on hills
often occupy earlier Celtic sites;
they are frequently named after
the ARCHANGEL Michael, who
was often shown slaying a
SERPENT or DRAGON, protecting
the church from the forces of the
UNDERWORLD – or perhaps from
those of earlier pagan worship?
(Thus Glastonbury Tor was also
said to be inhabited by the FAIRY
folk; comparable tales can be
found regarding many hills in
Celtic countries.) Hills were often
associated with beacon FIRES.

In alchemical illustrations, a
hill symbolizes the great JOURNEY;
there is often a choice of THREE
PATHS to follow to the summit,
which can either be straight,
rough but narrow, or winding –
in all cases symbolizing the
difficulties of the Work.

### Cave

The insides of caves are dark, so
astrologically they are associated
with the WINTER solstice and
CAPRICORN, just before the days
start lengthening.

As places of solitude and
religious insight, desert caves
provided homes to early Christian
hermits. Many religious figures
were believed to have been
born in a cave, such as CHRIST
(apocryphally, born under
Capricorn) and LAOZI, the
founder of Daoism. At the
beginning of the new year,
Chinese emperors were shut
into caves so that they could
be symbolically reborn.

Caves were also entrances to
the UNDERWORLD. Alchemically,
they represent a concealed place
or womb. Famous KINGS (such
as ARTHUR of Britain), leaders and
WARRIORS are said to lie asleep
in caves, to awake in times of
need: MERLIN is said still to be
entrapped in a CRYSTAL cave. The
Japanese SUN goddess AMATERASU
OMIKAMI once hid in a cave in
anger, thereby plunging the world
into darkness.

### Island

Distant islands are thought of as
ideal lands. In classical antiquity,
they were places of refuge and
paradises: ACHILLES was
supposedly united with Helen
of Troy on the Isles of the Blessed
after their deaths, while Socrates'
Atlantis was an island of fabled
peace and prosperity.

Celtic islands symbolized the
Otherworld: the Isle of Avalon,
or the Western Isles (the Islands
of the Blessed where the SUN sets)
were places where the dead
resided or the SPRING of eternal
youth could be found. Daoist
legends told of the Islands of the
Blessed – Fang-zhang, Peng-lai
and Ling-zhou in the Eastern Sea
– which were home to the EIGHT
IMMORTALS, thus symbolizing
everlasting life. Despite many
expeditions, they were never
found. Islands can be the homes
of deities: Tantric Hindu
paintings depict an island of
JEWELS, on which stands a
jewelled PALACE containing a
goddess – SHIVA's partner.

## Desert

To the Jews, the desert was a place of danger and exile in the forty-year Exodus from Egypt; yet this was also the period during which they were closest to God, who dwells in the desert. For early Christians, too, the desert was a liminal zone where God and mankind might meet: beyond the limits of civilization (as it was for the Ancient Greeks and Romans), it was a home to prophets and zealots (for example St John the Baptist).

In Ancient Egypt the encroaching desert was a dangerous place that brought infertility and death; Set, the Ancient Egyptian god of chaos and misfortune, was linked to its hot wind. However, the desert lands of Central and Western Australia are a rich source of spiritual sustenance to Aborigines: their ancestral spirits, the Dreaming, travel across the desert, and this is reflected in their ceremonial, highly sacred ground paintings.

## Earthquake

Earthquakes are often associated with deities: they often precede the appearance of God in the Old Testament. The Maori believe they are caused by Ru, one of the sons of Rangi, the sky father, and Papatuanuku, the earth mother; he was never born, but chose to remain inside the earth with his mother after his parents were separated.

Earthquakes may also relate to animals: for example, one Celtic legend told how the young Merlin was captured as a sacrifice to stop the daily destruction of the footings of Vortigern's new castle by earthquakes; he explained that it was caused by a battle between the Red and White Dragons in a deep pool underground. In Japan, one traditional explanation for an earthquake was that the animal that was thought to support the country on its back was moving.

## Hole

Holes in the earth are entrances to other states. They might symbolize entrance into the womb of the earth. In North-western Arizona, in Hopi *kivas* – enclosed ceremonial chambers entered using a ladder placed through a hole in the roof – the hole through which the Hopi are said to have emerged into this world is represented by a covered hole or shallow depression in the floor. Initiation into the sacred Ancient Greek mysteries of Eleusis involved a birth-like journey through subterranean passages; the Oracle at Delphi, centred on a chasm in the earth, gave access to hidden secrets.

Holes also lead to realms of darkness and the underworld, as suggested by the ritual placement of offerings in long shafts in Bronze Age and Celtic cultures.

In some parts of Africa, too, entrances into the earth and holes in rock surfaces may be seen as entrances and tunnels to the spirit world.

NATURAL FORMS

NATURAL FORMS

A

B

C

## Hell * Underworld

In many cultures, the underworld is the dwelling place of the dead and so is ruled by those cultures' gods of the underworld. In classical mythology it was governed by HADES, and lay at the centre of the earth; it was reached through a chasm flowing with dark waters (A). For the Maori it is symbolized by the goddess of the night, HINE-NUI-TE-PO, who took refuge in the underworld to hide her shame when she discovered that her husband TANE MAHUTA (the god of mankind and forests) was also her father. Arawan ruled Annwn, the Celtic Otherworld, whose many entrances could be found in CAVES, MOUNDS, FAIRY HILLS, LAKES, SPRINGS or WELLS. Norse deities, called the Vanir, lived in the underworld along with the elves, but this may not have been the same place as Hel – in early Scandinavian mythology, the name of the home of the dead and its goddess (B) – which was believed to be a dark and noisome place of death, and was thought to be haunted by SERPENTS.

Hell is also where the SOULS of the dead are tortured: the Chinese, influenced by Buddhist, Daoist and Confucian theories, believed that after death, the soul of an individual sinks down to a hell composed of NINE or TEN purgatories. Christians believe Hell to be a FIERY domain, the home of SATAN, where the souls of sinners are tormented by DEMONS (C). This is like the Jewish Gehenna, which in rabbinical literature refers to a place of torment by fire for the wicked. Jews also believe in Sheol, a shadowy place under the earth where the souls of the dead reside, to be released by the Messiah; this must be the Hell into which CHRIST descended after his crucifixion, breaking its gates to release the virtuous dead into HEAVEN before he returned to earth at the resurrection; this redeemed mankind from sin and death. Catholics, too, eventually divided Hell into different circles or realms.

The Catholic circles of Hell should not be confused with Purgatory, a place of trial in which the souls of the righteous perform penances on their way to HEAVEN. For some Native American tribes, the journey to the underworld is thought to be strewn with obstacles that reflect the way the dead had lived.

For others, the underworld is the place from which the first people emerged into this world. Butan, goddess of the EARTH and underworld of the Batammaliba of Togo and Benin, is also the goddess of childbirth, watching over SPIRITS coming from and going to the underworld.

The SUN may hide in the underworld at night: between sunset and dawn, RA, the Ancient Egyptian manifestation of the SUN, travelled through the Duat (Underworld), where he was confronted by the forces of the serpent Apep.

A

B

C

## Land ✳ Kingdom

Kingdoms, as the spaces occupied by individual communities, are the sources of those communities' identities. Like the image of the CITY beneath the HEAVENS, surrounded by land and SEA (A), the kingdom encloses and delineates a culture and a people.

Kingdoms can be wholly divine: the Judeo-Christian Kingdom of God is related to the belief that, after a final judgment, the terrestrial world will become perfect and at peace, similar to HEAVEN. The heavenly kingdom is itself described as the 'bride of God'. Divine kingdoms may be recreated on earth in certain shrines: these may be decorated with great reverence – on the coast of West Africa, for example, the shrines for the WATER spirit MAMA WATA are painted BLUE-GREEN and decorated with MIRRORS and things related to the water, such as paddles and FISH.

The Celts believed either that the land was itself a goddess, or was at least divinely protected by a goddess; she bestowed sovereignty upon its KINGS. If the rulership was just and the king virile, the land would flourish; should the king be maimed, the land could lose its fertility and become a wasteland (as told in the legends of the FISHER King and Nuada of the SILVER HAND). The kingdom of Egypt was ruled by a god-king, the Pharaoh; divided into TWO but ruled by ONE ruler, the kingdom signified unification within duality, emphasized by many of the myths surrounding the pharaoh . Upper and Lower Egypt were represented respectively by the WHITE and RED CROWNS (B).

Terrestrial kingdoms can be thought of as divinely ordained: Jews believe that the land of Israel (represented by the Holy Land) was promised by God to ABRAHAM and his descendants. Here, the belief in the Kingdom of God and in the Promised Land merge in the form of the holy CITY of Jerusalem.

The land can be sacred: Australian Aborigines consider the land, and its animals, birds and plants, to be sacred as the embodiment of the Aboriginal Dreamtime and ancestral SPIRITS. Sites of particular ceremonial and sacred significance – such as Uluru (Ayers ROCK) – are attended either by men or by women, but never the two together. Land is also the spiritual sustenance of the Maori: as their ancestral heritage, passed down as a sacred gift from TANE-MAHUTA (god of mankind and forests), it is a direct link to the creation of the world. The land is also part of the earth goddess PAPATUANUKU, symbolized as *whenua*, 'placenta'.

The land is also connected to the body in certain Ancient Chinese beliefs: the *Yellow Emperor's Book of Internal Medicine* relates how the government officials symbolize the meridians (energy paths) and their associated organs (C). Daoists believed that it was important to contact the spirits of these officials in order to rule one's own internal 'country' wisely.

### City

Cities represent protected, ordered communities: in Ancient Roman art they were depicted by FEMALE figures, wearing CROWNS in the shape of city walls. In the Judeo-Christian tradition the city symbolizes the harmonious community of humankind as perfected in the HEAVENLY city, the universal spiritual order that governs the world at the end of time. This finds its strongest expression in Jerusalem, both a temporal city and the city of God, in which the faithful live together in peace for all eternity – which St Augustine contrasted with the city of Rome (epitomizing all that is corrupt and unnatural). The names and forms of some Ethiopian churches suggest that they may have been intended to stand as replicas of Jerusalem. In alchemical illustrations, a GOLDEN or heavenly city (see image above) often symbolized the divine city or 'New Jerusalem' – the place that was the ultimate goal of the hero or traveller.

### Palace

On earth, palaces embody a ruler's status: as the Ancient Roman emperors became more godlike, so their palaces and court rituals became more elaborate, removing them more and more from the common gaze. Their purposely magnificent displays expressed their power and intimidated visitors.

Palaces can also house the unearthly: the Celts believed that FAIRY folk lived in mysterious palaces that floated on LAKES or hid in the mist, suddenly appearing and disappearing. Palaces house the gods in the Buddhist paradise, the Pure Land of the WEST (the abode of the principal divine BUDDHA of the Mahayana sect), which contains many heavenly palaces lived in by BODHISATTVAS. Many constellations are referred to by the Chinese as the residences or palaces of the gods.

Daoists imagine palaces to be placed at key points within the body, presumably originally believed to be the residences of SPIRITS within the body.

### Tower

Towers, as high buildings, are closer to the HEAVENS. However, their height may also symbolize ambition, pride and over-confidence, as in the Tower of Babel (depicted above). They often became forms of competition, embodying as they do their owners' wealth and power, whether in Gothic cathedrals, Renaissance towns or 20th-century CITIES. To cynics, they are simply PHALLIC, although the 'three-storey tower' is a Chinese metaphor for the VAGINA.

Towers were often built as fortifications: their impregnability may symbolize imprisonment or protection. (The tower is a symbol of the VIRGIN MARY.) As high vantage points they are watchtowers, symbolizing vigilance; the BELLS or DRUMS they held would warn the community of approaching danger.

Alchemically, towers can represent FURNACES; in the *Alchemical Wedding of CHRISTIAN ROSENKREUZ*, a tower was used to represent the stages of the alchemical process.

## Pagoda

Developed from the shape of Indian STUPAS, Chinese pagodas are built in WOOD, brick or STONE and have up to THIRTEEN storeys – usually an odd number. They were built in temple compounds to hold relics believed to come from the BUDDHA, or Buddhist *sutras* (religious texts). They therefore became symbols of Buddhism.

Pagodas were also associated with several Ancient Chinese and Japanese deities, such as Li Jing, the prime minister of heaven; the pagoda of Bishamonten, the Buddhist guardian spirit, symbolizes the protection he offered to the faithful. They were sometimes built outside Chinese towns to appease harmful SPIRITS, for example following a disaster; small, brick-built pagodas might also be built on the outskirts of a settlement to ward off evil from a neighbouring village.

With their distinctive silhouettes, pagodas were used in Western art from the late 18th century to suggest China and other East Asian countries.

## Minaret

The minaret, usually a slim TOWER connected to a mosque, holds the balcony from which the *muezzin* calls the Muslim faithful to prayer. The *muezzin's* call (*adhan*) to the faithful is a powerful and constant reminder of the divine presence, while the minaret itself is a symbol of mediation between the people assembled in the mosque and the HEAVENS above. The architectural splendour and beauty of minarets can be a particularly evocative symbol of the very public and openly devotional style of Muslim worship, which also strongly reinforces a sense of community.

'Minaret' derives from the Arabic *manara*, 'giving off LIGHT', probably alluding to the minaret's symbolic function – through the call to prayer – as a beacon of illumination to the surrounding community. They may also have been used as dwellings for ascetics or *muezzins* keeping vigil between prayers, hence their association with the Arabic *sawma'a* or 'monk's cell'.

## Stupa

Buddhists developed stupas from simple burial MOUNDS into great architectural features. (In ancient texts, 'stupa' meant 'summit'.) Stupas originally contained sacred relics (*dhatu*) of the BUDDHA himself, or of his main disciples; later, they became simply places of worship, or were constructed to commemorate important events or symbolize the tenets of Buddhism: the components of a stupa symbolize aspects of Buddhist philosophy. Venerating a stupa results in spiritual merit.

Although the expansion of Buddhism across Asia led to a variety of stupa types, the stupa typically consists of a DOME (*anda*) topped with a small SQUARE pedestal (*harmika*) supporting a CANOPY (*chhatra*) crowning the overall structure. Stupa centres – often incorporating monasteries and universities – were approached through ornamental GATEWAYS (*torana*) on FOUR sides, representing the crossing of a sacred THRESHOLD. Internally, stupas were constructed like the spokes of a WHEEL.

MAN MADE FORMS

MAN MADE FORMS

### Lighthouse

Lighthouses warn of impending danger and so symbolize protection. They occasionally appear on Early Christian tombs as symbols of CHRIST, embodying solid help amid the vicissitudes and dangers of life. As transmitters of LIGHT into darkness, they suggest regeneration and new growth; this (and their form) leads to an association with the PHALLUS.

### Obelisk

Obelisks represented the Ancient Egyptian *benben* or 'SUN' stone in Heliopolis. They signified the first manifestation of ATUM, marking where the first sun's rays fell. In later dynasties pairs of obelisks at temple GATEWAYS represented the SUN and MOON (and in the New Kingdom, also ISIS and NEPHTYS).

### Ruins

Images of CHRIST'S nativity may show two contrasting buildings, one new and in a modern style (Gothic or Renaissance), one ruined and old-fashioned (Romanesque or Gothic, or a synagogue). These symbolize the new dispensation replacing the old – that is, Christianity replacing Judaism.

### Road ✳ Path

In many cultures, roads symbolize JOURNEYS, often spiritual: the pilgrimages of major world religions are both physical and metaphysical journeys. Many cultures believe in roads that are travelled by the dead on their way to the afterlife. Such roads are often symbolized by the MILKY WAY. The ZODIAC is sometimes referred to as the Royal Road.

### Crossroads

When one comes to a crossroads, one must make a choice; they therefore symbolize opportunity, change, choice and transformation. HERAKLES is sometimes depicted at a crossroads, choosing between the easy PATH of vice and the rocky, MOUNTAINOUS path of virtue.

In Japan, people would traditionally go to crossroads at dusk and listen to the random words of others passing by, to hear what fate might bring: this was linked to the belief that TRAVELLERS might be deities bringing good fortune. This evolved into the practice of selling rice-crackers containing paper fortunes at crossroads.

In Europe, crossroads are liminal areas, where the powers of darkness are never far away: one might meet WITCHES or the DEVIL there (the Blues musician Robert Johnson was said to have sold his soul to the Devil at a crossroads). They were dedicated to HECATE, and were places of execution (especially by hanging, as above) and the burial of outcasts.

## Gate

Passing through a gateway marks a change in state. Jews believe there is only one gate to the GARDEN of Eden, but 40,000 to HELL, symbolizing the respective difficulty and ease with which one enters these realms. As the Ancient Egyptian sun god RA travelled through the UNDERWORLD each night he was thought to pass through TWELVE gates, marking the twelve hours of the night. Gateways called *torii* mark the entrances to Shinto precincts: archways with no doors, they represent permanent openness, and the shrines themselves.

Huge gates bearing depictions of the victory of the gods guarded Ancient Egyptian temples. Chinese cities had gates at each point of the COMPASS, through which good and evil entered and left; they were protected by images of DOOR gods. Gates can also symbolize secular power: those of the Forbidden City in Beijing represented the emperor's might, and Ancient Roman triumphal ARCHES embodied imperial victories.

## Bridge

A bridge links two separate realms, visible and invisible, known and unknown, like Bifrost, the RAINBOW bridge that links EARTH with Asgard in Norse mythology. Bridges also symbolize irreversible moments of transition (condemned prisoners crossed the Venetian Bridge of Sighs on the way to their execution).

SPIRITS and gods prevail over bridges and need to be propitiated; Japanese legends described the use of 'human pillars' when building bridges, to appease the WATER gods. The first person to cross a new bridge could die; sometimes, animals were sent over first.

Much significance is attached to the crossing of bridges. In China, a bridge god was believed to prevent DEMONS crossing from one side to another; and by crossing THREE bridges on the sixteenth day of the FIRST month, it was believed that people could leave evil spirits behind them.

In Chinese erotic literature, the 'bridge' represented a woman's perineum.

## Fountain

Fountains, like SPRINGS, are a source of WATER and therefore of life. In Christian allegory, the RIVERS of life spring from a source at the foot of the TREE OF LIFE. In alchemy, a fountain is often the source from which the various materials of the processes surface.

Fountains provide potable and healthy water; they are healing, medicinal, cleansing and purifying, which led to the myth of the Fountain of Youth. A fountain may symbolize the VIRGIN MARY, as life (CHRIST) appeared within her, not from the outside. Drinking from a fountain can symbolize the spiritual refreshment of meditation and prayer.

In Islamic GARDENS – which seek to replicate the features of the garden (*jannat*) of paradise – fountains are often used to mark the intersection between TWO separate water-courses, representing the connection between man and god.

In Celtic myth the FIVE streams flowing from the fountain in MANNANAN's underwater kingdom represented the five senses.

MAN MADE FORMS

MAN MADE FORMS

## Garden

Gardens are often associated with an earthly paradise; this was so in Sumerian culture, while the Jewish Garden of Eden symbolizes the state of innocence, bliss and purity from which humankind has fallen. A walled garden (*hortus conclusus*), a meadow of richness protected from outside contamination, was an emblem of the VIRGIN MARY.

For both Christians and Muslims, gardens symbolize paradise, rich with flowers, fed by streams and DEW; the Muslim paradise has rivers of WATER, WINE, MILK and HONEY. Ancient Egyptian gardens were places of enjoyment; they were often depicted on TOMBS as part of the delights of the afterlife, while the Ancient Greek Elysium, the abode of the virtuous dead, was envisaged as a garden.

In alchemy, the ROSE Garden of the Philosophers is the place where passions and matters of the HEART could be cultivated, and peace obtained. The Rosa Mystica will grow here, the mystical rose of the HEART centre.

## Labyrinth

Labyrinths and spirals have been found carved in ROCKS and burial chambers from the European Bronze Age; they are believed to symbolize cycles of nature, death and rebirth. More recent mazes cut into the EARTH or marked with STONES may have been followed in the spring to invoke fertility.

The Ancient Greek legend of Theseus, who slew the MINOTAUR at the heart of the Cretan labyrinth then returned safely with the help of Ariadne's THREAD, influenced the labyrinths created in medieval European cathedrals. If there are no choices to be made to reach the centre, the labyrinth represents faith and the inevitability of truth prevailing. If one can only reach the centre by choosing the correct turnings, the labyrinth reveals how great care and discrimination are necessary, and that mistakes are difficult to foresee when following the spiritual PATH.

## Mound

Early Egyptian texts refer to the 'first place' or primeval mound of matter that emerged from the infinite; considered a divine power, it was personified by the god Tatenen.

Mounds are raised over burial sites. They were used in various Norse cults: those shaped like a SHIP related to the cult of the Vanir deities, who were associated with water; others contained wagons. Both indicate the notion of a JOURNEY to the afterlife. They could also represent the halls of Asgard (the home of the Norse gods) and the Aesir (one part of the Norse pantheon), containing many grave goods in preparation for an afterlife of feasting. Burial mounds were also connected to elves, and to FREYR (said to dwell at Alfheim); the use of the word '*elf*' for a dead KING indicates that elves were seen as ANCESTORS. This belief led to burial mounds being seen as the homes of the FAIRY folk in later Celtic folklore.

A

B

C

## Macrocosm ✳ Microcosm

The macrocosm – the cosmos and the HEAVENS – is widely considered to be reflected by and related to the microcosm – the terrestrial, or even just the individual human being. The world is considered to have metabolic processes which resonate with those of human beings (A and C). As the macrocosm may symbolize the microcosm, and vice versa, this notion is fundamental to the concept of symbolism. One way in which this is theorized is the notion of vibrations at different levels, which can activate vibrations at other levels; but it may equally be due to visual resemblance or other systems of categorization or description.

This concept can be found in many different cultures. It is fundamental to the system of astrology, and the Ancient Greek and Chinese systems of elements. One of the most famous axioms from the mythical hermetic text known as the *Emerald Tablet* – said to have been written by HERMES TRISMEGISTUS – is that

'whatever is below is like that which is above, and whatever is above is like that which is below, to accomplish the miracle of one thing': an understanding of this will result in the accomplishment of the alchemical Great Work.

In *neidan*, the traditional Chinese system of 'internal alchemy', the body is considered as a microcosmic country with its own landscape of SEAS, RIVERS, MOUNTAINS and countryside, inhabited and governed by SPIRITS – especially those of the various organs. Thus, an awareness of the internal body, or the ability to see one's own organs is vital to self-development. Similarly, in Hindu philosophy every individual is a *sukshma jagat*, 'minute world', and so whatever exists in the cosmos exists within each individual. Thus, fully controlling oneself is no less of an achievement than controlling the universe; and therefore divinity is not external to man but can be found within him. Morality becomes not a matter of religious sanction, but an outcome of finding the right balance within oneself.

Some Native American tribes believed that the STAR map and EARTH map 'were really the same, because what's in the stars is on the earth and what's on the earth is in the stars (B)' (Arvol Looking Horse, Nineteenth Carrier of the Sacred PIPE of the Lakota (Plains) people). The façades of the shrine-houses of the Mambila of Cameroon carry depictions of a MALE–FEMALE couple, which is surrounded by the cosmic forces (SUN, MOON and RAINBOW) surmounted by a TRIANGLE (the village). This represents the idea that their community is a microcosm of the universe and that each individual in the community acts as a link between the spiritual and material realms.

Christians have found correspondences in all manifestations of nature, mostly on account of numbers (for example, THREE, FOUR and TWELVE), but also using names, anagrams and so forth.

P A T T E R N S

PATTERNS

## Directional Orientations

Many cultures have used the FOUR quadrants of the COMPASS and the directions 'up' and 'down' to organize space according to the order of the universe: for example, the Inca Empire was structured around four highways that radiated from Cuzco, the capital CITY of the empire and centre of the Inca universe. In Ancient Egypt, the four cardinal directions (A) were associated with the FOUR SONS OF HORUS.

The simplest form of orientation was by the SUN: thus, in Christian churches, the high altar is placed in the East (B), the place of the rising sun and hence of CHRIST. Other cultures orientate their devotions to a specific place: for Muslims, this is the *qibla*, marked by the ornate *mihrab* in a mosque; the *qibla* indicates to worshippers the direction of the KA'BAH in Mecca from whichever country they are praying in. Jews look in the direction of Jerusalem.

✴ NORTH

In China, the North is related to WINTER, WATER and a TORTOISE with a SNAKE wrapped around it; Japanese Buddhists believe it is protected by the BLUE god Bishamonten. On the Native American medicine WHEEL (C) it is the place of AIR, animals, the mind, HEART, wisdom, balance, harmony and the WHITE races who know the ways of mind, science, research and technology. In Nigerian Yoruba culture it is associated with RED and with the god OGUN.

✴ EAST

Related by the Chinese to SPRING and WOOD, symbolized by a BLUE (or GREEN) DRAGON; guarded for Japanese Buddhists by the RED-faced deity KOMOKUTEN. On the medicine wheel it is the place of FIRE, the human world, SPIRIT, the spark of life, spirituality and the place from which one sets out on the vision quest; it is also related to the YELLOW races, masters of the ways of meditation. The Yoruba associate it with GREEN and YELLOW, and the god ESHU.

✴ SOUTH

In Chinese culture, the South symbolizes SUMMER and FIRE, and is represented by a RED BIRD or PHOENIX; for Japanese Buddhists it is guarded by the WHITE-faced ZOCHOTEN. On the North American medicine wheel, it is the place of WATER, plants, emotions and movement, the innocence of the CHILD and the RED races who know how to dance in harmony with the EARTH. For the Nigerian Yoruba, it is associated with WHITE and the deity OBBATAL.

✴ WEST

In Chinese culture, the West was related to AUTUMN, METAL and a WHITE TIGER; it was guarded by the GREEN-faced JIKOKUTEN in Buddhist Japan. On the medicine wheel the West is the place of EARTH, minerals, the body, dreaming, intuition, memories and the BLACK races, who know how to DANCE and DRUM the natural rhythms of the EARTH. It is associated by the Yoruba with BLACK and with the LIGHTNING deity, SHANGO.

## Ages of the World

Many cultures believe the world and mankind have evolved through a sequence of ages, often descending from innocence and virtue to vice. The Ancient Greeks associated these with symbolic METALS: from the GOLDEN (depicted by a pastoral scene above), SILVER and BRONZE Ages to the IRON Age of war and bestiality. Hindus describe the ages of Krita-yuga, Treta-yuga, Dvapara-yuga and now Kali-yuga, which is characterized by anger, greed, hatred, lust and suffering.

Christians reversed the process, believing that man rises to perfection in three ages echoing the three persons of the TRINITY: the Old Testament (God the Father), the New Testament (God the Son) and the KINGDOM of God (the Holy SPIRIT).

Astrology measures a series of ages based upon the precession of the SUN through the twelve signs of the ZODIAC at the SPRING equinox; although the borders are imprecise, we are currently leaving the age of PISCES and entering the age of AQUARIUS.

## Seasons

The seasons are based on the climate's yearly cycle and hence are closely associated with the growing cycles of plants and with agriculture. Their numbers vary according to local conditions: the Ancient Egyptians had THREE, based on the Nile's annual rise and fall, as did the Ancient Greeks; theirs were represented by the Horae.

The Celtic year was marked by FOUR festivals: Samhain (during autumn), the start of the year; Imbolc, spring; Beltane, summer and courting; and Lammas, HARVEST and betrothals. Later European depictions show spring as a WOMAN garlanded with flowers; summer, a woman holding a SICKLE and sheaves of corn; autumn, a MAN holding vines and fruit; and WINTER, a thickly clad old MAN seated by a FIRE. In China, the same seasons fit into a symbolic system of DIRECTIONS, colours, animals and flowers, and in Japan many seasonal festivals (*matsuri*) are related to RICE growing, the most important occurring in spring and autumn.

# CHARACTERS AND PEOPLE

A R C H E T Y P E S

## Corn Woman

Associated with the MAIZE grown by many Native American tribes, Corn WOMAN is a beautiful young woman who brings knowledge of the cultivation of corn to the people. A Pawnee story in which the corn woman is named as Uti Hiata (above), tells how she came to a man in a dream and told him not to marry for two seasons (it would take him that long to come to understand her spirit). In return she would give him knowledge of the cultivation and HARVESTING of corn. Other legends tell of her being wounded or killed, and of corn growing for the first time where her BLOOD fell to the EARTH.

In the Celtic tradition the last sheaf of corn from the harvest was made into a corn 'doll', representing the spirit of the field. It was drenched with water to bring rain and preserved until the next crop was planted.

## Fates

The three Fates were called the Moirai by the Ancient Greeks and the Parcae by the Ancient Romans. According to Greek legend, Klotho spun the THREAD of life with her DISTAFF; Lachesis wrapped it around the SPINDLE, the random patterns made by the thread around the spindle representing the element of chance; and Atropos, the eldest, snipped the THREAD of life with her scissors (above).

Nordic cultures called them the Norns, three powerful women who 'cut on WOOD', connecting them with the notches cut on planks in the walls above windows in houses, which represented important dates in the lives of the occupants. They WOVE the web of fate.

In all cultures, the Fates were associated with the power of prophecy.

## Sophia

'Sophia' is the Greek word for 'wisdom'. She appeared in Jewish tradition as it began to be influenced by Greek philosophy, and is generally seen as FEMALE. In the Old Testament, Wisdom declares she was 'obtained' before the beginning of the earth and is thus the female part of God, 'God's missing wife', materialized in the numinous sense by the SHEKHINAH (the Kabbalistic divine presence) and trapped in matter by EVE.

The idea of wisdom as the female counterpart to a MALE God continued into the Roman Catholic tradition, appearing in a prayer to the VIRGIN MARY ('seat of Divine Wisdom, pray for us'). In the Latin Church Sophia is a female saint, shown crowned with her three daughters, Faith, Hope and Charity. She may hold a BOOK (wisdom) and a LADDER (access to the divine) (above).

In the Orthodox traditions some important churches were dedicated to her (Constantinople, Thessalonika, Kiev, Novgorod). She is depicted as a RED-skinned, seraphic, throned ANGEL.

A

B

C

# Angel

The angels take their name from the Greek *angelos*, 'messenger'. They are spiritual intermediaries or intelligences between God and humanity and are most common in Judaism, Christianity and Islam. There are many kinds of angel. The most common are:

∗ Seraphim ('the burning ones'): the highest-ranking celestial beings (apart from God) in Christianity. They are depicted with SIX WINGS (A) and coloured RED, symbolizing FIRE. In Jewish, Christian and Islamic literature they are the guardians of God's THRONE.

∗ Cherubim ('ones who pray'): also found in Jewish, Christian and Islamic literature, and God's THRONE-bearers. In the Bible they are described as winged beings, and usually a combination of four but sometimes two creatures. In later Christian art their imagery derives from Roman genii (attendant spirits of a person or a place) and they are shown as winged children, representing innocence, with BLUE wings signifying the SKY. A male and a female cherub, symbolizing

Yahweh and the SHEKHINAH, were depicted on the ARK OF THE COVENANT. They also guarded the GATES of Eden and protected the TREE OF LIFE from mankind.

∗ Archangels: are most often in contact with humans and are usually depicted as people with wings (B). In Christianity the Archangel Gabriel is the leader of the angelic hosts and the angel of the Annunciation. He is often depicted with the VIRGIN MARY, and may carry a SCROLL bearing the words 'Ave Maria' or hold a LILY. In Islam he is called Jibril and is the angel of the Revelation because he revealed the Qu'ran to Muhammad who is shown seated and veiled when in the presence of Jibril. In the non-canonical Jewish First Book of Enoch (Ch.20) Gabriel is described as the ruler of paradise, the seraphim and the cherubim. Michael (Islamic Mika'il) is the warrior archangel in Christianity and keeper of the KEYS of Heaven. He carries out God's judgments. As the chief opponent of SATAN, he is often shown wearing ARMOUR and spearing the DRAGON from the

Book of Revelation (12: 7–9). The non-canonical Jewish First Book of Enoch (Ch.20) describes Michael as the guardian of Israel. Raphael ('God is healing') is known to Christians only from the apocryphal Book of Tobit. He is thought by Jews and Christians to bring relief to the sick. In the non-canonical Jewish First Book of Enoch (Ch.20) he is described as the guardian of human SPIRITS.

∗ Angels (C): cannot necessarily be correlated across the three religions and are associated with the non-canonical, esoteric traditions of the faiths. For example, angels are central to Jewish Aggadic and Kabbalistic literature – in which Metatron is the highest-ranking angel.

In Viceregal Peru (1543–1776) archangels carried overtones of conquest, appearing as Spanish soldiers armed with arquebuses. Paintings of them were used as visual aids to teach the catechism of the Church, which emphasized the angel as protective soldier. But many such paintings are seen as symbols of conquest, conversion, and native attitudes to the Church.

ARCHETYPES

### Devil * Satan * Lucifer

Satan takes his name from the Hebrew word *Satan* ('adversary'). For Jews, Christians and Muslims he is the enemy of God, but he is not equal to God. However, Christians imbued him with greater power, so that he almost became God's equal, controlling numerous DEMONS (the counterparts to God's ANGELS). The Manicheans took this belief even further, believing him to be an evil God, identified with Lucifer ('light-bearer'), a fallen angel whom dualistic Gnostic sects believed had enviously stolen LIGHT from God, imprisoning it in matter and creating human lust in order to splinter the divine light into ever-more numerous particles of matter.

His appearance in Christian culture is derived from that of a pagan SATYR, half animal and half human. Satan is usually HORNED, with a barbed tail and cloven feet, and he sometimes has BAT-like WINGS (above). He is also depicted as a DRAGON (especially with the Archangel Michael and ST GEORGE). The Book of Revelation calls him 'many-headed'.

### Demon

The word 'demon' derives from the Greek *daimon*, 'god' – and demons became mediators between the gods and man. The Ancient Greek philosophers considered demons to be the divine part or voice in man. However, in the Judeo-Christian Bible demons become evil SPIRITS, associated by Christians with the veneration of pagan cults and believed capable of possessing animals, humans and idols. They are frequently depicted as impish BLACK figures, often being expelled by saints.

In Japanese folk tales and proverbs, demons were also feared and to be placated. Some were depicted as ferocious RED-faced beings; others were female and lived in the MOUNTAINS.

Indo-Aryan Vedic gods were divided into two classes, *devas* and *asuras*. In the Hindu tradition the *devas* came to dominate the *asuras*, so *asura* eventually took on the meaning of 'demon'. Conversely in Iran, Zoroaster (who founded Zoroastrianism in the 6th century BC) denounced *devas* as demons.

### Death

The Ancient Greek Thanatos (Death) was the son of **Nux** (Night) and elder brother to Hypnos (Sleep). He resided in the UNDERWORLD, but was generally depicted as a winged spirit. The sinister personification of death that appeared in the late Middle Ages – as a SKELETON in a BLACK hooded robe, carrying a SCYTHE for harvesting SOULS (above) and sometimes holding an HOURGLASS – symbolized mortality and the transience of time. But for Christians bodily death is the first stage on the road to resurrection at the Last Judgment, so its reality was also 'celebrated' by depictions of the DANCE of Death (in which Death is the great leveller) and *memento mori* (items reminiscent of death) such as SKULLS, skeletons and worm-eaten cadavers.

In Western alchemy images of death echo the medieval 'grim reaper' or skeleton, discussed above. His presence indicates the inevitable death that will occur at each stage of the process.

A

B

C

## Trickster

These figures are highly important in the folk tales and mythologies of many cultures. They are often of mixed nature, part-human, part-animal and part-divine. Usually amoral, their actions are judged ambivalently; they often perform tasks against the wishes of the gods, but which help mankind. The Nordic trickster LOKI, for example, was both a friend of the gods and a divine thief, who made illicit love with the goddesses and was usually responsible for the theft of divine treasures. Yet he also made the finest of these treasures and recovered them for the gods after their theft.

The MONKEY KING of the Chinese mythological novel *The Journey to the West* (transcribed into its current form in the 16th century) stole the PEACHES and the pill of immortality that belonged to the Queen Mother of the West (XI-WANG-MU) at a banquet for the gods, thereby making himself doubly immortal.

In the Celtic and medieval European traditions the trickster was closely associated with the FOOL or jester (A). The GREEN MAN and April Fool are also linked with a divine trickster who builds up the energy in SPRING, restoring eternal youth. Native American tricksters (for example, Heyoka of the Plains tribes, or Koshari of the Hopi and Pueblo peoples) perform sacred roles. Their teachings give valuable spiritual lessons, albeit in the form of pranks and tricks. The buffoonery of tricksters is often paradoxical, turning things on their heads and using opposites, as is reflected in the Pueblo Koshari custom of painting the body with BLACK and WHITE stripes and wearing matching headgear (B).

Native Americans consider many animals to be tricksters. The chief of these is the COYOTE, but there are also stories of the RAVEN, the mink, the BLUE jay, the RACOON dog, the RABBIT and the HARE. In Japan, the racoon dog (*tanuki*, C) – or BADGER – and FOX behaved as tricksters, changing their shapes, often to those of beautiful young women or Buddhist monks, and creating apparitions and sensations to deceive their victims.

Animals are also tricksters in African culture. The HARE is a trickster in the folklore of the Jukun and Angass of Nigeria and the Fulani of West Africa, and the TORTOISE fulfils this role for the Yoruba, Edo and Ibo of Nigeria (and also in Cuba). The SPIDER is a trickster in the culture of Sierra Leone and Liberia. He is called ANANSI and is an underdog, smaller and physically weaker than his opponents (thus gaining the audience's sympathy), but also much more clever than them and always in control of the situation.

African tricksters are not afraid to play tricks on the gods. Indeed, some are themselves divine, such as the Yoruba ESHU.

Slaves carried trickster tales from Africa to the Americas. Tales of Anansi reached the Caribbean, and he appears in the folklore of the southern USA as 'Aunt Nancy'. Brer RABBIT was also originally an African trickster, introduced into American culture through the 'Uncle Remus' series written by J. C. Harris (1848–1908), who took a particular interest in black American myth and culture.

A

B

C

## Mother

In many European languages the word for 'mother' is etymologically associated with the 'matrix' in which all things exist, the amorphous 'matter' from which all things are created (A). Thus a mother symbolizes fertility, through both the creation of life (from giving birth) and the maintenance of life (through breast-feeding and childcare).

The link between motherhood and fertility was reflected in the cult of Magna Mater, the great Mother Goddess, which was widespread throughout Western Asia from the Stone Age until the Roman Enpire. She embodied the earth's continuous cycle of DEATH and regeneration. The earliest clay figurines of the Goddess often feature enormous BREASTS and THIGHS, signifying her supreme fecundity.

Later, the various female deities that emerged also tended to take on this role. Thus, in later Ancient Egyptian imagery ISIS and HATHOR were shown as mothers suckling their sons. Similar imagery was used for the VIRGIN MARY, whose motherhood was perfected by the fact that she had not been 'defiled' by a man, but remained a VIRGIN. Her maternal role is stressed in standard Catholic images, such as the Mater Dolorosa, in which she is shown mourning her dead son, and the image called the Pietà, in which she cradles the dead CHRIST upon her lap. In fact, the Virgin Mary's importance in the Christian Church is directly defined by her role as mother of CHRIST (B). Conflicts over whether she was the mother of God or the mother of Christ were resolved in the 5th century in favour of the former, and she was declared Theotokos, or 'bearer/mother of God'.

The maternal role was also linked with QUEENship. Thus the image of the Ancient Egyptian VULTURE goddess MUT (Mother) was worn by the queens of the pharaohs, identifying them with the great mother and signifying their role as mother of Egypt.

Many alchemical illustrations depict pregnant women, or women who were giving birth (C). These symbolized the FEMALE aspects of the process, which are essential to its completion: the feminine *anima* or SOUL gives birth to the alchemical CHILD, who is the product of the alchemical union of opposites (usually MALE and FEMALE), or of the new growth of consciousness developing within the *anima*.

There are also many illustrations of a mother feeding a child, again symbolizing a stage in the alchemical process: the child (or what has been produced from the union of opposites) is nourished by the feminine aspect of the operation. MILK is sometimes depicted as pouring from the mother's BREAST. This often represents MERCURIAL milk, an important component at this particular stage of the Work.

A

B

C

## Twins

The birth of twins, being unusual, is loaded with meaning, and twins have had a symbolic and sacred role in many cultures.

The Batammalina (Togo) associate twins – necessarily a man and a woman – with the creation of the first humans on earth. Likewise, the Ancient Egyptians considered the twin deities SHU and TEFNUT to have been the first couple; theirs was the first SEXUAL UNION. They were associated with the constellation of GEMINI (B), like the Ancient Greek Dioscuri or 'sons of ZEUS', Castor and Pollux, whose myth reflected a common belief that one of a pair of twins would have divine parentage. Pollux was immortal but his twin Castor was not. Such was their grief at their separation by DEATH that ZEUS relented and also made Castor immortal, setting the twins in the sky as the constellation Gemini.

The Maya hero twins Hunapo and Xbalanque, recorded in the *Popol Vuh* (*Book of Council*, a text probably written in the 1550s, which outlines the Maya creation myth), were renowned for defeating the gods of the UNDERWORLD in the violent, ritual BALL game, thereby arranging the deaths of their father and uncle.

The double nature of twins symbolizes increased fertility. In the biblical Song of SOLOMON they represent abundance and fruitfulness. In a wider cultural context they often represent a doubling of fecundity. In West Africa they are believed to bring riches and good luck to caring parents; but conversely, if they are neglected they bring misfortune and bad luck.

Sculptures of twins are widespread in Africa, but are most common among the Yoruba of Nigeria (A and C), who have a high incidence of twins. They call them the children of SHANGO (the god of THUNDER. Sculptures of twins may be made if twins die, thus allowing their parents to ward off the seemingly inevitable bad luck by continuing to look at them, albeit in the form of statues.

In China, twins could also bring good and bad luck – they represented harmony and discord. Twins of different sexes were described as 'ghost spouses' and were left to die. However, twin boys were sometimes regarded as good luck. The mythical He-He were heavenly twins who symbolized togetherness and harmony, especially in MARRIAGE. They were depicted as two boys, one carrying a LOTUS, the other a box or a BOWL. In Hinduism twins are also auspicious and fortunate, and are so depicted in legends like that of Rama (an avatar of VISHNU and the hero of the Hindu epic, the *Ramayana*), who had twin sons and twins for half-brothers.

In Celtic and Arthurian tales, twins such as Balin and Balan represented the eternal conflict between WINTER and SUMMER, or the forces of darkness and LIGHT. They were depicted as two giant knights sitting by a FOUNTAIN, challenging all who came near them to duels.

## Ancestor

Ancestor worship is important in many cultures. The dead are believed to guide their descendants through life if they are worshipped; if they are ignored, they might become malevolent.

Ancestor worship is part of Daoism, Confucianism, and Chinese Buddhism. It is also important in Japan, where, on the thirty-third or fiftieth anniversary of their death, the SOULS of deceased relatives are believed to merge with the group of deities protecting the community.

In Africa, ancestors are widely represented using items such as statues. The Tallensi of Ghana set out BLACKENED STOOLS, which represent the SPIRITS of ancestors (above). Their functions are varied: they may define lineage, act as minor local deities, or make it possible for the deceased to be reborn. The Norsemen believed that **elves** were the souls of the ancestors, that they could be contacted by sleeping on MOUNDS and through dreams, and that they could give the gifts of poetry and prophecy.

## Virgin ✳ Maiden

Maidenhood is the first, chaste stage of the FEMALE life-cycle, representing innocence and purity of mind and body, and the greatest potential for fertility. Thus a virgin was seen as a special prize, and could convey special purity and even sanctity to its holder. Hence the importance of the virginity of the Vestal Virgins, who tended the sacred FIRE that represented the health of the Roman state.

Virginity is especially important in Christianity because MARY's (above) virginity was proof that, although she was his MOTHER, CHRIST was the son of God, and not of man. It also indicated that Mary was above the physical desires of ordinary humankind.

Similarly the Greco-Roman virgin goddesses MINERVA and DIANA were depicted as immune to the petty jealousies of espoused goddesses, who – by contrast – were portrayed as emotionally enslaved and undermined by sexual passions.

## Children

Children symbolize innocence to Christians, SOULS untutored in the ways of the world, although marked from birth by original sin. In alchemical illustrations they are also symbols of innocence, usually appearing after the process of death and resurrection, indicating their status as the children of, or the reborn, Sol and Luna, or KING and QUEEN.

## Black Goddess

Depictions of the VIRGIN MARY, black-skinned, seated with CHRIST on her lap, found mainly in Spain, France and Switzerland, may relate to cults of pagan goddesses such as Cybele, worshipped as a BLACK STONE; ISIS, who has a black and a WHITE form and DIANA of Ephesus. They symbolize loss of beauty, age, death and miraculous healing.

## White Goddess

The Celtic goddess Cerridwen (WHITE Sow, above with her magic CAULDRON) was called the White Goddess. She was said to devour her young like a farrowing sow, but was also the Great MOTHER – the harbinger of DEATH who also gives life. She was thus associated with the phases of the MOON, which waxed like a pregnant woman and waned as it was eaten or became the dark mother. Robert Graves (1895–1985) wrote of his psychological encounter with the White Goddess, whom he believed to be the goddess of inspiration, empowering the muse who brought initiation to the bard through madness and confrontation with self-annihilation.

She is also associated with the Egyptian goddess ISIS in her form as widow and lover. In Western hermeticism Isis and NEPTHYS are sometimes called the 'BLACK and White Isis', possibly symbolizing duality. It is preferable to meet the Black Isis first because her lessons help the initiate overcome the inevitable glamour of the White Isis.

## Fool

The paradoxical nature of the fool is illustrated by the traditional role of the European court jester (above): an outcast performing an important, socially cohesive role. He parodies unacceptable behaviour, encouraging people to laugh at themselves and so bringing the community together in a cohesive view of right and wrong. Similarly, Native American Zuni clowns perform horrifying acts, showing how awful are the alternatives to an ordered society.

The Romans celebrated the fool at the FEAST of Saturnalia, which was later subsumed into the Christian ritual of Twelfth Night, traditionally governed by the Lord of Misrule.

The Celts associated the Fool with SPRING – for example, the April Fool, the GREEN MAN, Jack in the Green and Robin Hood (see also TRICKSTER). The Christian holy fool is wise in the ways of God but naive in wordly matters, and is often represented naked (innocent, untrammelled), or as a HERMIT.

## Queen

A queen naturally provides the FEMALE complement to the MALE KING, so that the Jews considered the Queen of Sheba SOLOMON's equal in wealth and in wisdom. This linked her to the Judaic idea of SOPHIA ('Wisdom') as God's female counterpart. In Christianity the VIRGIN MARY is the Queen of HEAVEN, the consort of the King of Heaven. Belief in her coronation (the last great mystery of the Virgin after her assumption) may have evolved in the 2nd century, although depictions only become common as the cult of the virgin developed in the 12th century. She is usually shown being crowned by CHRIST rather than by God the Father.

Western queens (above) are usually shown wearing a CROWN (sovereignty), carrying an ORB surmounted by a CROSS (Christian rule over the globe) and a SCEPTRE (authority). In Western alchemy the queen represents the feminine energy or counterpart in the process. She is associated with LUNAR SILVER, whereas the KING represents SOLAR GOLD.

A R C H E T Y P E S

A

B

C

## King

In Western art (A) kings are generally shown seated on a THRONE (the seat of authority, raised above ground level to signify their greater proximity to god), usually with their traditional regalia of CROWN, ORB and SCEPTRE.

Kings were often associated with the ruling male deity. The king or pharaoh of Egypt (B) was considered to be the god HORUS, and he died as OSIRIS, the lord of the UNDERWORLD. Similarly, the Oba (or King) of the West African Yoruba (C) is thought to be the earthly counterpart of OLOKUN the sea god, and a descendant of the earth god ODUDUA.

Gods may also be thought of as kings. The Christian God is referred to as the King of HEAVEN or King of Kings; CHRIST is also given this title, and was given a CROWN of THORNS on the way to his crucifixion to mock his disciples' claim that he was the King of the Jews.

In Imperial China the king was called the 'Son of Heaven' and was thought to rule by virtue of a celestial mandate. Kings ruled in China until the end of the Zhou Dynasty, c. 1050–221 BC, when they became known as emperors. The divine connection is also hinted at in Celtic folklore and the Arthurian tradition of sovereignty bestowed from higher sources, such as the feminine deity of the LAND or the Otherworld.

The king is often believed to have a sacred connection with his KINGDOM. He came to symbolize the land, so that his rule and his wellbeing were often seen as linked directly with the state of the kingdom. In China, a true king epitomized virtue and ensured the wellbeing of his subjects through his own good example and wise rule. This idea was also found in Celtic traditions, where it was believed that the king must rule the kingdom wisely in order to prevent the land from becoming an infertile wasteland.

The line of descent often governs the choice of a king, so the notion of bloodline is often paramount. Thus, it was important to the early Christians (who were largely Jewish) that CHRIST was believed to have been a descendent of David, the first King of the Jews. This was symbolized by depictions of the genealogical line as a tree stretching from David to Christ.

In many cultures, the term 'king' is used to denote the supreme example of something. In Japan, for example, the CARP is called the 'king of RIVER FISH', while the sea bream (tai) is the 'king of SEA fish' and the CRANE the 'king of BIRDS'. Together these are known as the 'THREE ultimates' in food.

In Western alchemical illustrations a king often symbolizes the ego. The old king would be destroyed during the stage of the NEGRIDO, indicating the DEATH of the old ego. Such illustrations use the Western visual tradition.

## Queen Mother

Queen mothers were the most powerful women in many African societies. While a KING might have many wives, he could only have one MOTHER, and so their status was considered higher than that of a queen. Consequently, they were often classified as MALE.

The queen mother was frequently regarded not only as the king's creator but also as the promoter of ideas and artists from her home. Politically powerful, her court was often a refuge for people critical of the king.

The Ashanti of Ghana linked their queen mothers to the EARTH Goddess, so they also represented fertility and agriculture. Their regalia included a special CROWN made from CORAL beads which reflected the hairstyle worn by court women (above).

In Chinese beliefs, XI-WANG-MU (Queen Mother of the WEST) rules over the element METAL. The alchemically important metal MERCURY is also associated with the WEST (and with VENUS), so the Queen Mother of the West was the Chinese goddess of alchemy.

## Shaman

The word 'shaman' has Siberian origins, meaning 'he who knows': Siberian and Central Asian shamans (male and female) have healing powers and can communicate with other worlds. Shamans use dreaming, dancing, fasting and psychotropic drugs to enter trance states in which they assume the identity of a particular animal, allowing them to see, do and know what ordinarily they cannot.

Native American medicine men (above) or women are healers, guardians of their tribe's well-being, intermediaries between the people, the ANCESTORS and the world of SPIRIT, and can communicate with all creation on all levels of awareness.

Many African cultures have shamans, such as the San people of South Africa. Through dancing and trance, their shamans release a supernatural power with which they heal, make RAIN, and control and transform into animals.

In the early Shinto religion *miko* or female shamans were vessels for spirits of deities. In some areas of Japan today, BLIND female mediums act as mouthpieces for the gods.

## Witch

Witches symbolize evil intent and are closely associated with the fear of FEMALE subversion. In cultures where magic is integral to the belief system, such as Africa and Native America, witchcraft is usually malevolent magic and may be associated with women or men.

Patriarchal religions have often labelled as witches women who were originally prophetesses or priestesses, such as the Witch of Endor consulted by Saul (Samuel 1: 28).

The origins of the Western concept of the witch may well lie in the ancient DRUID priestesses, said to have worn BLACK. Early modern European tradition depicts the stereotypical old woman (above) wearing black and a tall pointed hat, flying on a BROOMSTICK, accompanied by 'familiars' in the form of CATS, COCKERELS or TOADS, and perhaps with unnatural marks on her body (for example, an extra nipple, finger or toe). However, witches today are more likely to represent women of magic and healing, followers of nature.

A R C H E T Y P E S

### Wizard

Wizards are wise or dangerous
men of mystery and magic, or
they are healers. They are often
shown wearing a cloak covered in
mystical symbols and sometimes
a pointed hat. Their origins may
lie in the DRUID priests who, like
MERLIN, would advise rulers and
weave spells of natural magic.

### Hermit

Usually shown as an old MAN with
a long beard and unkempt hair
symbolizing unworldliness, the
hermit seeks enlightenment
through isolation. He lives in
CAVES, DESERTS or forests (symbols
of isolation) or by WELLS (founts
of wisdom). Many of the earliest
Christian saints were hermits.

### Amazon

In Ancient Greek culture the
Amazons (above) were a mythical
race of WOMEN who excelled at
HUNTING and war. Ruled by their
QUEEN, Hippolyta, they admitted
no MEN into their society; they
therefore represent strong, defiant
women. They were associated
with the cult of ARTEMIS at
Ephesus. They were said to have
cut off their right breast in order
to draw their BOW more easily.

Their real counterparts existed
in the 17th century in the West
African kingdom of Dahomey,
where a king employed a legion
of female fighters to capture a
succession of cities. They held
semi-sacred status as the celibate
WARRIOR 'wives' of the king, vying
in strength and skill with male
warriors. They were renowned for
fighting and parading topless, but
they were finally defeated by the
French Foreign Legion in 1892.
In the Ukraine, graves of women
buried with war gear have been
found, and some think that these
– non-Greeks from the margins of
the known world – also gave rise
to the Amazon myth.

### Fisher * Fisherman

In Arthurian legend, when
PARSIVAL first met the GRAIL KING
he thought him a fisherman –
hence his other name, the Fisher
King. The Grail King is wounded
in the THIGH, representing
his impotence and thus the
impotence of the LAND (the
'wasteland'), which can only
be healed by the Grail.

Although pagan in origin, the
legend later became Christianized
and the Fisher King became more
CHRIST-like. His role was to
initiate Parsival into the quest for
the Grail, representing the human
SOUL's search for CHRIST. The
quest ultimately meant SACRIFICE
for Parsival and the King,
representing the inevitability
of death before resurrection
into the Kingdom of HEAVEN.

In Christian art fishermen also
represent the APOSTLES and
brothers Peter and Andrew, who
first met CHRIST when they were
fishing in the Sea of Galilee. They
were called by Christ to become,
symbolically, 'fishers of men'.

## Warrior

The warrior is an archaic or poeticized form of soldier, embodying courage, self-discipline, dynamism, strength, determination, fearlessness and above all courage – virtues which, in turn, were embodied in war-like societies such as the Ancient Greek city-state of Sparta (A).

Warriors were traditionally seen as epitomizing MALE virility (female AMAZONS being the exception that proves the rule), so when peoples were embattled or at war, they appealed to the warrior aspects of their deities, for example, the Roman MARS or the Jewish Yahweh, the 'champion of Zion' who brought retribution in battle.

Many Celtic deities possessed attributes of warriors, such as remarkable fighting skills or magical weapons. But the ancient Celts, like many other cultures, did not restrict warriorship to men, and there are many famous warrior QUEENS, and warrior goddesses, such as the Ancient Roman MINERVA and the Ancient Egyptian NEITH and SEKHMET. Celtic warrior goddesses included the Irish Celtic MORRIGAN.

Warriors' deaths are often seen as especially holy. Nordic warriors were the only dead to be given a place in ODIN's Valhalla, where they feasted eternally. The Christian warrior or knight (C) was sanctified by the Crusades, the medieval missions to regain the Holy Land for Christianity. Fighting for CHRIST was considered a kind of religious heroism and was rewarded with indulgences – effectively concessions in the afterlife. In the West the tradition of noble self-sacrifice carried on to the 20th century, with statues of soldiers or warriors used to commemorate the 'glorious dead' (the inscription on the Cenotaph commemorating the war dead, in London).

The principle of the 'spiritual warrior' is also present in the Eastern tradition of martial arts, in which skills such as swordsmanship can become contemplative arts of perfect achievement, with parallels in Zen Buddhism and Daoism.

Similar attributes are accorded to the Japanese samurai (B), the elite warriors of Japan from the 10th century onwards.

Christian warrior saints such as ST GEORGE (usually shown conquering the DRAGON, a scene from the best-known tale about him) and the ARCHANGEL Michael symbolize the conquest of good over evil, personifying courage, faith and commitment. The idea of a battle over the forces of evil or immorality came to be personified in the Salvation Army, spiritual 'soldiers' for God.

The times of the Crusades also saw the flourishing of chivalric literature. The most important was the collection of legends surrounding KING ARTHUR, based on earlier Celtic tales of warrior heroes. The chivalric hero was usually a young man with precocious gifts, or a FOOL, who became a warrior or a knight. His exploits in battle distinguished him from the crowd and, sometimes, marked him as being semi-immortal. He became the idealized warrior and lover, both brave and courteous.

## Shepherd

In Western culture shepherds were archetypal happy rustics, often depicted on classical sarcophagi as symbols of the *vita felix* or 'blessed life' that awaited the deceased in the HEAVEN of the Ancient Greeks, Elysium. Likewise, from the 17th century the VIRGIN MARY and St Genevieve were occasionally represented as shepherdesses, reflecting the idyllic pastoral life of Heaven.

More significantly, the shepherd is one of the most ancient symbols of CHRIST as leader and protector of his congregation of Christians. He is often represented carrying a lost SHEEP, symbolizing the retrieval of a SOUL from sin, and thus release from DEATH into eternal life.

This link between the benign role of the shepherd and the protective role of the gods occurred in other religious traditions, including the Sumerian, Vedic and Hebrew cultures. The Ancient Egyptian RA was known as 'the shepherd of all men', and pharaohs were thought of as shepherding their people.

## Sower

The Christian symbolism of the sower was elaborated in some of the parables told by CHRIST (for example, Matthew 13: 18). He symbolizes the wise man who knows that his present thoughts and actions will affect his future destiny and prepares himself accordingly, rather than gratifying the impulses of the moment without caring about the consequences. The sower thus embodies wisdom, caution, preparation and attention.

The symbol of the sower also appears in Eastern and Western alchemy. In Western alchemy, he sows seeds of GOLD into the WHITE, foliate EARTH, surrounded by symbols of DEATH, at the stage when *coagulatio* combines with the process of fermentation. The white STONE turns YELLOW. In traditional Chinese alchemy, the sower also sows GOLD COINS, which will later grow, and usually also ploughs the land, a symbol of the early SPRING sowing.

## Captives

Images of captives – such as those on Ancient Egyptian, Greek and Roman temples and important buildings – were often used to symbolize the might of their captors, thereby indicating the strength of their armies and rule. In early cultures, parts of the bodies of dead captives, such as SKULLS, were kept for the same reason.

In Mesoamerican cultures, captives symbolized and reinforced the divine right of KINGSHIP. Territorial raids were undertaken regularly to capture prisoners, whose ritualized bloodletting, torture and execution affirmed the absolute power of the ruler. In Maya stone carvings captives were shown playing a ritualized form of BALL game, in which the ruler was their opponent and the DEATH of a captive was the outcome. The ball was frequently depicted as a HEAD or a SKULL, and 'skull racks', rows of stone skulls, decorated ball-courts, because losers (defeated captives) were decapitated or used as the ball.

## Smith

Many cultures saw the ability of blacksmiths (A) to use FIRE and WATER to transform unrefined METAL into useful tools and artefacts as spiritual and mysterious, attracting a reverence similar to that which was later given to alchemists. Smiths were traditionally feared and revered for these skills in most parts of Africa, where in addition to making pots and tools, they produced ritual objects such as highly decorated STAFFS, AMULETS, and sacred objects such as statues. These things were empowered through the sacredness of the metals from which they were made, and through the mysteries of the smith's art. Numerous African peoples, among them the Kubu of Kongo, believe that women gave birth to the natural world and that blacksmiths created the cultural world. Thus while potting and smithing both transform natural materials into cultural artefacts using the elements, smithing is often gendered MALE in sub-Saharan Africa, while potting is seen as an essentially FEMALE art. Priests of the Binukedine tribe (Dogon) use the ritual ADZE (an axe-like tool) when undertaking important acts of worship, and smiths also carry adzes as an emblem of their connection to the SPIRIT world.

In the Celtic tradition, metal-working was associated with the divine smiths: the Irish gods LUGH and Goibiniu, and the Welsh Govannon. Later, BRIGID (B) – who presided over fire, magic and transformation – became the patroness of smiths. Smithing was often an attribute of FAIRIES, although they were said to shy away from IRON. Hence the importance of the fairy smith god, Weyland, who would shoe a HORSE if it was left overnight with a SILVER COIN at the ancient chambered TOMB called 'Weyland's Smithy' in Wiltshire (C). Artefacts depicting HAMMERS and tongs, which have been found as grave goods and as religious relics, are thought to have been associated with beliefs involving the sacredness of the craft of smithing.

Metalworking was also associated with dwarves. They are, for example, shown working metal in several tombs from the Egyptian Old Kingdom. In Teutonic legend, dwarf smiths led by Alberich hammer away at their ANVILS in the UNDERWORLD. The Greco-Roman smith god was HEPHAESTUS/VULCAN, said to have used his extraordinary skills to furnish the PALACES of the gods and forge the SHIELD of ACHILLES. He also used his skills for personal advantage when he caught his adulterous wife VENUS sleeping with MARS, covering them with a NET of metal thread so fine that it was invisible. Physically grotesque and raised outside Olympus, Hephaestus was the archetypal smith, and he represents the social outsider in a community whose skills are feared but needed.

For Christians, St Eligius, a goldsmith, is the patron saint of metalworkers. He is sometimes represented with a smith's ANVIL or as a farrier (maker of horseshoes), or clenching the DEVIL'S nose in pincers.

A F R I C A N

## Mama Wata

A seductive WATER goddess, Mama Wata is related to love and childbirth, and her followers are found along the African coast from Senegal to Angola. She is most commonly depicted in a form derived from a 19th-century European lithograph, as a non-African female with long flowing HAIR covered in medallions, manipulating SNAKES with her hands (above). The lower half of her body is often concealed, as she is believed to be MERMAID-like, half-WOMAN and half-FISH. Some of the artefacts most commonly placed on her shrines are MIRRORS and sunglasses, suggesting her love of beauty and fashion and the reflective nature of the surface of water, the boundary between her watery realms and the land.

Other items on her shrines emphasize the influence of European culture and foreign imports, underscoring a perceived relationship between Europeans and water deities along the coastal areas of Africa.

## Anansi

Anansi is a part-human, part-spider TRICKSTER figure, usually shown as a human body and head resting in a cradle of spider legs. Originating in the legends of the Ashanti of Ghana, he symbolizes story-telling and the craft of WEAVING. He tricked the SKY- and creator god Nana Nyankopon into giving him his stories by completing (with the help of advice from his wife) the difficult task of capturing four fearsome creatures. Anansi then brought the stories to the earth. In another version of this story he brought not harmless stories but disease.

Anansi's stories travelled with slaves to the Caribbean and the USA, where he is known as Anancy (Jamaica), and Aunt Nancy (in parts of South Carolina and in Voodoo lore). These stories tell of him outwitting other animals – his physical superiors – with tricks of deception, leading the victims into self-defeating traps. They represent techniques of survival at their best, and offered hope and relief to a population in slavery and poverty.

## Obbatal

One of the creator gods of the Yoruba of Nigeria, Obbatal is sometimes shown with children emerging from his head (above). A SKY god, he commanded sixteen subject gods to create the world and fill it with life. Obbatal received the material for this task in a GOURD filled with EARTH and a FIVE-toed HEN, but on his way down from the sky he drank so much palm WINE that he fell asleep. He is therefore associated with INEBRIATION.

ODUDUA then came, and took the gourd and the hen. Travelling down to the first SEA, he scattered the earth on the waters, the hen scraped it into a heap, and thus land was created where Ife (the chief religious town of the Yoruba) now stands. The other gods then descended to the land of Ife.

Obbatal decided to create beings like himself for company. He found some earth and began to model them, but again he drank too much palm wine and this time created cripples, the LAME and the hunch-back: and so he protects the misshapen and the disabled.

## Odudua

Odudua is an EARTH god of the Yoruba of Nigeria, often depicted wearing a tall, thin HEAD-DRESS. He created the first LAND, the centre of which is said to be Ife the Yoruba religious capital (see OBBATAL). After the land was created the gods fought for its control. Odudua was the victor and became the first ruler of Ife and the first ancestor of the Yoruba. Hence the Yoruba KINGS or *oba* are seen as Odudua's representatives on earth.

Odudua's festival is celebrated during the YAM harvest. This marks a CROSSROADS in the year, so his followers wear BRASS masks with CROSSES inscribed on them, and carry crosses and AXE-shaped STAFFS. Rites are held during the festival to honour the royal dead, because he is also considered to be the king of the dead. Crosses and staffs or SPEARS found on Catholic images of St Michael led to Odudua being associated with him by Africans transported to Cuba as slaves.

## Ogun

The god of warfare and sacrifice of the Yoruba of Nigeria, Ogun is also the SMITH god, and is associated with all implements and sacred items made of IRON, and therefore steel. He is usually depicted standing holding two SWORDS, symbolic of material wealth and success. Ogun always eats before any other god, since the BLOOD from a SACRIFICE always touches the KNIFE before it falls on the deity for whom the sacrifice is intended. His followers were traditionally SMITHS and WARRIORS, although they now include all those who depend in some way on METAL for a living, such as train and lorry drivers, and particularly WOOD-carvers, textile-workers and body-artists who use metal instruments.

Ogun's cult is also found in the Americas, where he has become a Voodoo deity (his traditional voodoo symbol is illustrated above). He is called Ogou in Haiti, where his military attributes led to an association with ST GEORGE.

## Shango

The THUNDER god of the Yoruba of Nigeria, Shango (above) was originally a KING of Oyo (the ancient Yoruba capital), whose SPIRIT was elevated to the level of a god after DEATH. While still alive on earth he showed no mercy to his enemies, and so his fame spread over much of Africa, so that even the Bantus of the Congo area came to honour him.

Today Shango personifies thunder, lightning and storms, because of his wrath. His symbol is the double-headed AXE, which represents the thunderbolts of STONE that drop from the HEAVENS during a storm and, like lightning, destroy things deserving of his wrath. Carved mortars are also placed on his altars, because the pounding of food in a mortar sounds like thunder.

Shango is also worshipped as a Voodoo deity in the Americas, and is associated with ST BARBARA, the patron saint of comfort in times of danger from thunderstorms (and FIRES).

A F R I C A N

A
F
R
I
C
A
N

## Eshu

A TRICKSTER god of the Yoruba of Nigeria, Eshu's long HEAD-DRESS and half-shaven head indicate his status as a royal messenger. His FLUTE symbolizes communication with the SPIRIT world and his role in divination. He is the youngest deity and is often shown sucking his thumb. His association with trade means that he wears COWRIE SHELLS (a traditional currency).

## Ifa

God of wisdom and divination of the Yoruba of Nigeria, Ifa is not shown directly but his worshippers (above) are shown kneeling, holding containers shaped like CHICKENS (his usual offering). They hold sixteen PALM nuts he gave to his CHILDREN after he ascended to HEAVEN, to be used for divination.

## Obalufon

The Yoruba god associated with the beaded CROWNS worn by the KINGS of Ife (the chief religious town of the Yoruba), Obalufon was one of Ife's founders. He is the god of bead-working, WEAVING and coronations. His HAIR is white and his face SCARIFIED. When he goes to war he is described as shaking with rage.

## Olokun

The WATER god of the Edo of Nigeria, Olokun is associated with the WEST. His symbols are mudfish, PYTHONS, CROCODILES (his messengers), and CLAY and chalk (used to mark his ALTARS). His territory is the RIVERbank. In royal regalia he is represented by CORAL beads. He is also associated with wealth, because foreigners sail to Africa over the SEAS.

## Ogiwu

God of THUNDER and DEATH of the Edo of Nigeria, Ogiwu is associated with the NORTH. His symbol is the PYTHON, which, depicted in a zig-zag shape imitating lightning, often decorates the roofs of PALACES. He is also associated with the STONE AXES (above) of royal regalia, representations of the king's power over life and death.

## Ala

The EARTH goddess of the Igbo of South-eastern Nigeria, Ala is the source of all beauty in nature, and of morality and goodness. She punishes those who transgress against the laws of nature and society by causing failed HARVESTS and natural disasters. Women uphold her laws, and translate her beauty into everyday life in body and wall paintings.

## Haile Selassie

The Emperor Haile Selassie I is hailed by the Rastafarian movement as a messiah. As the LION is the KING of all beasts, the title 'Lion of Judah' also portrays Haile Selassie as the King of Kings (above). The religion has its roots in the teachings of the Jamaican black nationalist Marcus Garvey (1887–1940). In the 1920s he prophesied that a messiah would come out of Africa 'when a black king shall be crowned, for the day of deliverance is at hand'.

Many thought the prophecy was fulfilled when Ras Tafari was crowned Emperor Haile Selassie I of Ethiopia in 1930 and proclaimed 'King of Kings, Lord of Lords and the conquering lion of the Tribe of Judah'; he claimed to be a direct descendant of King David, from a line of Ethiopian kings stretching back to SOLOMON and the Queen of Sheba.

## Gu

A Dahomey god of war, SMITHING and IRON, whose image would be brought onto the battlefield to terrify the enemy. These images were usually made of METAL, and show him, TEETH bared, holding two large, pierced SWORDS, his large flat FEET ready to trample on his enemies. Some have a CROWN made from miniature weapons.

## Ashtart

Ashtart (Womb) was the Assyrian Great Goddess and a consort of the Phoenician SKY god BAAL. She was linked with the planet VENUS, the SEA, SEXUAL LOVE, and fertility, represented by LOTUS flowers in her hands and SNAKES around her waist. The LION on which she stood symbolized her fierce aspect. She was patron of war and HUNTING.

## Ahura Mazda

The supreme deity of the Zoroastrian faith, Ahura Mazda (Lord of Wisdom) created the HEAVENS, the WATERS, the earth, the plants, the animals, mankind and FIRE. As absolute goodness, he is in constant opposition to Angra Mainyu, the embodiment of absolute evil.

As a transcendent deity with no incarnate form he cannot be depicted, but his attributes are manifested in the symbol of the *faravahar*, a KINGLY figure rising out of a WINGED disk (above). The figure represents the human SOUL, gifted with free will. One hand points to HEAVEN where, eventually, it will unite with Ahura Mazda. The other hand holds a RING, symbolizing kingship, the cycle of rebirth that purifies the soul, and the covenant between the creator and his creation. The disk encircling the figure's waist symbolizes eternity and the law of moral consequences. The wings, skirts and ribbons also symbolize various aspects of Zoroastrian belief.

MIDDLE EASTERN

### Inanna ✳ Ishtar

The most important female fertility deity in the Assyrio-Babylonian pantheon, Inanna (or Ishtar) was the goddess of love and war. She was represented standing on a LION (indicating her ferocity in war), and with OWL's wings and talons. She was clothed with the HEAVENS and CROWNED by the STARS, and her LAPIS LAZULI jewels and her RAINBOW necklace reflected her association with the SKY. She is often shown holding two looped bands, wearing a necklace, and with a THREE-tiered crown on her head.

Inanna's descent into HELL to release her lover TAMMUZ from her sister Ereshkigal (QUEEN of the UNDERWORLD) related to her role as a MOON goddess. The phases of the moon were reflected in her descent through the underworld, while the SEVEN GATES through which she passed were also associated with the dance of the seven VEILS. She was related to the planet VENUS, and her priestesses were sacred prostitutes, so Jews and Christians called her the Whore of Babylon.

### Lamassu

Lamassu are associated with the ancient Assyrian culture (1000–600 BC), although they embody even older Mesopotamian symbolism partly derived from Babylonian magical traditions. They usually took the form of monolithic sculptures that stood up to 5 m (about 16 ft) tall and weighed up to 30 tonnes (29½ tons) (above). They were incorporated into the structures of important CITY and PALACE GATEWAYS. They were portrayed with a BEARDED MALE head, in the style of a deity or a KING (whose authority and protective benevolence they represented), surmounted by the HORNED cap that signified divinity. The body was that of a LION or a BULL, both animals redolent of virility, power and sovereignty. They were WINGED, indicating their supernatural ability to ascend to the HEAVENS or descend to the depths; and they had FIVE legs, demonstrating their perpetual vigilance against both mortal and supernatural foes, who may attack from any direction.

### Lilith

In Jewish mythology, Lilith is the queen of DEMONS and consort of SATAN. She symbolizes lust and temptation (Isaiah 34: 14). Lilith is associated with the night and the dark side of the MOON: her name and the Hebrew word for night – *laila* – have the same root. She derives from Mesopotamian demons called *lilu* and the Libyan SNAKE goddess Lamia. She is represented as a snake with a female head, long hair and WINGS. As a result of her union with ADAM, she is said to have given birth to demons called Lilim; and she is associated with the SERPENT who symbolizes forbidden wisdom, and who tempted Eve to eat the fruit of the TREE OF THE KNOWLEDGE OF GOOD AND EVIL in the GARDEN of Eden.

Lilith is also associated with the OWL, because it is nocturnal and linked with wisdom. It may be that there was an early association between Lilith and the Ancient Greek goddess ATHENA, who was also associated with owls.

## Mithras

Elements of the cult of the SUN god, Mithras, were imported from Persia and India, but its synthesis into a new religion occurred in the crucible of the Ancient Roman army, from which it spread through Roman society and the Empire to many of its frontiers.

Mithras was the creator and controller of the cosmos. Several reliefs depict him spanned by the circle of the ZODIAC. He was worshipped in subterranean temples where the *taurobolium* (ritual SACRIFICE of a bull) took place. This was a re-enactment of Mithras slaying the bull (above), and possibly alludes to the end of the AGE OF TAURUS and the advent of the AGE OF ARIES. Thus his symbol – the bull (Taurus), the SCORPION (SCORPIO), the DOG (Canis Major) and the SNAKE (Hydra) – probably alludes to the constellations particular to the Age of Taurus.

## Adonis

Adonis, originally called Tammuz, was the Phoenician god of corn. His cult celebrated his DEATH and resurrection, reflecting the cycle of growth and harvest in arable agriculture. These themes continue in the later Ancient Greek legends, which describe how his pregnant mother, Smyrna, was transformed into a MYRRH tree by ZEUS. She burst open to reveal a child of extraordinary beauty. APHRODITE hid the boy in a chest, which she gave for safekeeping to PERSEPHONE, QUEEN of the UNDERWORLD; but Persephone decided not to return the exquisite infant. Zeus mediated in the goddesses' quarrel, decreeing that Adonis would spend half the year on earth and half in Hades.

Later loved by Aphrodite, Adonis was killed by a wild boar while out HUNTING (above). During the annual festival of the Adonia, 'Adonis GARDENS' were planted, and then thrown into FOUNTAINS or into the SEA.

## Baal

The Canaanite SUN and fertility god, Baal was associated with the SKY and storms. He was depicted as a KING. He had a volatile temper and was frequently engaged in a feud with Yam, god of the SEA and RIVERS. The main theme of the First Book of Kings is his worship by the Israelites in the Promised Land.

## Melchizadek

Melchizadek was the priest-KING of Ur Salem (Jerusalem). When ABRAHAM brought his tribe to Palestine, Melchizadek blessed him and gave him BREAD and WINE. Hence Melchizadek is considered to prefigure the Last Supper. He is also believed to have been of the order of priesthood that was prefigured in Christ.

A

B

C

## Adam and Eve

Jews, Christians and Muslims believe that Adam was the first MAN, created by God in his own image on the SIXTH day of creation from dust and EARTH (his name comes from *adamah*, the Hebrew word for soil).

Eve, the first WOMAN, was created out of Adam's rib to provide a companion for him. Her name means 'MOTHER of all living things'. Her curiosity led to the downfall of mankind when she followed the SERPENT's advice and ate the FRUIT from the TREE OF THE KNOWLEDGE OF GOOD AND EVIL, tempting Adam to copy her (A). As a result, she is commonly associated with shame, lust and corruption.

This event is commemorated in the standard depiction of Adam and Eve standing on either side of the Tree of Knowledge, naked except for FIG leaves covering their genitals. This is related to earlier Sumerian images of the MOTHER Goddess and her consort, who sit around the TREE OF LIFE. The Goddess is accompanied by a SNAKE (signifying her regenerative powers). The image encapsulated their gifts of immortality, fertility and regeneration.

Christians believe that the first sin of Adam and Eve was redeemed by CHRIST who, according to legend, descended into HELL on Easter Saturday and rescued fallen mankind in the form of Adam and Eve. They are often depicted as representing toil (as a penance) – Adam tilling the earth (B), and Eve spinning (C).

Adam is often seen to correspond to Christ, the 'new Adam', whose crucifixion took place at Golgotha, the 'place of a SKULL' and the site of Adam's burial. Adam's skull is sometimes represented in a CAVE beneath the CROSS in depictions of the crucifixion. The BLOOD dripping from Christ's wounds into the mouth of Adam's skull symbolizes the redemptive power of Christ's last blood, cleansing Adam and Eve's first sin.

Eve corresponds to the VIRGIN: her Latin name, Eva, was a reflection of 'Ave', the first word of the 'Ave Maria' (Hail Mary), the ARCHANGEL Gabriel's greeting to the Virgin at the Annunciation.

The Christian background of most Western alchemists manifests itself in the way they compare their work with Christ's redemption of Adam and Eve. The first Adam was made from the corruptible FOUR elements, and Eve appears in the first conjunction of alchemy, representing the *anima*, which is perceived by the male alchemist as the WOMAN who is the focus for lust, desire and procreation. With the completion of the Work, a second Adam arises, becoming the incorruptible quintessence, like the risen Christ. The first Eve is transformed into the idealized woman, the MOTHER of God (or Virgin Mary).

## Shekhinah

The Hebrew Shekhinah is the
divine presence in the world,
described in the Old Testament
as a pillar of CLOUD by day and
a pillar of FIRE by night. She
guided MOSES and his people in
the DESERT, and surrounded the
sacred ARK: 'and the cloud
covered the tent of the Presence,
and the glory of the Lord filled
the Tabernacle' (Exodus 40: 34).

On the Kabbalistic TREE OF
LIFE, she is embodied in the tenth
*sephirah*, Malkuth (EARTH).
Essentially FEMALE, in MARRIAGE
she is symbolized by the wife
in the conjugal act, bringing
spiritual completion for the
husband. She is a manifestation
of SOPHIA (Wisdom), the female
aspect of God, and is therefore
sometimes depicted as a V-shape,
representing a stylized dove. She
is thought to prefigure the Holy
Spirit in the Christian TRINITY,
and is believed to be present
when Jews study the Torah
together – perhaps recalled by
CHRIST when he said 'when two
or three are gathered in my
name…' (Matthew 18: 20).

## Moses

Born to enslaved Israelite parents
in Egypt, Moses was fostered by
Pharaoh's daughter. After seeing
God in a burning bush and
experiencing the TEN plagues of
Egypt, he led the Hebrews (the
'chosen people') out of Egypt,
parting the Red SEA. They
disobeyed God, so they wandered
for FORTY years in the DESERT.
Moses received the two stone
tablets inscribed with the Ten
Commandments before reaching
the Promised Land.

The BRASS STAFF encircled by the
figure of a SERPENT, which Moses
used for healing, is thought to
prefigure the salvationist
symbolism of CHRIST's body on
the CROSS. Christians believe
Moses to have been a prophet
of Christ, symbolizing the law
of the Old Testament that was
superseded in the New Testament
by Christ's love.

A mistranslation in the first
complete Latin Bible led to
representations of Moses with
HORNS, either placed on his
head (above) or in the form of
a forked BEARD.

## Abraham

Abraham is significant in Judaism,
Christianity and Islam (in which
he is called Ibrahim) for faith and
his obedience to God, for whom
he was willing to sacrifice his son
Isaac. Christians believe that
episodes from his life prefigure
events in the New Testament. The
aborted sacrifice of Isaac therefore
prefigures CHRIST's crucifixion; the
priest-king MELCHIZADEK's offering
of BREAD and WINE to Abraham
prefigures the Eucharist; and the
appearance of THREE messengers
of God to Abraham and his wife,
Sarah, announcing that they
would have a son, prefigures the
annunciation of Christ's birth to
the VIRGIN MARY.

Usually depicted as an old man
with a flowing white BEARD and
the KNIFE with which he would
have killed Isaac (above) had
God not intervened, Abraham is
also represented as a merciful
recipient of SOULS into his bosom.

Muslims believe that Abraham
rebuilt the Ka'bah, the sacred
monument in Mecca, with his son
Ishmael. (The Ka'bah is believed
to have first been built by ADAM.)

JUDEO-CHRISTIAN

## Solomon

The son of King David and Bathsheba, Solomon was KING of the Jews. In historical terms, he came to the throne in 1015 BC. He was renowned for his great justice and wisdom (see I Kings 3: 16–28), and he symbolizes kingship, piety and wisdom in Judaism and in Freemasonry.

Identified as the builder of the Temple in Jerusalem, Solomon was an ideal symbol for Freemasons. The Temple took SEVEN years to complete and was made without any harsh sounds. A perfect monument, it demonstrated that the silent forces of the universe (such as love) are the greatest, and so is a symbol of the body of man, containing the sanctuary of the human HEART.

Solomon is also credited with writing the Song of Solomon, a compilation of erotic verses, which in ancient times was understood to symbolize the relationship between God and the individual SOUL or the Church.

## Adam Kadmon

Adam Kadmon first appeared in 13th-century texts as the spiritual prototype of MAN, created by God and said to be a symbol of the ideal, universal man. In Kabbalistic literature he is related to the Sephirot on the TREE OF LIFE, and mediates between God and mankind. Thus, he is identified with the Messiah, and contrasted with Adam Beliyyal (the evil man).

## Moloch

Moloch was a FIRE god. He was reinstated by the Judeans as one of a pantheon of Middle Eastern gods, most notably by Manesseh, one of the last KINGS of Judah. His worship involved the SACRIFICE of CHILDREN, in a figure of a BULL containing a FIRE, through which they were made to pass.

## Sibyl

The Greeks and Romans identified ten inspired sibyls or prophetesses, priestesses of APOLLO who were imbued with the gift of prophecy. Their predictions were written on SCROLLS. The most famous, the Sibyl of Cumae, sold her BOOKS of prophecy to the Roman KING Tarquinius (d. 510 BC), who lodged them in Rome. They were known as the Sibylline Books and were consulted for divine advice at times of war and national crisis.

During the Middle Ages, the prophecies of the Erythrean sibyl (from Ionia, modern Turkey) were seen as evidence of a pagan prediction of the coming of CHRIST. ST AUGUSTINE records an apocalyptic prophecy attributed to the sybil, in which the first letter of each line forms a prayer: 'Jesus Christ, Son of God, Saviour'. In the original Ancient Greek, the first letters from each verse formed the word 'ICHTHYS', 'FISH', also symbolic of Christ. Christians identified TWELVE sibyls, who were usually depicted holding a scroll or (anachronistically) a book containing their prophecies.

A

C

B

## Marian Symbols

Aspects of the VIRGIN Mary's holiness are represented by a great variety of symbols. These were most commonly represented in images depicting the Immaculate Conception – the doctrine that Mary was conceived free from original sin – which gained in popularity around the 17th century, and was defined as an article of Catholic faith in 1854.

However, many Marian symbols have much older origins. The enclosed GARDEN or *hortus conclusus*, which represented the sanctity and beauty of her VIRGINITY, is an example. Other symbols were added to depict the Immaculate Conception, such as the SUN, the MOON and a *halo* of TWELVE STARS (A), all of which appear in ST JOHN THE DIVINE's apocalyptic vision of a young woman 'robed with the sun, beneath her feet the moon, and on her head a crown of twelve stars' (Revelations 12: 1). The moon, usually depicted as a CRESCENT, was often related to virgin goddesses in Europe during the pre-Christian era.

Sometimes the Virgin is seen with a MIRROR, the *speculum sine macula* (mirror without a flaw, Song of Solomon 7: 26), or a closed GATE, *porta clausa*, again representing her virginity. She also holds a Madonna LILY, representing her purity and position as the 'lily among thorns' and indicating her uniqueness among women. She is also related to the STAR of the SEA, or Stella Maris, an old symbol of pre-Christian goddesses (for example, the Ancient Egyptian ISIS). Her BLUE robe represents the HEAVENS and symbolizes her role as their QUEEN. When she appears with a RED and a WHITE ROSE, these are associated with the ROSARY, and with the blood of Christ's martyrdom and her purity respectively. Mary was also described as the 'rose without a thorn', being free from original sin.

Other attributes are the OLIVE branch of peace and wisdom, a corn stalk (B) indicating her fruitfulness, and the GIRDLE she threw to DOUBTING THOMAS upon her Assumption. When adorned with three knots this recalls the girdle worn by Franciscan friars, who championed the doctrine of the Immaculate Conception. The three knots embody their vows of poverty, chastity and obedience.

Mary is also associated with a sealed FOUNTAIN, representing her virginity; the untilled soil of Eden, symbolizing her lack of sin; and a round TOWER (or David's tower), indicating her descent from King David and her virginity once again.

The Virgin also became a symbol in her own right. Depictions of her in colonial Latin America can be potent embodiments of the synthesis of native and European cultures. She was often shown with the SUN and MOON (C), powerful symbols for pre-Conquest cultures. Native advocations of the Virgin mix traditional and local elements, such as indigenous musical instruments and flowers notable for their bright colours, with echoes of indigenous costume.

In alchemy, the Virgin Mary represents the idealized state of realization and transformation of the *anima*, as the 'Mother of God'.

A

B

C

## Apostles

The TWELVE disciples of CHRIST who, after being visited by the Holy Spirit, went on to spread his word around the world.

∗ St Peter: named by Christ after the STONE or rock on which he wished to build the Church, subsequently interpreted as giving Peter supreme authority among the apostles and implying the institution of the papacy (Peter became the first Bishop of Rome). Attributes: the papal KEYS (A) and tiara; a COCKEREL (which crowed at his denial of Christ).

∗ St Andrew: venerated as the apostle of Russia and parts of Asia Minor, and the patron saint of Scotland since the 8th century. Attribute: the saltire CROSS (B) on which he was crucified.

∗ St James the Greater: present with Peter and John at the Transfiguration and the Agony in the Garden. His body is believed to have floated miraculously in a BOAT to the North-west coast of Spain, where it came to rest in a field and was identified by STARS. The location became Santiago de Compostela (St James of the Field

of Stars), the second most important pilgrimage site in Western Christendom after St Peter's tomb in Rome. Attributes: the purse, hat, STAFF and SCALLOP SHELL of a pilgrim; a SPEAR (instrument of martyrdom).

∗ St John the Evangelist or the Divine: author of the fourth Gospel and the Book of Revelation, traditionally recognized as Jesus' 'beloved disciple'. He is sometimes shown holding a CHALICE containing an asp or a SERPENT, having managed to survive an attempted poisoning.

∗ St Philip: having spoken at the feeding of the five thousand, he is associated with BREAD, and the CROSS on which he was crucified.

∗ St Bartholomew: martyred by being flayed alive, he is associated with a flaying KNIFE and a skin, and is therefore the patron saint of leather workers, including bookbinders.

∗ St Matthew: the author of the first Gospel and originally a tax-collector, his symbols are a money bag and a SWORD (instrument of martyrdom).

∗ St Thomas: apostle to India, where, by giving the money intended to build a PALACE to the poor, he built a palace in HEAVEN. One of his attributes is therefore a T-square. He symbolizes doubt, having questioned Christ's resurrection until he touched Christ's wounds; he also doubted the VIRGIN's bodily assumption until, rising, she dropped her GIRDLE to him as proof. This is one of his attributes, with a SPEAR (his instrument of martyrdom).

∗ St James the Less: the first bishop of Jerusalem, martyred with a fuller's CLUB (C).

∗ St Thaddeus (Jude): the saint to whom one appeals as a last resort, associated with a CLUB, the instrument of his martyrdom.

∗ St Simon: his attribute is a BOOK (from which he preached the gospel) or a saw (his instrument of martyrdom).

∗ St Matthias: replaced Judas as the twelfth apostle, identified by an AXE (instrument of his martyrdom).

## Trinity

For Christians the Trinity represents the belief that the 'substance' of God is divided into three Persons – the Father, the Son (Jesus CHRIST) and the Holy Ghost/SPIRIT (shown as a DOVE, above). This was symbolically prefigured in the Old Testament as the three men (usually represented as ANGELS) who told ABRAHAM and Sarah of the forthcoming birth of their son Isaac (Genesis 18); and in Isaiah's vision of the seraphim exclaiming 'Holy, holy, holy' (Isaiah 6: 3).

The Trinity is also identified with events in the New Testament, for example the baptism of Christ (God the Father manifest in his voice, the Holy Spirit in the form of a dove). The spirit is sometimes represented as rays of LIGHT or FLAMES.

In alchemy, the union of MALE and FEMALE, or of opposites, which come together to produce a third state or CHILD, indicates the ultimate divine, holy, Christian Trinity.

## Christ

Christ is the human incarnation of God and is represented by his symbol of a FISH (above), a visual pun on the Greek for 'Jesus Christ, Son of God, Saviour'). Christians believe that he fulfils the Jewish prophesy that a Messiah (saviour) would come to save the world, a God-man, teacher and healer during his lifetime. Rejected by some Jews, he was recognized by others, who became the first Christians. The Roman state condemned him and crucified him, and he is believed to have risen from the dead. Thus, Christ is a symbol of victory over DEATH and of the bodily resurrection of Christians at the Last Judgment. This is most obviously represented by symbols such as the CRUCIFIX and the CROSS.

Christ is a symbol in alchemy. Having suffered, died and been reborn through the various processes, and having thus achieved spiritual immortality, the alchemist has become like the risen Christ.

## Four Living Creatures

Representing the FOUR Evangelists and surrounding the throne of God, the four living creatures (above) were identified in the apocalyptic visions of the prophets Daniel and Ezekiel, and also in the Book of Revelation.

✳ The ANGEL, Matthew: associated with Christ's nativity (his Gospel opens with the genealogy of Christ, foretold by the Angel of the Annunciation).

✳ The LION, Mark: associated with the resurrection (his Gospel opens with the 'voice crying in the wilderness').

✳ The sacrificial OX, Luke: associated with Christ's crucifixion or sacrifice (his Gospel opens with Zacharias's sacrifice).

✳ The EAGLE, John: associated with Christ's ascension (the eagle can look into the SUN, symbolizing the 'true LIGHT' described at the beginning of his Gospel).

In the Western hermetic tradition the beasts are linked with the four Archangels: Raphael is the angel, Michael the lion, Gabriel the eagle and Uriel the ox.

JUDEO·CHRISTIAN

A

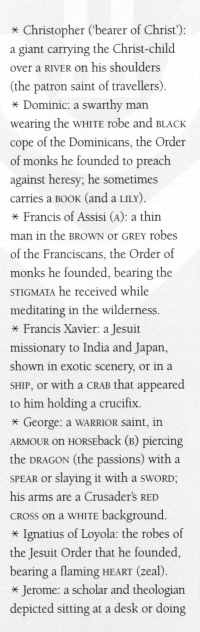

B

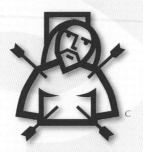

C

## Saints' Attributes

Saints are often identified by objects that relate to their legends, miracles or martyrdoms. The more important among them are:

✳ Ambrose: a BOOK, as a learned doctor of the Church; his bishop's robes; the BEES that put HONEY on his lips when he was a CHILD, anticipating his eloquence.

✳ Augustine: the TRINITY, which he contemplated as a notable theologian; a flaming HEART (symbolizing zeal) held in his hands; his bishop's robes.

✳ Barbara: the TOWER in which her father imprisoned her to hide her from suitors and/or Christianity (he was struck by LIGHTNING, against which she protects).

✳ Basil: his robes as Orthodox bishop of Caesarea; a SCROLL, perhaps connected with his founding of the Orthodox Liturgy.

✳ Catherine of Alexandria: shown putting a RING on Christ's finger in a mystic MARRIAGE; the spiked wheel on which she was tortured (Catherine's WHEEL); the SWORD with which she was martyred.

✳ Christopher ('bearer of Christ'): a giant carrying the Christ-child over a RIVER on his shoulders (the patron saint of travellers).

✳ Dominic: a swarthy man wearing the WHITE robe and BLACK cope of the Dominicans, the Order of monks he founded to preach against heresy; he sometimes carries a BOOK (and a LILY).

✳ Francis of Assisi (A): a thin man in the BROWN or GREY robes of the Franciscans, the Order of monks he founded, bearing the STIGMATA he received while meditating in the wilderness.

✳ Francis Xavier: a Jesuit missionary to India and Japan, shown in exotic scenery, or in a SHIP, or with a CRAB that appeared to him holding a crucifix.

✳ George: a WARRIOR saint, in ARMOUR on HORSEback (B) piercing the DRAGON (the passions) with a SPEAR or slaying it with a SWORD; his arms are a Crusader's RED CROSS on a WHITE background.

✳ Ignatius of Loyola: the robes of the Jesuit Order that he founded, bearing a flaming HEART (zeal).

✳ Jerome: a scholar and theologian depicted sitting at a desk or doing penance in the DESERT by beating himself with a ROCK. He is thought to have removed a thorn from the paw of a LION, and may wear a cardinal's robes and hat to convey authority in the Church.

✳ Nicholas: his episcopal robes as bishop of Myra. THREE GOLD BALLS symbolizing the money bags with which he saved three poor women from prostitution by paying their dowries. The balls later became the emblem of pawnbrokers, suppliers of ready cash.

✳ Peter: a ROCK (a pun on his Latin name, 'Petrus') as the rock on which Christ founded the church (as the first Pope, he symbolizes the Papacy); the COCK, before whose crowing he denied Christ; the KEYS to HEAVEN.

✳ Paul: a preacher's BOOK or SCROLL, or the SWORD with which he was martyred.

✳ Sebastian (C): depicted as being pierced with ARROWS before he was beaten to death with cudgels.

✳ Veronica: the 'VEIL' that she offered Christ on the road to Calvary, and which retained the impression of his face (her name puns *vera icon*, 'True image').

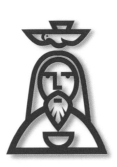

## John the Baptist

His birth foretold by an ANGEL, John was born of aged parents, Zachary and Elizabeth (a kinswoman of the VIRGIN MARY), He became a prophet, living in the DESERT, calling people to repent and BAPTIZING them in the RIVER Jordan. He was visited by CHRIST, whom he then baptized and called 'the LAMB of God, who takes away the sins of the world'. In depictions of the scene, John holds water from the River Jordan in a bowl or a shell, and the Holy Ghost appears as a DOVE (above).

Because he prepared the way for Christ, he was called the 'Forerunner' in the Orthodox Church, emphasizing his role as the last of the prophets. In Greek Orthodox art he is sometimes shown with a messenger's wings.

John was finally beheaded on the wish of Herodias after condemning her incestuous marriage to Herod. He is sometimes represented holding his own head on a dish, but he is usually shown as a hermit, wearing a camel hair tunic, sometimes holding a lamb.

## Magdalene

'Mary of Magdala' (a fishing town on the Sea of Galilee) or 'the Magdalene' was one of the women present at CHRIST's crucifixion. She frequently kneels at the foot of the CROSS. She also incorporates aspects of two other women described in the gospels as being close followers of Jesus: the sinner who washed Christ's feet with ointment and dried them with her HAIR, and the sister of Lazarus and Martha. She is often compared with Martha, who came to embody the active life while Mary embodied the contemplative life.Her attributes are therefore the long HAIR (above) with which she washed Christ's feet, and a jar containing the ointment with which she soothed them.

Originally a prostitute, Mary Magdalene repented and became an abiding symbol of penitence in the Catholic Church. She is believed to have been the first person to have seen the risen Christ (depicted as 'Noli me tangere'). Arcane heresies maintain that she fathered the founder of the French royal line with Christ.

## Ecclesia

Ecclesia (from the Greek for 'assembly') represents both the hierarchy of the Christian Church and the community of all Christians. She is sometimes represented as a WOMAN dressed as a pope and holding a CROSS (above), or as the VIRGIN MARY at the foot of the cross, symbolizing the New Testament, superseding the Old Testament, and represented in turn by the Jewish Synagogue. Both images are also included in Medieval and Renaissance descriptions of the VIRTUES and VICES.

The Virgin is sometimes contrasted with ST JOHN THE EVANGELIST, who represents Synagogue because, at the empty tomb of CHRIST, he allowed PETER, symbolizing the Church, to go first. Likewise, the centurion who pierced Christ with his SPEAR and had his eyes opened by a falling drop of BLOOD (Ecclesia) is contrasted with the man who offered Christ old, bitter WINE on a sponge (Synagogue).

## Judas

The APOSTLE who betrayed CHRIST for thirty pieces of SILVER, Judas is often shown carrying a money bag. His betrayal was marked by the KISS he gave Christ in the GARDEN of Gesthemane (above), identifying him to the soldiers who took Christ to be tried. He hanged himself out of remorse.

## Golem

A MAN made by men (in contrast to ADAM KADMON, made by God). Golems were clay figures made for use as helpful servants. Most golem legends date from the Middle Ages, when golems were created by Jews using formulae from the *Sepher Yetsirah*, the basis of later Kabbalistic doctrine. The golem is related to the alchemists' *Homunculus,* or artificial man.

## Ali

Depicted here by his Kufic symbol (above), Ali was the cousin of Muhammad, and his son-in-law through marriage to his daughter Fatima. He became the fourth Muslim Caliph (AD 656–661). He was a loyal and trusted associate during the Prophet's later years, so closely identified with many important events in his life.

Ali is considered by the Sunnis to be one of the patriarchs of the faith, who upheld the traditions of simplicity, piety and purity bequeathed by Muhammad. He is also revered by the Shias as a martyr because of the manner of his death – he was stabbed with a poisoned KNIFE while at prayer in a mosque and died three days later.

Because of his close association with the Prophet and his exalted status in both Islamic traditions, Ali is second only to Muhammad and is revered as a warrior and a saint.

## Nun

The Ancient Egyptian Nun ('Inert One') or Nu ('Watery One') personified the primeval WATERS from which all creation emerged. He was sometimes represented by two wavy lines, symbolizing water, and very occasionally appears in human form. He rejuvenated the SUN at dawn and so holds the solar barque.

## Heket

An Ancient Egyptian WATER goddess associated with fecundity and resurrection, Heket is depicted as a FROG or with a frog's head. She was said to have been in the NUN (primeval waters) before creation began. She was KHNUM's wife and gave life to everything made on his potter's wheel, and she helped ISIS to resurrect OSIRIS in order to conceive HORUS.

## Mut

The Ancient Egyptian 'Great MOTHER', wife of AMUN and mother of KHONSU, Mut was often shown wearing the double CROWN of Egypt (above) to symbolize the union of Upper and Lower Egypt. In early times she was thought to take the form of a VULTURE, for reasons that remain obscure; the wives of pharaohs wore vulture emblems to emphasize their relation to her. Later depictions often show her wearing a vulture head-dress and holding a papyrus SCEPTRE (symbolizing protection and renewal) and an ANKH (symbolizing protection, strength and eternal life).

Mut had originally been a Theban goddess, but when her cult extended through Ancient Egypt she began to take on attributes associated with the SKY goddess HATHOR, the feline goddess SEKHMET/BASTET (she was sometimes shown as LION-headed, symbolizing power and fury), and ISIS.

## Khonsu

The name of Khonsu, the Ancient Egyptian MOON god, means 'Traveller', reflecting the moon's path across the sky. His main centre of worship was the Egyptian city of Thebes, where he was believed to be the child of the creator god AMUN and the pre-eminent Egyptian mother goddess MUT.

The earliest images of Khonsu show him as a mummy, wrapped in a tightly fitting garment, wearing a side-lock (representing his youth) and with the moon's disc and a CRESCENT moon upon his head. In the image above he also carries the CROOK and FLAIL associated with royalty.

In later dynasties Khonsu was depicted as a young man with a FALCON's head and a SUN disc, since he was believed to be a youthful sun god, like HORUS, and so absorbed the falcon's imagery of protection and nobility. In this form he was the defender of the sun god RA, and – again like Horus – was sometimes shown spearing a CROCODILE, an animal associated with the forces of SET.

## Amun

A primeval Egyptian God, said to have been self-created, having masturbated himself into existence. Amun was therefore unknowable, even to the Gods, and was called 'The Hidden One'. His creative powers were symbolized by the RAM and the SNAKE, his sacred animals. He is shown wearing a double plumed CROWN or with an erect PHALLUS (above).

## Atum

Atum ('The Complete One' or 'The All') was the primeval creation god of Heliopolis. Before creation he existed in CHAOS, and arose as a MOUND or a HILL (symbolized by a stepped pyramid, above). He then spat forth his first children, SHU and TEFNUT, who were the forerunners of the gods. Atum's cult object was a BULL or a SERPENT.

E G Y P T I A N

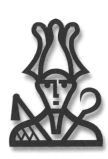

## Apep ✕ Apophis

The SERPENT Apep personified
the hostile powers met by the sun
god RA as he passed through
the Duat (the Ancient Egyptian
UNDERWORLD) and the twelve
GATES of the night. He is usually
depicted coiled in a concertina-like
fashion, but he was also shown
with the HEADS of those he had
swallowed on his back, or being
decapitated by BASTET.

## Tefnut

Daughter of ATUM and TWIN sister
of SHU ('AIR'), Tefnut represented
moisture. She was depicted with
a LION's head (power). As the
primordial couple, the twins
enacted the first SEXUAL UNION.
They were later said to be Ra's
EYES, the sun and the MOON.
Tefnut was later linked to the
solar eye and to Ureaus.

## Geb ✕ Nut ✕ Shu

Geb personified the EARTH, and
Nut the SKY. They were the
children of Shu (atmosphere)
and TEFNUT (moisture) and as
husband and wife they produced
the SUN and the MOON, and the
gods OSIRIS, SET, HORUS, ISIS
and NEPTHYS.

Geb was usually shown lying
recumbent, with a bent leg
representing the MOUNTAINS,
beneath the arched STARRY body
of Nut, her hands and feet
representing the FOUR pillars of
the world. She gave birth to the
SUN every day, and swallowed
him at night. She was lifted above
Geb by their father Shu (above),
who separated them because they
lay in such a close embrace that
they would not stop creating.

Shu later became a symbol for
life. According to the 'coffin
texts' (descriptions of funerary
rites, often inscribed in coffins
and on the walls of pyramids),
the dead had to identify
themselves with Shu in order to
be able to breathe the AIR of the
UNDERWORLD, and thus live.

## Osiris

Originally a god of vegetation,
Osiris ('He Who Sees the
THRONE') was depicted with
a GREEN face, in mummy
wrappings, with the WHITE *atef*
CROWN (with two FEATHER EYES)
on his head, holding the regal
CROOK and FLAIL. Other related
symbols are the *djed* (a bundle
or COLUMN of REEDS), the BULL,
the throne and the PHOENIX or
Bennu bird.

Osiris taught humanity how to
take advantage of the fluctuating
WATERS of the Nile using the arts
of cultivation and civilization.

His brother SET killed him and
dispersed the dismembered parts
of his body. But his wife, ISIS,
found all the pieces and
resurrected him in order to
conceive their son, HORUS.
Osiris became the Lord of the
UNDERWORLD, and was often
shown sitting in the Halls of
Judgment in the Duat, ready
to accept the just dead into his
kingdom and to reject the unjust.

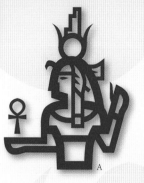

A

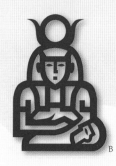

B

C

## Isis

An important female deity not only for the Ancient Egyptians but later for the Ancient Greeks and the Romans, Isis is said to have been known by many names and to have become a symbol of all goddesses.

'Isis' means 'Seat' or 'THRONE', and she was often depicted with one upon her head (A). In this form she represented sovereignty, which she bestowed upon all pharaohs in her role as mother of HORUS the KING and as sister and wife of OSIRIS.

When Osiris was killed by SET, Isis sought out his dismembered body, which had been scattered through Egypt. She mourned over him with her sister NEPTHYS, both goddesses being in the form of kites at that time. They were often depicted together on sarcophagi, standing with WINGS outspread to protect the mummy within. Using magic, Isis was able briefly to resurrect Osiris – in particular his PHALLUS – enabling her to conceive her son, HORUS. This act was depicted with her fellating the prone Osiris, either in human form or as a kite. Isis then used her magic to protect her growing son Horus from SNAKES and predators in the marshes of the Nile Delta. She was therefore often invoked by the Ancient Egyptians to protect CHILDREN, and there are many images of her seated, suckling Horus, as a protectress of royal births (B). These are likely to have influenced images of the VIRGIN MARY with the infant CHRIST in Christian Coptic art.

Isis was connected with the STAR, Sirius, which rises with the SUN at the inundation of the Nile. Later, in the New Kingdom, she was portrayed wearing the sun disc between COW'S HORNS like HATHOR, representing her role as mother of HORUS, the rising sun. Her association with Hathor also extended to her taking Hathor's SISTRUM (a musical instrument) and necklace (MENAT) as her symbols (C). At the same time she also gained the attribute of the TET, a loop known as the 'KNOT of Isis', which is connected with the ANKH as a symbol of life force.

The cult of Isis became widespread in Ancient Greece and Rome, with sanctuaries on the Acropolis in Athens, on the Island of Delos, and at Pompeii. The Greek symbol for her was the RUDDER because she became a protector of sailors as a form of the Stella Maris. ROSES were her symbol in Rome. They are pivotal in the novel *The GOLDEN ASS*, written by the Romanized North African Lucius Apuleius (*c.* AD 125–after 170), which describes the initiation of a Roman priest of Isis in allegorical form. The priest is transformed into an ass and can only recover his human form by eating the roses carried in Isis's processions.

In alchemy Isis represents nature in all her glory and mystery. She is veiled because her mysteries can never be entirely known.

## Horus

Originally a SKY god called Horus the Elder or Haroeris, Horus was associated with the pharaohs (who were thought to be his human AVATARS). In this form, he was considered to be the son of the SUN god RA. He was also called Ra-Herakhty, 'The Rising Sun', and was the god of the horizon.

Horus was depicted as a winged FALCON (A and C), whose EYES were the sun and the MOON. The falcon was said to be able to fly higher than any other bird (even into the sun), to see everything, and was renowned as a hunter.

Horus ruled Lower Egypt. As a sun god, associated with the day and the LIGHT, he was continually at war with his brother SET, who murdered his father and ruled Upper Egypt. THOTH eventually caused a treaty to be made between them, allotting rulership of the day to Horus, and of the night to Set. However, Set continued to be jealous, and wounded one of Horus's EYES, the MOON, cutting pieces out of it until there was nothing left. But

Thoth frustrated Set by making Horus a new eye every month. Eventually Horus defeated Set, and became known as the 'Ruler of the Two Lands', while Set was demoted to a god of the DESERT.

With the rise of the cult of OSIRIS, Horus was believed to have been magically conceived from the dead Osiris by ISIS. Set was then considered his uncle, from whom he had to be protected by his mother Isis until he was old enough to avenge his murdered father. As Osiris's child he became known as Harpokrates, ('Horus the Younger'). In this form he is often depicted with a CHILD's side-lock of HAIR, being suckled on his mother's lap, sometimes with his finger in his mouth, representing nourishment and silence. He was also depicted as a child seated on a LOTUS blossom (an Egyptian symbol of primeval CHAOS or rebirth), or with a pot (B), which is a symbol of fertility.

The *udjat*, the eye of Horus, represents the moon, the eye that had been wounded by Set. Horus is said to have given it to his

father Osiris to renew his life. Images of it were therefore used for protection, and it became a symbol of kingship. Horus's weapon was a SPEAR whose barbs were the rays of the SUN, and which had been blessed by the goddess NEITH. He used it to defeat the powers of Typhon (a god of chaos, associated with the UNDERWORLD), who was depicted as a HIPPOPOTAMUS in the marshes. These creatures, who lived around the Nile, were thought of as malevolent, and it was royal sport to hunt them.

## Hathor

Originally a SKY goddess, believed to be the mother of the SUN, Hathor was the wife of HORUS, and they met once a year at the festival of the beautiful embrace. She was often depicted as a WOMAN carrying the SUN disc between a pair of HORNS on top of her head (because of the myth in which she raised the sun up to HEAVEN with her horns). Her cult symbol was a pillar bearing either two cows' heads or two women's heads, which was said to represent the 'female SOUL with two faces'. Her SYCAMORE TREE stood at the GATES of sunset, giving succour to the dead before they entered the Duat (the Ancient Egyptian UNDERWORLD). Her other symbols were the SISTRUM (a musical instrument; she loved music and DANCE) and the MENAT, a type of necklace carried by her priestesses, which held divine powers of healing.

## Four Sons of Horus

The Four Sons of HORUS were responsible for protecting the bodies of the dead and their embalmed internal organs, and for making sure that they did not suffer from hunger or thirst. They were most commonly depicted in the form of CANOPIC JARS, which contained the mummified organs of the dead. Each jar had on its stopper the head of the son responsible for protecting the organ inside. Hapi had an APE's head and guarded the LUNGS (North). Imsety (above) had a human head and was thought to guard the LIVER (South). Qebsennuef had a HAWK's head and protected the intestines (West). Duamutef had a JACKAL's head, and was believed to be responsible for protecting the STOMACH (East). They were associated with the four cardinal DIRECTIONS.

The Four Sons of Horus were also usually depicted standing on a single LOTUS, symbolizing the rebirth of the dead.

## Set

The Egyptian god of CHAOS and misfortune associated with the UNDERWORLD. His face had a gently curving muzzle and RED eyes. He wore a stylized head-dress with donkey's EARS squared off at the tips (above). His colour was red, and as befits the god of METAL, his bones were made of IRON.

Set murdered his brother Osiris to obtain rulership, but he was finally defeated by HORUS, the son and heir of Osiris, and as a result he lost his testicles and a foreleg. Set then lived with RA, his voice being the THUNDER in the sky, and assisted the SUN god by defending the sun BOAT from APEP as it sank over the WESTERN horizon.

The Ancient Greeks linked Set with Typhon, a god of chaos associated with the UNDERWORLD. He was also linked with Sebek, the ferocious CROCODILE god of WATER and fertility.

E
G
Y
P
T
I
A
N

## Serapis

A late Egyptian god who originated in Alexandria, Serapis came to be worshipped all over the Ancient Roman world. A composite of ZEUS and OSIRIS, he was a god of the UNDERWORLD and of regeneration. His symbol was a corn bushel, which he wore upon his head.

## Nepthys

'Mistress of the House', Nepthys wore a house or a CHALICE in her HEAD-DRESS. She was sister of Isis, wife of the infertile SET, and mother of ANUBIS by Isis's husband OSIRIS. She could communicate with the dead, so she helped Isis search for the body of Osiris. Symbols of DEATH attributed to her include kites, CROWS and bones.

## Anubis ✳ Wepawet

Depicted as a BLACK JACKAL or a jackal-headed man because of his associations with Wepawet, Anubis was the guardian god of the necropolis, and god of the dead and of embalming (resin for embalming was coloured black). His image was used to guard TOMBS and to guide the dead into the UNDERWORLD.

Wepawet (Opener of the Ways), depicted as a jackal for reasons that remain obscure, was an older form of Anubis. He was the leader of the gods, and so always led and opened the royal processions, including funeral processions.

Anubis later became identified as the son of OSIRIS and NEPTHYS and the half-brother of HORUS, and was responsible for mummifying the body of the dead OSIRIS. He was therefore said to have brought the art of mummification to Egypt. He was the psychopomp (guider of souls) who brought the dead to stand before OSIRIS and the forty-two *neters* (assessors) in the Hall of Judgment, and who weighed the dead person's HEART on the SCALES of MAAT.

## Ra

Ra was the Ancient Egyptian SUN god who travelled the SKY by day and the Duat (the UNDERWORLD) by night in his solar barge. He sometimes took on the form of Khepra, depicted as a SCARAB or dung beetle. Khepra was the earliest sun god, first associated with the creator god ATUM and then with Ra, whose rising at dawn and subsequent progress across the sky is mirrored by the beetle pushing before it a ball of dung containing its eggs. At dawn Ra was also sometimes shown as Ra-Herakhty (with a FALCON's head, above – falcons being common symbols of the SKY); Ra at midday, and Atum Ra in the evening. When travelling through the Duat, he had a RAM's head.

The Aten (sun disc) was originally associated with Ra. However, during his short reign (*c.* 1353–1336 BC) the pharaoh Akhenaten named the Aten as representative of the one and only true god – the first time such a monotheistic philosophy was proposed in a religion of the Near East.

## Thoth

The MOON god of the Ancient Egyptians was Thoth ('the Leader'). He was depicted as a squatting BABOON wearing a moon disc, a DOG-headed APE, or an IBIS-headed man. It was suggested that the baboon could be seen in the moon (like the 'man in the moon') and that the beak of the ibis represented the moon's CRESCENT.

Thoth was also 'Lord of the Moon', 'Lord of Time' and 'Lord of the Sacred Words'. The writing PALETTE and the reed PEN are also his symbols. He invented writing and gave it its magical power, so he is associated with knowledge and truth. As the patron of scribes he was sometimes shown squatting on a scribe's shoulder and giving advice. He recorded everything, including the names of all who entered the UNDERWORLD and the outcome of the weighing of their HEARTS in the Halls of Judgment.

Thoth was also said to have invented magic and the hermetic tradition. He is associated with HERMES TRISMEGISTUS, who took on many of his attributes and associations.

## Sechat

The goddess of writing and the patroness of architecture, Sechat was shown with a STAR HEAD-DRESS and carried a notched PALM leaf (marking important events in the royal calendar; she was associated with historical records). She wore a PANTHER or LEOPARD SKIN, which was associated with funerary rites.

## Maat

Maat ('Truth') represented justice, law and perfect equilibrium. She was associated in astrology with AQUARIUS and LIBRA, symbols of balance. Her RED ostrich FEATHER (above) was placed in the balance of the SCALES of justice, in which the HEARTS of the deceased were weighed before OSIRIS.

## Sekhmet × Bastet

Sekhmet was a fierce LIONESS deity from the Nile Delta. Her statues were appeased with RED beer (an emblem of BLOOD) to make her drunk and prevent her from annihilating the human race. This she once came close to doing when humanity offended the sun god RA, her father.

Later Sekhmet became the more beneficent CAT goddess Bastet, who was usually shown with a cat's head (above), carrying a SISTRUM (a musical instrument) and a box or a BASKET. In this form she was the protectress of the nation and the family, and was either the wife or the daughter of RA.

Sekhmet and Bastet were thought of together as the two EYES of Ra, representing the SUN and the MOON respectively (this symbolism was also associated with the lioness goddess TEFNUT).

Sekhmet was Ra's instrument of vengeance. She was called 'the FLAMING eye of Ra', eliminating his enemies with FIRE. Bastet was also shown beheading the greatest enemy of Ra – APEP, the SERPENT of the UNDERWORLD.

E G Y P T I A N

## Ptah

An Ancient Egyptian creator god from Memphis, Ptah is said to have created using his HEART and TONGUE, implying that he created though the word. Represented as a mummy with a shaven head wearing a tight-fitting cap, he holds a *djed* (above, see OSIRIS) surmounted by an ANKH or a sceptre. His consort was SEKHMET and their son was NEFERTUM.

## Nefertum

During creation Nefertum ('LOTUS') arose from the lotus – a symbol of rebirth – and he was often shown smelling a lotus. The son of SEKHMET/BASTET he was linked with CATS or LIONS, with life and precious unguents.

## Khnum

One of the Ancient Egyptian creator gods, whose mythology links him strongly with fertility. The RAM's head with which Khnum was commonly shown (above) was often used as a symbol of KINGship because it implied virility and leadership. (*Khenum* was the ancient Semitic name for a certain breed of ram.) Khnum was often depicted in front of a potter's wheel, moulding CLAY, since this is the way in which he was said to have made the gods, humans, cattle, BIRDS and FISH. He was also believed to have made the primordial EGG out of which the SUN first arose when the world began, and is regarded as the *ba* or SOUL of the sun god RA.

Khnum also controlled the annual FLOOD of the River Nile as it rose from the caverns of HAPY, the god of the inundation. This task was of vital importance to the survival of the Ancient Egyptians. His connection with the Nile led to Khnum also being called 'Lord of the CROCODILES'.

## Selket

The SCORPION goddess, Selket (or Serket) was usually represented as a woman with a scorpion on her head, its tail raised to sting. Originally a protector of the pharaoh's THRONE, she later became the protector of canopic chests and sarcophagi. She was linked with the DESERT heat.

## Neith

One of the most ancient Egyptian goddesses, Neith ('One Who Is') had as her symbols the BOW, SHIELD and ARROWS of a war goddess, and the shuttle of a goddess of WEAVING (which was related to creation). She is shown wearing the RED CROWN of the NORTH.

## Bes

Bes originally came from the Sudan as the protector deity of the royal household. Later he became a popular household god for the general populace. He was the bringer of happiness and joy, presided over childbirth and MARRIAGE, and was the protector of the family. Despite his ugly, dwarf-like looks, he was associated with women's beauty preparations and his comically ugly face was believed to frighten away DEMONS and dangerous animals and ensure sound sleep. He was often portrayed DANCING about a new mother while sometimes beating a small DRUM and brandishing the KNIFE with which he was skilled at killing SERPENTS (above).

The image of Bes was frequently depicted at the heads of marriage beds, on cosmetic jars, MIRRORS and domestic articles, and on supporting pillows for mummies, as he was the bringer of peace to the dead.

## Hapy

The patron of the life-giving RIVER Nile, Hapy was depicted with a pendulous BREAST and a large belly, holding a tray of food (signifying abundance), with a PAPYRUS in his hand or on his head, symbolizing the world that rose from the primeval WATERS. He also had a balance on his head for measuring the rise of the Nile waters.

## Min

A fertility god who bestowed sexual powers, often depicted as an ithyphallic mummy with AMUN's head-dress, wielding a THUNDERBOLT. His symbols were the PHALLUS and the WHITE BULL. He was also a god of RAIN, and his festivals proclaimed the harvest. He was god of the ROADS between the Nile Valley and the Red Sea.

## Prometheus

One of the Titans (the TWELVE sons of Gaia, the personification of the earth and Uranus, the personification of the HEAVENS), Prometheus was credited with forming the first man out of CLAY and WATER.

Prometheus was in part a TRICKSTER, having fooled the gods into feasting on bones and FAT (rather than their preferred cuts of meat) during a meal shared with men. The angry ZEUS removed FIRE from mankind, but Prometheus returned it, hidden in a fennel stalk, thus displeasing Zeus. As a punishment, Prometheus was nailed alive to Mount Caucasus (or a pillar), where an EAGLE visited daily to feed on his LIVER (above), until he was freed by HERAKLES. He scorned Zeus's thunderbolts while chained to the MOUNTAIN, and he has come to symbolize defiance of the gods (hence the sub-title of Mary Shelley's *Frankenstein: or, the Modern Prometheus,* 1818). His associations with fire often connected him with HEPHAESTUS, the SMITH or fire god.

G R E C O · R O M A N

## Cronus ✳ Saturn

Although the youngest of the Titans (the earliest gods), Cronus was associated with old age, time and DEATH, so he is often shown with an HOURGLASS (above).

At the instigation of his mother, Gaia, he castrated his father, Uranus. From his marriage to his sister Rhea the race of Olympian gods was born. Fearful of being usurped by them, he ate his children, but ZEUS was saved because Rhea gave Cronus a STONE wrapped in swaddling clothes instead. He later vomited up the other children and was overthrown by them.

Another myth calls him the god who ruled over the GOLDEN AGE, retiring to become the ruler of the mythical 'isles of the blessed'.

Cronus's name changed gradually to Chronos, or 'time' – hence his personification as Father Time. In Rome he became SATURN, associated with the WINTER festival of the Saturnalia, where masters and servants swapped places. In alchemy he is linked with LEAD.

## Hera ✳ Juno

The wife (and sister) of ZEUS, Hera presided over the Olympian gods. A matronly figure, she was venerated in FEMALE matters of MARRIAGE, fertility and childbirth. One of her attributes was a SCEPTRE crowned with a CUCKOO, the symbol of Zeus's infidelities; another was the PEACOCK (above), which drew her CHARIOT.

## Poseidon ✳ Neptune

Poseidon, sibling of ZEUS and HADES, was the god of all bodies of WATER. He was the first to tame HORSES and he was often portrayed in a chariot drawn by *hippocampi* (horses of the SEA). His attribute was the TRIDENT, a traditional FISHING tool (above), and he became associated with the Roman sea god Neptune.

## Zeus ✳ Jupiter

The most senior member of the Ancient Greek pantheon, Zeus was lord of the SKY, the WINDS and the weather. His attributes were the THUNDERBOLT and the EAGLE (above). He was worshipped in high places, such as Mount Olympus, and he was omnipotent and wise, dispensing judgment with firmness and compassion.

Zeus was married to his sister HERA, but still managed to father a host of progeny on goddesses and on mortal women – often while in duplicitous disguise in forms such as a SWAN, a BULL, a HORSE or a shower of GOLD.

He was later merged with the identity of the Roman Jupiter, originally an Etruscan thunder god. Jupiter was associated with LIGHT and storms and originally protected agriculture. Later, he also became the protector of the Roman state, especially at times of war, symbolizing justice, faith and honour.

## Demeter ⚹ Ceres

A goddess of agriculture and animal husbandry linked with the EARTH and with VIRGO – the sign of the ZODIAC that contained the SUN when her main festival took place. Demeter's attributes were the WHEAT sheaf, the SICKLE and the CORNUCOPIA. Her daughter PERSEPHONE returned from HADES in the SUMMER to be with her.

## Persephone ⚹ Proserpine

The daughter of DEMETER, Persephone was abducted by HADES and became his QUEEN. She sealed her fate by eating food of the UNDERWORLD: six POMEGRANATE seeds. As a compromise she spent half the year with her husband and half with her mother, causing the SEASONS of autumn/winter and spring/summer.

## Helios ⚹ Apollo

A pre-Hellenic SUN god, Apollo developed into a complex deity with many roles and attributes. As a sun god he was depicted with a sun CROWN or HALO, driving the sun-CHARIOT across the SKY. As patron of agriculture and a shepherd, he also held a CROOK. As god of music and poetry, and inspirer of the MUSES, he wore a LAUREL wreath (a symbol of excellence, associated with poets) and held a LYRE (above). As patron of archers, he was also depicted holding a BOW AND ARROWS (above), the arrows representing the sun's rays.

Apollo was also the god of prophecy, and was especially venerated at the Oracle of Delphi. He was linked with medicine, and was said to have fathered the great physician Asclepius. Finally – but not least – he was an athlete and was believed to have been a victor at the first Olympian games.

## Hades ⚹ Pluto

The ruler of the UNDERWORLD, god of DEATH and the dead. 'Hades' was the name of the underworld of the Ancient Greeks – whereas Pluto, the name of Hades' Roman counterpart, stems from the word *ploutos* or 'riches'. Pluto's realms abounded in mineral and agricultural wealth, indicating that by Roman times Hades had become a more benevolent deity.

## Artemis ⚹ Diana

The twin sister of APOLLO and the daughter of JUPITER and Leto, Diana was a VIRGIN, a huntress with her SILVER BOW AND ARROW, and a protector of wildlife. She was associated with WOMEN and their transitions – notably from VIRGINS to women – and with the MOON. Her cult continued in Italy after the fall of Rome, where she became the goddess of WITCHcraft.

## Hermes ✳ Mercury

As befits the Ancient Greek god of travellers, Hermes wore a WINGED *petasus* (sun hat, above) and winged sandals. He carried his symbol, the winged CADUCEUS. As Hermes Psychopompos (a psychopomp is a guide of SOULS) he acted as intermediary between the living and the dead, escorting souls to the UNDERWORLD. He was a messenger for the gods and was the patron of racing and of athletes. Over time, he also became the god of commerce and merchants because of his association with travel and communication.

Hermes was related to the Roman god Mercury, who was the deity of merchants and business people and the mediator between gods and mortals. Both versions of the deity were thought to be TRICKSTERS and were not above stealing if they needed to.

As HERMES TRISMEGISTUS he was the god of alchemy, whose Ancient Egyptian counterpart was THOTH. He also symbolizes the 'MERCURY of the wise', or the transformative agent in alchemy.

## Hephaestus ✳ Vulcan

The god of SMITHS and METALlurgy, Hephaestus was thus associated with FIRE and terrible heat. He was the son of ZEUS and HERA, and the spurned husband of APHRODITE. He crafted all manner of wondrous objects out of GOLD, SILVER, COPPER, BRONZE and IRON for gods and heroes, including the fabled armour of ACHILLES. He was LAMED by his fall to earth when he was thrown out of HEAVEN for a day.

Vulcan, his Ancient Roman counterpart, was a more general god of all types of fire – including volcanoes, from which his name was derived.

Alchemical illustrations depict Hephaestus aiding the birth of ATHENA from her father by splitting open ZEUS's HEAD. Here, Hephaestus represents the archetypical smith and alchemist who assists in the alchemical process of the spiritual rebirth of the feminine principle from the masculine principle, on the level of mind.

## Aphrodite ✳ Venus

The goddess of love and the epitome of beauty, Aphrodite (or the Ancient Roman Venus) was born when the castrated Uranus' semen fell upon the foam of the SEA. She was often shown naked, but covering herself modestly (above). She was frequently unfaithful to her husband, the ugly smith god HEPHAESTUS. Notable lovers included ARES, with whom she protected the Roman state, safeguarding its prosperity and fecundity. She had a child called Hermaphroditus (HERMAPHRODITE) with HERMES, and she was the mother of EROS. Venus sometimes represents the first steps of the alchemical stage of *coagulatio*, the process of the YELLOWING of the WHITE STONE. She also represents WOMAN and the *anima*, and the consort of ARES/MARS, the MALE aspect. On a deeper level, Venus has the quality of EARTH. She also epitomizes the power of attraction, a necessity if the union of opposites in the alchemical process is to succeed.

## Ares ✳ Mars

Ares embodied the destructive forces of war, whereas ATHENA represented the intelligent use of war as a defence. His attendants were Deimos (fear) and Phobos (panic), and he was associated with the frenzy of fighting.

Mars, his Roman counterpart, was believed to be the father of the TWINS Romulus and Remus, the mythical founders of Rome, so he is occasionally shown accompanied by a WOLF. He was an agricultural deity at first, but later he became the god of war and is shown wearing ARMOUR. With his adulterous lover VENUS (the mythical ancestress of Julius Caesar), Mars was the virile protector of the Roman state.

In alchemy Mars is often represented by a male figure holding a SWORD. He symbolizes the MALE energy, often in its early state, transformed into Mars from the energy of the SUN, or the KING. The attributes of Mars were FIRE and RED, colours associated with the initial processes of the alchemical stage of the *rubedo*.

## Eros ✳ Cupid

According to the *Theogony* of Hesiod (an early epic about the gods of Ancient Greece, written *c.* 8th or 7th century BC), Eros was the child of CHAOS, embodying the primordial life-force (desire). However some thought he was the son of APHRODITE and either ZEUS, ARES or HERMES. The Romans thought Cupid was the son of VENUS, a charming yet cruel boy, with BOW AND ARROWS (above) and a TORCH (a symbol of torch-lit wedding processions).

Eros embodied love, and could cause it in others with his ARROWS; but he too suffered when he fell in love with PSYCHE, a mortal female so beautiful that she aroused APHRODITE's envy. They wed after many tribulations, symbolizing the union of body and SOUL. Cupid was more widely associated with lust than with love.

In alchemy Eros often represents romantic love. On another level, ready to let his arrow fly, Eros was the event or force that initiated the attraction between opposites, or the MALE and FEMALE energies.

## Athena ✳ Minerva

The most masculine of the Ancient Greek goddesses, Athena was a VIRGIN, but she sprang to life from Zeus's head fully armed with her characteristic HELMET, SHIELD and SPEAR. She was the goddess of wisdom and warfare, assisting warriors who fought a just cause in battle. One of her titles was Promachos or 'Foremost Fighter'. She was also known as Athena NIKE and associated with victory.

Athena also oversaw the peacetime activities of carpentry, WEAVING (she was often depicted holding a SPINDLE or with a loom) and olive cultivation (one of her symbols was the OLIVE branch). She was venerated at the Acropolis of Athens, the city that bore her name and which she protected. Her attributes included the owl, a symbol of wisdom (see LILITH).

Minerva was her Roman counterpart – her name derives from *meminisse*, 'to remember'. Originally a goddess of handicrafts, she became associated with skilled craftsmen, including writers. She shared Athena's warlike qualities.

## Pan

The bearded god of woodlands and pastures, Pan sported the HORNS, hairy flanks and hooves of a GOAT, a common symbol of lasciviousness. This gives a clue as to his nature and his role in protecting and promoting the fecundity of flocks and fields. He was said to have invented the REED PIPE (*syrinx*, above) and was fond of making merry in the company of nymphs.

Pan delighted in sudden appearances to startled mortals, from which the word 'panic' derives, reinforcing his anarchic identity with wild, rocky landscapes set outside the bounds of ordered civilization. However, he was also associated with the more gentle, bucolic arts of BEE-keeping, WINE-making and OLIVE growing. In Roman culture he became associated with Faunus, the god of fields and flocks. In Asia Minor he merged with the identity of the PHALLIC agricultural god Priapus, and in astrology he was linked with the planet SATURN.

## Hecate

In early Ancient Greek accounts Hecate had power over the HEAVENS, the EARTH and the SEA. She was able to bestow abundant flocks or catches of FISH, and was associated with childbirth and the nurture of the young.

Later called a goddess of night, darkness and the dead, Hecate guarded the gate to HADES. She seems originally to have been a MOON goddess in some cults, closely identified with ARTEMIS. The moon's phases may be reflected in representations of her with THREE bodies, faces, or pairs of arms (above), with which she holds her attributes: a DAGGER (destructive powers), a whip (with which to control her pack of HELL-HOUNDS), and a TORCH – with which she searched for PERSEPHONE (sometimes identified as her sister) in the Underworld. She was associated with liminal spaces, such as DOORWAYS and the outside of city walls. Her triple nature led to her association with three-way CROSSROADS, where pillars were erected to her and offerings left to mark a new moon.

## Janus

A specifically Roman god, Janus was associated with the DOORWAY of the year at the SUMMER and WINTER solstices, and was therefore associated with the SUN and with SATURN. He was often depicted with two faces that looked in opposite directions, alluding to his patronage of doorways: he oversaw all those who entered and left the house. He became the protector of beginnings, of the daybreak and of new enterprises, and so his name was given to the first month of the year, January. He was also associated with the beginnings of wars, and the construction of TRIUMPHAL ARCHES to mark their end. In some accounts, he was also associated with CHAOS and the creation of the world and was venerated as the father of all gods, Janus Pater.

## Eos ✳ Aurora

The daughter of Titans, Eos was a sister to HELIOS and SELENE. She personified the dawn, so she was a mother to the morning and evening STARS, and to the WINDS, as well as to the WARRIOR Memnon. When he was killed at Troy, Eos wept for him daily, thereby forming the DEW. She was often depicted being drawn across the SKY in her CHARIOT bringing the new SUN behind her.

One of her chief attributes was the ability to awaken desire. Although her human husband, Tithonus, was granted immortality by Zeus, he was not granted eternal youth. Eos shunned her aging husband in disgust, but eventually the gods took pity upon him and turned him into a CICADA. Eos also dallied with several other mortals, including the HUNTER Orion (later killed by the jealous gods). Her pursuit by ARES so infuriated his adulterous lover APHRODITE that she condemned Eos to a state of perpetual infatuation.

## Dionysus ✳ Bacchus

A fertility god and protector of the vine, Dionysus was linked with WINE and revelry. Among his attributes are a THYRSUS (a wand tipped with a pine cone) and a wine CUP. His devotees, Maenads and Bacchantes, ate SACRIFICIAL BULLS raw in frenzied ecstasy and indulged in orgies. His associates were Priapus, PAN, Silenus and the SATYRS, and the CENTAURS.

## Selene

The personification of the MOON and sister to HELIOS (Sol, SUN) and EOS. She was usually shown as a beautiful woman with a pale or WHITE face, wearing white or SILVER robes and an upturned CRESCENT MOON on her head, being pulled across the SKY by her white HORSES, sometimes BULLS.

## Erinyes ✳ Furies

The Furies were born from the BLOOD of Uranus, which fell on the EARTH (Gaia, his wife) after he had been castrated by his son CRONUS. They could be hideous in appearance: the dramatist Aeschylus describes them in the *Oresteia* (a cycle of plays first performed in *c.* 458 BC) as BLACK-faced, their HAIR alive with SNAKES, brandishing WHIPS and TORCHES in their talon-tipped hands (above). They symbolized retribution, appearing when a murder was committed in a family, or a serious oath broken. They also accompanied ARES onto the battlefield. They would pursue the guilty to the UNDERWORLD and beyond, torturing them in Tartarus, the part of Hades to which sinners were confined. They were also believed to ensure the stability of the natural order, guarding the underprivileged and righting wrongs. Over time they developed three separate identities: Alecto (Unnameable), Megaera (Resentment) and Tisiphone (Vengeance).

## Tyche ✳ Fortuna

Goddess of chance, associated with female personifications of CITIES, and invoked to protect communities. Tyche appeared as a BLINDFOLDED figure with a WHEEL or globe (indicating inconstancy), or a RUDDER or SAIL buffeted by the winds of chance, and with a long forelock that could be seized by the fortunate.

## Nike ✳ Victory

An aspect of ATHENA, Nike was shown as a winged goddess of victory, often with a globe and a victor's WREATH. SACRIFICES were made to her before and after battles. Her imagery was later adopted by Christians: the LAUREL leaves awarded to winners at the Olympian Games were adapted for martyrs, whose sacrifice made them victors over mortality.

## Muses

The nine Muses were Ancient Greek goddesses of inspiration, learning, arts and culture. The daughters of Mnemosyne, guardian of memory, they were accompanied by the GRACES and Desire, and led by APOLLO. Shrines to the Muses (*mouseia*) gave us the word 'museum'. Although their associations were not fixed, they were generally as follows:
✳ Calliope: philosophy and epic poetry. Symbols: a stylus and tablets.
✳ Clio: history. Symbols: a TRUMPET (above) and a *clepsydra* (water CLOCK).
✳ Euterpe: song. Symbol: FLUTE.
✳ Erato: music, love poetry. Symbols: a LYRE and a plectrum.
✳ Terpsichore: dance. Symbol: the *cithara*.
✳ Urania: astronomy. Symbols: a globe and a COMPASS or astrolabe.
✳ Thalia: comedy. Symbol: a comic MASK or SHEPHERD'S CROOK.
✳ Melpomene: tragedy. Symbol: a tragic MASK or a HERAKLES' CLUB.
✳ Polyhymnia: fame or mimic art. Symbols: a portable organ or a LUTE.

## Herakles ✳ Hercules

A SOLAR hero embodying nobility, courage and strength, but parodied as a tyrant, Herakles is often shown wearing the skin of the Nemean LION, which he killed, and carrying his CLUB. Born from JUPITER's adultery with Alcmene, a mortal, Herakles provoked JUNO's enmity. She sent SNAKES to kill him in his cradle but he strangled them. She drove him mad, so that he killed his wife and children. His penance was the TWELVE Labours (his encounters with the: Nemean LION; Lernaean HYDRA; Erymanthean BOAR; Stymphalian BIRDS; Ceryneian Hind; Augean Stables; Cretan BULL; Mare of Diomedes, GIRDLE of Hippolyta; Cattle of Geryon; APPLES of Hesperides; and Descent into the UNDERWORLD), signifying endurance, aggression and, later, the triumph of right over wrong, and relating to the sun's journey through the ZODIAC. Sentenced to serve Omphale for three years, Herakles is shown with her in women's attire (he is MALE strength overcome by feminine wiles). After death he entered Olympus and married Hebe.

## Psyche

An exquisitely beautiful princess, Psyche was worshipped by many in lieu of VENUS. CUPID fell in love with her, and arranged that she should unknowingly marry him. In fear of his mother's mounting jealousy, Cupid kept their liaison and his identity secret by visiting Psyche only in the dark. When, overcome by curiosity, Psyche accidentally woke Cupid as she gazed at him by the light of a dripping LAMP (above), he fled. Psyche was then condemned by Venus to undertake all manner of difficult tasks, including descending to the UNDERWORLD.

Eventually she and her beloved were reunited and had a child, Voluptua. The story is said to represent the search of the SOUL (*psyche*) for desire (*eros*), which in turn creates pleasure (*voluptua*). It also symbolizes the purification of the soul through arduous trials and its ultimate salvation through divine grace.

## Graces

Aglaia, Euphrosyne and Thalia, the Three Graces (or Charities), were messengers of APHRODITE embodying beauty and grace. According to one account, they personified generosity, bestowal, acceptance and reciprocation. During the Renaissance they were reinterpreted as representing three stages in physical or spiritual love – beauty, desire and consummation. Alternatively, they were chastity, beauty and love.

## Iris

Iris was the gods' messenger of either peace or vengeance. She personified the RAINBOW and could fly from the HEAVENS to the UNDERWORLD in a moment, aided by her GOLDEN WINGS and CADUCEUS.

## Achilles

An archetypal WARRIOR, one of the most valiant in the *Iliad*, Achilles was the son of the sea nymph Thetis and the mortal Peleus. Thetis held Achilles by the ankle when she dipped him in the RIVER Styx to ensure his immortality, but he was eventually killed by Paris or APOLLO who shot an arrow into his one vulnerable spot, his heel.

## Icarus

Icarus was the son of Daedalus, architect of the Cretan LABYRINTH, where both were imprisoned by King Minos. Daedalus built WINGS of wax and FEATHERS for their escape, warning Icarus not to fly too close to the SUN. Icarus, ignoring him, plummeted to EARTH as the wax melted and his wings disintegrated.

## Mother Goddess

Many families of Celtic deities are described as being descended from a named but mysterious goddess, such as the Irish Dana, mother of the Tuatha Dé Danann (a tribe of godlike beings), who was later confused with Anu or Ana and BRIGID.

The Welsh had their own version in Don, who, like Dana, was seen as the mother of the other gods, such as Govannan, GWYDION and ARIANRHOD.

Modron was a Romanized version of the Celtic MOTHER goddess. Her name means 'Divine Mother'. As the mother of Mabon ('Divine Son'), one of the GODS OF ETERNAL YOUTH, Modron is closely related to the Romano-Celtic Matrona, mother of Maponus. Her legends were changed and Christianized over time. For instance, Carn Fadrun on the Lleyn Peninsula in North Wales is said to be the home of Queen Madrun, and in Cornwall St Madron is remembered as a male saint.

## Gods of the Wild Hunt

The Anglo-Saxon Herne the Hunter had a Welsh counterpart, Arawn ('SILVER TONGUE'). Arawn was Lord of Annwn (the Otherworld), and related to Gwyn Ap Nydd, an ancient Celtic god of battle and the dead, who was later designated king of FAIRIES. The totem of both huntsmen was the STAG.

Arawn rode out astride his GREY HORSE and hunted with WHITE HOUNDS with RED EYES and EARS – the colours of the creatures of Annwn. Herne rode out wearing CHAINS and STAGS' antlers, terrifying those who blew on his horn in Windsor Great Park, his hunting ground.

Their stories employ the theme of the eternal battles between LIGHT and dark and SUMMER and WINTER. Gwyn ap Nydd fought Gwyrthur ap Greidawl ,'Victor, Son of Scorcher', on May Eve for the hand of the beautiful Creudylad. Pwyll, Prince of Dyfed, exchanged kingdoms with Arawn for a year and a day, and promised to fight Hagfan, 'Summer White', in Arawn's stead.

## Gods of Eternal Youth

Miraculous youths, accompanied by song BIRDS, such as the Scottish Angus and the Irish Oengus, are believed to have been Celtic gods of love. Oengus may have been related to midWINTER, because the interior of his legendary stronghold Bruig na Bóinne (New Grange), an ancient megalithic tumulus, is lit by sunlight only on Midwinter's Day. His lover Caer became a SWAN on 1 November. Likewise, Angus is the son of the CAILLEACH (WINTER), but married BRIGID, Maid of SPRING.

The Welsh Mabon ('Son') was also known as Maponus, the Romano-Celtic APOLLO, and was related to the rising SUN. He is said to have been stolen from his mother when he was just three nights old, and only one of the animals, a SALMON, was old enough to know where he was. Thus the youthful Mabon was older than the oldest creature. A medieval text mentions Mabon van Melt, which may derive from the earlier Welsh *meldos* (LIGHTNING).

## Celtic Queen

The QUEEN who represents sovereignty and the land is a frequent theme in Celtic mythology. She appears as a beautiful MAIDEN chosen and won by the future KING, or as a great WARRIOR queen and ruler in her own right. She rules with a strong and mighty hand – like Maeve, who yearned to possess the BROWN BULL of Quelgny, thus becoming embroiled in a long drawn-out battle with the Ulster hero CUCHULAIN, which brought about his DEATH. (The bull, often sacred to the land, reinforces Maeve's identification with the land.) Maeve was described as frequently visiting an ISLAND within a LOCH, where she bathed in a WELL. Such bathing in wells by queens and heroines often tells of the renewal of youth, and is linked to the cycle of the SEASONS and growth, connecting them with the land, the goddess and sovereignty.

## Horse Goddesses

Rhiannon, a Welsh version of the Gaulish HORSE goddesses Rigantona and Epona, was first seen by her husband, Pwyll, riding a grey mare (the colour grey being associated with the beasts of the Celtic UNDERWORLD). She was also called the Great QUEEN, indicating her role as goddess of sovereignty, who became the wife of Manawyddan (the Welsh form of MANNANAN).

Horse goddesses were often depicted with BIRDS, like Rhiannon's messengers, known for singing the dead to life and sending the living into the sleep of DEATH.

Images of Epona (above) show her riding a horse side-saddle, or as a horse with her foal. She was a Celtic MOTHER Goddess of fertility, healing and abundance, associated with the fertility of the land, the destinies of young CHILDREN and the care of animals. She was called on by horse-breeders, and her cult was popular with the Roman cavalry because she protected the horse and the rider.

## Gwydion

Gwydion, son of Don, was said to have chased BLODEUWEDD across the skies, thus creating the MILKY WAY. In the *Cad Goddeu* (a seminal Celtic epic poem) he is spoken of as the wisest of DRUIDS, and was an archetypal TRICKSTER, MAGICIAN and master of illusion. He tricked his sister ARIANRHOD into giving birth to Llew by making her step inadvertently over his WAND. From EARTH and LEAVES he created magnificent GREYHOUNDS and HORSES with GOLD accoutrements, tricking Pryderi into exchanging them for Otherworldly PIGS, and he created BLODEUWEDD, Llew's wife, using flowers and WATER from the NINTH wave.

Gwydion was punished for his trickery by being changed with his brother into a STAG, a sow and a WOLF. Between them they gave birth to children in the form of each animal. These, like TALIESIN'S SHAPE-SHIFTING, may have been cryptic references to stages in an initiatory process.

C E L T I C

### Nuada

The Irish Nuada Argatlam ('Nuada of the SILVER HAND'), KING of the Tuatha Dé Danaan (a tribe of godlike beings), was linked to healing, HUNTING, DOGS and fertility. He lost his arm in the first battle of Mag Tuireadh against the Fir Bolg (a mythical tribe predating the Tuatha Dé Danaan), and had to relinquish his kingship because the king could not be physically imperfect. Eventually he had a new hand made from silver by Dian Cecht, the Tuatha's healer. Nuada was guardian of the SWORD of Nuada (above), which was so powerful that when it was unsheathed, no enemy could escape it. Yet despite the power of his sword, Nuada was eventually killed in the second Battle of Mag Tuireadh, fought against the gigantic Fomorians (the original inhabitants of Ireland). Nuada appears to have been related to the Welsh Ludd (or Nudd), 'Llaw Ereint' ('Silver Hand'); he was also known as the Romano-Celtic god Nodens, a healer and protector of FISHERMEN on the River Severn.

### Cernunnos

Cernunnos ('The HORNED One') has been associated with the many images of horned gods that can be found across Europe. However, his attributes and the forms of his horns (STAG's, above, RAM's or GOAT's) vary, and the identification of these images with a single god called Cernunnos has thus been questioned.

His figure seems to have been part-human and part-animal. The Nordic Gundestrop CAULDRON portrays a stag-horned figure holding a TORC (a neck-ring that denoted prosperity) and a SNAKE (wisdom). Seated next to a STAG and other wild animals, he seems to have been presented as a deity or lord of the animal kingdom.

The Celts associated horns with fertility, so other archaeological finds showing him holding a ram-horned SERPENT perhaps indicate his PHALLIC prowess as a fertility god. He is also likely to have been a SOLAR deity, as horned figures and antlers are often depicted alongside solar symbolism.

### Taranis

A Celtic god of thunder – 'Taranis' means 'Thunderer'; the word *taran* in Welsh and Cornish means THUNDERBOLT. The symbol of Taranis is a spoked WHEEL, a common symbol of the SUN and the SEASONS. The Romans linked him with JUPITER. The Roman Lucan recorded that PRISONERS were offered up to Taranis, probably as SACRIFICES.

### Beli

The Celtic Beli (or Bellenos/ Belenus; 'Shining' or 'Brilliant One') was a SOLAR deity connected by the Romans with APOLLO. He was associated with healing SPRINGS. His name was associated with that of the fertility festival of Beltane on 1 May, when cattle were driven through FIRES to increase their fertility.

## Goddesses of Springs

Deities related to SPRINGS and WELLS were an important part of Ancient Celtic religion, and many springs and wells still bear the names of saints such as St Anne or St Bride: Bride may have been the ancient goddess BRIGID (above), and Anne may have been associated with the ancient Irish mother goddess Anu, or the Ancient Roman goddess Anna, the wife of the sun god BELI.

FIRE and WATER often appear together as a motif associated with springs, as in the French goddess Serona. And Sul, the Celtic goddess of healing, is associated with the hot springs on the River Avon. She gave her name to Aquae Sulis, the city built there by the Romans, which became modern Bath. Sul is also linked with Mabon (one of the GODS OF ETERNAL YOUTH), the Romano-Celtic APOLLO. Spring goddesses were also associated with childbirth. Running water was commonly associated with fertility, and springs were thought to have healing properties.

## Triple Goddesses

Inscriptions suggest that the Triple Goddesses, who were linked to the Ancient Roman Deae Matres or Matronae, were probably mother deities of the land and locality. They are mainly Gaulish, although there are British, Roman and Celtic examples. They were usually depicted seated together, often with CHILDREN or babies in swaddling bands, or with BASKETS of fruit, CORNUCOPIAE, loaves of BREAD or FISH, and they were sometimes accompanied by DOGS – all common symbols of fertility or prosperity. Shrines to the Triple Goddesses were linked to healing, the SUN, local SPRINGS and the protection of WOMEN.

The characteristics of the THREE women varied, a reference to the three aspects of womanhood – the VIRGIN, the MOTHER and the wise WOMAN – or to the phases of the moon and changing SEASONS. They may occasionally indicate the characteristics of the three FATES, as for instance when they hold a DISTAFF or scissors.

## Dagda

The Dagda ('The Good God') had many titles, such as Father of All and Lord of Perfect Knowledge; he was the god-chief of the Irish tribe of godlike beings, the Tuatha Dé Danaan. Represented as a pot-bellied man wearing a short hooded tunic (like those worn by agricultural workers), he was armed with a magical CLUB, so large that EIGHT men were needed to carry it. With one end of the club he was able to kill NINE people at a time; with the other end he could restore life. Despite his physical drawbacks, the Dagda was a god of fertility and had a tendency to seduce Irish heroines, producing many progeny. He also owned a CAULDRON of inspiration and regeneration (above), which was able to produce abundant amounts of food. In addition, as a harpist he could call the SEASONS of the year into existence.

CELTIC

### Lugh

Lugh ('light'), was the Irish counterpart of the Welsh Llew. Both were related to the SUN and had the gift of spear-throwing. Their GOLDEN SPEAR (above) was probably related to the sun's rays. Lugh also had the ability to SHAPE-SHIFT and curse. In a battle with the tribe of the Fomorians (GIANTS, the original inhabitants of Ireland) he took on the form of an old WOMAN with one EYE, one leg and one HAND (possibly related to the Celtic cursing posture: standing on one leg, closing one eye and staring down a pointing finger with the other eye).

Lugh was said to be the immortal father – by mortal women – of many Irish heroes, doubtless because these heroes displayed his WARRIOR talents.

He also presided over the quarter-day festival of Lughnasadh, a tribal gathering at which games and races were held. In addition, he is associated with the invention of draughts, BALL games and horsemanship.

### Mannanan

An Irish SEA god, Mannanan Mac Lyr (Mannanan, Son of Lyr) wielded a SWORD named Retaliator and possessed a bag made from CRANE skin in which he kept many TREASURES. He was related to the Welsh Manawyddan. He also kept many treasures in his underwater kingdom (sometimes known as the Land of Promise), which was associated with magical powers and rebirth. It was said that he lived on Emhain Abhlach (the island of Arran), which was associated with the Isle of Avalon.

The Irish hero Brân Mac Febal encountered Mannanan in a vision in which he told of Tir fa Thon, the Land Beneath the Waves. In Mannanan's PALACE there was a FOUNTAIN with FIVE streams. NINE HAZEL TREES grew in the stream and their PURPLE nuts dropped back into the fountain, where five SALMON ate them and sent the husks downstream. Mannanan explained that the five streams were the five senses through which knowledge is obtained.

### Brigid

An ancient British goddess of territory and rulership, known by several names. Brigantia (above) was warlike and associated with WATER, FIRE and the SUN (and, by the Ancient Romans, with MINERVA and VICTORY). She also appears as a TRIPLE GODDESS. Brigid, her later counterpart, was the patroness of SMITHS and an inspirer of poets. She endowed healing powers and assisted in childbirth. In Scottish folklore Brigantia appeared as Bride, consort of Angus. She was goddess of SPRING, SUMMER and the HEARTH – whose fire was doused on Imbolc (Candlemas Eve) and rekindled as she was invited back into the house for the spring. As Brigantia and Bride, therefore, she was linked with transformation.

Her identity may have altered when she was Christianized and became associated with St Bride, whose nuns were said to have kept her sanctuary FLAME kindled for more than 500 years. She was also said to be the midwife and the foster mother of CHRIST. Her final manifestation was as Britannia, the personification of Britain.

## Cuchulain

The hero of Ulster in Irish myth, Cuchulain had all the attributes of heroic youth in battle and romance. He was fathered on three levels: by LUGH, the SUN god, who took on the form of a mayfly that hatched at Beltane and which was swallowed by Cuchulain's mother; by his mother's husband, an Ulster chieftain, who became his earthly father; and by the warriors of Ulster, who fostered him. His epic saga told of the struggle between the Irish of Connaught and of Ulster.

Cuchulain is related to the SUN and FIRE. He had RED HAIR like a THORN BUSH (a symbol of his ferocity); in battle, his heat melted the surrounding snow; and his body turned red as he dipped into the bath, like the sun dipping into the SEA. He died aged twenty-seven at Samhain, the end of the Celtic year.

## Arianrhod

The name of this Welsh goddess means 'SILVER WHEEL', relating to her LUNAR associations and to her identification as a goddess of WEAVING or spinning. She was said to have tried to become the royal FOOT-holder to her brother, the KING, for which she had to be a VIRGIN. However, she was tricked by the magician GWYDION, who made her tread over his wand and so give birth to TWINS, thereby showing herself unsuitable for the post. She refused to give one of the twins a name, weapons, or a wife, but Gwydion inevitably tricked her into naming her son Llew and arming him. Gwydion then created a wife, BLODEUWEDD, for him from flowers.

Arianrhod was said to have a spinning castle, Caer Arianrhod, which was represented by the constellation of Corona Borealis whose sparks formed the AURORA BOREALIS. In some traditions this castle is a tower of initiation in which poets were thought to learn wisdom. Alternatively it is where the dead return between their mortal incarnations.

## Brân

A WARRIOR deity, Brân was a GIANT with the appearance of a MOUNTAIN and EYES like LAKES. His attribute was the CAULDRON, able to give life to dead warriors, which had been given as a dowry to his sister Branwen (WHITE CROW) on her marriage to the KING of Ireland.

When Branwen was ill-treated by the king, Brân made war upon him. The battle was a stalemate, and the dying Brân returned home, ordering that his HEAD should be cut off after his DEATH – this request was related to the Celtic cult of the head. Brân's name means 'RAVEN', and his head (above) is said to be buried under the TOWER of London, symbolically guarding Britain against attack. Ravens are still kept at the Tower in the belief that when they leave, the island of Britain will fall. KING ARTHUR was believed to have dug up Brân's head, and taken over his guardianship of Britain.

C
E
L
T
I
C

### Cerridwen

Cerridwen ('WHITE SOW') was a
mother goddess. She appeared in
the story of TALIESIN as the owner
of the CAULDRON of inspiration
(above), in which Taliesin, then
a young child called Gwion Bach,
stirred it for a year and a day to
create a brew of THREE drops. They
were to transform Cerridwen's
ugly son Afagddu ('Darkness';
also known as Morfran or
Morvran, and sometimes
identified as one of the Knights of
the Round Table). However,
Gwion accidentally imbibed
the drops, and so obtained
inspiration and the ability to
SHAPE-SHIFT. He was then chased
by Cerridwen, both of them
shifting their shapes into those
of various animals. Cerridwen, in
the form of a GREYHOUND, chased
Gwion in the form of a HARE, then
as an OTTER pursuing a FISH. Finally
Cerridwen, in the form of a HEN,
swallowed Gwion in the form of
a WHEAT grain. Cerridwen became
pregnant and later gave birth to
Taliesin. The story identifies her
as a goddess of sorcery, initiation,
DEATH and rebirth.

### Blodeuwedd

Made of wild flowers and given
life by the magician GWYDION,
Blodeuwedd, whose name means
'Flower Face', was created to
overcome ARIANRHOD's curse that
her son, Llew, should never have
a wife. Inevitably, Blodeuwedd
destroyed Llew by obtaining from
him the secret of how he could
be killed, and passing this on to
her lover, who murdered him.
Blodeuwedd was henceforth fated
by Gwydion to be an OWL, and
from that point owls were
considered to be unlucky.

This story was the forerunner
of many Celtic tales of adulterous
relationships resulting from ill-
fated MARRIAGES (such as the
story of ARTHUR, GUINEVERE and
LANCELOT). The inevitable
disaster caused by the creation
of a non-human being for a
spouse is also a theme found in
many Celtic legends concerning
marriage with FAIRY folk or
elemental WOMEN.

### Culhwch and Olwen

Culhwch's name means 'BOAR' –
traditionally an animal from
the Otherworld, linked to the
guardianship of sovereignty and
the British-Celtic WARRIOR. His
tale is a typical one, of the hero
who falls in love and is sent out
to achieve certain impossible
tasks in order to win his bride,
Olwen. The name Olwen means
'WHITE Track' because white
trefoils (three-leafed clovers)
appeared wherever she walked.
This symbolized her connection
with the TRIPLE GODDESSES, and
with land and sovereignty.

Culhwch's task was to find,
with the help of ARTHUR and
his warriors, THIRTEEN sets of
TREASURES in order to prepare
Olwen and her ogreish father
for the wedding. It has been
suggested that this story could
be a cryptic means of aiding
memory relating to the hidden
Celtic tradition. The wedding
gifts may echo the folklore of
thirteen hidden treasures, such
as the legendary thirteen hidden
treasures of Britain.

## Nehellenia

A goddess with many Romano-Celtic shrines in Holland, Nehellenia protected seafarers. She is usually shown with a DOG, perhaps symbolizing healing and guardianship, and with a BASKET of fruit (above) or a CORNUCOPIA, since she was a goddess of HARVEST and prosperity.

## Morrigan

The Irish Morrigan were terrifying war goddesses, sometimes appearing in their triple aspect (war, DEATH and slaughter) and sometimes singular. They were seen on the battlefield in the form of CROWS or RAVENS (their symbols) feasting on the dead. They had the gift of prophecy, were skilled in magic and could SHAPE-SHIFT to seduce a man to satisfy their strong sexual appetites.

## Cailleach

The crone aspect of the goddess, or the goddess of WINTER, was the Cailleach ('Hag'), also known as Bhéara. She harrowed the land in winter, covering the bare HILLS with her brown shawl (signifying earth). Her entourage of hags sitting on wild hogs (beasts of the UNDERWORLD) crossed the land causing storm and havoc. In various versions of this archetype they are said to have let GOOSE feathers fall from their skirts as they flew, creating snow.

She was also associated with mountains and said to be able to leap from crag to crag, letting enormous ROCKS fall from her apron. She could transform herself into a young girl.

The Cailleach was often linked with WELLS, especially in the legend in which she was said to visit the well of eternal life in the WEST. She drank its WATER and slept through the summer, being ritually reborn in the autumn at the festival of Samhain (All Hallows Eve, 31 October).

## Taliesin

Taliesin ('Radiant Brow') was a bard and a magician. Bards were trained to memorize stories and poems, and to compose their own. They spoke in riddles to emphasize points or to reveal mysteries in Celtic legends.

As the child Gwion Bach ('Young' or 'Little' Gwion), Taliesin stirred CERRIDWEN'S CAULDRON of inspiration for a year and a day to create a brew of THREE drops for Cerridwen's son Afagddu ('Darkness'). Gwion accidently drank the three drops, and by doing so gained the inspiration and ability to SHAPE-SHIFT. Cerridwen, in the shape of a GREYHOUND, chased Gwion, who had transformed himself into a HARE, then as an OTTER and a FISH, respectively. Finally, Gwion, as a WHEAT grain, was swallowed up by Cerridwen in the form of a HEN. Cerridwen then became pregnant and Gwion was reborn as Taliesin. This tale may be a story of initiation by the elements, EARTH, WATER, AIR and FIRE.

CELTIC

**117**

### Druid

The Druids were learned Celtic priests, teachers and lawgivers. The image above shows a druid with a WREATH of OAK LEAVES – the word 'druid' may have evolved from the Welsh word for 'oak' – and carrying a SICKLE, with which druids gathered healing plants. They worshipped in woodland GROVES, although some surviving stone structures (for example, Stonehenge in Wiltshire) have also been identified as their temples.

The Ancient Romans thought the druids filled huge wickerwork images with human SACRIFICES and burned them alive. The last druids were massacred by the Romans on the island of Mona (Anglesey), probably their main stronghold and the site of their college.

The most famous druid was MERLIN. Like him, all druids were believed to have magical powers, to be able to change the weather and create mists in which to hide from their enemies. Their religion was revived by the Victorians, and they now embody the old religions and complex systems of lore outlined in the Celtic myths.

### Merlin

Merlin (Welsh Myrddin) was a DRUIDIC WIZARD, born of a human mother but without a mortal father, suggesting that he was part-immortal. He was the enabler of King ARTHUR's birth through magic and intrigue, and he went on to foster him.

Britain was known as 'Clas Merlin' ('Merlin's Enclosure'), which reveals Merlin to have been one of Britain's archetypal guardians.

Merlin's demise was said to have come about either through the machinations of Arthur's half-sister MORGAN LE FAYE, who became his apprentice and wrought her revenge on him and Arthur, or through the temptation and enchantment of Nimue, an enticing young lover who sought to learn his magic. In both cases he was entrapped in a CAVE, a CRYSTAL or a HAWTHORN tree (a symbol of death or transformation), where he still sleeps – a hint at his immortality.

### Arthur

King Arthur is the focus of many medieval myths regarding the Holy GRAIL, MERLIN, the city of Camelot and the Round TABLE. He is said to have held the magical SWORD Excalibur, given by the Lady of the LAKE. Arthur was the son of Ygraine, the Duchess of Cornwall (who magically assumed her husband's form) and Uther Pendragon, but he was tutored and raised by Merlin.

The original stories of Arthur are probably related to a 6th-century Celtic warlord. They are far removed from the medieval tales of chivalry and a British GOLDEN AGE, in which Arthur was a perfect king who brought peace and civilization by uniting Britain's warring tribes under one KING and one Christian religion. Arthurian tales became popular in the courts of medieval and Renaissance Europe, to whose courtiers Arthur signified just rule and the kingly ability to unite spiritual and temporal matters by initiating the quest for the GRAIL. He is said to lie SLEEPING in Avalon, and will reawaken when Britain needs him.

## Guinevere

King ARTHUR's wife Guinevere (Welsh Gwenhwyvar) embodied the archetypal chivalric QUEEN: appearing to be beautiful, pure and perfect. Her virtues were reflected in the state of the LAND, a symbol of which was the Round TABLE (above) which formed part of her dowry. She was worshipped by her husband's knights and inspired them to attempt ever-greater feats of bravery.

But Guinevere remained human. She was forced to play the role of perfection, but her beauty became her downfall when, because of Arthur's neglect, she fell in love with LANCELOT, her husband's most loyal, good and perfect knight. The discovery of their adulterous relationship inevitably caused instability in King Arthur's court – and in the land, because the land and the KING were one.

The source for her legend may well have been the story of BLODEUWEDD, who was made from flowers by GWYDION, and whose adultery brought about her husband's downfall.

## Morgan Le Faye

King ARTHUR and his half-sister, Morgan Le Faye, shared the same mother, Ygraine. Early texts mention Morgan Le Faye as a healer, and she was one of the three QUEENS who sailed away with the dying King Arthur to the island of Avalon.

Morgan Le Faye means 'Morgan the Healer' or 'Morgan the WITCH'. She was married to King Urien of Gore (Gower), who had connections with the elemental kingdom. Later Arthurian romances depicted her as a femme fatale who destroyed the stability of Arthur's kingdom by her acts of revenge for the death of her father, using the lust of Arthur's father and the magic of MERLIN. In these tales, Morgan Le Faye tricked Merlin into teaching her his magic and seduced her half-brother Arthur in order to father the evil avenger Mordred. They also recount how she stole the scabbard of Excalibur, taking away its protection, control and FEMALE balance.

## Lancelot

In the Arthurian romances, Lancelot was said to be the best knight in all the world. His character was possibly derived from the image of early Celtic gods who carried a lance, such as LUGH. Lancelot was the epitome of chivalry and medieval courtly love, joining the Round TABLE and becoming King ARTHUR's 'goodly' knight and Queen GUINEVERE's champion.

However, this later prompted his downfall when courtly love developed into sexual love with the QUEEN, initiating the break-up of the fellowship of the Round Table and ultimately the descent of Arthur's kingdom into a wasteland. This in turn led to the quest for the Holy GRAIL, which would revive the KING and his kingdom. Lancelot should have achieved the quest, but failed because of the blemish of his adultery. Instead he fathered Sir Galahad, who eventually found the Holy Grail.

A R T H U R I A N · N O R S E

## Parsival

The archetypal FOOL and youthful hero, Parsival left the home of his mother as a youth, and arrived at the castle of his uncle, the FISHER KING. There he managed to see the GRAIL procession, but he was too courteous to ask about the mystery he saw before him. He was later told that if he had asked, the Grail would have healed his uncle's sickness (a wound to the THIGH), and, because the health of the king and his KINGDOM are inextricably linked, brought the dying kingdom back to life.

With his first quest so easily found and so quickly lost, Parsival continued on to King ARTHUR's court, where he joined the other knights in their quest for the Holy Grail. Eventually, he overcame his first foolishness, becoming one of the three knights who discovered the Holy Grail (above). His character was probably inspired by the older Welsh story of Peredur, from the *Mabinogion*.

## Odin

Odin appeared in Northern myths in three main guises: as ruler of the Land of the Dead; as god of battle; and as god of inspiration, magic and wisdom.

When he appeared on earth, Odin was disguised as an old man (symbolizing wisdom) with ONE EYE (he gave up the other so that he might drink from the WELL of Mimir, which bestowed great knowledge). His deformity was hidden by a hood or a broad-brimmed hat. Otherwise he was represented riding on his EIGHT-legged HORSE, Slepnir, with his two RAVENS, Huggin and Muggin ('Thought' and 'Memory'), flying over him (above); or feasting in his great hall, Valhalla, in Asgard.

His name meant 'Fury' or 'Madness' – he could inspire a berserk rage in battle, in which the WARRIOR felt and feared nothing – but he could also inspire poets and story-tellers.

Odin hung upside-down (a SHAMANISTIC activity associated with reincarnation) on YGGDRASIL, the World Tree, in order to gain knowledge of the runes.

## Freyja

The main Nordic goddess was Freyja ('Lady'). Although she was the daughter of Njörd and the sister and bride of FREYR, both of whom were Vanir (Norse deities of fertility and predecessors of the Aesir), she later became associated with Frigg, the wife of the Aesir deity ODIN.

Freyja was related to the MOON. She was an UNDERWORLD goddess whose domain was the Folkfeild, where she welcomed WOMEN after DEATH. She had a cloak of FEATHERS, which enabled her to become a FALCON and fly to the underworld in order to bring back prophecies. Her marriage to Odin caused her to be associated with the leader of the VALKYRIES. She was also a war goddess, and rode a GOLDEN battle-BOAR (boars being favourite symbols of WARRIORS) made by dwarves (the SMITHS of the gods), with a battle-CHARIOT pulled by CATS (above). Depicted in her myths as sexually prolific, she was also worshipped as a goddess of love and fertility.

## Balder

The divine son of ODIN and Frigg, Balder was the god of LIGHT and radiantly handsome. His death came about through the machinations of LOKI. It was caused by a shaft of MISTLETOE, the only plant that had failed to promise Frigg not to harm her son. Balder's death served as a prelude to Ragnarok, when the ruling gods were destroyed and the EARTH, engulfed in FLAME, sank beneath the SEA.

Hel, ruler of the Land of the Dead, declared that Balder could only return to life if everything on earth wept for him. Once again Loki intervened, appearing as a GIANTESS who refused to weep with the others.

Balder's continued defeat at the hands of Loki embodied the inevitability of death and destruction. (However, Loki was punished for his deeds – although his wife helped to save him from the worst of his fate.)

Balder was considered to be a master of healing herbs and was associated with Odin's magical arm-RING, Draupnir.

## Thor

The Norse SKY god Thor was described as a huge RED-BEARDED man with FLAMING EYES and a quick temper. His symbol was his great HAMMER, Mjöllnir (above). He used the thunder and LIGHTNING it produced to great effect in killing the gods' adversaries, the GIANTS.

Known for his strength, Thor naturally became a WARRIOR's god and was related to JUPITER by the Ancient Romans. But he was also called upon in ordinary life, since his hammer was associated with the marking of boundaries of all types, from physical ones to ritual boundaries such as birth, MARRIAGE and DEATH. As a sky god he was also called upon to calm the SEAS at the start of a voyage.

The most popular story about Thor tells of him fishing for the World SERPENT. He proved his strength to the giant Hymir by reeling in the serpent Jormungand, which surrounded Midgard.

## Freyr

The principal god of the Vanir (Norse deities of fertility, who lived in MOUNDS, HILLS and bodies of WATER) was Freyr ('Lord'). His father was Njörd and his sister and bride was FREYJA. He was also associated with elves, who were believed to live under hills and in mounds.

Freyr's link with natural features seems to be related to his association with the LAND. Those who looked to him for protection were usually connected with its husbandry. He was also the patron of many Scandinavian rulers.

Freyr also had a WARRIOR aspect, and, like his sister Freyja, his symbol was the BOAR (above), a favourite emblem of warriors. Even so, the saga-writer Snorri depicted his hero drinking to ODIN for power and victory in war, and to Freyr for peace and good SEASONS, emphasizing Freyr's more dominant role as a protector of the land's fertility.

NORSE

### Loki

A dual-natured character who was a friend of both ODIN and THOR, Loki was not a god, although he possessed a SHAMANistic ability to SHAPE-SHIFT into either gender or become a mare (to run), a HAWK (to FLY) or a SALMON (to swim). He was neither good nor evil, but simply a TRICKSTER whose deeds were fundamentally selfish. The image above shows him being carried by the GIANT Thiani, disguised as an EAGLE, in a tale about him.

His unparalleled wit and cunning allowed him to get away with challenging the gods themselves. On one occasion he insulted each of them personally at a banquet, and was driven from the hall by Thor. He was also sexually predatory, and not above sleeping with the goddesses.

In the end, he was part of the gods' downfall: he created the WOLF Fenrir and the SERPENT Jormungand that were fated to destroy the gods at Ragnarok, the battle at the end of time.

### Valkyries

The Valkyries ('Choosers of the Dead') were female goddesses who decided the fate of WARRIORS during battle. They also fought themselves. They resided with ODIN in Valhalla, greeting the most heroic of slain warriors and inviting them to join in the FEAST; the image above shows a Valkyrie with a drinking HORN.

The Valkyries were usually shown as HELMETED women, grasping SPEARS crowned with FLAMES and FLYING through the SKY on HORSES, from whose manes fell DEW or hail. They were also depicted wearing SWAN plumage, which enabled them to fly, and as swan-maidens. They occasionally shed their FEATHERS and took on human form, and any man who stole their plumage could force them to obey him. By these means Hagen forced the Valkyrie Brynhild to help him defeat Hjalmgunnar, Odin's protégé, thereby incurring Odin's wrath, which eventually led to her liberation from imprisonment as a mortal by Sigurd.

### Seven Liberal Arts

The SEVEN Liberal Arts embodied the content of classical learning, as categorized in late antiquity. They were divided into two groups, containing the following arts (whose attributes, also listed, vary considerably).

*Trivium (basic):*
∗ Grammar: WRITING IMPLEMENTS.
∗ Rhetoric: arms and ARMOUR, or a BOOK or SCROLL.
∗ Logic/dialectic: a SERPENT for sophistry and a hook for cunning.
*Quadrivium (advanced):*
∗ Arithmetic: a tablet covered with NUMBERS.
∗ Geometry: COMPASSES (above) and globe.
∗ Music/harmony: a musical instrument.
∗ Astronomy/cosmology: a globe and an astronomical measuring device.

The arts are often shown being nourished by the super-subject Philosophia, depicted as a central figure uniting all the arts.

A

B

C

## Virtues and Vices

The Christian notion of virtues and vices, and their imagery, have been shaped primarily by the *Moralia on Job* of Pope Gregory I (540–604) and the *Psychomachia* of Aurelius Prudentius (348–405). They are usually depicted as women, the virtues often having WINGS (A). The virtues are more common than the vices, who are seldom represented on their own.

✳ VIRTUES
These (listed here with their attributes) are most frequently divided into two groups:
The biblical theological virtues of I Corinthians 13: 13 are:
✳ Faith: a font (BAPTISM) or a BOOK (study).
✳ Hope: an OLIVE branch (peace) or a EUCHARISTIC host; sometimes shown holding a banner or reaching for a CROWN.
✳ Charity: a loaf of BREAD, a VESSEL; may be shown giving alms from a casket, or giving clothing to a freezing person, or holding a LAMB (a symbol of CHRIST).
The classic 'cardinal virtues' of classical antiquity are:

✳ Prudence: a SNAKE and sometimes a DOVE ('wise as serpents … simple as doves', Matthew 10: 16) and a SCROLL or a BOOK (discernment).
✳ Justice: a SET SQUARE, a PLUMB RULE and a measuring rod (discrimination), or a SWORD (punishment for wrongdoing).
✳ Fortitude: a SPEAR and a SHIELD; may be shown overcoming a LION.
✳ Temperance: a TORCH (watchfulness) and a jug of WATER (to extinguish passions); may be shown mixing the contents of a CUP and a bottle (moderating WINE with water).

Other texts and traditions gave rise to other virtues, most commonly:
✳ Obedience: ABRAHAM (because of his willingness to sacrifice Isaac) or a CAMEL, a docile beast of burden.
✳ Purity: Moses, a DOVE (simplicity) or a Madonna LILY (a MARIAN SYMBOL).
✳ Penitence: David (signifying his pride and later repentance).
✳ Patience: Job, an OX or an ASS.
✳ Perseverance: a CROWN.
✳ Sobriety: Elijah, drinking from a small CUP.

✳ Peace: a DOVE or LAUREL.
✳ Humility: Judith or Jael, a DOVE, a woman with her arms crossed over her chest.
✳ Chastity: a BIRD hovering above a FLAMING MOUNTAIN.

✳ VICES
The Virtues are often represented in conjunction (or in combat) with corresponding vices. The most famous are the 'seven deadly sins':
✳ Pride: a rider or a MONARCH, shown falling.
✳ Avarice/covetousness (B): a man with a purse hanging around his neck, harassed by DEVILS; a woman sitting on a TREASURE-chest, trying to keep it closed.
✳ Lust (C): a woman with SERPENTS and TOADS biting her BREASTS.
✳ Envy: a woman gnawing her HEART or entrails; a SNAKE or a DOG.
✳ Gluttony: a FAT person gorging on food.
✳ Anger: a monk being threatened.
✳ Sloth: an obese figure riding an ASS, an OX or a PIG.

Finally, another common vice is:
Luxury: a VENUS-like figure, sometimes riding a GOAT; a woman looking at herself in a MIRROR.

## Green Man

The GREEN Man was often depicted on medieval European religious architecture: he was portrayed as a MALE face within foliage (above), or a face of LEAVES, which often looked down on the congregation. Sometimes leaves issued out of his MOUTH, EARS and EYES, representing the unrelenting growth of nature. In folklore he was the energy of plant life and the greenwood, the rising force of fertility in the SPRING, which was equated with figures such as Jack in the Green or the FOOL. (It has been suggested that such carvings in churches represent hidden pagan beliefs in the spirit of nature and the promise of resurrection within the seasonal cycle.) His depiction may even have been intended, in some instances, as a warning against the temptations of the sins of the flesh that are influenced by the rising energy of the spring.

## Great Architect

For Freemasons, the Great Architect represents the main governing principle at work in the physical universe, the builder of all – God. The Great Architect is usually depicted as the all-seeing EYE of God (above). The phrase 'Great Architect of the Universe' came into Freemasonry as early as 1723, but was first used by the Reforming theologian John Calvin (1509–1564) in his commentary on Psalm 19. The Great Architect is not a specific Masonic god or an attempt to combine all gods into one. Instead it is a generalized description allowing men of different religions to pray together without offence being given to any of them.

Anglo-Saxon Masons work to the glory of the Great Architect, to whom they are introduced in the First Degree of Masonry, and seek to become perfect representatives of his truth, modelling themselves on his laws of moral rectitude, charity and brotherly love.

## Hermes Trismegistus

The Hellenistic HERMES Trismegistus ('Thrice Greatest Hermes') was related to the Egyptian THOTH. Alchemists consider him the author of their primary text, *The Emerald Tablet of Hermes Trismegistus*, which is said to contain the secret teachings of Egypt conveyed through divine revelation from Hermes or Thoth. He is believed to represent the archetypal alchemist.

## Soror Mystica

The Soror Mystica ('Mystical' or 'Soul Sister') is sometimes the male alchemist's female assistant in the Work, and sometimes the FEMALE figure that he internalizes as a representative of the inner feminine archetype.

## Christian Rosenkreuz

Christian Rosenkreuz was a mystical figure, first described in a pamphlet of 1614, *Account of the Brotherhood of the Meritorious Order of the Rosy Cross*, from which originated the Rosicrucian movement. The pamphlet recounts the journeys of Rosenkreuz, who was allegedly born in 1378 and lived for 106 years, as he gained his wisdom on trips to Egypt, Damascus, Damcar in Arabia and Fès in Morocco. This wisdom was imparted to a group of disciples after Rosenkreuz's return to Germany. Upon his DEATH, his body was enclosed in a SEVEN-sided TOMB (above, seven being a number of mystical powers), which was said to hide a great secret, and from which he was to be resurrected.

Although treated as a historical being in the pamphlet, providing a legendary explanation of the order's origin, it is clear that Rosenkreuz is an allegorical figure with alchemical overtones, related through his resurrection to CHRIST and OSIRIS.

## Father Christmas

Santa Claus (from the Dutch Sinte Klaas, 'St Nicholas') is a version of ST NICHOLAS, the Bishop of Myra, whose legend relates the resuscitation of THREE CHILDREN who had been chopped up by a butcher, and an anonymous gift of three bags of GOLD to three VIRGINS who had been abandoned by their father without a dowry. These stories led to his fame as a giver of gifts to children (and to an association with pawnbrokers, whose three gold BALLS reflect his gift to the virgins).

On his feast day, 6 December, St Nicholas brings presents to children in most of Europe. On Christmas Eve in the UK and the USA Santa Claus (above) visits in a sleigh drawn by reindeer through the SKY, delivering presents via the chimneys of houses. This legend was developed by Dutch New Yorkers in the early 19th century, and disseminated by the poem 'Twas The Night Before Christmas', apparently by Henry Livingston Jr (1748–1828), having long been attributed to Clement Clarke Moore (1779–1863).

## Vishnu

The Hindu deity Vishnu originally symbolized the THREE stages of the SUN: dawn, noon and sunset. He then became 'all-pervasive', embracing within himself the universe (composed of the HEAVENS, earth and the UNDERWORLD). In his role as preserver of the world he is said to have assumed AVATARS or incarnations, which are usually numbered as TEN *dasavatar*. Among these are Rama and KRISHNA.

Vishnu has FOUR arms in which he holds his four main symbols (above): the *shanka* or CONCH SHELL with which he dispels demons, the *chakra* or discus used against evil forces, the *gaddha* or CLUB (representing power) and the *padma* or LOTUS (symbolizing reincarnation). In his function as lord of the cosmos he floats on the primeval WATERS, asleep on the SERPENT Ananta. He also has another vehicle in the form of the great bird GARUDA. His characteristic colour is dark BLUE and he is clothed in YELLOW.

EUROPEAN • HINDU

**125**

## Avatar

An avatar in Hinduism is a divine incarnation in earthly – but not necessarily human – form. They are usually shown carrying symbols of their protective powers. Avatars possess special or superhuman qualities, but they may have human weaknesses.

Most avatars are of VISHNU (the lord of protection and the most widely worshipped of the Trinity that also includes BRAHMA and SHIVA), who periodically assumes corporeal form to battle with evil. TEN avatars of Vishnu are widely recognized and deeply ingrained in popular Indian mythology, though some texts mention up to thirty-nine. Of these, Rama and KRISHNA are the best known and most widely worshipped. The illustration (above) shows the Sixth Avatar of Vishnu, depicted as Rama with an AXE.

BUDDHA is also mentioned as an avatar, but he may have been imported into the tradition to incorporate Buddhism within the Hindu fold. Kalki, the last, has yet to appear. He is expected to arrive riding a WHITE HORSE.

## Shiva

Shiva, 'the Destroyer', represents darkness (*tamas*) and is the 'angry god'. He is one of the three gods of the Hindu Trinity or Trimurti, and is seen as a pre-Vedic god allied to the lord of beings on Indus Valley SEALS. He is depicted above holding two of his attributes: a *vajra* or THUNDERBOLT and a *shanka* (a stylized CONCH SHELL). His consort is PARVATI.

Shiva is very complex. He not only destroys but also generates and restores, because creation comes from destruction, so he is often represented by the PHALLUS-shaped *linga*. He has a THIRD EYE of higher perception, directed inwards. When it looks outwards it unleashes a destructive force.

Shiva is also the supreme ascetic or *mahayogi*, clad in ASHES and ANIMAL SKINS, denoting the highest form of penance and meditation. As Nataraja he maintains the balance of the universe, and performs the ecstatic cosmic DANCE or *tandava* in a circle of flames representing the SOLAR disc, symbolizing creation and the perpetuation of the cosmos.

## Brahma

With VISHNU, 'the Protector', and SHIVA, 'the Destroyer', Brahma 'the Lord of Creation' forms the supreme trinity of Hinduism. He is traditionally depicted as less important than Vishnu and Shiva, both of whom are extensively worshipped. There are only two known temples dedicated exclusively to him in India, although he is worshipped in almost all temples, albeit not as the principal deity.

Brahma is often depicted with FOUR HEADS, '*chaturmukha*', facing in four directions (above). These represent the four Vedas (devotional texts), the four cardinal points, the four *yugas* or AGES OF THE WORLD, and the four *varnas* or CASTES of Hinduism. His consort is SARASWATI, the goddess of wisdom and science.

He was later adopted by Buddhism and taken up in turn in China and Japan as the attendant of Shakyamuni and AMITABHA. In Japan he was known as 'Bonten'.

## Shakti

The feminine principle among the deities of Hinduism is Shakti ('The Great Goddess'). She personifies the power that connects the other great gods of the Hindu pantheon, BRAHMA (creation), VISHNU (protection) and SHIVA (destruction): she is the force that activates their powers, and is considered to be female, perhaps because force or energy causes creativity and this fecundity is deemed feminine.

Without Shakti, the other gods are passive and distant, and there can be no motivation. She is the eternal energy in the overall processes of the universe. But force or power has no morality, and so Shakti represents the creative and dynamic aspect of this element, which can be dark and fearsome or bright and life-saving. She is worshipped in both her forms – formidable, and shining and maternal. Although far more than a deity's consort, Shakti is often shown embracing Shiva (above).

## Kali

One of the most powerful Hindu deities, Kali is closely associated with DURGA. She is a particular form of SHAKTI, the MOTHER goddess, and embodies her terrifying and destructive aspect. Kali is depicted as a dark woman with a fierce mien, a BLACK TONGUE, rolling EYEBALLS and pointed canine TEETH, and festooned with a garland of bloody HEADS. She holds a SWORD in one hand and a severed head in another; another hand is raised in a gesture of peace while the other grasps for power.

She is considered to be the goddess of smallpox and other virulent diseases in the form of such deities as Mariyamman and Sitala. She is also called Bhadrakali, Mahakali, Shyama and Kalika. She is a central figure in Tantric rituals, and was the goddess to whom the Thugee cultish movement (the word is the origin of the English word 'thug') would pray. She is widely worshipped in Bengal, Eastern India and Nepal.

## Krishna

Krishna ('The Dark One') signifies joy, romance and playfulness. He was born a prince of the Yadava clan, but fostered by cowherds. He saved his people from the tyranny of his evil uncle Kamsa. As the incarnation of VISHNU in the Hindu epic *Mahabharata* he reveals a key text of Hinduism, the *Bhagavadgita* (*Song of God*) to the WARRIOR Arjuna.

The CHILD Krishna is illustrated (above) DANCING on a cobra, holding its tail with one hand and with a foot on its raised hood, representing the conflict between heavenly and earthly powers. As a man he is described as dark-skinned and fond of playing the FLUTE. He often cavorts with cowherds and SHEPHERDESSES, suggesting that he originated as a pastoral god or a vegetation deity, perhaps from a pre-Vedic tribal culture. With the object of his passion, the shepherdess Radha, Krishna forms the central theme of much Indian mystical-erotic poetry and song. Radha's love for Krishna symbolizes the yearning of the SOUL for union with God.

H I N D U

### Lakshmi

Lakshmi is the auspicious Hindu goddess of fortune, riches and glory. As Shri she is the goddess of beauty. She is the consort of VISHNU, and when she is worshipped she multiplies riches. Legend has her emerging from the froth of an SEA of MILK churned by the gods.

Lakshmi may originally have been a goddess connected with WATER and fertility, and a personification of the earth. She is usually shown sitting on a LOTUS, a flower associated with water, and sometimes holds lotuses in two of her FOUR HANDS, and precious stones in the others (above). She is associated with ELEPHANTS and is usually depicted being lustrated or sprayed by them. This symbolizes her regal power, because elephants are attributes of royalty.

One legend says that Lakshmi is the daughter of 'Ritual FIRE' (Bhrigu) and 'Hymns of Praise' (Khyati), ancient Hindu deities, symbolizing the fortune that results from ritual sacrifice (*yagna*).

### Ganesh

The son of SHIVA and PARVATI, Ganesh is the lord of the Gana, a semi-divine group of SPIRITS attendant upon Shiva, and so he is also called Ganapati ('A Gana Lord').

A popular god of Hindu mythology, Ganesh is depicted as a pot-bellied figure with an ELEPHANT'S HEAD, FOUR ARMS and ONE tusk. He sits on a RAT (signifying shrewdness), which ferries this improbable cargo around. He received his elephant's head when he lost his own and was brought back to life using the nearest available head, that of an elephant. He is identified as a god of good fortune and wisdom, who intercedes with other gods. He is always invoked before any venture and his name is invariably inscribed at the beginning of literary works. He is particularly worshipped by the merchant community as a god of new ventures and good luck.

### Kartikeya * Skanda * Murugan

Kartikeya or Skanda is the young god of war and commander of armies of gods. He was formed during a FIERY union of SHIVA and PARVATI, which spilt Shiva's burning seed. Fostered by the six Krittikas (or Pleiades), he is known as Kartikeya. He grew SIX HEADS to suckle from them. He destroyed evil Taraka whose austerities gave him power against the gods. The eternal youth (*kumara*), Skanda is particularly venerated in South India under his epithets Murugan or Subrahmanya.

The cult of the god of war is ancient, and Kartikeya may have been integrated into an older cult of Murugan, from the ancient Indian state of Dravida. He rides on a PEACOCK, a bird that is fleet and a killer of SERPENTS (symbolizing evil). Dressed in RED, he holds a SPEAR and a BOW AND ARROWS (above), or a SWORD and a THUNDERBOLT. The celibate Kartikeya symbolizes the power of chastity.

## Durga

Durga is a menacing form of SHAKTI, the mother goddess of Hinduism. She was created by BRAHMA, VISHNU and SHIVA to kill DEMONS and subdue evil. She is depicted as a beautiful but fierce woman, riding a TIGER, with TEN ARMS and HANDS, in each of which she holds a special weapon, rendering her invincible. She probably derives from a pre-Vedic god, and is closely associated with KALI.

## Devi

For Hindus, Devi refers either to SHAKTI, the wife of SHIVA, or to any goddess. She represents the FEMALE power of Shiva. She has two personas: one gentle and serene, the other formidable and fierce, as which she appears multi-armed astride a LION.

## Parvati

The name Parvati means 'The MOUNTAIN Daughter' – she is the daughter of Himavat, Lord of the Himalayas. Parvati is usually shown as a beautiful woman. This gentle goddess is the consort of the great god SHIVA, and is seen as the gracious serene aspect of Shiva's female force, or the mother goddess SHAKTI.

Parvati won the attention of the reclusive, meditating Shiva with rigorous penances and austere worship, and is thus a symbol of the perfect devotee or disciple. Shiva and Parvati can be seen to symbolize the tension between domestic bliss and isolated renunciation. Parvati often tries to tempt the ascetic Shiva into making love to her, and she is maternal and nurturing to her sons SKANDA and GANESH. She therefore symbolizes all the positive aspects of womanhood and MOTHERHOOD. Her principal symbol is the *yoni*, the female equivalent of the phallic *linga*.

## Agni

Agni is the Hindu god of FIRE. Just as life cannot exist without LIGHT, heat and fire, the universe cannot exist without the SUN. Humans can communicate with the gods only through offerings of fire, so Agni's position is powerful and unique. He is represented as a powerful creative force in the Vedic texts.

## Hanuman

The MONKEY god Hanuman is one of the chief characters in the Hindu epic the *Ramayana*, in which he is the companion and defender of Rama. The son of the WIND god Vayu, Hanuman can FLY. He symbolizes loyalty, courage and devotion, and also strength and speed. He is greatly idealized in Hindu literature.

HINDU

H I N D U • B U D D H I S T

## Saraswati

Saraswati ('The Flowing One') or 'essence of self' symbolizes all intellectual and artistic pursuits: learning, speech, poetry and music. The image (above) shows her with her symbols, the LUTE and the LOTUS. She is the consort of BRAHMA, the Lord of Creation: creation requires knowledge. An early goddess, Saraswati seems to have evolved from RIVER-worship. She is also associated with speech.

## Garuda

The mythology of Garuda, traditionally shown as a huge BIRD, half-GIANT and half-EAGLE, may derive from the Sumerian legends of the bird of HEAVEN and the SERPENT of EARTH. He also symbolizes the SUN, being so brilliant and fiery that the gods mistook him for FIRE when he was born.

## Buddha

Buddha was born in the 6th century BC as Prince Siddhartha, a member of the Gautama clan of the Sakya tribe on the border between Nepal and the modern Indian state of Bihar. The title of Buddha, meaning 'Wise' or 'Enlightened One', was bestowed on him after his enlightenment. This he achieved at the age of 39, after seven weeks of meditation (A) under a BODHI TREE in the village of Bodhgaya. He abandoned his wife and child for the ascetic life.

For the next forty-one years until his DEATH at the age of 80, Buddha preached his philosophy, repudiating some aspects of Hinduism – such as ritual worship and SACRIFICE – and denouncing the CASTE system. In its place, he offered a moral code of conduct that mentions neither HEAVEN nor HELL, nor any religious sanction, but relies on the self-discipline and autonomous spirit of the individual to guide him or her towards salvation. He taught that to live is to suffer, and the WHEEL of birth and rebirth will continue to turn unless humans can

contain their desires, and so release themselves from this process. To achieve this, people should follow the 'EIGHTfold PATH' of Buddhism, which leads to wisdom, calmness, knowledge, enlightenment and release.

Buddha organized his followers into an order of monks called the Sangha, which grew rapidly to include an order of women. They were not allowed to own any personal property and had to live simple, austere lives, depending on the generosity of the public to keep them clothed and fed. Their guide in terms of personal conduct was the law (dharma) in the Buddhist scriptures. In general this forbade the destruction of life, the causing of pain or injury, theft, falsehood and self-indulgence. Its purpose was to lead people away from life's many temptations, which sustain the cycle of desire and disappointment and hence the cycle of birth and rebirth. By Buddha's death in about 483 BC Buddhism was a powerful and influential philosophy that went on to shape the lives of some of

C

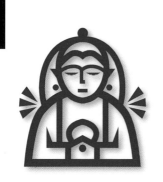

India's most famous rulers, including Ashoka, Kanishka and Harsha. It was introduced into Sri Lanka by Ashoka's son Mahinda in the 3rd century BC, into China in the 1st and 2nd century AD, and into Japan in the 6th century AD.

Buddha exists in various incarnations (some of whom have become BODHISATTVAS). They are generally thought to embody wisdom and compassion. Some of these have become particularly popular: Sakyamuni (Shaka in Japanese), the historical founder of Buddhism; AMITABHA (Omi to fo in Chinese and Amida in Japanese); and Mahavairochana or Vairocana (Pi lu she na in Chinese; Dainichi in Japanese), an embodiment of the essence of the universe.

Buddha's symbols include the WHEEL (the cycle of reincarnation), the LOTUS (another symbol of reincarnation) and the DEER, because his first sermon is said to have been given in a deer park. He is often depicted reclining (B) and as a POT-bellied figure (C).

## Amitabha

The *dhyani* (meditative) BUDDHA Amitabha, venerated in China as Omi to fo and in Japan as Amida, is the personification of compassion and grace, the Buddha of Infinite LIGHT and guardian of the WEST. He is the transcendent form of the human Buddha Sakyamuni, who was the historical Gautama BUDDHA.

Amitabha offers a place in his Pure Land of boundless joy, or 'Sukhavati'. He was filled with compassion on seeing the suffering of this world and created a paradise into which even those who are too weak to perform severe austerities to gain spiritual merit can be reborn. Even sinners who remember Amitabha's grace are absolved by him.

Amitabha has three aspects: first, Boundless Light; second, Boundless Compassion through AVALOKITESHVARA, his BODHISATTVA form; and third, Infinite Life in his form of Amitayus, particularly important in Tibet. He is shown holding a LOTUS flower, and is often accompanied by a PEACOCK.

## Manjusri

One of the five chief *dhyani* (meditative) BODHISATTVAS of Mahayana Buddhism, Manjusri embodies wisdom. He carries a SWORD with which to sever ignorance and falsehood, and is closely associated with the sacred scripture *Pragñaparamita*. He often holds this BOOK in one hand.

Manjusri, whose name denotes a pleasant or splendid aspect, is a popular Bodhisattva who is worshipped widely in the belief that he bestows intelligence and grace. He may have been a real and deified hero. Some believe him to have founded civilization in Nepal and to have disseminated Buddhism there. Alternatively he may have been a Tibetan who took up Buddhism, or a hero of an Ancient Chinese tribe.

Sometimes Manjusri holds a BLUE LOTUS or *utpala* (above), which symbolizes the BUDDHA's teachings. In the form of Manjughosha (Gentle-voiced), he is seated on a LION.

BUDDHIST

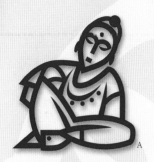

## Bodhisattva

A Bodhisattva is a disciple of Buddhism, either male or female, who is capable of attaining personal salvation through Nirvana, but resolves to postpone doing so in order to help others. The name comes from Pali (a language derivative of Sanskrit), and means 'one who is the essence of truth and wisdom'. Bodhisattvas are usually shown seated on the floor (A), differentiated from the BUDDHA by their relaxed pose, which signifies their continuing relationship with humankind (as opposed to the lotus posture of the ascended Buddha).

Bodhisattvas first emerged as personifications of the Buddha's previous incarnations, thus explaining how he had attained Nirvana in his incarnation as the Gautama Buddha. They were also based on the various individual qualities of the Buddha, to add meaning and richness to his teachings and to elaborate on his philosophy.

The Bodhisattva belongs to the compassionate doctrines of Mahayana Buddhism, which differs markedly from the austere traditions of Hinayana Buddhism. Mahayana philosophy seeks to reassert Buddha's mission on earth, which was to help mankind attain salvation through personal conduct and public behaviour that is courteous, modest, compassionate and respectful of all living things. In Hinayana Buddhism, the disciple focuses only upon personal salvation.

Bodhisattvas are an important feature of Buddhist life, and are usually depicted as selfless and compassionate. In their more determined forms they resolve not to attain salvation for themselves until every creature, however wicked or sinful, has been saved. This selflessness is the hallmark of an ideal Bodhisattva.

Many Bodhisattvas became popular in China and Japan as Buddhism gained popularity in those lands. Among the most important are the following.

✳ MAITREYA, 'the Benevolent': (Mi lo fo or Mili in China, Miroko in Japan), the next and last Bodhisattva, who will appear like a messianic messenger when mankind faces its next great crisis.

✳ AVALOKITESHVARA (B): (Guanyin in China, Kannon in Japan), embodying compassion and mercy, and prayed to by Chinese and Japanese women who hope to conceive a CHILD.

✳ Kshitigarbha (C): (Di Zang in China, Jizo in Japan), who could mitigate the tortures of the SOULS in the UNDERWORLD. He (or sometimes she) was believed to take particularly close care of the SOULS of CHILDREN.

✳ MANJUSRI: (Wen Shu in China and Monju in Japan), and Samantabhadra (Bu Xian in China and Fugen in Japan) could assist people in attaining wisdom and divinity.

Initially, images depicting Bodhisattvas were merged with local deities; thus, in Tibet, they have both benign and wrathful forms and are shown in a sexual embrace with a goddess or TARA.

## Maitreya

A benevolent figure of the future, an awaited messiah of Buddhism, and a kind of equivalent to the Hindu AVATAR Kalki, Maitreya is a BODHISATTVA worshipped in the Hinayana and Mahayana branches of Buddhism. He is called Mi lo fo or Mili in China, and Miroko in Japan. A GOLDEN, smiling figure, he lives in Tushita (HEAVEN), and is typically depicted as smilingly dispensing salvation.

Maitreya is supposed to be the fifth BUDDHA in the cycle of time (the historical Buddha was the fourth). He is a future human Buddha or Manushibuddha, and as such he will visit the earth to restore purity to the Buddhist truths when there is a deterioration of doctrinal adherence. Buddha Shakyamuni is said to have visited him in Tushita and appointed him as successor, and many Buddhist sages have sought his enlightenment on points of doctrine. Maitreya is usually shown seated in the Western style, rather than cross-legged.

## Avalokiteshvara

The 'Lord with Merciful Glances' or the 'Lord who Heeds', Avalokiteshvara is a very popular BODHISATTVA of Mahayana Buddhism. He is represented as male. He developed in China into the popular Guan-yin (Kannon in Japan), where he is depicted as both MALE and FEMALE.

Avalokiteshvara is the emanation or spiritual son of AMITABHA and is supposed to have created the cosmos. He represents compassion and helps free humans from suffering. Represented standing, he symbolizes readiness to respond to others; seated with one knee raised, he shows that the rigours of religious discipline can be worn lightly; seated in a meditative pose with the knees crossed, he teaches us to be peaceful with whatever we face.

Guan-yin also represents compassion and mercy, and is said to hear the cries of the world. In female form, often depicted holding a CHILD, she is particularly popular with women, who pray to her for children, especially boys.

## Pragñaparamita

The Buddhist goddess of transcendent knowledge, and the personification of the *sutra* or scripture *Pragñaparamita* (*Perfection of Knowledge*), which lays down the TEN 'perfections' of Mahayana Buddhist philosophy.

Pragñaparamita is conceived as a female BODHISATTVA. In the exoteric belief she is the embodiment of the true doctrine, the mother of all BUDDHAS. Some regard her as the female energy (SHAKTI) of the *adibuddha* Vajradhara. Some worship her as an emanation of the *dhyanibuddha* Akshobya. In esoteric belief she is the mystical form 'Productive Energy'. She is usually WHITE, but sometimes YELLOW, shown holding a LOTUS and the scripture in her hands. The ten perfections are: *dana* (generosity), *shila* (good life), *santi* (patience), *virya* (energy) *dhyana* (meditation), *prajna* (perfection), *upayakaushalya* (skilled application of the means of salvation), *pranidhana* (firmness), *bala* (spiritual strength) and finally *jnana* (knowledge).

B U D D H I S T

### Tara

The Buddhist goddess Tara is shrouded with infinite legends. Her symbolism is complex. In Sanskrit, *tara* means 'STAR' and symbolizes the power of hunger. At the beginning of creation hunger was born with the Golden Embryo Hiranyagarbha. The pure, primeval hunger of creation is the star Tara, appearing in the universe as a source of LIGHT.

The word *tara* is also associated with the verb 'to cross', taken to mean 'that which leads to the other shore' and thus, in Buddhism, 'saviouress'. Thus Tara became a manifestation of the Divine MOTHER.

In Mahayana and Vajrayana Buddhism, Tara is the SHAKTI of the different *dhyanibuddhas*. Therefore there are many Taras. She is also regarded as a female BODHISATTVA. Taras are fierce or pacific. Tantric Buddhism worships the fierce, devouring aspect, while Gracious Taras are divided into the 'WHITE' (Sitatara) and the 'GREEN' (Shyamatara) forms (above), which fight evil and save humanity.

### Four Celestial Kings

The Four Celestial Kings (Shitenno in Japanese) were incorporated into Buddhist iconography from Hinduism. They guard the FOUR DIRECTIONS in the temple and are known as Vaishravana (Tamonten or Bishamonten in Japanese), guardian of the North and a legendary warrior; Virupaksa (Komokuten), guardian of the West; Virudhaka (Zochoten), guardian of the South; and Dhrtarastra (Jikokuten), guardian of the East (above).

The *Sutra of the Golden Light* tells how the Celestial Kings promised to protect nations that obeyed the teachings described in the sutra. Shitennoji temple was built in Osaka in AD 593 and dedicated to the deities, and many statues of them were produced in later periods.

In China the Celestial Kings were known as Moli Shou (NORTH), Moli Hai (WEST), Moli Hong (SOUTH) and Moli Qing (EAST). Their attributes – a mongoose, a LUTE, an UMBRELLA and a SWORD – were weapons used against evil-doers.

### Yama ⁎ Yan-luo ⁎ Emma-o

Yama is the Buddhist lord of the UNDERWORLD who sits in judgment on the dead. For forty-nine days after DEATH, people's SPIRITS face a series of trials before they reach Yama, who decides to which HEAVEN or hell their spirits should be assigned. He sits at a table and has a terrifying countenance, a long RED BEARD and a CROWN. He is assisted in his work by DEMONS or a group of NINE or TEN kings. A characteristic of his court is a MIRROR, which is held up to the spirits of the dead to reflect their deeds and give them a glimpse of their fates.

In China, Yama is called Yan-luo. In Japan he is known as Emma-o and is commemorated at O-bon, the festival for the ANCESTORS held in July or August.

A

B

C

## Eight Immortals

The Eight Immortals are a Chinese group of Daoist saints, some based on historical figures, who have attained immortality through their special powers. As a group they symbolize longevity. They are often depicted travelling on CLOUDS or riding on the waves, signifying their superhuman powers, supported by their various attributes, which are sometimes depicted separately as decorative motifs on items such as ceramics, silk FANS and other applied arts. They are also represented sailing together in a BOAT, crossing the SEA to meet the QUEEN MOTHER of the WEST (XI-WANG-MU).

✻ Zhong-li Quan (A): leader of the group, a pot-bellied, BEARDED sage. He is shown holding a FAN with a horsehair TASSEL, with which he was able to bring the SOULS of the dead back to life. He is purported to have discovered the secret of the PHILOSOPHER'S STONE.

✻ Zhang Guo-lao: was originally a BAT, but became a MAN. He is depicted as a BEARDED man with his two attributes: a magical WHITE mule, which he could fold and put in his pocket when it was not needed; and a long bamboo cane, which was called the 'FISH DRUM'.

✻ He Xian-gu (B): became immortal after eating a PEACH, one of her attributes. She was rescued from a DEMON by Lu Dong-bin, another of the Eight Immortals. She is shown holding a LOTUS.

✻ Han Xiang-zi (C): a scholar, depicted as a youthful man. He could make flowers blossom and attract birds and animals by playing his FLUTE. He is usually depicted holding a FLOWER BASKET and a flute; he is the patron saint of musicians.

✻ Lan Cai-he: a young man, depicted carrying a BASKET OF FLOWERS and occasionally shown wearing only one shoe. He is sometimes described as a woman or a HERMAPHRODITE. He has become the patron saint of florists.

✻ Li Tie-guai: depicted as an elderly, bearded, LAME beggar, walking with a CRUTCH. His attribute is a bottle-GOURD out of which flies a BAT. It is said to hold medicine that he dispensed to the poor and needy.

✻ Lu Dong-bin: had magical powers. For example, he once converted a WELL for WATER into one producing WINE. He was a slayer of DEMONS, and is depicted carrying a FLY-BRUSH and a SWORD across his back. He is the patron saint of barbers.

✻ Cao Guo-jiu was the uncle of an emperor. He is shown wearing court dress and holding an official SCEPTRE or CASTANETS. He is the patron saint of actors.

C H I N E S E

## Confucius

Confucius (Kong zi) lived from 551 to 479 BC. He held that the social order should rest on the moral example of those in authority: just as CHILDREN should honour their parents, so subjects should obey their rulers. He taught that advancement in society should be based strictly on merit, and that men should study to become 'superior' by cultivating knowledge and VIRTUES such as loyalty and altruism.

Although he did not produce original literature himself, Confucius is credited with editing some of China's oldest texts, such as the *Yi jing* (*Book of Changes*) and the *Shu jing* (*Book of Documents*). After his death he became the focus of a cult. His followers published his teachings in a work called the *Analects*, and his philosophy has had a great influence on Chinese government, education and society for almost two thousand years.

## Laozi

The sage Laozi (the name means 'Old Master') is believed to have lived in China in the 6th century BC, and to have written the *Daodejing* (*The Way and its Power*), the main text of Daoism (which is believed to have been written in the 2nd or 3rd century BC). The text says that the Dao or Way is the fundamental principle in the universe, and affects everything.

Laozi is frequently depicted as an old, BEARDED man riding an OX or a WATER BUFFALO. This image came from myths that described him travelling WEST in search of Buddhist teachings or the Daoist paradise. He is often shown carrying attributes such as a BOOK to represent his learning, a piece of magic FUNGUS representing longevity, or a RU-YI SCEPTRE, a token of good wishes. He can be seen as a symbol of Daoist teaching and long life, and in Chinese alchemy he represents the idealized immortal state.

## Caozhun ✳ Kojin

The kitchen god, Caozhun, is the most important deity in a traditional Chinese house. His image on RED paper is hung in a niche above the stove in the kitchen, from where he monitors the family's behaviour and bestows wealth or poverty.

On the twenty-third day of the twelfth lunar month Caozhun is believed to ascend to HEAVEN to report on the family's conduct to the JADE Emperor. On this day the men of the household offer the god sweet sticky rice cakes or HONEY to sweeten his report. His image is then burnt and replaced seven days later on the Chinese New Year's Eve.

The Japanese equivalent of the kitchen god is Kojin, a deity of the FIRE or household who dislikes uncleanliness and can be malevolent if not properly cared for. He often shares the kitchen with two of the SEVEN DEITIES OF GOOD FORTUNE.

## Zhong Kui ✳ Shoki

Images of Zhong Kui are displayed in China to drive away DEMONS because he exorcizes evil. He brandishes a SWORD and is often accompanied by a BAT, a symbol of happiness and of longevity.

According to legend, Zhong Kui was a poor man who, on his way to take the state examinations, disgraced himself at a Buddhist monastery. As a punishment, demons disfigured his face and gave him a comic BEARD. When he later passed his exams, the emperor refused to give him a job on account of his ugliness, and he committed suicide in despair. The emperor was filled with remorse, especially when Zhong Kui's SPIRIT cured him of a fever, and he honoured Zhong Kui with the title 'Great Chaser of Demons for the Whole Chinese Empire'.

In Japan he is known as Shoki, and his image is displayed at the Boy's Festival to ward off disease.

## Creator Gods

One of the earliest of China's many creation legends concerned Nü Gua, a FEMALE deity with the lower body of a SNAKE or a FISH (above), who made all living things as she transformed herself into seventy shapes. Being lonely, she fashioned the first humans out of YELLOW CLAY – these became rulers – and others out of mud, who became the poor.

Pan Gu is sometimes shown with the HAMMER and chisel with which he carved the world out of ROCK over eighteen thousand years, growing six feet higher every day. As he lay dying, exhausted by his labours, each part of his body became a part of the world: his flesh became soil; his BREATH became WIND and CLOUDS; and the insects crawling on his skin were the first humans.

Zhuan Xu ordered his grandsons to keep the sky and the EARTH separate. The DEATH of Hun Dun, a faceless CHAOS deity, engendered the creation of the world.

## Rulers of Heaven

In traditional Chinese beliefs, various different gods have been said to rule together over the EARTH and cosmos. One of the most ancient is Shang Di, 'the Lord on High', who controls the workings of the universe. The word 'HEAVEN' (Tian) came to sum up this power.

The supreme deity of Daoism is known as the JADE (or PEARLY) Emperor, Yu Huang or Yu Di (above). Associated with the qualities of jade, such as its healing power and purity, he is one of the 'Three Pure Ones' who rule the cosmos: the others are Dao Zhun, who controls the principles of YIN AND YANG, and the deified philosopher LAOZI. On Yu Huang's birthday, the 'Festival of the Gathering of the Hundred Gods', all the lesser deities report to him on the activities of humans. His wife is said to be Wangmu Niang-Niang, another name for XI-WANG-MU.

## Xi-wang-mu

In early stories Xi-wang-mu, the QUEEN MOTHER of the WEST, was described as a ferocious goddess who sent disease and disaster to humans. She was said to have the features of a TIGRESS and a LEOPARD's tail. In later times she has been portrayed as an elegant lady who holds the keys to immortality, and lives in the fabled earthly paradise of the Kunlun MOUNTAINS where the PEACHES of immortality grow. Xi-wang-mu is also said to have the elixir or herb of immortality. She is sometimes shown riding a CRANE, a symbol of long life, and was associated with JADE, believed to have powers of longevity.

Xi-wang-mu embodies the FEMALE principle, YIN. She is viewed as being particularly representative of women, and is venerated as the patron saint of female musicians and prostitutes, and as a symbol of sexuality. She is often depicted sitting on a 'DRAGON-and-TIGER' THRONE (above), which symbolizes the unity of YIN AND YANG.

## Three Star Gods of Happiness

These THREE Chinese Gods represent different STARS in the sky.
✳ Shouxing: god of longevity, is depicted as an old man with an abnormally high bald HEAD (indicating intelligence) and a BEARD; he also has a STAFF, and holds – or is shown emerging from – the PEACH of immortality (*pan dao*). He is usually accompanied by other symbols of longevity, such as a DEER, a CRANE or a magic FUNGUS (*lingchi*) and perhaps a servant boy.
✳ Luxing: one of several Chinese gods of riches, holds a BASKET OF FLOWERS to symbolize riches, and he may be attended by one or more CHILDREN.
✳ Fuxing: the god of happiness. He holds a RU-YI SCEPTRE, which symbolizes the wish 'may everything go as you desire'. The robes of all three gods are adorned with stars.

## Guan-di

A WARRIOR in the civil wars in China during the 2nd and 3rd century, Guan Yu (AD 162–220) became a folk hero and was deified as Guan-di, a god of war, loyalty, wealth, literature and justice. A uniformed general with a RED face, he is the main hero in many theatre productions based on the *Romance of the Three Kingdoms*.

## Five Gods of Good Luck

These FIVE Gods personify the 'five blessings' (*wufu*) of long life, riches, welfare, virtue and health. They are often portrayed as men in the RED robes of officials, accompanied by BATS, symbols of happiness. They may also be represented by five bats on their own, such as those that appear with the THREE STAR GODS.

### Amaterasu Omikami

The highest Shinto deity is Amaterasu Omikami, a SUN goddess. Members of the Japanese imperial family are said to be her descendants. She is depicted with a halo of SUN's rays, and holding a SWORD (above) or a MIRROR (both are regal attributes). She is sometimes accompanied by a THREE-legged CROW, which keeps evil spirits away, or the COCK that announces the sunrise.

Born when IZANAGI, one of the creator gods, cleansed his left EYE after a visit to the UNDERWORLD, Amaterasu Omikami was charged by Izanagi with ruling 'the high plain of HEAVEN', while her two brothers Tsukiyomi no Mikoto and Susano o no Mikoto rule the MOON and the SEA respectively. After having been offended by Susano o no Mikoto, Amaterasu Omikami withdrew into a CAVE, plunging the world into darkness and chaos. She was brought out by other gods, however, so that light and order returned to the world.

### Hachiman

Hachiman is a Japanese god of war, who is thought to be the deified SPIRIT of the legendary 4th-century emperor Ojin. People believe that he protects both WARRIORS and the community at large, and so there are thousands of shrines to him in Japan. Although he is primarily a Shinto deity, Hachiman is also seen as a protector by Buddhists, for whom he has the alternative name of Daibosatsu (Great BODHISATTVA).

Hachiman is portrayed as a warrior, or alternatively as a man with a bald head wearing court robes (above). He is usually accompanied by his legendary MOTHER, the Empress Jingu, and his wife, the deity Hime Okami. His other attributes are a DOVE, which symbolizes the peace that follows his actions, and a STAFF.

### Izanagai and Izanami

The Japanese creation gods, the male Izanagi and the female Izanami, created the first ISLAND, Onogorojima, by dipping a SPEAR into the SEA from the Floating BRIDGE of HEAVEN (above).

Descending to the island, they married. Izanami gave birth to the Japanese islands, and deities such as the WINDS and MOUNTAINS, but was burnt to DEATH bearing the FIRE god Kagutsuchi. The distraught Izanagi beheaded Kagutsuchi, then followed Izanami to the UNDERWORLD. Disobeying her entreaties not to look at her, he saw her body crawling with maggots. Enraged, Izanami chased him from the underworld and the two were divorced. The ablutions Izanagi performed to rid himself of the contamination of DEATH are the prototypes of cleansing ceremonies performed by Shinto priests.

The SUN goddess AMATERASU OMIKAMI was born from Izanagi's left EYE, the MOON god Tsukiyomi no Mikoto from his right eye, and the god of storms, Susano o no Mikoto, from his nose.

A

B

C

## Seven Deities of Good Fortune

These Japanese deities were believed to bring wealth and long life, and were widely worshipped from the 15th to the 17th century. The group was usually formed from the following characters.

* Ebisu, 'the smiling one': one of the more important members of the group. He was the guardian deity of people's occupations, and is venerated as a patron of farmers, FISHERMEN and merchants. He is shown wearing a kimono, a divided skirt (*hakama*) and a large cap. He carries a fishing rod, a fish basket and a golden bream (*tai*).

* Daikokuten (or Daikoku, B): the god of wealth. With Ebisu he was a more important character, and was venerated as a deity of the kitchen. He is shown dressed as a miner, with a flat BLACK hat, and carried a SACK of grain and a mallet. He was able to grant wishes. Another of his attributes was a RAT.

* Benzaiten (or Benten): a female deity of speech, music, WATER and love. She was generally shown playing a LUTE (*biwa*).

* Bishamonten (or Tamonten): a deity of riches and also, as one of the FOUR CELESTIAL KINGS, the guardian of the NORTH. He was always depicted in ARMOUR and sometimes with a SPEAR, signifying his role as a protective figure, and a small PAGODA, a symbol of Buddhism.

* Fukurokuju (C): dispensed good luck, prosperity and long life. He was a BEARDED old man with a tall bald HEAD. He was attended by CRANES (signifying longevity), DEER (to symbolize riches) and a long-tailed TORTOISE (longevity again). His major attribute was a SCROLL (wisdom).

* Hotei (A): a Chinese mendicant monk and the god of goodness and contentment. He was believed to be an incarnation of the BODHISATTVA MAITREYA, and was a protector of children. He was bald with a large STOMACH and is often depicted accompanied by children. His attributes were a large SACK which was said to contain the twenty-one 'precious things' (*takaramono*) and a Chinese FAN, with which he could drive away the dead.

* Jurojin: the god of learning and literature, sometimes linked with Fukurokuju as a god of longevity. He had a domed head (signifying intelligence) and rode a DEER (riches). His attributes were a STAFF with SCROLLS (wisdom) attached to it, and a PEACH (representing immortality).

Other deities sometimes included in the group are Shojo and the goddess Kichijoten. The seven are often depicted aboard a 'treasure SHIP' with the twenty-one 'precious things' (*takaramono*). There is still a custom in Japan of putting an image of the Seven Deities in their ship under one's pillow on New Year's Day, 1 January, to ensure that the first dream of the year will be a good one, bringing good luck.

## Inari

The Shinto deity of cereals, Inari is widely worshipped in Japan. He is also venerated as a god of wealth and a healer of disease. His shrines carry images of FOXES, believed to be his messengers, and worshippers often give offerings of tofu, loved by foxes. In some places, foxes are worshipped more than Inari.

## Illapa

The Inca deity of weather, especially THUNDER and RAIN, Illapa was often paired with the SUN god Inti. Their images were displayed in Cuzco, the Inca capital. The pair shared the main altar in the Qoricancha temple complex with the deity Viracocha. During the colonial period (above) Illapa became identified with SAINT JAMES THE APOSTLE.

## Quetzalcoatl

The FEATHERED or Plumed SERPENT, Quetzalcoatl, was worshipped universally by pre-conquest Mesoamerican cultures. He was also known as a god of the WIND and master of life, and he was creator and patron of every art, particularly SMITHING. His emblems were a TURQUOISE-encrusted SNAKE and a cloak.

Quetzalcoatl was often taken by rulers to affirm their right to rule, and to suggest a peaceful, just approach that usually belied their warlike natures.

Native Americans recount that the Medicine WHEEL teachings were brought to the South-west by priests who travelled north with five great migrations of people from the Maya city-states of the Yucatan. These were the traditional teachings of the followers of Quetzalcoatl, known as the people of the Morning STAR, or alternatively as the people of the Feathered Serpent.

## Pachamama

The fertile, EARTH MOTHER Inca goddess was Pachamama, and one of her offspring was Pachacamac, the universal creative spirit. Thus the worship of Pachamama was adapted in colonial times to the adoration of the VIRGIN MARY. Her images became the most prolific devotional images in viceregal Peru, and a huge variety **of indigenous advocations exist.**

## Smiling God

The most important deity of the Chavín culture of Peru, the Smiling God was thought to be androgynous or HERMAPHRODITIC because of its shell attributes. It probably had agricultural or fertility associations. The TEETH of its 'smile' resemble a CAYMAN's, and these animals were associated with agriculture.

## Vision Serpent

The Vision SERPENT appeared on Maya images depicting ritual BLOODLETTING by the ruler; the Maya believed that bloodletting caused the gods to become manifest in the earthly world. A transitional symbol, the Serpent denoted the moment during the bloodletting at which the ruler's vision materialized before him.

## Amala

The Tsimshian of the North-west North American Coast believe that the world spins on top of a pole supported by Amala, who lies on his back. His strength is renewed annually by having his back rubbed with DUCK OIL; but this is nearly all used up, and when it is finished Amala will die and the world will end.

## Spider Woman

To the Navajo of the south-west USA, SPIDER WOMAN is creator, the weaver of the patterns of time and space, the symbol of fate. Sometimes known as Changing Woman, she is mother of the WARRIOR TWINS, Monster Slayer and Born for Water, whose father is the SUN Father. She is said to live on the high (2094-m) rock spire known as Spider Rock in Canyon de Chelly in Arizona. She gave the gift of WEAVING to the Navajo, whose women are famed for their skilled weaving of blankets, rugs and sashes.

The Pawnee know her as RED Spider Woman, who in DEATH was transformed into the healing root of the squash plant. Her death resulted from the trampling of her fields by the BUFFALO people, and from that time on the buffalo roamed all over the land.

## White Buffalo Maiden

WHITE BUFFALO Maiden brought the Sacred PIPE to the Sioux Nation from the Great SPIRIT. She was seen first by two young men who were impressed by her beauty. One approached her lustfully, although his companion urged him to be cautious. But she took him into her arms and when they parted nothing remained of the young man but bones, for White Buffalo Maiden is sacred and timeless, and he paid for the ecstasy of her embrace with his life.

Recognizing that she was divine, the other young man welcomed White Buffalo Maiden with courtesy and took her to his village. After she gave the pipe to the people and explained how to use and care for it, she left as a white buffalo calf.

When a young woman goes through puberty, she is under the special guardianship of White Buffalo Maiden.

## Black God

Haschézhini is Black God, the Navaho god of FIRE, who knows the ways of fire – how to control fire, and how to make it. It is said that he created the STARS and set them in the thirty-seven constellations in the night sky.

Haschézhini came into being with the earth and is an ancient, dark and masculine force. He is often seen as old and slow-moving, but brave and steady in the face of danger. His MASK is BLACK and may sometimes show the Pleiades on the left forehead. He is a haughty God and quick to anger, not easy to approach or appeal to for aid. It is sometimes told that, by setting the first and lowest world on fire, he forced the first migration of the people that led, eventually, to their emergence in this, the fifth world.

## Pautiwa

Lord of the UNDERWORLD for the Native American Zuni people of the south-west USA, Pautiwa is the Chief of Kachina Village (Kothluwala), a mythological place at the bottom of a lake near Zuni.

For all Pueblo peoples, Kachinas are SPIRIT beings who embody the essences of all aspects of life; in Pautiwa's case, these are dignity, beauty and leadership. When Zuni people die, their spirits go to the Kachina Village, where they are received by Pautiwa. The people turn to him at times of trouble and great need, for he is beneficent and will act for the wellbeing of the people, as well as for the Kachinas. Ceremonial Kachina DANCES, in which the men emerge from the Kiva wearing Kachina MASKS, are believed to work by calling on the Kachina spirits. In the dry DESERT lands of the south-west, many Kachina Dances are performed to pray for RAIN.

Pautiwa is usually depicted as a Kachina bearing FEATHERS (above).

## Kokopelli

A hunch-backed FLUTE player, Kokopelli is a deity of magic, a traveller and a bringer of babies. To the tribes of the south-west USA, Kokopelli symbolizes fertility, sexuality, procreation and a passion for life. He is associated with the strong, bright colours of the macaw, symbolizing the vividness of life lived to the full.

## Bright Cloud Woman

The Bright Cloud Woman of the Tsimshian people of north-west North America is guardian of SALMON. Marrying the TRICKSTER Raven, she changed him from a black and ugly being into one of LIGHT and beauty. Raven became greedy and she left him; trying to hold her, Raven was scorched, becoming black and ugly again.

NATIVE AMERICAN

**143**

## Grandmother

To Native American peoples, a grandmother is the holder of wisdom. In mythology, the Grandmother teaches HUNTING and spiritual powers. In the tribes, the grandmothers often raise the boy CHILDREN, and oversee their transition into manhood and MARRIAGE.

## White Owl Woman

To the Arapaho, WHITE OWL Woman is the WINTER bird that brings the snows. Each year she must fight THUNDERBIRD, the bird of SUMMER who calls up great black CLOUDS accompanied by noise and WIND. White Owl Woman brings the white clouds of winter, which overcome the black clouds of summer, releasing the first snowfall of the year.

## Rangi

The father of the Maori is Rangi, the god of the SKY. He existed in darkness with his wife, the earth goddess PAPATUANUKU, conceiving seventy offspring; but their close embrace killed their children. At the behest of the other gods, the couple were separated by their son TANE-MAHUTA – and only then did light spread over the earth.

## Papatuanuku

The mother of all the Maori people is Papatuanuku (or Papa), goddess of the EARTH and ROCK. She lived with her husband RANGI until they were separated by their son TANE-MAHUTA, when she was forced to dwell in the earth. The mists that rise up from the MOUNTAINS in the SUMMER are said to represent her sighs as she laments her separation from Rangi.

## Tane-Mahuta

Tane-Mahuta, or Tane, is the Maori god of forests, BIRDS and man, and a son of PAPATUANUKU and RANGI. He created the realm of LIGHT by separating his parents, pushing up the sinews connecting the upper and lower world with his feet. He created trees and plants to cover Papatuanuku, and he clothed Rangi with the STARS.

## Tawiri-matea

The Maori god of WIND and storms, Tawiri-matea, stayed in the SKY with his father, the sky god RANGI, when his disobedient brother TANE-MAHUTA, the god of mankind and forests, separated his parents to create LIGHT. Storms and strong winds are seen as the revenge that Tawiri-matea exacts for his brother's disloyal act.

## Ru

Ru is the Maori god of
EARTHQUAKES, son of RANGI and
PAPATUANUKU. He was never born,
but remained in the centre of
the EARTH with his mother. In
Tahitian culture, Ru, which
means 'Transplanter', was the
great explorer who raised the SKY
from the earth and discovered
Tahiti with his sister Hina.

## Hine-nui-te-po

The Maori goddess of night and
the UNDERWORLD, Hine-nui-te-po,
moved to the underworld, called
Raro-henga, to hide her shame
after finding that her husband,
TANE-MAHUTA, was also her father.
The Polynesian hero Maui tried to
make men immortal by penetrating
her body – an unsuccessful act
that cost him his life. She is
depicted as a lizard-like animal.

## Lono

In Hawaiian culture, Lono-makua
(Long God) is the most important
god of the *makahiki*, a three-month
period during the rainy season
when all wars are ended and the
gods are celebrated with DANCES,
FEASTS and athletic competitions.
Lono symbolizes maturation,
forgiveness and healing, and
although it is powerful it is the
most human of all the gods.

Lono is also called Lono-i-ka-
makahiki, and is symbolized by
a tall STAFF with a crosspiece near
the top, from which WHITE cloth,
FEATHERS, and other sacred
materials were suspended.
The image, which usually had a
human head representing the
god, was carried in the opening
procession of the *makahiki*. (A
similar image symbolizing the
god of sports, Akua pa'ani,
overlooked the arena during the
festivities). When Captain Cook
arrived in Hawaii it was during
the *makahiki* festival, and the
islanders, seeing the white sails
on his ship, believed that he
was Lono.

## Vahine-nui-tahu-ra

In Polynesian culture, Hina, who
discovered the islands together
with her brother RU, has a great
friend and ally, Vahine-nui-tahu-ra
(Great WOMAN Who Set FIRE to
the SKY), a powerful chieftainess
who, as her name suggests, has
the power to control LIGHTNING.
(above). The Tahitians believe
that she protects women from
authoritative men during times
of restriction and oppression.

# THE BODY AND ACTIONS

THE BODY

STATES

ACTIONS

T H E   B O D Y

## Man

In Judeo-Christian cultures the first man, ADAM, was made in the image of God. In one of the most popular Chinese creation myths (CREATOR GODS), a dead male body may have been the source of the world: that of the first, semi-divine man, Pan Gu; or that of the GIANT Ymir, whose body formed the earth in the Norse myths.

Chinese physicians see the human body as a MICROCOSM of the universe (as did Western Kabbalists). Man is imbued with the active, strong YANG principle, which corresponds with HEAVEN and the SUN. The glyph illustrated above, used in science to represent the male, is the ancient classical symbol for the planet MARS. In Western alchemy, man represents the male principle and SULPHUR.

Most cultures that depict the human form directly tend to create idealized images (for example, the Greek *kouroi*). For the Baule peoples of central Côte d'Ivoire, carvings of men are made for women to represent the male SPIRIT from the Otherworld who is their perfect partner.

## Woman

In many cultures woman is the Great MOTHER, linked with the EARTH. The glyph shown above, used in science for the female, is the Ancient Greek and Roman symbol for the planet VENUS. Yet woman's position tends to be secondary to MAN's, reflecting the dominance of patriarchal societies. In Maori mythology the first gods were all male; EVE was created from Adam's rib, not moulded directly by God.

This secondary position means that women often symbolically bear life's woes and sufferings – for example, in depictions of the grieving VIRGIN MARY. This negative conception is reflected in the Chinese YIN principle, which is passive, weak, and linked with the earth and MOON. Maori women by contrast exert magic over suffering and drive out evil and sickness.

Menstruation has widespread negative associations. It is thought to be unclean and is sometimes used to bar women from entering sacred places, yet it is also related to fertility, creative power and shamanesses and priestesses.

## Hermaphrodite

The word derives from the Greek Hermaphroditus, the child of HERMES and APHRODITE, who was drowned in a lake by an over-amorous nymph who desired never to part with him; the couple were fused into one.

Hermaphroditism symbolizes the state of perfect wholeness that existed before the division of the sexes. In Ancient Egypt many CREATOR GODS, for example NUN and PTAH, had male and female attributes. Western alchemists sometimes describe the hermaphrodite, born out of the union of Sol and Luna, as being ADAM and EVE conjoined before they were parted, as depicted in the illustration above. For the Gnostics, hermaphroditism represented a state free from desire and original sin.

Certain West African KINGS are portrayed with hermaphroditic features, such as BREASTS, indicating royal dualism and fertility. Some African diviners and SHAMANS cross-dress to emphasize their supernatural status and thus their ability to control nature.

## Spirit

The spirit differs from the SOUL in that all things, inanimate as well as animate, are said to possess a spirit. In ancient animistic belief systems such as Shinto (Japanese), objects such as trees and ROCKS are held to possess a spirit. The Maori believe that all people and things have a spirit (*wairua*) as well as a life force (*mauri*), which is a power bestowed by the gods.

Spirits may be good or evil and need to be propitiated to prevent them from harming the living. In Hawaii, family or personal gods called *aumakua* may be destructive if neglected, while several Native American tribes believe that spirits appear in people's dreams, bringing messages or protection. Certain rituals, for example, some African tribal masquerades and Native American spirit journeys (associated with SHAMANS), are a way in which participants can communicate with the spirit world.

In Christianity the Holy Spirit is the third part of the Holy TRINITY, depicted as a DOVE (above), and is associated with the FEMALE wisdom of God.

## Soul

Many cultures assert that an individual has more than one soul. In Ancient Egypt, the *ka* was a sort of double of the person and the *ba* was the soul or astral body (above), while the *ab* or mind included memories. In China, the *po* gives life to an individual and dissipates after DEATH, and the *hun* is responsible for the character of that person.

In Judaism, *neshamah* is the divine soul that makes man in God's image, *nefesh* is the animal soul, and *ruach* is the WIND or SPIRIT. These THREE aspects prefigure the Christian TRINITY. However, Christians believe in only one soul, which survives DEATH and is reunited with the body at the resurrection of the dead. Although reincarnation of the soul is an idea associated principally with Asian religions, some Middle Eastern religions (for example, Ancient Greek Orphism, Kabbalism and Hasidic Judaism) and heretical Christian sects (notably Manicheism and Gnosticism) also held, or hold, this belief.

## Chakras

Chakras, from the Sanskrit *cakra*, are points in the body where psychic energy can be tapped. The illustration shows the seven chakras aligned along the central meridian, which rises from its root in the sexual organs to a point just above the crown of the HEAD. They represent a centre for the supply and distribution of psychic energy in the physical being. Hindus and Buddhists accord great importance to the chakras and their role in bridging the divide between physical and psychic energy fields. Their significance lies in the power (for good and evil) this role confers on individuals. Hindu and Buddhist philosophies describe contests between benign and malign deities who tap into psychic energy.

A chakra is also a WHEEL, a disc or a discus. It is akin to the SOLAR symbol, representing power; a warrior; a cutting weapon; or the solar disc, symbol of completeness. The chakra is associated with the Hindu god VISHNU. In Buddhism the *dharmachakra* symbolizes the WHEEL of the Law.

THE BODY

**149**

THE BODY

## Four Humours

Followers of the Ancient Greek physician Hippocrates (469–399 BC) theorized that FOUR bodily vapours or 'humours', each related to one of the four elements and symbolized by its colour, regulate health, character and temperament. The idea of balancing the humours to ward off disease and restore mental equilibrium became central to Western medieval medicine. Physicians prescribed medicines with this in mind.

✴ BLOOD (colour: RED): hot and moist, associated with AIR and a sanguine temperament (amorous, happy, generous and optimistic).

✴ YELLOW bile: hot and dry, associated with FIRE and a choleric temperament (violent, angry, unreasonable, vengeful (above).

✴ Phlegm (colour: GREEN): cold and moist, associated with WATER and a phlegmatic temperament (slow, dull and cowardly).

✴ BLACK bile: cold and dry, related to EARTH and associated with a MELANCHOLY temperament (gluttonous, lazy, sentimental, pensive and depressive).

## Qi

Traditional Chinese medicine is based on the belief that every living thing is composed of fundamental energy, called qi. Through YIN AND YANG, qi is transformed into the FIVE elements (*wuxing*): FIRE, WATER, METAL, WOOD and EARTH. In Daoist internal alchemy, traditional medicine, and acupuncture, qi is the body's vital force found in the BREATH and the body fluids. Blockages in the flow of qi along meridians (above) cause ill-health.

## Breath

Breath is linked with power and the animating SPIRITS, whose breath set the WINDS and planets in motion. In Native American tradition, power may be passed between people through the breath. The Celtic NINE MAIDENS fanned the CAULDRON of inspiration with their breath.

## Left and Right

In many cultures the dominant right hand carries weapons and symbolizes strength, while the subordinate left hand brings ill-fortune. This is the origin of the word 'sinister', from the Latin word for 'left'.

In Judaism and Christianity the right side of the body represents the first stage of Creation, daytime, consciousness, ADAM, MAN, and active power. The left represents the second stage of Creation, EARTH matter, night, EVE, WOMAN and receptivity. In alchemy the right and left hands reflect conscious and subconscious actions, the active and the passive. Right symbolizes SOLAR and left LUNAR.

These concepts are reversed in traditional Chinese beliefs: the left hand is YANG (MALE), and the right is YIN (FEMALE). When an emperor faced SOUTH to receive homage from his subjects, the sun was on his left, which was therefore the superior side. In Japanese Shintoism, the ropes (SHIMENAWA) that demarcate a sacred place are twisted to the left because it is considered to be the lucky side.

A

B

C

# Blood

Blood is associated with life force in many cultures and in the Hebrew Bible it is equated with life itself. In Imperial China fresh blood embodied the SOUL, and so blood was smeared on the images of deities to bring them to life or 'give them a soul'. In West African Voudon and in Voodoo CHICKEN's blood is smeared with a mixture of other powerful substances over sacred statues to activate them, or bring them to life.

In Maya culture, blood was the most valuable commodity. The illustration A above is a stylized Maya image of a ritual beheading. Bloodletting (B) was a way to express piety, affirm rulership and to call the gods into attendance.

In early Judaism the blood of animals (particularly GOATS and OXEN) was held to be sacred and was sprinkled on ALTARS to purify them. Norsemen are said to have activated their sacred runes by smearing them with ox blood; and in the Ancient Roman MITHRAIC ceremony of the *taurobolium* initiates were covered with the blood of a sacrificed BULL – one of

the most important of all sacrificial animals (C), whose blood was believed to have magical powers.

In Christian belief the normal functions and roles of religious sacrifices are reversed, so that God (in the form of CHRIST) sacrifices himself, and his blood (in the form of WINE) is drunk by the faithful so that they may receive the gift of everlasting life. In some representations of the crucifixion Christ's blood drips into the mouth of ADAM'S SKULL, buried at the foot of the CROSS, symbolizing the redemption of the first sin by Christ's sacrifice. It is the blood of Christ that gives the Holy GRAIL (or San Greal, 'Holy Grail/Royal Blood') its significance and importance.

Blood has been the traditional way of sealing sacred oaths in many cultures. Fourteenth-century Japanese WARRIORS stamped their fingerprints in blood to confirm contracts. Members of Chinese secret societies mixed their blood to confirm allegiance to each other. In the West, the term 'blood brothers' describes a relationship confirmed by mixing blood.

Although it is sacred, blood also has the power to contaminate. Kosher or halal meat, eaten by Jews and Muslims, must not contain blood. In many cultures the blood from childbirth or menstruation is regarded as unclean. In Shinto even the word for blood, *chi*, is taboo.

The blood of the living earth has been symbolized by WATER in many cultures. In Nordic culture the RIVERS and SEAS were believed to have been created from the blood of the GIANT Ymir, from whose body the earth was made. Likewise, traditional Chinese physicians link blood with RAIN in the system of correspondences between the human body and the universe. In Ancient Egypt the waters of the FLOODING Nile, RED with silt, were associated with menstruation, fertility and the rebirth of the land.

THE BODY

### Skeleton

Skeletons have been symbols of DEATH in Europe since the late Middle Ages: a prime example is the common medieval allegory called the DANSE macabre, in which skeletons and all ranks of humanity are shown DANCING around each other, indicating that death was no respecter of position, age or gender. By the 17th century a skeleton dressed in a hooded robe and holding a SCYTHE personified DEATH. The skeleton has the same meaning in alchemical imagery of the time, although when shown lying like a corpse it also represents a stage of putrefaction.

The Mexican Día de los Muertos or 'Day of the Dead' (2 November), which is related to the Western festivals of Halloween, All Saints and All Souls (31 October, 1 November and 2 November), marks the point in the year at which the SOULS of the dead are released to join the living. It is associated with colourful images of skeletons dressed up as though they were alive, FEASTING and food prepared in the form of skeletons.

### Fat

In societies prone to crop failure, fat is a sign of health and wellbeing and is associated with fertility (for example, HAPY). Central Australian Aborigines believe that fat protects the body against evil SPIRITS.

Fat is related to humour and merriment: the fat figure of Carnival (above) contrasts with the FASTING Lent, and the MAITREYA BUDDHA is shown baring his large STOMACH and laughing.

### Spittle

Spittle is associated with regeneration. Ancient Egyptians believed that ATUM's spittle was used to create SHU and TEFNUT. The Norse gods' spittle created the sage Kvasir.

In religious practices originating in Africa, gin sprayed from the mouth awakens spiritual power in humans and objects.

### Halo ✳ Nimbus

A halo (or nimbus) is usually a CIRCULAR area of LIGHT behind the heads of a being, and indicates divine power. Related to the Ancient Egyptian SUN-disc, haloes were first depicted around deities associated with the SUN, such as the Zoroastrian god AHURA MAZDA. The sun-rayed crowns of Ancient Roman deities, such as APOLLO and MITHRAS, are variations.

From Rome haloes spread to early Christian art. At first they were restricted to God, CHRIST and the ANGELS, but later they were used for SAINTS. Chris with a CRUC God and the SPIRIT have which repres Living peopl distinguished

In Buddhis (above), haloes are associated with the concept of an aura (prabha), the supernatural power inherent in all people and all things.

## Head

The Maori consider the head to be the most sacred part of the body. In Daoist systems of inner alchemy the head is the most important of three 'crucibles' within the body: the STAR god, Shou Lao, is depicted with an elongated head because of all the energy he has accumulated there.

In some tribal cultures in Benin in West Africa, ALTARS made to the heads of leaders are associated with knowledge, character, judgment and hereditary leadership. An artefact from Benin is illustrated above. A cult of the sacred head in Celtic times was illustrated by numerous legends, such as that of BRÂN, whose severed head guards Britain.

Decapitating one's enemy destroys and humiliates the individual; this is illustrated in the Judeo-Christian tradition by stories such as David and Goliath and Judith and Holofernes. Alternatively, the Hindu goddess DURGA is often depicted holding her own decapitated head – symbolic of DEATH and of the release of life-generating BLOOD.

## Skull

Associated with the cult of the HEAD, skulls kept over the THRESHOLDS of Celtic tribal huts were probably thought of as guardians. Some tribes in Congo, Cameroon and Gabon venerate the skulls of their most important ANCESTORS, as they believe that a person's vital force resides there.

For the Maya, skulls signified conquest and the capture and sacrifice of prisoners, as well as DEATH (above). Gruesome stone skull-racks adorned ceremonial buildings and BALL-courts.

Skulls worn as jewelry by Hindu and Tibetan Buddhist deities – for example Chamunda, KALI and Padamasambhava – symbolize their destructive aspects.

From the Middle Ages in the West, skulls acted as *memento mori*, reminders that time passes rapidly, life is not endless, and earthly things are transient. They appeared on funerary monuments, in still-life paintings, and were held in representations of SAINTS. The skull and crossbones now symbolize the danger of death.

## Tears

Tears are associated with mourning. In Greco-Roman and Middle Eastern cultures, an open show of grief was expected at funerals. Professional mourners were sometimes hired to show proper respect for the dead.

Tears can also be creative. In Ancient Egypt, humanity was said to have sprung from the tears of NEFERTUM, and the tears shed by the Japanese deity IZANAGI became Nakisahame no Mikoto (Crying-Weeping-FEMALE Deity).

Tears are associated with JEWELS. A traditional Chinese tale tells of a MAN-FISH who pays a shopkeeper with a basin full of tears, which then turn into PEARLS. The tears of the Nordic deity FREYJA were drops of GOLD.

The Trail of Tears marks the route along which 14,000 people of the Cherokee nation were forcibly marched from their homeland in the south-east United States to Indian Territory (now Oklahoma) in autumn and winter 1838–39; 4,000 died along the way. 'Apache tears' are nodules of OBSIDIAN found along this trail.

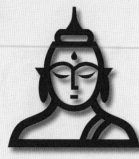
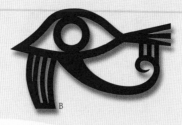
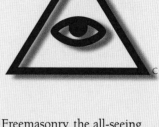

A B C

## Eye

The eye's ability to see reaches beyond the physical to the SOUL and the SPIRIT. Thus the Norse god ODIN's sacrifice of an eye as he hung on the world tree YGGDRASIL enabled him to divine using runes.

The Hindu god SHIVA and the BUDDHA are both depicted with a THIRD eye (A) in the centre of the forehead. This is the eye of inner or higher perception, and is generally closed and directed inwards in meditation.

For Bering Straits Alaskans, closing or covering the eyes is believed to enhance supernatural vision. Native Americans also restrict visual and social contact before a 'vision-quest' or other personal ceremony in order to improve their spiritual sight.

Conversely an icon of the Russian Orthodox Church depicts the legend in which Christ slept on the road to Jerusalem with his eyes open, which symbolizes his state of total awareness.

The gaze of the eye also implies magical power. For some Native American tribes, to 'exchange' eyes with an animal – seeing as it sees, as if through its eyes – is to take on that animal's particular attributes or 'medicine' – its spiritual power, which can be used for healing and for other magical and spiritual actions. In Hinduism, being seen by a holy person or by the image of a deity in a temple is also thought to confer luck or protection upon the devotee, but being seen by a malign spirit or deity is supposed to bring bad luck; children, in particular, are thought to be vulnerable to this influence. In the Middle East, BLUE AMULETS, often in the shape of an eye (such as the blue stone in the middle of a god, a HAND shaped amulet), have been worn for millennia to protect their wearers against the 'evil eye'.

Similarly, in Ancient Egyptian mythology the eye served a healing and protective function: the Wadjet or eye of HORUS (B) became the Ureaus or FIRE-spitting SERPENT that protected RA and the pharaoh. In Hinduism SHIVA's third eye heralds destruction and incinerates everything in front of it when it is opened.

In Freemasonry, the all-seeing eye, depicted within a TRIANGLE or – as on the back of a US dollar bill – inside a pyramid (C) demonstrates the watchfulness of God, and his eternal justice.

In Hinduism the eye is thought to be the last sensory organ to develop, and a person is not thought to be complete until this happens. Hence, in painting and sculpture the eyes are the last part to be made, usually after an eye-opening ceremony is performed. Similar eye-opening rituals are performed by Daoist priests to invoke deities that take up residence in WOODEN statues. In Russian Orthodox Christianity the eyes of an icon are often painted last because they cause the image to become empowered. Iconoclasts often scratch out the eyes of images with the intention of disempowering them.

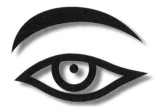

T H E   B O D Y

## Eyebrow

Japanese women traditionally shaved their eyebrows and painted in perfectly shaped replacements to indicate that they had come of age. Several *luohan* (worthies) in Chinese Buddhism are depicted with incredibly long eyebrows that reach to the ground, perhaps as a sign of old age and wisdom.

## Ear

The ears of Ancient Egyptian gods symbolized the receptivity of the deities to their worshippers' prayers. In some Orthodox Christian depictions saints have large ears, indicating their receptivity to the word of God. The BUDDHA's large ear-lobes, naked of the heavy earrings he wore as a prince (above), symbolize his renunciation of wealth.

## Nose

In Maori culture, the pressing together of noses (above) symbolizes the gods BREATHING life into humans. It is also a sign of peace, alluding to the harmony that existed between the EARTH and the SKY before their separation.

The Japanese point to the nose instead of the HEART to indicate themselves. Boastful people are said to have long noses, like the TENGU.

## Teeth

Sharp teeth are associated with Otherworldly savagery. In Japan, DEMONS and EMMA-O, Lord of the UNDERWORLD are depicted with the protruding teeth of carnivores. Teeth symbolize the destructive aspects of Hindu deities such as KALI. In African sculptures they indicate the figures' terrifying power (illustrated above). By contrast the EIGHT IMMORTALS of Chinese Daoism had perfect teeth.

## Mouth

In Cameroon, open mouths on statues suggest royal speech, or BREATH and song. In Ancient Egypt the mouths of the deceased were ceremonially opened during mummification with METAL ADZES in order to enable them to eat, drink and breathe in the Otherworld. A similar rite was enacted on divine images in order to instil the god inside them.

In China at New Year, people smear the mouth of CAOZHUN, the kitchen god, in their homes with HONEY, in order to sweeten his report on the household to other deities.

The Hebrew word for mouth, *peh*, symbolizes the Word made flesh. Substance and SPIRIT are bound up in this word, as the mouth is the part of the body that both eats and speaks.

Christians have envisaged the entrance to HELL as being a gigantic fanged DEMON's mouth (above) – it was probably intended to be the Biblical LEVIATHAN (a sea monster).

### Tongue

The tongue often represents ferocity: in India, tongues (above) are only revealed by fierce personages – hence DEMONS and the bloodthirsty goddess KALI have lolling tongues. In Japanese folklore tongues are associated with ghosts such as the Mikoshi Nyudo, a bald-headed SPIRIT who appeared over the tops of screens to frighten people.

Lolling tongues are found on Ancient Chinese sculpted tomb-guardians, which were created to frighten away evil spirits. Throughout the Pacific and Asia, the out-thrust tongue is a magical protector. In Maori culture it is both protective and defiant. In Tibet, on the other hand, sticking out the tongue is seen as an amiable greeting.

The tongue is also associated with speech. Native American Tinglit SHAMANS sought to be given the 'gift of the tongue' of animal helpers in order to search for spirit helpers (*yeks*).

### Hair

Through history hairstyles have been signifiers of racial difference (Rastafarian dreadlocks, for example, grown as a contrast to the hair of the white races) and social status (the side-lock of the Ancient Egyptian deity HORUS denoted youth). Hair embodies MALE strength and spirituality: by cutting Samson's hair, Delilah stripped him of his strength. Sikhs do not cut their hair and Hasidic Jewish men grow ringlets in front of their ears (above).

Cutting one's hair may signal the renunciation of earthly concerns and vanity: Buddhist and Christian monks shaved their heads as they entered religious life. It is also a punishment and can symbolize imprisonment or atonement.

Orthodox Ashkenazi Jewish women shave off their hair on marriage. In many cultures married women's hair is covered. The uncovering of a woman's hair is often explicitly sexual. In Biblical times adulterous women would have their hair uncovered publicly by priests.

### Topknot

To Hindus, Jains and Buddhists, the topknot or scalplock symbolizes the *ushnisha,* the Sanskrit term for the small protuberance at the top of the head, one of the twelve stigmata associated with holy people. Images of BUDDHA often have topknots, which are related to the spires on top of the traditional STUPA.

The maintenance of a single tuft of hair (*chuda*) through life is obligatory for Brahmins (who form the priestly caste of Hinduism). The tuft is believed to cover the area where the divine SPIRIT of BRAHMA enters the body at birth and leaves it at DEATH.

In Polynesia the topknot is associated with the discovery of New Zealand, which was dragged out of the SEA by a young demigod called Maui, the youngest of the goddess Taranga's five sons. Maui was so weak when he was born that Taranga threw him into the sea in disgust, wrapped only in the topknot (*tikitiki*) from her HAIR.

## Beard

Beards have long been associated with divinity, KINGship and MALE maturity. Ancient Assyrian reliefs depicted gods and kings with the longest, most luxurious beards. In Ancient Greek images, ZEUS, POSEIDON, philosophers and eminent elder statesmen were always bearded. The beard was also an important part of the pharaoh's regalia – even Queen Hatshepsut was depicted with a beard.

Jewish mysticism forbids the cutting of the corners of the beard, while Orthodox Christian priests are forbidden to shave their beards, which are sanctified by the traditional bearded image of CHRIST. Sikhs are identified by their beards which, like their HAIR, they are forbidden from cutting.

In Imperial China a beard symbolized bravery or supernatural power. Historical and mythological figures such as CONFUCIUS, LAOZI and Shouxing, the god of longevity, were depicted with beards. A RED or a PURPLE beard was a particular sign of special powers.

## Scalp

Some Native American tribes believe that the life and SPIRIT of a person resides in the HAIR, thus the scalp of a slain enemy was taken to capture the WARRIOR's soul. Other tribes tanned scalps and displayed them as trophies.

## Lungs

In traditional Chinese medicine, the lungs are considered to be the seat of righteousness and the location of inner thoughts, where the *po* or animal SOUL resides. They correspond to the CANOPY in the Buddhist group of the EIGHT TREASURES.

In Ancient Egypt, the lungs of a mummified body were placed in the CANOPIC JAR protected by HAPI. The image above represents upper and lower Egypt, through which the Nile runs.

## Heart

In Ancient Egypt the heart was believed to contain the mind and SOUL. Hence it was believed to be weighed against a FEATHER in the Halls of Judgment and was left in the mummy after a body was embalmed. In China it is thought to be the source of intelligence, where the *shen* or SPIRIT resides. In the Buddhist EIGHT TREASURES, the heart corresponds to the WHEEL of the Law.

In the West the heart is the site of the emotions, particularly love and desire; the Sacred Heart of Jesus CHRIST (surmounted by a FLAME and encircled by THORNS, above) represents Christ's desire to be loved by mankind, and his unending love and mercy. In Judaism, the heart is the seat of life, symbolizing unity and also the homeland.

Both the Maya and the Aztec killed CAPTIVES by removing their hearts, considering this a suitable SACRIFICE to affirm KINGSHIP, combining the BLOOD and death that the gods desired.

THE BODY

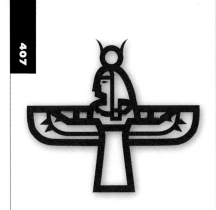

## Breast

Images of mother deities, such as Isis and the Virgin Mary, suckling a child symbolize motherhood and nourishment. In Western alchemy, a mother feeding a child represents the nurturing and feeding process.

Hera was sometimes depicted breast-feeding Herakles which made him immortal; the milk that spilled from her breast created the Milky Way.

In 14th-century Christian art, Charity is sometimes depicted as a woman breast-feeding two or more infants. Similarly, in a Chinese legend, Cui-she, a paragon of filial piety, breast-fed her toothless great-grandmother.

Male deities are occasionally depicted with breasts, such as Hapy, an Ancient Egyptian god symbolizing nourishment from the Nile. The Ancient Chinese believed that it was lucky for men to have a well-developed breast. In Judaism, men traditionally tore their clothes to reveal a breast as a sign of mourning for their parents.

## Arms

Upraised arms are often a sign of power or strength, especially the right arm. When Moses' arms were raised, the Israelites were victorious in battle; when they fell to his sides, they started to lose (Exodus 17: 12). In Ancient Egypt, different positions of the arms carried different meanings. For example, two upraised arms symbolized the *ka* (soul), a being's intellectual and spiritual power, which continued after death. In Judaism, arms also represent divine judgment: retribution is symbolized by God's (right) arm.

The many arms (four, six, eight or ten) given to most Hindu deities symbolize the complexity of their attributes: their arms are appendages that hold their emblems or distillations of power. Vishnu has four arms to carry his emblems, the conch, discus, lotus and mace, while the goddess Mahishasuramardini has ten arms with which to hold the various weapons bestowed upon her by different gods. In many cultures arms are raised in supplication or prayer.

## Wings

Wings symbolize the ability to fly and to travel between human and Otherworldly realms, and freedom from matter and mortality. They are often associated with deities (for example, the winged solar disc of the Mesopotamian Lord of the Heavens), and are signs of supernatural creatures (for example Tengu, the long-nosed tricksters of Japanese folklore).

Outspread wings may be a sign of protection, such as the wings of the Ancient Egyptian goddess Isis (above) and the Ancient Assyrian *apkallus*, spirits in the form of winged men, who were carved in pairs to protect doorways. Various Japanese and Chinese myths associated wings with supernatural foreigners, such as the Chinese Meng Xi people and the Japanese Umin.

Wings can also symbolize idealism, naivety and pride, for example in the story of Icarus. In Renaissance emblems, wings attached to objects indicated their supersensory intellectuality.

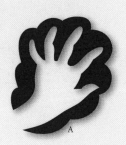
A

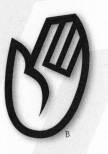
B

C

## Hand

The hand has been a symbol of active divine power for millennia. Hand prints (A) are often found alongside sacred rock paintings, such as those made by the Aborigines, who used them as a form of signature, representing the spiritual imprint of the artist.

In India, hand prints on walls, DOORS or objects are a form of protection. This relates to Hindu and Buddhist beliefs that the hand is a fragment and guardian of the *atman* (the universal SOUL), so hand prints reflect its attributes.

AMULETS in the form of a HAND, called *yod* in Hebrew and the 'Hand of Fatima' (the daughter of Muhammad) in Muslim cultures, are sacred and have been worn for protection in the Middle East for centuries. In Islam they symbolize the religion's FIVE tenets – profession of faith, prayer, pilgrimage, fasting and charity – each represented by one of the hand's five digits.

In Benin, ALTARS to the HEAD were complemented by altars to the hand, which is associated with particular actions and strategy, while the head represents destiny and inborn powers.

Hands have also symbolized divinity more directly. For example the Ancient Egyptian Aten or SUN-disc, worshipped in the time of the pharaoh Akhenaten (1353–36 BC), showed hands radiating out from the rays of the sun as a form of blessing. In Christian art a hand is also used to represent the blessing and intervention of God (B), so as to avoid depicting him directly. An upraised hand also signifies blessing more generally, and was a gesture commonly used by CHRIST, the SAINTS and members of the priesthood. The belief in the transmission of God's blessing through the hand is directly related to the imposition, or 'laying on of hands' used in blessing, healing and ordination, in which the hands are placed palms-down on the head.

A similar belief in the ability of the hand, and especially the fingers, to connect with divine power is found in India. Certain fingers, especially the thumb, are particularly powerful because they are also the location of one of the energy centres. The fingertips (*daiva*) are also thought to be divine as they conduct divine energy through the hand and into the body (C). It therefore follows that HAND GESTURES and hand positions (*mudras*) assume a major cultural and spiritual significance.

In Ancient Egypt, hands were also associated with the creative principle. AMUN, the primeval creator god, was said to be self-created and the hand symbolized the abstract means by which he masturbated himself into existence. (Later, his wife Amunet was said to be 'the hand of Amun'.) PTAH and KHNUM were both creator gods who used potter's wheels to create, and they were always depicted showing their hands when represented in the process of creation.

## Fingernails

Long fingernails are often a sign of wealth, as their owners clearly do not have to work. The belief is widespread that nail clippings can be used magically to damage or control the person they came from. Claw-like nails were attributes of the African Dahomey KINGS, and were signs of their powerful and Otherworldly status.

## Stomach

In Chinese alchemy and traditional medicine, the stomach is the seat of the will; it is pierced in Japanese ritual suicide or *seppuku* (*harakiri*). The Ancient Egyptian son of HORUS, DUAMUTEF guarded the CANOPIC JAR with the stomach of the deceased. Special herbs are placed in the stomachs of Central African *nkisi*, or 'power sculptures', to empower them.

## Liver

The Bamana of Mali view the liver as a connecting point between the SOUL and the body because of its role in making BLOOD, which represents the spiritual and the physical life force. It is therefore eaten after an animal is SACRIFICED. Likewise, the Chinese had a custom of eating the livers of those they had slain, because they symbolized the courage of the dead and the soldiers thereby ingested some of their valour. The Ancient Romans sacrificed animals for their livers, using them for *haruspicia*, or divination using entrails.

In Chinese alchemy and medicine the liver is said to be where the *hun* or SOUL resides. It corresponds to the LOTUS in the Buddhist group of the EIGHT TREASURES.

The liver was removed by the Ancient Egyptians during mummification and placed in a CANOPIC JAR protected by Imsety (The Kindly One), one of the FOUR SONS OF HORUS.

## Navel

In West Africa the navel reflects the concept of fertility and the promise of a young WOMAN'S future procreative role. It also reminds women of their ANCESTRAL mothers, reaching back to their Ancient Mother. These beliefs are embodied in prominent navels on statues, and SCARIFICATION marks (above) made around women's navels during puberty. In yoga, contemplation of one's navel also reaches back to one's ancestors, and ultimately to divinity.

Some of the sites held to be most sacred by various religions have been described as the 'world's navel': for example the Omphalos of Delphi, held sacred by the Ancient Greeks and represented by a carved STONE. Medieval Arabian geographers described Mecca, where Muhammad was born, as the 'navel of the world'. For the Jews it was Moria, where ABRAHAM took Isaac for SACRIFICE, at which site the Temple of Jerusalem was ultimately built.

## Vulva

The vulva is usually associated with MOTHER goddesses: in Hinduism the *yoni*, a vulva-shaped object which is often carved in conjunction with the *linga*(m) (see PHALLUS) symbolizes the goddess's womb and is an attribute of SHIVA's spouse.

In Ireland, carvings known as *Sheela na gig* (above) found on the walls of medieval religious buildings, depicted an almost BIRD-like hag with pendulous BREASTS, holding open her prominent vulva. These may have been pagan fertility icons, revealing our entry into life through the vulva, to be subsumed into the body of mother EARTH at our DEATH.

Daoist doctrines suggest that it is important for each individual to have a balance of YIN AND YANG within their bodies. It was believed that could be achieved through the exchange of yin and yang essences during SEXUAL INTERCOURSE. Vagina-shaped cups were used to administer 'yin' medicine to the sick as a substitute for the sexual act.

## Vagina Dentata

The *vagina dentata* (toothed vagina) symbolizes the dangerous side of female sexuality and procreation. Found in some Native American stories, it is sometimes possessed by the daughter of a creator, and it often falls to the TRICKSTER figure, COYOTE, to make her 'safe' for sex and reproduction – to 'make her a wife'. In a Paiute story, the Old Woman and her daughter sought out Coyote for this purpose. Understanding her need, Coyote gave the daughter an animal bone with which she broke the teeth out of her vagina, whereupon Coyote was able to have sex with her.

*Vaginae dentatae* were shown on some Pre-Columbian Peruvian Chavín deities of an otherwise androgynous nature, especially the important STAFF goddess. The symbolism of this deity is unclear, but it probably had associations with fertility.

## Phallus

In Hinduism the phallus is symbolized by the *linga*(m), associated with SHIVA. Often carved from STONE, it arises from a *yoni* or VULVA-shaped stone; together they symbolize fecundity and prosperity. Likewise, phallic-shaped objects were linked with fertility cults and worshipped in Ancient China. Konsei, the Japanese god of MARRIAGE, is portrayed in a phallic shape. Gods associated with fertility are sometimes depicted with an erect phallus – for example, the Norse FREYR, the Ancient Roman Priapus and the Ancient Egyptian MIN and AMUN. OSIRIS lost his phallus after his dismemberment; it was related to his life force and his ability to overcome DEATH.

Erect phalli are sometimes associated with humour. Many Native American animal TRICKSTER figures possess penises so large they sometimes have to be carried in packs. In classical antiquity, where they were ridiculed, SATYRS were portrayed with enormous erections, indicating their libidinous, uncouth nature.

T H E   B O D Y

**161**

THE BODY

### Intestines

One of the FOUR SONS OF
HORUS, Qebsennuef guarded the
intestines of the dead in CANOPIC
JARS. The Norse TRICKSTER LOKI
is sometimes shown hanging
upside-down, bound by the
intestines of his son Narvi and
poisoned by a SNAKE's venom,
the gods' punishment for the
death of BALDER.

### Thigh

The FISHER KING's wounded thigh
and LAMENESS symbolized sexual
impotence. Tibetan Buddhists made
TRUMPETS from human thigh bones
to call up the SPIRITS. Powers were
attributed to BULLS' thigh bones
when used as SACRIFICIAL offerings
in Ancient Egypt. In hieroglyphics,
a bull's thigh denoted the human
ARM, suggesting strength.

### Blindness

Blindness is often used
metaphorically, to denote an
inability to perceive spiritual and
moral truth; thus, some Christian
legends hold that Jews were
present at the BAPTISM of CHRIST,
but did not notice the event
because they were spiritually
blind. Conversely, justice is
depicted as blind because she is
never swayed by appearances.

Blindness can indicate wisdom:
Saul (ST PAUL, above) was blinded
on the road to Damascus, after
which he converted to Christianity;
the Norse god ODIN was blinded
in one eye while he hung on the
World Tree, YGGDRASIL, and gained
insight into runes; in Ancient
Greek myth, Tiresias was struck
blind by HERA or ATHENA, and
received the gift of prophecy from
ZEUS or Athena in compensation.

The blind harpist was a
common phenomenon in Celtic
lands: it was believed that
blindness increased musical
ability, and inspired musicians
who entertained either important
patrons or the royal household
were greatly honoured.

### Footprint

Footprints are particularly
important in the Vedic, Vaishnavite
(Hindu worship of VISHNU) and
Buddhist traditions. The FOOT,
when in direct contact with the
bare EARTH, is believed to draw
energy from it as a root does from
the soil. The footprint of a holy
person or a deity is greatly
venerated as the unique 'SEAL' or
image of that person, and is thus
seen as a representation of them,
together with all their qualities
and attributes. The mosque of the
DOME of the ROCK in Jerusalem is
built around the rock from which
Muhammad ascended to HEAVEN,
leaving his footprint upon it.

Copies of the footprint of the
first (Gautama) BUDDHA are
carved in stone at Buddhist
temples throughout India, China
and Japan; they often contain
auspicious Buddhist symbols,
for example WHEELS symbolizing
the Buddha's law (above).

Many Celtic folk tales stressed
the importance of the footprint in
relation to the goddess, who was
described as leaving flowers or
WHITE trefoils in her footsteps.

## Shadow

Shadows are insubstantial reflections of their physical counterparts. In Ancient Egypt, the shadow (*khaibit*) was the SOUL of the physical body. Some Native Americans called photographers 'shadow catchers'; seeing black-and-white photographs as shadows, they feared that their SPIRITS (shadows) would be caught for all time.

Shadows are often associated with the dead. In Judaism, Sheol (Shadow) is the dwelling place of the dead, and in antiquity the inhabitants of the UNDERWORLD were imagined as shadows.

The lack of a shadow is unnatural, and identified immortals and spirits of the dead in China. In the WEST, the lack of a shadow identified the evil, the DEVIL and vampires.

Associated with darkness, the shadow is the opposite of LIGHT. At the end of the Work, the alchemist is surrounded by a HALO with a shadow like a SOLAR ECLIPSE, which symbolizes the darkness of DEATH and the rebirth of the light.

## Foot

CHRIST washed the feet of his disciples on Maundy Thursday (the day before Good Friday) as a sign of humility; hence washing another's feet shows humility and homage, particularly when performed by the powerful.

In the Fon Republic of Benin, the war- and SMITH god GU is depicted with large feet, symbolizing his ability to trample on and destroy his enemies.

## Stigmata

The five wounds received by CHRIST at the PASSION: four from NAILS (two in his HANDS, two in his FEET) and one in his side from Longinus' SPEAR. They may be transferred to Christians, mostly women, as a symbol of mystical identification with Christ. ST FRANCIS became the first to receive the stigmata, in the 13th century.

## Lameness

The Greco-Roman god HEPHAESTUS (above) was depicted as lame, his physical imperfection corresponding to his relatively lowly role of heavenly artisan, SMITHing metal and creating practical (but magical) objects for his fellow deities. In alchemical illustrations, the god SATURN is also shown with an artificial leg.

Lameness is sometimes associated with healing deities: one of the Daoist EIGHT IMMORTALS, Li Tie-guai, is depicted as a lame man with a CRUTCH and a GOURD of magic medicine that can bring the dead back to life. He is venerated as a tutelary deity by Chinese doctors of herbal medicine. Similarly Asclepius/Aesculapius, the Greco-Roman god of healing, was sometimes shown using his SNAKE-entwined STAFF as a crutch.

Such physical imperfection was considered unclean in Judaism, barring sufferers from the priesthood; although the disabled could be blessed, they could not approach the ALTAR.

THE BODY · STATES

## Sleep

Great Celtic heroes were frequently described as sleeping, awaiting a time of need when they would be reawakened. These sleepers in the LAND may originally have been buried or drowned SACRIFICIAL victims.

In China, the human SPIRIT was believed to leave the body for a while during sleep; in Japan, people's spirits were thought to enter their pillows, so there are still superstitions about stepping over or throwing pillows.

Sleep is also a time of defencelessness: in China, it was believed that DRAGONS could be killed and people tricked when they were asleep. European folk tales contain similar stories of GIANTS and other seemingly unassailable enemies being overcome as they slept. It is also dangerous to sleep in forests or on MOUNDS associated with FAIRIES, who might abduct the defenceless sleeper. In much European literature, sleep is used as a metaphor for DEATH.

## Dreaming

Dreaming allows humans to contact and communicate with the Otherworld; in European folklore dreams were the means by which one could reach the world of the FAIRIES.

Jews traditionally believed that dreams were divine communications; they could be instructions, prophecies or answers to prayers. In China and Japan, dreams were a means of divining the future.

In Ancient Greece and Rome, HERMES, as psychopomp (guider of the SOULS of the dead), led the dead or the dreamer through the dream-state. The Greco-Roman god of healing, Asclepius/Aesculapius, was associated with dreams showing sick people how to heal themselves.

The Dreamings of the Australian Aborigines (as depicted in bark and rock paintings, above) represent the totality of all stories, myths and legends. SHAMANIC practices include dreaming: a shaman will deliberately set out to have a dream or vision of the Otherworld to gain knowledge of the spiritual side of the world around them.

## Melancholia

Melancholia is a state caused by an imbalance in the FOUR HUMOURS. The famous print *Melancholia* (1514) by Albrecht Dürer (1471–1528) – which shows a winged woman lost in contemplation and surrounded by various symbols of mathematics, astrology and religion – has been related to the supposed dispositions of the emerging humanist thinkers. In the 16th century it became fashionable for young men to be shown in contemplative, melancholic poses, typified by folded ARMS and downcast gazes, supposedly resulting from philosophical and romantic trains of thought.

Melancholia or a state of depression is often referred to in alchemy. This primarily occurs during the blackening or NEGRIDO stage associated with the planet SATURN. At other stages melancholia can indicate a period of brooding gestation, a loss of spirit or the state of the *anima*/SOUL after conjunction.

S T A T E S

## Caste Symbols

Hindus use caste marks (*pundra*) to denote an individual's devotion to a particular deity, or adherence to a particular doctrine within the broad pantheon of Hinduism. They may consist of lines, CIRCLES, dots, rectangles or TRIANGLES, depending on the sect. They are normally applied to the forehead (above), but can be applied to almost any part of the body depending on the level of devotion. They can also be made permanent – as with many *sadhus* (ascetics and holy men) – by branding. These symbols often reflect a devotion to just one attribute of a deity, and so express adherence to that aspect alone. For example, the CONCH SHELL, the discus, the MACE, the LOTUS and so on are each held in one of the Hindu god GANESH's hands, and each represents a different quality of that deity.

## Tattoo ✳ Scarification

In the South Pacific islands, tattooing (from the Polynesian word 'tattoo') is a MALE rite of passage indicating honour, courage and manhood. Intricate spiral tattoos symbolizing life are commonplace in Maori culture (above); they were believed to have been lifted by SPIRITS from the faces of the dead.

In Africa, painting, tattooing and scarification are often used to mark bodies in patterns that match those on objects which have religious and tribal significance.

There are accounts of tattoos in Ancient China and Japan differentiating between social groups and classes. Today, Japanese gangsters (*yakuza*) wear tattoos as signs of allegiance. Designs related to Buddhist deities or lucky symbols are also chosen to bring the wearers good fortune, health and other benefits.

Among Hawaiians, tattoos on the forehead are signs of slavery, and the tattooed registration numbers of concentration camp survivors have come to symbolize the Jewish Holocaust.

## Silence

For followers of Neoplatonism, silence symbolized the ineffability of God and the consummation of wisdom; they regarded silence as the highest form of understanding, and named the mathematician Pythagoras (*c.* 580–500 BC) 'the master of silence'.

The Blessed Silence is occasionally depicted in Orthodox Russian icons from the 16th century; represented as an ANGEL in a STAR, it is a mystical image, said to represent the SPIRIT of CHRIST before his birth.

In Hebrew, 'silence' means not only refraining from speech, but also ruin, subjection, destruction and DEATH, as in 'the silence of the grave'. It also represents personal communication with God, and silent prayers form part of services in the synagogue.

Ancient Egyptian images of the young god HORUS often show him holding a finger to his mouth (above), indicating a hidden secret and silence, because he grew up hidden away from SET in the marshes of the Nile Delta.

S T A T E S · A C T I O N S

### Circumcision

The ritual removal of the foreskin, practised by Jews and Muslims. It is compulsory for Jews, who believe that the PHALLUS is purified by circumcision, becoming an instrument of union on all planes because sexual longing is God-given. The custom dates from the time of ABRAHAM, and is performed at a boy's naming ceremony, confirming his covenant with God as a Jew.

CHRIST was circumcised eight days after his birth (Luke 2: 21), and the Feast of the Circumcision was celebrated from the 6th century onwards on 1 January, possibly in order to counteract pagan new year celebrations (a mass against idolatrous practices was also traditionally celebrated on that day). Christ's foreskin was venerated as a holy relic from at least the 12th century.

Female genital (clitoral) excision is practised widely in Central Africa, but more as a practical proof of VIRGINITY than as a spiritual act.

### Inebriation

The feasts associated with the cult of DIONYSUS led to inebriation, the means by which ecstatic communion with the god was achieved; hence SATYRS and Dionysus were often shown drunk. For Christians, drunkenness can symbolize religious ecstasy or mindless consciousness of the divine presence.

### Kneeling

Kneeling is a symbol of respect and humility. Female worshippers of the Yoruba god SHANGO are often sculpted kneeling, holding an object sacred to him. Genuflection (a momentary kneeling on, or bending of, the right knee) is practised by some Catholics as they pass in front of the sacraments, humbly acknowledging God's presence.

### Shape-shifting

Celtic heroes and gods (such as TALIESIN and MERLIN) often took on the forms of different animals, perhaps representing the stages of initiation. There were myths in which WITCHES, DRUIDS or SHAMANS changed their physical shape to assume the abilities and behavioural characteristics of the animals they became. To do this, a person had to be prepared to surrender themselves totally to the creature's character, but must also have a sufficiently strong sense of their own self to ensure a safe return from the experience.

TRICKSTERS are often shape-shifters. The Japanese *tanuki* (racoon dog/BADGER) transforms itself in order to repay human kindness: in one story, a *tanuki* transformed itself into such things as tea-kettles and prostitutes, useful commodities that could be sold by those who had freed it from traps. The Nordic trickster LOKI transformed himself into a flea, a FLY, a BIRD and a SALMON in order to escape his adversaries, including the gods themselves.

## Posture

In India, *angika*, 'poses of the body', form a stylized means of communication, with meanings suggested by the arrangement of limbs, facial expression, movement and stance.
These postures are particularly important in ritual and meditative practice, and in DANCE, drama and sculpture.

In a spiritual sense, arranging the body in a certain way 'communicates' with the divine, and the power of cosmic energy is channelled through it; SEVEN recognized postures are supposed to achieve this. The choice of posture, and its consequences, therefore has an occult dimension. Associated with this are the positions of yoga, generally known by their Sanskrit name of *asana*, which relates to the disposition of the lower limbs. The word also means 'pedestal', and hence the LOTUS position or *padmasana* (also called *dhyanasana*) is associated with the lotus pedestal on which many deities, such as the BUDDHA, are shown sitting. The pose is achieved by sitting with both LEGS crossed with the underside of the FEET facing upwards (A).

Another common posture is the *rajalilasana*, or 'posture of royal ease/relaxation' (B), in which both legs are bent, one lying flat against the floor and the other with the knee raised, and the weight of the upper body is supported by one ARM, the other being bent across the knee of the upright leg. This is typical of certain East Asian BODHISATTVAS in their princely form, as it is seen as an informal but regal position.

The pensive posture, in which the chin rests in one hand while the arm is supported by the elbow resting on the leg, is associated with AVALOKITESHVARA and sometimes MAITREYA. It also occurs in Western art, where it is also associated with thought.

Standardized postures were used over centuries in Ancient Egyptian art. For example, the posture of the enthroned pharaoh, seated with his legs together and back upright while holding a CROOK and FLAIL crossed in front of him (C), symbolizes the position held by OSIRIS as ruler over the two lands of Egypt. ISIS and NEPTHYS are often depicted with their WINGED arms outstretched over a mummy, in protection; the posture is also adopted by the CHERUBIM (or the SHEKHINAH, the Jewish divine presence) depicted over the ARK OF THE COVENANT.

An upright posture expressed the dignity of the monarch in the Ancient Near East, a tradition continued by the emperors of late Imperial Rome: the arrival of Constantius II (AD 317–61) in Rome in 357 was noteworthy because of his composure. He looked neither left nor right, and remained aloof as befitted a being who was situated halfway between mortality and divinity.

A

C

## Hand Gestures

Of all cultures, India has the most complex system of HAND gestures. The symbolic positioning of the hands (in Sanskrit *mudrika* or *mudra*) is used in religious ritual, DANCING and occult symbolism, and is common to most Indian religious traditions. Hand gestures are often depicted in sculpture and are particularly important in completing the symbolism of the image. It is thought that the symbolic position of the hand and its fingers draws down divine power, which can heal, wound or bless. Some gestures are considered too sacred to be seen and are hidden beneath robes.

In dancing alone there are thirty-two major hand positions, twelve hand movements, and twenty-four combined hand positions; there are thought to be, theoretically, at least eighty-eight billion (i.e. million millions) minor variations of these. Carried by Buddhism, these gestures spread throughout Asia, where their meanings became varied and were extended.

Some of the most common religious gestures are as follows.
* The right hand raised with palm outwards (*abhaya-mudra,* A): a symbol of protection. This is common to many traditions: when given to CHRIST or the SAINTS in Christian art it symbolizes blessing; in Maori culture it is a religious symbol called the *ringatou*. With the left hand placed on the HEART, a Bible or another sacred object, this sign has come to symbolize an oath, and is still used for that purpose in British courts of law.
* Both hands lying in the lap, palm-side up, the right over the left (*dhyana-mudra*): symbolizes meditation, and is often seen in statues showing BUDDHA in the LOTUS position.
* The right hand raised with thumb and forefinger touching (*vitarku-mudra,* B): teaching or disputation, commonly associated with the BODHISATTVAS.
* Both hands pointing upwards with palms together (*anjali-mudra*): a symbol of supplication and prayer for Hindus and also for Christians.

* The hand palm-side up, the forefinger pointing downwards and the thumb curled over it (*tarjani-mudra*): a threat.

There is a modest Christian system of hand gestures. TWO raised fingers (C) symbolize the two natures of CHRIST: divine and human; THREE raised fingers represent the TRINITY.

In parts of Africa, placing one's left hand, fingers closed, into the right is a symbol of deference.

In Europe, there is a whole vocabulary of gestures whose purpose is to insult or offend. Many originated as protective symbols, such as the *fica* (made by closing the hand into a fist, the thumb protruding between the second- and forefingers): said to symbolize SEXUAL INTERCOURSE, it was originally used to protect against the evil EYE.

During the Hundred Years War, the French would cut off the fore- and middle-fingers of captured English longbowmen, stopping them from drawing their bows; raising these two fingers became an insulting gesture of defiance.

## Bowing

The practice of bowing to one's superiors has all but died out in Europe; it survives largely in royal rituals, such as the State Opening of Parliament in the UK, during which the Lord Chancellor bowed while walking backwards away from the Queen until 1988. In Islam, the faithful bow and prostrate themselves in humble supplication of God's grace.

In China, the kowtow (*gedou*) was a formal way of bowing, which symbolized respect to a superior. Similarly, in Japan bowing is a mark of respect and accompanies greetings and expressions of thanks, apology, goodbyes, and many other forms of social interaction. One may bow standing, or from a kneeling position when indoors.

*Davening*, a Yiddish term for praying, which originated among Ashkenazi Jews, describes the bowing movements made by devout Jews while repeating the names of God. Jews, both men and women, can be seen *davening* at the Western (Wailing) Wall in Jerusalem every day.

## All Fours

In the Greco-Roman world, depicting a figure – such as a SATYR – on all fours indicated that its nature was closer to that of a beast than a human.

This debasement is manifest in the medieval legend of Aristotle and Phyllis (or Campaspe), which was often depicted in medieval and Renaissance art. Aristotle upbraided his pupil, the Emperor Alexander, for becoming distracted from his studies by the feminine charms of Phyllis. Piqued by the diminution in Alexander's attentions, Phyllis took revenge on the elderly philosopher, parading her charms before him. He soon became besotted with her, to the extent that he promised to don a saddle and BRIDLE and give her a ride in the orchard in return for her favours. In this way, the greatest philosopher succumbed to feminine wiles and was humiliated before his young pupil.

## Flying

Humans cannot fly naturally, so flight symbolizes the 'other': mythical beings such as FAIRIES and DRAGONS, or outsiders such as WITCHES who fly with magical assistance from BROOMSTICKS or special ointments.

BIRDS' FEATHERS were used to help humans to fly. FREYJA lent the TRICKSTER LOKI (who was also called the SKY TRAVELLER) her feathered cloak when he needed to fly.

WINGS also indicated the ability to fly and they were often attached to early gods, such as the Mesopotamian INANNA-ISHTAR and the Ancient Egyptian HORUS, who had the ability to transform into a FALCON. The messengers of the gods, such as IRIS, or ANGELS, can fly, symbolizing their swiftness.

In China, the ability to fly was associated with immortality; hence the Daoist EIGHT IMMORTALS were said to be able to levitate and fly. The word 'flying' was also associated with sexual pleasure.

The image depicts GARUDA, the deity who carries VISHNU.

A
C
T
I
O
N
S

## Dancing

In many religions ritual dancing is an outward form of ecstasy: for example, Sufi whirling dervishes (Islam); DIONYSIAN or Bacchic dances in classical antiquity (above); and African masquerade dances, through which the initiates reach trance states that enable them to be possessed by SPIRITS or divinities.

For Hindus, Shiva depicted in a WHEEL of FLAMES as the Nataraja (Lord of the Dance) symbolizes the cyclical dance of destruction and renewal of the universe. In China, dances such as the LION dances performed at New Year are believed to ward off evil SPIRITS. In the West, Round dances, like the English morris, are traditionally danced to help the SUN on its path through the HEAVENS.

Dancing has long been associated with Jewish religious celebrations and is still a form of worship for Hasidic men. Dance is also very important in Maori culture. The traditional *haka* is performed to express displeasure, but it can also be used to recount great exploits or to welcome honoured guests.

## Anointing

Anointing usually signifies the crossing of a symbolic threshold and a change of status. It is common to most Indian religious traditions (above), and involves the use of 'wet' elements (WATER, OIL, MILK, BLOOD and so on) to mark events such as the consecration of a priest, a coronation, or the inauguration of a project. For Christians it is a sign of sanctification, usually performed with holy water (for example, BAPTISM) or oil (for example, death, ordination or coronation). In Britain, the practice of anointing young hunters with the blood of their first kill signals their initiation into the HUNTING community.

For Jews, anointing signifies divine blessing, usually of a priest or KING ('Messiah' means 'anointed one'), and was originally one of their principal methods of healing. In Egyptian religious practice, anointing was used as a form of purification of shrine statues and human bodies, alive and dead.

## Baptism

A Christian naming and initiation ceremony involving ANOINTING with WATER in the name of the TRINITY to erase original sin; it was instituted when CHRIST was baptized by JOHN THE BAPTIST, symbolizing rebirth. A type of baptism in a sacred pool or WELL was also part of Celtic naming ceremonies.

## Singing

Singing can move the emotions: the SIRENS' song, for example, was enchanting and seductive. Song is important in religious ceremonies. In a synagogue the quality of the cantor's voice is more important than his piety. Christian ANGELS are often shown singing, notably in medieval and Renaissance art. They are reflected by church choirs singing in praise of God.

## Bathing

Bathing is often associated with ritual purification. It is central to most Indian traditions, usually taking place before praying, FASTING or starting an important venture. Worshippers at Shinto shrines in Japan wash their HANDS and MOUTHS as they enter, while Muslims must complete a strictly prescribed series of ritual ablutions prior to prayer.

Bathing in the WATERS of holy RIVERS (such as the Ganges in India) or SPRINGS is considered especially important in many cultures; the water for the Jewish *mikveh* (ritual bath) should come from such a source. Japanese Buddhist ascetics bathed under waterfalls as part of their spiritual training.

Celtic stories of the Goddess or CELTIC QUEEN tell of her bathing in special springs or WELLS once a year, in order to regain her youth.

In alchemical illustrations, bathing can represent purification or the process of immersion in the MERCURIAL SEA.

## Sacrificing

Sacrifice derives from the Latin *sacrum facere*, 'to make holy'. Native Americans and Christians consider that any act or gift can be rendered sacred and be considered a 'sacrifice': joy, humility, the ability to give freely.

Ritual BLOOD-sacrifice of animals to please the gods took place in ancient Near Eastern and Mediterranean religions. The Jews offered animal sacrifices until the time of CHRIST, whose own sacrifice made the literal offering of flesh and BLOOD unnecessary for Christians.

Human sacrifice was a key component of Mesoamerican and Celtic cultures, ensuring the continuation of the cosmic order. The death of a ruler often necessitated the sacrifice of servants, animals and even family members who would accompany the ruler to the afterlife. Chinese Shang rulers (*c.* 1700–1050 BC) were buried with their servants. This practice later developed into the famous 'terracotta armies' of the Qin Emperor (259–210 BC).

## Harvesting

In Celtic traditions the harvest was sacred to the Goddess, symbolizing the blessings of her fertility. Many carvings showed the TRIPLE GODDESS holding CORNUCOPIAS or sheaves of corn. The Lammas festival at harvest time was also known as 'loaf mass'. On the English–Scottish border a 'kern baby' or CORN MAIDEN, made from the last corn gleanings, accompanied the last cart home.

The harvest was equally important in other cultures. Celebrations varied with the local staple crop; in Ghana and Nigeria the YAM harvest is celebrated by offering yams to the gods and ancestors, while in Japan the RICE harvest is traditionally marked by festivals at which sexually explicit objects are worshipped, and banquets held to honour the local deities of the rice fields (*ta no kami*).

Harvest is a time of fruition and completion, but also of gathering in and dying back. In Western Europe, DEATH harvests souls with his SCYTHE.

A C T I O N S

### Journeying

Journeys usually symbolize spiritual quests; they are metaphors for the journey through life. The 16th-century Chinese novel *Journey to the West*, probably by Wu Chengen and based on the real pilgrimage of a 7th-century monk, tells of the MONKEY KING accompanying the monk Xuanzang on his travels WESTwards towards India, the home of Buddhism.

Various Chinese emperors or their servants undertook famous journeys in search of the ISLANDS of the Blessed (the fabled homes of the EIGHT IMMORTALS) and Mount Kunlun, which was believed to be the centre of the world.

Christian pilgrimages (above) to sites of religious importance – especially burial sites of the holiest figures, such as Jerusalem, Rome and Santiago de Compostela – sanctify the pilgrim, and for Catholics they might attract indulgences (decreasing the time spent in purgatory). Similar pilgrimages are made to Mecca by Muslims (the Hajj) and to Jerusalem by Jews.

### Fasting

Fasting symbolizes devotion, renunciation and penance. Christians associate it with Lent, doing penance by abstaining from self-gratification. During the Renaissance period, Lent was popularly represented as a gaunt figure (above), sometimes engaged in a comic battle with a rotund Carnival.

Major Jewish fasts for repentance, mourning and atonement, such as Yom Kippur, involve the entire community, and last from sunset to sunset.

In Islam, fasting from sunrise to sunset every day during the month of Ramadan is one of the FIVE pillars of the faith, to be observed as a spiritual discipline by all adherents. Predating the Prophet Muhammad, it was institutionalized as a compromise between the practices of Jews (who fasted for TEN days) and Christians (FORTY days).

Fasting is central to many Indian religious traditions, reminding man of his humility and insignificance in nature and before the power of the gods.

### Drinking

Communal drinking symbolizes a group partaking of the same SPIRIT. The WINE drunk by worshippers of the Greco-Roman god DIONYSUS (above) symbolized the god's BLOOD; Christians drink red wine in the COMMUNION service as CHRIST's blood, or a symbol of it. In Shinto ceremonial feasts, food and sake offered to the gods, blessed by them, then eaten by the worshippers symbolized communion with the gods.

In Cameroon, the KING drinks palm wine as a sacrosanct activity with life-giving properties for both ruler and populace.

Many societies drink to good health: one example is the Saxon practice of *wassailing* ('being of good health' or 'being whole'), during which a specially-made BOWL containing alcohol was taken around a community at feasts and festivals (especially Yule and New Year). At Chinese banquets, toasts of *maotai* (distilled from sorghum) are drunk to the health of the host and to the guests.

## Feasting

Feasts have many meanings. They mark rites of passage such as birth, DEATH and MARRIAGE, or SEASONAL events such as the HARVEST, which in Japan is celebrated with banquets honouring the local RICE deities.

In Celtic and Nordic traditions, feasts are associated with WARRIORS: the 'hero's portion' of meat, the hindquarters, was given to the greatest warrior (and this portion is often found in warriors' graves), and in Valhalla the valiant dead feast eternally.

FAIRIES are also said to hold great feasts, but if a human eats fairy food they will never return to their own world.

Feasts mark significant events in Jewish history (for example Passover, commemorating the Hebrew slaves' flight from Egypt), and seasonal events in the Christian calendar.

In the ancient Near East and classical antiquity, feasts were occasions at which, through libations, communion was sought with gods, mythical heroes and the dead.

## Hunting

The right to hunt is often a royal prerogative, especially where it concerns specifically 'royal' animals such as the TIGER (India), STAG (Europe) or the LEOPARD (Africa). Depicted in many ancient Near-Eastern reliefs, the hunt provided an opportunity for a public display of manly prowess with arms and HORSES. Skill in hunting was one of the elements of Roman masculine virtue, although hunting was also associated with ARTEMIS.

Hunting BIRDS, BOAR and DEER was also favoured by the Celts, who related larger prey to the Otherworld; the STAG lured heroes into the forest to begin their adventures. The mythical 'wild hunt' was associated with Gwyn ap Nydd, who was said to hunt the SOULS of the dead across the SKY with his HOUNDS, and the Anglo-Saxon Herne the Hunter is said to take part in a wild hunt around Windsor, in southern England.

In medieval art, a UNICORN hunt symbolized persecution: hunted by MEN, as CHRIST was, unicorns may easily be tamed and pacified in the lap of a VIRGIN.

## Sexual Intercourse

In early Middle-Eastern religions such as the Babylonian cult of INANNA-ISHTAR, the high priestess and the KING would promote the LAND's fertility by re-enacting sexual intercourse between the god and the goddess.

Tantric aspects of Hinduism and Buddhism involve the use of sexual intercourse as a key element in the attainment of spiritual power, control and bliss (above).

In China, sexual intercourse is associated with the ability to prolong life. Mystical Daoists believe that it helps to balance the forces of YIN AND YANG within their bodies; it is also associated with *jing*, a form of QI that determines the sex drive, and the onset of puberty and old age. By attempting to preserve the *jing*, Daoists attempt to prolong life.

In Western alchemy, intercourse is related to the conjunction that causes procreation to occur. In Tantric forms of alchemical practice, this could be enacted through actual sexual intercourse.

ACTIONS

## Wedding

In many cultures, the bride leaves her parental family when she marries. Japanese brides traditionally wore WHITE when leaving their home, symbolizing their 'DEATH' to their family. Brides in Ancient Greece left home accompanied by lamentation and TORCHES to ward off malevolent SPIRITS. The Greco-Roman god of marriage, Hymen, son of APHRODITE and DIONYSUS, was represented holding a torch and a VEIL. In China, a DRAGON symbolizes the groom, a PHOENIX the bride. The phoenix also represents an empress, brides sometimes being described as 'empress for the day'. Similarly, 16th- and 17th-century depictions of weddings in northern Europe show the bride seated under a CANOPY and wearing a bridal wreath or CROWN, as if she were the QUEEN. The crown is still worn by brides marrying in the Orthodox Christian church.

The alchemical process may be represented as a royal wedding, in which processes are undergone to achieve a final union of SPIRIT and SOUL, and resurrection (above).

## Triumph

The Roman 'triumph' ceremony expressed the state's power. The emperor and military leaders received adulation from the people as they rode through Rome in CHARIOTS. The spoils of conquest (vanquished rulers, slaves, exotic animals, costly goods) were also paraded in a display symbolic of Roman military supremacy and geographical domination. The ARCH of Constantine in Rome is an example of a triumphal arch erected as a permanent reminder of such an event. The Greco-Roman goddess of victory, NIKE, is often shown riding in triumph in a chariot.

The concept was adapted by the humanist Petrarch (1304–74) in a long poem called the *Trionfi* (1351–74), in which he illustrated the stages of life as a series of triumphs. In the triumph of Love over War, for example, VENUS, riding in her triumphal chariot, dominates an imprisoned MARS. The *Trionfi* influenced the art of its time to the extent that even tarot cards are said to be based on the idea (above).

## Washing

For Jews, HAND-washing symbolized innocence. Washing a guest's FEET was a sign of honour: CHRIST washed his disciples' feet on Maundy Thursday. But Pontius Pilate symbolically washed his hands of any moral responsibility for Christ's crucifixion.

In Japanese and Chinese folklore clothes-washing beside a RIVER is associated with WOMEN, and is a common locus for significant events. The Washer by the FORD, a terrifying Celtic woman who washed the shrouds of the dead as they crossed the ford to **death**, symbolized the clearing away of all that clung from the mortal life.

In India objects, people, animals and religious images can all be ritually purified by being washed in different substances (WATER, MILK, OIL, HONEY, and so on). In medieval China and Japan statues of the BUDDHA were also cleansed.

In alchemy, washing is related to the albedo stage, in which the 'BLACK body' produced during the NEGRIDO was 'burned in WATER and washed in FIRE' – that is, purified by heat and distillation.

## Weaving

Weaving is often seen as a magical activity, allied to the creation of life. Often presented as the work of WOMEN, it is related to female deities such as the Babylonian INNANA-ISHTAR or ATHENA. The gift of weaving is also associated with the SPIDER, for example in West Africa (ANANSI), Native America (SPIDER WOMAN), and Ancient Greece (Arachne).

Weaving and spinning are often associated with the idea of fate: the Greek Moirai (Roman Parcae) spun the thread of life, while the Norse Norns wove the web of life.

On other occasions, weaving is a Herculean task, for example in a Chinese folk tale, Dong Yong sold himself to a weaver and had to weave three hundred pieces of silk to free himself. Luckily the celestial Weaving Maid came to his rescue.

The weaving of special cloth can be associated with royalty and royal regalia. AMATERASU OMIKAMI, the Japanese SUN goddess, and the Chinese celestial Weaving Maid (the STAR, Vega) wove raiments for the gods.

## Labours of the Months

Images depicting the tasks carried out during each month of the agricultural year were popular in medieval manuscripts and sculpture. They illustrated peasant life, but were commissioned by courtiers and other wealthy figures, and some of the cycles show court scenes. The activities depicted varied according to local climate and crops, but the following were most common:
January: FEASTING and resting.
February: trimming vines or sitting by log FIRES.
March: vine-dressing or digging.
April: growing corn.
May: riding, picking flowers, sometimes hay-making.
June: hay-making.
July: cutting hay, sharpening or carrying SCYTHES.
August: threshing (above).
September: gathering and treading GRAPES.
October: ploughing, sowing.
November: cutting firewood, herding or slaughtering PIGS.
December: slaughtering pigs, sitting by the fire.

## Kissing

For Christians, a highly charged sign of love or acknowledgment: CHRIST was betrayed by the kiss of JUDAS (above). In some Christian church services a 'kiss of peace' is disseminated from the celebrant through the congregation to symbolize mutual love and unity. It is omitted on Maundy Thursday in remembrance of Judas's kiss, which took place on that day.

When Muslims kiss the KA'BAH, their kiss is a sign of devotion; and when Roman Catholics kiss the RING of a pope or a bishop they are expressing loyalty. When a sovereign's subjects kiss the FEET of their KING, however, they are demonstrating both loyalty and self-abasement.

A kiss can seal a pact, effect a reconciliation, or express goodwill. It is most often a token of affection, but the etiquette governing whom to kiss, on what occasions, where on the body, and how many times varies from culture to culture. Kissing in public is uncommon in China and Japan, where in some ceremonies for newly-weds it represents SEXUAL INTERCOURSE.

# LIVING CREATURES

**4**

A

B

C

## Lion

As emblems of divine SOLAR power, ferocity (A) and DEATH, lions were associated with the warlike and fearsome aspects of early forms of the Goddess, and symbolized the Assyrio-Babylonian ISHTAR and her Phoenician equivalent ASHTART. Lions also drew the chariot of Cybele, the fertility goddess from Asia Minor. Reliefs from Mesopotamia of conflicts between lions and BULLS symbolized cosmic combat between the creator-destroyer Great MOTHER (the lion) and MALE divinity (the bull).

The Egyptian goddess SEKHMET, the destroyer and the protectress of the pharaoh, was also leonine. However, as vigorous GOLDEN creatures of the sun they have also represented masculinity, especially strong and just KINGship. In Africa, tribal kings such as Gele (Dahomey, 1858–89) used images of lions as personal symbols. The Ancient Egyptian solar deity AMUN RA was symbolized as a lion with a solar disc (B), and the god Aker, who protected the sun barque in the UNDERWORLD, was depicted as a double-headed lion. Lions on Egyptian DOOR-bolts, lock gates and WATER spouts may have been the precursors of Ancient Roman lion-headed door furniture.

A solar animal in alchemy, the lion represented sexual passion. A two-headed lion demonstrated the conjoined incestuous passion of the alchemical king and QUEEN (who were also brother and sister). The GREEN lion was linked with the wild forces of nature. When swallowing the sun it represented the dissolution of solar gold, which produced a solution that tinged other METALS with gold.

In the Bible the lion is a metaphor for courage, strength and power. The prophecy that 'the lion shall lie down with the LAMB' contrasts the two animals' ferocity and gentleness. A WINGED lion, the Lion of Judah, represented the Southern Kingdom (Israel had split in two after Solomon's DEATH in c. 928 BC), and was a symbol of royalty, dignity and pride. For Rastafarians, the Lion of Judah, KING of beasts, represents HAILE SELASSIE, the King of Kings.

Lions can be associated with death, as they were in Babylonian lion HUNTS (where they were also symbolic of resurrection). In Ancient Greece they guarded the dead. Jews and Christians linked them with resurrection, believing that lion cubs were born dead and had life breathed into them by the male lion after THREE days. (This belief probably arose because lion cubs are blind for the first few days of life.)

In China and Japan lions are symbols of bravery and protection. Pairs of stone lions guard the entrances to Buddhist temples and official buildings. The right-hand lion, with a decorative BALL (symbolizing the sun) under its left paw, is male (C); the left-hand lion is female and has a cub under its right paw (for compassion). DANCERS in lion costumes perform at Chinese New Year to scare away evil SPIRITS. Japanese lion dances (*shishi-mai*) are held in the SPRING and AUTUMN as a form of exorcism. The lion is believed to absorb evil influences and help to ensure abundant harvests.

## Tiger

In China the tiger takes on much of the symbolism associated with LIONS in the West. It symbolizes courage, and military equipment often bears tiger imagery. Tigers are also depicted on graves, since the Ancient Chinese believed that they could drive away evil SPIRITS. In the ancient system of the four cardinal DIRECTIONS, the WHITE Tiger represented the West and the SEASON of autumn.

The tiger is also the THIRD sign in the Chinese ZODIAC: those people born in the Year of the Tiger are said to be brave, stubborn and sympathetic.

In Hinduism, fierce cats, such as tigers and lions, symbolize man's rampant appetites and passions. SHIVA sits on a tiger SKIN (above) to demonstrate that he has subdued the unbridled passions to which others are prey. As lord of all terrestrial creatures, the tiger is a symbol of strength and fearlessness. Bellicose deities such as DURGA ride tigers. However, in Buddhism the tiger symbolizes senseless anger.

## Jaguar

The jaguar is the biggest cat in the Americas, so pre-Columbian civilizations of Central and South America (and many tribes living in the Amazon today) revered it as sacred (above): a *nagual* or spiritual guardian and a source of healing, signifying spiritual powers, fertility, WATER and RAINFALL. The Amazonian Matses people believe jaguars eat the SOULS of the dead.

## Panther

Panthers are BLACK LEOPARDS. They drew the CHARIOT of DIONYSUS, (above) who wore a panther SKIN. The Ancient Greeks believed their sweet BREATH lured other animals to their death. This magnetism was a medieval Christian metaphor for the Holy SPIRIT. Panthers signified savagery in West China and their tails adorned war CHARIOTS.

## Leopard

Like LIONS, leopards symbolized early FEMALE deities: a clay figurine of the Great Goddess (*c.* 7200 BC) discovered at Çatal Hüyük (in modern-day Turkey) depicts her giving birth flanked by two leopards. Because of their ability to leap they were associated with the ecstatic DANCING of DIONYSUS's *maenads* or female followers. They were also associated with the destructive aspects of Dionysus.

Mafdet, the Ancient Egyptian goddess of judicial authority and execution and the helper of the dead, was depicted as a leopard. The priests who ceremonially opened the MOUTHS of the dead wore leopard and PANTHER SKINS.

As a solitary hunter and a shedder of BLOOD, the leopard symbolized the supreme judicial authority of the KINGS of Benin (as only they had the right to take human life) (above). In China the leopard, like the TIGER, is an emblem of ferocity and bravery. Both animals guard the GATES of HEAVEN.

MAMMALS

M A M M A L S

## Lynx

For Native Americans the lynx is the guardian of secrets, enigmatic master of concealment linked to the occult and other mysteries. Greco-Romans believed the lynx had particularly keen eyesight and could see through walls. Christians have used the lynx as an emblem of CHRIST's watchfulness. It was a symbol for sight in cycles of the FIVE senses.

## Ape

For the Ancient Egyptians, apes were associated with the MOON god THOTH (above), who was sometimes shown as an ape with a DOG's head (he was also associated with BABOONS). Apes screech at dawn, so they were associated with the act of worship that took place at sunrise. For some Christians, apes represent evil or the DEVIL.

## Monkey

The monkey is the NINTH animal of the Chinese ZODIAC. People born in the Year of the Monkey are thought to be clever, competitive, selfish and lovable. Monkeys are TRICKSTERS in many Japanese and Chinese tales, occasionally revered for their active sexuality. The early Japanese monkey god Sarutahiko was worshipped as a PHALLIC deity. The THREE monkeys covering their eyes, ears and mouth so that they see, hear and speak 'no evil' are Sarutahiko's messengers. They also represent the 'three truths' of Tendai Buddhism. The Aztec also regarded the monkey as mischievous and licentious.

Hindus revere monkeys and many Hindu legends are associated with them. HANUMAN the monkey god is a key figure in the epic *Ramayana* and a symbol of loyalty and strength.

In Western art the monkey is a symbol of ingenuity, pretentiousness and the ability to imitate or 'ape'. In alchemy, the monkey represents the human dominated by animal instincts.

## Baboon

The Egyptian god Hedj-wer was depicted as a crouching baboon (above). He later became known as the MOON god THOTH, patron of intellectual and literary pursuits and inventor of hieroglyphs. It has been suggested that the squatting baboon represented the full moon because of its shape. The Ancient Egyptians also depicted the baboon with uplifted hands as 'hailer of the dawn'.

## Rhinoceros

In Chinese culture, rhinoceros HORN is lucky and associated with good character. In the 'EIGHT TREASURES', a pair of rhinoceros horns symbolize joy. Powdered rhinoceros horn has long been included in elixirs used to prolong life and in aphrodisiacs.

## Hippopotamus

To the Ancient Egyptians, Greeks and Romans the hippopotamus was synonymous with the RIVER Nile. The Egyptian Nile god was often depicted riding a hippopotamus. The 'Great Mother of Amenti' (known as 'the bringer forth of waters') and Rerat (a wife of SET, who lived on the Nile and was one of the GATEkeepers of the Duat) were both depicted as hippopotami. Rerat was the patron of childbirth and is shown as a pregnant hippopotamus (above) standing on her hind legs. In her avenging aspect she appears as a hippopotamus with the head of a LION.

The hippopotamus was the largest animal known to the Hebrews and symbolized the Behemoth, a mythical creature, the counterpart of LEVIATHAN (the giant SEA SERPENT of Mesopotamian and Biblical mythology). The Behemoth represented the power of the EARTH as opposed to Leviathan's power of the sea. (The Behemoth is sometimes shown as a CROCODILE.)

## Bear

Venerated bear bones and SKULLS survive from Neanderthal times. Traditional Siberian cultures, the Mongols and the Ainu people of Northern Japan all regarded them as mythological ANCESTORS. The Celts, originating in once-forested areas of Europe, worshipped them as the goddess Artio. Artio is linked etymologically to KING ARTHUR, who, like a bear in hibernation, SLEEPS in a CAVE until the time of awakening – the Great Bear constellation is also known as Arthur's Wain (wagon). In Greco-Roman myth, Callisto, one of ARTEMIS's nymphs, was raped by ZEUS and bore him a son, Arcas. Both were transformed into bears by HERA, and were placed among the STARS as the Great Bear (Callisto) and the Little Bear (Arcas).

Bears play an important part of many Native American initiation rituals, representing strength, transformation and healing. Medieval bestiaries describe how bear cubs are born as formless masses of flesh and licked into shape by their mother.

## Buffalo

In Indian mythology buffalo are associated with DEMONS (*asuras*), so they symbolize fearsome power and are considered valuable SACRIFICIAL offerings. Hindus tell how DURGA killed Mahishasura, who is usually depicted as half-buffalo, half-man, and YAMA, the Vedic god of the dead, was said to ride a buffalo. In Central and Northern Asia, BLACK buffalo are sacrificed to gods associated with HUNTING. The Chinese sage LAOZI is depicted riding a buffalo.

The buffalo was central to the life of tribes of the American Central Plains. (Strictly speaking, the North American buffalo is a bison – a different animal – but is commonly called a buffalo). The spirit Ta Tanka is the buffalo bull from whom all buffalo are said to be descended. He is the patron of ceremonies, provisions and health. He is responsible for the fertility of WOMEN and a protector of unmarried women, and is associated with supernatural power, strength and generosity.

MAMMALS

A

B

C

## Boar

The boar (A) is a courageous and strong beast, and so is associated with WARRIORS in many cultures. Japanese samurai warriors who refused to retreat were called 'wild boar samurai'. The Ancient Persians depicted Verethragna, the god of victory, as a wild boar. Norse warriors wore the 'battle boar', totem beast of the gods Freyr and FREYJA, on their ARMOUR. The mythical boar Saehrimnir willingly sacrificed itself repeatedly in ODIN's Valhalla to provide food for the slain warriors.

Celtic warriors also sported images of boars on their HELMETS (C) and battle TRUMPETS. The best part of a cooked boar was called the 'champion's portion' because it was served to the best warrior.

As a result of their ferocity and their associations with the primeval depths of forests, boars were frequently said to be the prey of great heroes. Examples include ARTHUR's hunt of the mythical boar Twrch Trwyth in the tale of CULHWCH AND OLWEN; the Ancient Greek legend of

Herakles' capture of the Erymanthean boar, which was ravaging the town of Psophis; and the myth of the Calydonian boar, sent by ARTEMIS to ravage the town of Calydon (a boar was Artemis's agent of nemesis). The Ancient Greeks associated the boar with WINTER, so its killing represented the slaying of winter by the SOLAR power of spring. They also represented destruction, and were sacred to ARES, the god of war.

A boar killed ADONIS, VENUS's lover, so alchemists link boars to the SACRIFICE and dismemberment of the old KING as they enter the depths of the NEGRIDO stage.

Celtic cultures connected the boar with sovereignty and protection of the LAND (B). Boar heads appeared on the crests of royal houses in Wales, Scotland, Cornwall and Ireland. Boars were emblems of magic and the supernatural, and their heads symbolized vitality and good luck. The boar was BRIGID's totem animal, and carvings of its head have been found on a coronation STONE in Scotland.

In Chinese mythology, the boar is 'the wealth of the forest' – perhaps because it was hunted for food. It is the TWELFTH animal in the Chinese ZODIAC, and people born in the Year of the Boar are believed to be hard-working, honest and courageous. The boar symbolizes virility and unmarried girls were dissuaded from eating knuckle of pork because it was associated with pregnancy. Conversely, pregnant women were encouraged to eat it for nutrition.

In Hindu mythology the boar also symbolizes potency. Varaha, the boar AVATAR of the Hindu protector god VISHNU, rescued the EARTH from the cosmic WATERS, into which it had been cast by a DEMON. The boar dived into the waters, rooted along the bottom until he found the earth, pinned it down with his tusks, and hurled it clear of the water.

In Jewish culture the boar – like all cloven-hoofed animals – is considered unclean. As the destroyer of vines in the Lord's vineyard, the boar is also a powerful symbol of the enemies of Israel.

A

B

C

## Wolf

Wolves are associated with bravery and fierceness, as well as with devouring and the darker forces of evil. MORRIGAN, the Celtic goddess of the battlefield, took on a wolf's form when taunting CUCHULAIN, who appeared as his own totemic animal, the DOG. Wolf WARRIOR societies were common among Native American tribes.

The wolf was one of THREE beasts of battle in Norse literature, symbolizing victory but also evil. ODIN, the god of slain warriors, had TWO wolves (A), while the wolf Fenrir, the offspring of the trickster LOKI, was feared by all the gods. He bit off the right hand of Odin's son Tyr when Odin bound him. He was eventually to kill Odin at the battle at the end of the world.

Wolves have been honoured as pathfinders or scouts. The Shoshoni of the Great Basin and Snake River Plains (which spread across parts of California, Nevada, Utah, Idaho and Wyoming) traditionally regard the wolf as the guardian of the PATHS travelled by the dead.

Wolves were also guides in the Classical UNDERWORLD. WEPAWET, the Ancient Egyptian deity of funeral processions, is sometimes depicted as a wolf (B).

In Celtic folklore wolves were associated with the wild, wisdom and transformation. The Irish DRUID Bobaran tried to obtain the wisdom of the WHITE wolf Emmaine Abhlac. (The fact that the wolf was white suggested that it was an Otherworldly animal.) MERLIN was accompanied by an elderly wolf, representing nature in its primitive state, when he went mad and became a 'WILD MAN of the woods'. An Irish story in which three sisters appeared as disruptive wolves and had to be killed in their human form, reflected a belief in the werewolf, a creature that was half-human and half-lupine. The Ancient Greeks and Romans held the ferocious wolf sacred to ARES/MARS. For Christians they are spoilers of the flock, heretics, or even the DEVIL – although ST FRANCIS is sometimes depicted with the wolf that he tamed on behalf of the people of Gubbio, by bargaining with it.

In traditional Chinese culture wolves symbolize cruelty and greed. They were considered dangerous because they hunt in packs and supposedly avenge the deaths of other wolves. In Japan the traditional symbolism of the wolf was more ambivalent: it was feared, but also worshipped as a deity capable of protecting crops against damage by other animals.

The wolf has also been seen as a fosterer and protector. The mythical Irish KING Corma was suckled by a she-wolf, and was accompanied by wolves when a ruler. The mythical founders of Rome, the TWINS Romulus and Remus, were also suckled by a she-wolf (C). The wolf became a symbol of Rome, denoting valour.

Western alchemy consequently saw the wolf as having a dual nature (the she-wolf would suckle a human child, yet was wild and devouring), and linked it with the dual nature of the philosophical MERCURY. The chemical element antimony was called 'Grey wolf'. When molten it appeared to swallow METALS such as COPPER, tin and LEAD, forming alloys.

M A M M A L S

## Fox

In Christianity foxes symbolize the cunning of the DEVIL and are associated with heresy and trickery. But in China and Japan they were believed to know many secrets of nature, and to live to a great age. They were also worshipped as bringers of wealth. In Japan, the fox was the messenger of INARI, god of cereals and wealth. Foxes also had the power to transform themselves, particularly into WOMEN. In China it was thought that after 1,000 years they turned into celestial foxes with NINE tails, which could become manifest as dangerously attractive women.

The Celts associated foxes with the DEVIL and with WITCHES who could change into foxes. The practice of fox-hunting may be related to these ancient associations. In Japanese culture they were also believed to be witch-animals, and commonly thought to be responsible for possessing people and causing mental illness.

## Coyote

For many Native American tribes the coyote is both a TRICKSTER and a creator figure. In the lore of the Miwok tribe of California, Coyote and SILVER FOX sang the universe into being (above). Lakota people call him Heyoka, which means 'contrariness'. Coyote has many magical powers, which do not always work in his favour. He is often fooled by his own trickery and no one is more astonished by this outcome than he is. However, while Coyote never seems to learn from his mistakes, he brings teachings and gifts to humans who are willing to laugh at themselves and to see through their self-deceptions. In a legend told among the Salish tribes of the North-west Coast Tribal Territories in British Columbia, Coyote was sent by the Old One (the creator) to teach humans, who, having been made out of CLAY, were somewhat stupid and bumbling.

Those wishing to learn from Coyote 'medicine' should beware: they will never know where the next lesson will come from.

## Dingo

The Australian dingo (*warrigal*) is seen as intelligent, resourceful, secretive and independent. The Ngauri people of the Flinders ranges tell how the dingo Manindi fought bravely with a giant LIZARD to protect the people. He was victorious, and the dead lizard's BLOOD stained the soil, causing the REDNESS of the CLAY in the area.

## Jackal

Jackals, who prey on carrion and prowl around burial grounds, are widely associated with evil and DEATH. ANUBIS, the psychopomp and god of mummification in Ancient Egypt, was often depicted as a jackal (above). The Old Testament calls jackals 'unclean'. They symbolize desolation: to be 'carrion for jackals' is the ultimate humiliation.

## Stag

Stags are widely associated with the SUN and renewal. The stag's antlers (above), grown in SPRING and shed in AUTUMN symbolized seasonal DEATH and rebirth for the Celts, who sometimes depicted them with a WHEEL motif placed between them, linking them with solar deities. The stag was also a fertility symbol, and PHALLIC carvings made out of stags' antlers have been found in the UK. Many Celtic HUNTING gods were depicted with antlers.

Stags were linked with the hunt in Greco-Roman mythology: the huntsman Actaeon, having seen the hunter goddess ARTEMIS/DIANA bathing, was punished by being turned into a stag, and was torn apart by his own HOUNDS.

In Celtic folklore the WHITE stag, a divine messenger, often led the hero into the forest or to the realm of the gods. In Christianity the white stag is a symbol of piety, and sometimes of Christ: KING ARTHUR hunted one, returning with its head, and St Eustace and St Hubert saw a crucifix between a stag's antlers.

## Deer

Graceful and swift, yet gentle and vulnerable, the deer often appears as a victim or companion in Hindu mythology. Deer are depicted on either side of the WHEEL of Law, set in motion by the BUDDHA's first sermon in a deer park at Sarnath.

In traditional Chinese culture deer were believed to live to a great age, and so they symbolize long life. They accompany Shou Lao, the Chinese god of longevity, and his Japanese counterparts Fukurokuju and Jurojin.

In Japanese folk religion, deer are AVATARS of the MOUNTAIN gods. In north-east Japan, deer DANCES (*shishi odori*) take place in late SUMMER or the AUTUMN: men dress up in deer MASKS and perform a dance from door to door to avert evil.

There are many deer tribes and clans in North America, for whom deer were an important source of food, clothing, and other resources. The deer dance ceremonials of the Yaqui in the south-west call for food and fertility for the people and for the deer.

## Antelope

Antelope were associated with the Ancient Egyptian goddesses Satis and Anukis. As DESERT animals they were later sometimes linked with SET. In Africa, antelope symbolize the MOON and fecundity (above). The Bambara of Mali believe the creator god Faro sent an antelope to teach agriculture to humans. The San of the Kalahari say that the antelope was the first thing made by their creator god, Mantis.

## Badger

To the Chinese, the badger is a YIN animal linked with play. The Japanese racoon dog (*tanuki*) is often translated (into English) as a 'badger'. It is thought to have supernatural powers, such as shape-changing and smothering pursuers with its giant scrotum.

<div style="writing-mode: vertical">M A M M A L S</div>

## Otter

In British folklore the otter appears most commonly as a helper, leading a hero out of trouble or a seaman to shore. Its waterproof pelt was believed to have special protective properties, and is the traditional covering of the Welsh HARP.

In traditional Chinese culture otters symbolize insatiable sexual desire. Tales are told of male otters who make love to trees in the absence of females, and of men seduced by otters in the guise of WOMEN. The Yup'ik people of Western Alaska and the Bering Sea also believed that the otter was able to take on human form. By contrast, the Celtic mother goddess CERRIDWEN took the guise of an otter (above) to chase TALIESIN, who was in the form of a fish (this tale may symbolize initiation by WATER). Native American otter 'medicine' (or power) was most often associated with women and healing, although the Lakota people of the North American Central Plains thought of the otter's courage as a MALE attribute.

## Ermine

Ermine is the stoat in winter, its coat turned WHITE. Ermines are stealthy HUNTERS; BLACK-tipped ermine tails, when attached to Native American HEAD-DRESSES or clothing, confer alertness upon the wearer. In Europe, the ermine's white fur was associated with purity and chastity. It was also used on the robes of KINGS and has come to be associated with nobility.

## Racoon

Adaptable, opportunistic and intensely curious, the racoon is a mischievous TRICKSTER in much Native American lore. The Kathlamet of North-west Tribal Territories tell how the racoon got into trouble with his GRANDMOTHER by eating her store of nuts. She hit him across the face with a poker, causing his distinctive black facial markings.

## Hare

In Celtic and Greco-Roman cultures hares were associated with the MOON, intuition, magic and enchantment. The Chinese and Japanese see a hare (or a RABBIT) in the moon. The hare is a YIN animal and is the FOURTH sign in the Chinese ZODIAC. People born in the Year of the Hare are said to be kind, peaceful and scholarly.

Its reputation for fecundity made the hare sacred to the Ancient Greek goddess of love, APHRODITE, and ARTEMIS, protectress of childbirth. In Christian cultures the hare is a symbol of lust.

In Japan the hare is a TRICKSTER: in the *Kojiki* chronicle (written in the early 8th century), a hare tricks some CROCODILES into forming a BRIDGE so he can cross a RIVER. In a later tale the hare outwits the BADGER-like *tanuki*. Many cultures have associated the hare with wisdom and craftiness.

The Ojibwe tribe of the Western Great Lakes, Minnesota and North Dakota consider Hare, or 'Big Rabbit', to have been the first teacher of animals and plants and founder of the art of decoration.

MAMMALS

## Rabbit

In many cultures the rabbit is a lunar animal, associated with MOON goddesses and MOTHER goddesses. The Bible often calls rabbits 'coneys' (rock rabbits). These were sacred to the Syrian version of the TRIPLE GODDESS because of their triangular TEETH and litters of THREE. This might explain why the Ancient Hebrews rejected the rabbit as food or for SACRIFICE.

Rabbits often appear in Native American tales as TRICKSTERS. The Ojibwe people of the Western Great Lakes, Minnesota and North Dakota, tell of Missapos, a big rabbit who SHAPE-SHIFTS in order to fool or deceive. In Maya lore, however, the rabbit invented writing and was revered as a scribe.

The rabbit is a common symbol of fecundity and lust because of its great breeding rate. Its association with early European moon goddesses – such as the Teutonic Oestra – whose festivals were celebrated in the SPRING has led to its modern incarnation as the 'Easter Bunny'.

## Beaver

The Dunne-za (Beaver Tribe) of the sub-Arctic believe that beavers have healing powers. Those who DREAM of beavers may share these powers. In Christian symbolism beavers represent chastity and the renunciation of evil. Male beavers were said to bite off their own testicles (which were valued for the medicinal castor which they contain) in order to stop hunters from pursuing them.

## Muskrat

The muskrat (or musquash) is an excellent swimmer. The Native American Blackfoot people of Alberta and Montana relate how the muskrat dived down beneath the primeval FLOOD waters and found mud, which it brought to the surface to make the earth.

## Mink

The mink is famed for its coat, which is a rich brown. The tribes of the North-west Tribal Territories see the mink as a TRICKSTER and tell stories of its erotic escapades and its ability to SHAPE-SHIFT. The mink and COYOTE are said to have prepared the way for the arrival of humans in the world.

## Mouse

In Greco-Roman literature mice were thought lecherous and voracious. They symbolized FEMALE sexuality. Although they seem insignificant, mice with their scurrying movements and voracious appetites are associated with destructive or dark forces. In the Welsh *Mabinogion*, Manawydan lost his crops to a band of crafty and secretive mice through enchantment.

M A M M A L S

### Rat

In the West the rat is commonly thought of as a plague animal and is often associated with decay and DEATH. However, traditional Chinese culture characterizes rats as industrious hoarders, and associates them with wealth and plenty. In Japan their symbolism is more ambivalent, however. They are the companions of DAIKOKUTEN, the Japanese god of wealth, and are shown peeping out of his SACK of money or RICE, but they are also regarded as pests who carry wealth away if one is not vigilant.

The rat is the FIRST animal in the Chinese ZODIAC. Those born in its year are thought to be clever, restless, charming and secretive.

For Hindus, the rat is the steed of the ELEPHANT-headed god GANESH – who is revered for overcoming obstacles – because it is not easily vanquished. Although it is small, the rat can tackle huge tasks, and its habit of nibbling at almost everything it encounters is used as a metaphor for the acquisition of knowledge.

### Bat

In Chinese, the word for 'bat' (FU) sounds the same as the word meaning 'good fortune', so images of the bat (above) symbolize good luck and happiness. The bat is associated with Fu Xing, one of the THREE STAR GODS OF HAPPINESS.

Bats symbolized impurity and idolatry to the Hebrews because they were said to sit on the heads of Babylonian idols. Medieval Christians saw them as evil parasites, giving rise to their later association with vampires; they were associated with the DEVIL.

To some Native American tribes of the Great Plains, bats symbolize diligence; for others, they signify prosperity and successful hunting. In general, however, Native Americans associate the bat with DEATH, rebirth and transition.

Bats are associated with the human SOUL in South America. They were thought to flock around Mictlantecuhtli, the Aztec god of the UNDERWORLD, carrying human HEADS in their claws.

### Flying Fox

A SPIRIT of the Asmat people of New Guinea, the flying fox is a symbol of HEADhunting. An Australian Aboriginal story relates that the singer Purupriki disturbed a colony of flying foxes. They lifted him angrily into the SKY, where he became a bright STAR, while the flying foxes were transformed into the MILKY WAY.

### Kangaroo

A familiar symbol of modern Australia, the kangaroo has long been significant to many Aboriginal clans. Extremely fast and a formidable fighter, it is said that it was given a pouch in which to carry its young because it was such a careful MOTHER. Images of the kangaroo found across Australia symbolize the SPIRITS of particular ANCESTORS and the prey they hunted.

## Opossum

In the face of danger, the opossum, an American marsupial, plays dead. It even seems to be able to excrete the smell of DEATH at will. Native American warriors have thus used opossum wisdom for centuries. This involves 'playing possum' (dead) and relying on an element of surprise to survive against overwhelming odds.

## Calf

Calves were important SACRIFICIAL animals for the Jews even after MOSES destroyed the GOLDEN Calf (above, an idol made by the Israelites for the Canaanite god BAAL in Moses' absence). Calves were often killed as food for a FEAST, and so became symbols of hospitality and celebration.

## Ox

Oxen symbolize the SPRING, agriculture and fertility in China and Japan. In Ancient China ceremonial spring ploughing was performed with oxen. They were seen as kind, patient animals, and were ridden by the sage LAOZI and other Daoist immortals. The ox is the SECOND animal in the Chinese ZODIAC. People born in the Year of the Ox are thought to be hard-working, stubborn, trustworthy and calm. In Chinese Buddhism a WHITE OX signifies wise thought.

In Ancient Greek and Roman mythology the ox symbolized strength and self-sacrificing, peaceable hard work in the service of man, so it became an early symbol of Christ. The ox is also one of the FOUR LIVING CREATURES, the symbol of St Luke, whose gospel stresses Christ's sacrifice. According to the 8th-century *Gospel of Pseudo-Matthew*, an OX and an ASS were present at CHRIST'S nativity. They symbolize Gentiles and Jews, respectively.

## Bull

The bull is a common symbol of virility and patriarchal authority, and has SOLAR, masculine and regal connotations. It was associated with the Ancient Egyptian god RA, the Greco-Roman god ZEUS/ JUPITER and the Norse god THOR. The Hindu god SHIVA also rides a bull, symbolizing instinctive sexual force and energy. However, bulls may also be LUNAR symbols: they were associated with moon goddesses, such as the Syrian ASHTART. Images of her riding a bull symbolize the taming of nature. They were also associated with fertility and with NUN, the Egyptian god of the primeval water. Zoroastrians believe the first animal to be created was a WHITE bull, from whose seed diverse plants and animals sprang.

Bulls were kept in temples in Ancient Egypt because they were thought to mediate with the gods. Bullocks were important SACRIFICIAL animals for the Hebrews, as bulls were for the Romano-Persian MITHRAS, and the Celtic sun god BELI.

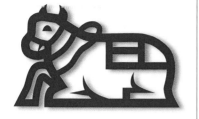

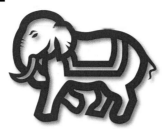

### Cow

Cows are LUNAR animals associated with creation, nourishment, rebirth and MOON goddesses; a cow HORN can symbolize the CRESCENT moon. In Norse mythology the first cow, Audumla, gave her MILK to the sleeping frost-GIANT Ymir and licked ODIN's father Buri out of the ice. BRIGID was suckled by a FAIRY cow. The Ancient Egyptian mother goddess HATHOR was depicted as a cow with a SOLAR disc between her HORNS. OSIRIS, the god of the UNDERWORLD, was laid in a cow-shaped coffin so that he might be reborn.

In traditional Chinese culture the cow is a YIN animal and is associated with the EARTH.

For Hindus the cow is a symbol of fertility and plenty (above). Anything related to cows is sacred and killing them is forbidden. The celestial cow Kamadhenu was one of the treasures that floated to the surface when the primordial SEA of milk was churned by the gods and DEMONS. Cows also feature in the legends of KRISHNA because he was a Yadava (the cowherd caste).

### Elephant

Elephants figure prominently in African royal regalia, emphasizing their association with royal might. In Hinduism the sacred WHITE elephant Airavata (above) is the mount of Indra, king of the gods. Elephants are called 'the removers of obstacles', an attribute given to GANESH.

In Greco-Roman times elephants symbolized power tempered by prudence, and were associated with military leaders such as Alexander the Great (356–323 BC) and Hannibal (247–182 BC). The Romans paraded elephants in their TRIUMPHS. Their longevity led to their association with wisdom: the warrior goddess ATHENA was sometimes depicted wearing an elephant's-scalp HEAD-DRESS.

The elephant is a symbol of BUDDHA's serenity and power. Before his birth, Maya, his mother, dreamed of a white bull-elephant.

Elephants symbolize innocence and faithfulness because they mate only for reproduction. They represent chastity in medieval bestiaries. They may also be a symbol for CHRIST.

### Ass

*Chamor,* the Hebrew word for 'ass', sounds like the word for 'body' or 'matter'. Both bear the weight of a man, so the ass was analogous to the SKELETON. Hence, CHRIST rode into Jerusalem on an ass, signifying his humility and his role as a beast of burden for mankind.

In Ancient Egypt asses were associated with SET (the god of misfortune) and certain DEMONS who carried the burden of unfortunate fate (which counter-balanced more beneficial forces and good).

In Greco-Roman mythology (above) asses were associated with rampant sexual desire, and thus with the gods DIONYSUS and Priapus. They were also objects of ridicule, deemed lazy and stupid. Similarly, in traditional Chinese culture they are seen as stupid, and symbolize poverty. However, the WHITE donkey ridden by one of the Daoist EIGHT IMMORTALS, Zhang Guo-lao, was portrayed more positively. It could cover a thousand miles, and could be folded up like a piece of paper and put in his pocket.

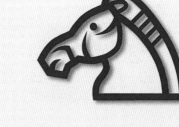

A

B

C

## Horse

WHITE horses were sacred in early Northern European culture. The Celts kept white horses in sacred GROVES and used them to draw the CHARIOTS of priests and KINGS. White mares were associated with HORSE GODDESSES such as the Welsh Rhiannon (in Celtic, Epona), and this link may be the origin of the white horses cut into English hillsides (A). In the Irish kingship rite, a new king simulated copulation with a white mare. It was then SACRIFICED and cooked, and the king bathed in her broth. Yule and New Year were celebrated in many parts of Britain by groups of people going from house to house. One, dressed in a horse's head, challenged each household with riddles to gain admittance, bringing good luck. This may have been the winter aspect of the GODDESS disguised as a fearful old grey mare.

Horses are also associated with Otherworldly transport: the Celtic gods LUGH and MANNANAN rode white horses (Mannanan's made its rider invulnerable). Slepnir, the mount of the Norse

god ODIN, had EIGHT legs, denoting its great speed. The Hebrew prophet Elijah was carried to Heaven in a chariot pulled by horses of FIRE.

The stallion (C) was a pivotal symbol of virility and procreation. It was associated with WATER, especially storms, and the seahorses that drew the chariot of the sea god POSEIDON. (The Celts believed that seahorses had backward hooves.) The mythical winged stallion Pegasus (B) was born either from the union of POSEIDON with a GORGON or from the blood of Medusa, the decapitated Gorgon. Pegasus eventually ascended to the HEAVENS, where he was captured by ZEUS and made to carry the god's THUNDERBOLTS.

Many Native American peoples associate horses with the power of thunder reflected in the sound of their hooves. The horse was unknown in North America until its introduction by Europeans. Its arrival had a profound effect on the way of life of many tribes, and it became a measure of wealth and power among them.

The Japanese gave horses as offerings to Shinto gods and sacred horses are still kept in some Shinto shrines. In some, ritual horse races and mounted archery contests, which take place annually, were originally held as prayers for peace and a good harvest. (Likewise, horse races were the focus of the Celtic tribal meetings at the harvest festival of Lammas.)

A horse is one of the group called the SEVEN TREASURES of Buddhism, and is associated with indestructibility. In Buddhist texts, a white horse symbolizes purity and loyalty.

The horse is the SEVENTH animal in the Chinese ZODIAC. People born in The Year of the Horse are thought to be good with money and cheerful but quick to anger. In traditional Chinese culture the horse is a YANG animal and symbolizes good luck, as does its hoof, while HORSESHOES are common luck totems in Europe.

The lower half of the Greco-Roman CENTAUR was a horse's body, symbolizing the creature's half-animal nature (as opposed to their human upper halves).

MAMMALS

### Camel

The Hebrew system of relating the ALPHABET to numbers equates the word for 'camel', *gammel*, with the name of the ANGEL of DEATH, Samael, a symbol of degenerate MALE power and the evil influence of the material world and death. The camel was therefore considered Samael's bearer – one commentator stated that 'the SERPENT was of the size of a camel and Samael was mounted upon it'. Although camels do not have cloven hooves, they chew the cud so the Jews were forbidden to eat their meat or to SACRIFICE them. The camel was, and still is, an important animal among nomadic desert cultures, where a man's wealth is judged by the number of his camels (Job is said to have owned 3,000).

In medieval Europe the camel exemplified temperance, because of its ability to carry WATER in the DESERT and to go for days without drinking. In Christianity it is associated with obedience and dignity. In Renaissance depictions of the continents of the world it was associated with Arabia.

### Ram

In Ancient Egypt rams symbolized fertility and SOLAR energy, and were associated with the creator god KHNUM, the primeval god AMUN and the sun god RA. Greco-Roman mythology associated them with the virile war god ARES. Consequently, the ram is the FIRST sign in the ZODIAC, associated with the SUN and the renewed vitality of the earth's life force at the SPRING equinox. HERMES Kriophoros, the Ram-bearer, was an ancient manifestation of the god in his original role as protector of flocks and herds.

A ram was substituted for Isaac when the Biblical ABRAHAM offered him to God, symbolizing the transition from human to animal SACRIFICE. Rams were widely used as sacrifices thereafter. A ram's HORN is used as the *shofar*, the ceremonial HORN blown at the Jewish festival of Yom Kippur (The Day of Atonement), and rams' SKINS dyed RED were used for the inner covering of the Tabernacle, the portable sanctuary in the desert during the Exodus.

### Lamb

The Jewish Paschal Lamb, so named because it is cooked and eaten at *Pesach* or Passover, recalls the Exodus from Egypt, and the last plague visited by God on the Egyptians: the ANGEL of DEATH took all first-born children in the KINGDOM, save for those of the Israelites, who daubed the lintels and DOORposts of their houses with BLOOD from sacrificed lambs so that their houses would be passed over. This event symbolizes leaving the world of the flesh (Egypt) for the world of the SPIRIT, and thus signifies redemption for the chosen race.

The SACRIFICIAL lamb signified purity, meekness and innocence, and for Jews is a symbol of the coming Messiah. In Christian art it is widely identified with CHRIST. The Lamb of the Resurrection (*agnus dei*), holding a WHITE pennant bearing a RED CROSS (above), symbolizes the risen Christ. The Lamb of the Apocalypse, whose blood washes the Christian saints and martyrs, has SEVEN HORNS, which represent the seven gifts of the SPIRIT.

## Sheep

Sheep are gregarious and so symbolize humanity, and CHRIST is called the Good SHEPHERD. Trouble-makers are described as BLACK sheep in Europe, which were said to bring misfortune and disaster. The EIGHTH animal in the Chinese ZODIAC (above) is the sheep or GOAT. People born in its year are said to be sensitive and creative but eccentric and **disorganized**.

## Kid

A kid was a popular early Jewish SACRIFICE. When offered at the new MOON a kid symbolized the birth of new life from the death of the old. The Mosaic prohibition 'thou shalt not seethe (boil) a kid in its mother's MILK' was one of the ancient taboos on pagan practices from which kosher regulations stem – this particular practice was part of Dionysian orgiastic rites.

## Goat

In Greco-Roman culture goats were thought of as libidinous creatures, because they allowed other goats free access to the females of their own flock. Thus they were associated with gods of love and fertility, such as DIONYSUS, PAN and APHRODITE, and the SATYRS, who had the BEARD, HORN and hind-quarters of a goat. The myth of the nanny-goat Amalthea, who nurtured the infant ZEUS, also relates to fecundity: when she broke off her horn, the god filled it with fruit, flowers and grain, forming the first CORNUCOPIA.

The Semitic goat god Azazel symbolized life and creative energy, but became the 'scapegoat' at the Jewish festival of Yom Kippur (Day of Atonement), used to carry the sins of the people away into the wilderness, thus freeing the people from the consequences. Christ was later regarded as a 'scapegoat' of the Jewish communities. But the goat as a pagan symbol of lust and life survived in the DEMON or DEVIL of later Christian culture.

## Pig

In Maori mythology the pig is negatively associated with the demigod Kama-pua'a, a lecherous half-pig, half-human turncoat. Similarly, in Ancient Egypt it was associated with SET, the god of misfortune, who was sometimes depicted as a BLACK BOAR. As lunar animals, pigs were also SACRIFICED at festivals of the MOON gods OSIRIS and ISIS, to whom they were held sacred. The sky goddess NUT was also called the 'celestial sow', giving birth to her children, the STARS, and yet devouring them every evening. Images of the sow and piglets were used as AMULETS for FEMALE fertility and the ever-replenishing spring of life.

The close relationship between sows and ancient goddesses may explain why the Jewish and Muslim taboos against the pig are so strong that a touch requires a cleansing.

From medieval times in Europe, pigs have been associated with gluttony, stupidity and filthiness.

MAMMALS

M A M M A L S

### Cat

Ancient Egyptian cat deities were associated with wild cats who fought DESERT SNAKES. The cat in the SUN god RA's BOAT conquered the SERPENT APEP. Later, the domestic cat goddess BASTET (above) became a protective deity, a mother who protected her young, so that cats were often venerated and mummified in Ancient Egypt.

The CHARIOT of the Norse goddess FREYJA was said to be drawn by two cats.

Cats were reviled as unclean by the early Jews. In medieval times they were feared by Christians, who associated them – particularly BLACK cats – with WITCHcraft. The Chinese and Japanese believed cats could release evil SPIRITS in corpses. In Buddhism they are cursed because, along with the snake, they did not weep at the BUDDHA's DEATH.

However, models of cats with one paw raised in a beckoning gesture, called *manekineko*, are put in the windows of bars and restaurants in Japan because they are thought to bring prosperity.

### Dog

In many cultures dogs are regarded as noble and faithful companions, and as HUNTERS. In Ancient Greek myth, the hunter Orion was accompanied by the vigilant dog Sirius. In Western art (particularly portraiture) dogs symbolize fidelity. To the Lakota people of the American Central Plains, the canine SPIRIT brings faithfulness to the people.

People born in the Year of the Dog, the ELEVENTH sign in the Chinese ZODIAC, are thought to be honest, affectionate, fair and open-minded.

Dogs may be associated with the dead. Zoroastrians believe that a dog accompanies the SOUL on its journey to the next world. Maori carvings of dogs symbolize departed SPIRITS, and are thought to protect the tribe. Some African peoples believe dogs have clear vision, enabling them to see into the spirit world.

Dogs have also been associated with healing, because they lick their wounds. They were depicted accompanying the Ancient Greek physician Asclepius.

### Hound

As hunting dogs, hounds often accompanied Celtic heroes, leading them into or out of the UNDERWORLD (above). The hounds of Gwyn ap Nydd/Arawn, called the 'hounds of Annwn', were WHITE with RED EARS and EYES, and hunted the SOULS of the dead across stormy night SKIES. The hound of LUGH, the Irish SUN god, had god-like abilities: its bathing WATER turned to WINE, and it could never be defeated in battle. CUCHULAIN, the legendary Celtic hero, won his name after killing the SMITH Chulain's hound, and it became his totem animal.

KING ARTHUR's hound Cabal helped chase the BOAR called the Twrch Trwyth into the SEA. The hounds of MANNANAN, the Celtic sea god, also hunted a mythical boar, while the FAIRY QUEEN Aine had a STONE that attracted all the mad DOGS of Ireland, who then plunged into the sea. The Celtic NEHELLENIA, also connected with the sea, was often depicted with a hound or a dog.

A

B

C

## Bird

The ability to fly means that birds are widely associated with gods. The Norse ODIN and the Ancient Greek ZEUS were symbolized by eagles, and various Ancient Egyptian gods were depicted with the heads of birds: GEB, who was associated with creation, had a GOOSE's head, THOTH used the head of an IBIS (a sign of the moon), HORUS used a FALCON's head, Nekhbet and MUT used the heads of vultures, and ISIS used a kite when she mourned OSIRIS.

Many gods in the South Pacific islands are half-bird, half-man in form. Maori gods, called *manaica*, are also represented in carvings with a heavily stylized or abstract human form and birdlike characteristics (B).

In Western alchemy, birds symbolized communication between HEAVEN and the material world. The DOVE sent out by Noah after the Biblical FLOOD returned with an OLIVE branch as a message of God's peace and a sign that the flood waters were lowering. A dove is a representation of the Holy SPIRIT in Christianity. Ascetics and saints are said to have been fed by birds in the DESERT (for example, the Israelite prophet Elijah by the RAVEN). Avian observation was an important form of augury in Ancient Rome. The HORNBILL (A) was considered a bird of prophecy in Benin. In China and Japan birds were traditionally thought to be message-bearers, and people who could understand their language would have good fortune.

Birds are associated with the human SOUL. During the Ancient Egyptian New Kingdom (1550–1100 BC) the *ba* – the imperishable aspect of the soul – was depicted as a bird with a human head. This symbolized the soul's ability to leave the body. In alchemical illustrations birds represented the soul at various stages of development. These stages were mirrored in the chemistry of the alchemical process.

In Greco-Roman mythology birds often have repellent, cruel associations. The Stymphalian birds were monsters that inhabited Lake Stymphalus and were eventually defeated by HERAKLES. They ate humans and obscured the SUN's light when they flew en masse. They had IRON WINGS, beaks and claws. The alluring but destructive SIRENS had a human upper body and a bird's lower body. A bird (sometimes identified as a COCKEREL) is portrayed in the Tibetan Buddhist WHEEL of Life of as one of the 'three poisons', along with a PIG and a SNAKE; in this case the bird represents lust.

The week in the Aztec calendar had thirteen days, each of which was associated with a different bird, and little birds became the hallmark of Inca art (C). Birds also feature strongly in the symbols of South Pacific peoples.

Birds have been popular motifs in China since neolithic times. Chinese philosophers divided the animal world into five categories: the hairy, naked, shelled, scaly and FEATHERED. The mythological PHOENIX (*fenghuang*) was considered the ruler of feathered creatures. Birds were often related to the sun, and a RED bird symbolized the SOUTH. In Western alchemy, however, birds represent the element AIR.

A

B

C

# Eagle

The eagle is often associated with nobility. In early Zoroastrianism the eagle symbolized the divine glory of the Persian KING. The nobility of the eagle was also one of the chief attributes of ZEUS, the Greco-Roman lord of the HEAVENS, and the eagle was adopted as a symbol by the emperors of Ancient Rome. It was the agent of their apotheosis, conveying them toward the HEAVENS and deification after their death.

The double-headed eagle, a SOLAR symbol representing the absolute power of royalty and SKY deities, was already familiar to the Mesopotamian Third Dynasty of Ur (2112–2004 BC), and it appears in the Hittite sanctuaries of the 13th century BC in central Anatolia. Several millennia later it became the imperial symbol of the Holy Roman, Prussian and Russian empires (B).

The eagle's role as the chief winged predator has led to military associations. It was one of the THREE Norse beasts of battle. Maya war leaders seeking victory adorned themselves with eagle FEATHERS. Each of the Ancient Roman legions, which represented the emperor's might throughout his dominions, cherished their standard, a golden eagle (*aquila*) mounted on a THUNDERBOLT. Napoleonic troops carried eagles on the poles of their standards. For Christians, the eagle sometimes symbolized CHRIST: when defeating a SERPENT (A), it represented his defeat of evil.

In Chinese culture the image of an eagle on a ROCK represents a solitary hero and is a symbol of strength, while pictures of eagles given to old people signify wishes for strength in old age. The eagle is also a Hebrew symbol of the renewal of youth because this bird moults visibly, renewing its plumage. Similarly, in Celtic folklore eagles were said to be long-lived because of their powers of rejuvenation. They were thought to fly up to the sun and scorch their FEATHERS, falling into a SEA or a LAKE to emerge as young birds.

Its ability to fly high made the eagle a symbol of the SUN. In their Sun DANCE ceremony, Native American tribes of the Central Plains use whistles made from an eagle's leg bone decorated with eagle fluff. According to legend, the first shrine of the Aztec war and sun god Huitzilopochtli was built on a spot where an eagle (the rising sun) was found devouring a snake (light and darkness). Likewise, the Hindu solar deity GARUDA – half-man, half-eagle – is the great enemy of NAGAS or SERPENTS, and is a vehicle for the god VISHNU. Garuda's name in the Vedas (the devotional Hindu texts) is Garutman ('Winged Words'), symbolizing the fleet power of the ancient words of wisdom. The eagle is also an emblem of the Christian ST JOHN THE EVANGELIST because it was believed to be the only creature able to look directly at the sun (and therefore able to see God).

In Norse mythology an eagle called Hraesvelg, the 'corpse-eater', made the WIND blow by flapping his wings (C).

## Falcon

In early Egyptian hieroglyphs the falcon represented the word for god. It was associated with SKY deities, who may have had falcons' heads. Examples include the SUN gods HORUS (wearing the double CROWN of Egypt) and RA (wearing the solar disc), and the MOON deity KHONSU. In early dynasties the king's ascension was known as the 'FLIGHT of the falcon'.

A cloak of falcon FEATHERS gave the Norse goddess FREYJA the power of flight.

The sport of HUNTING with falcons was associated with nobility in Europe, Japan and China, where falcons symbolized keen vision, boldness and swiftness. Banners with falcon designs were emblems of the authority of certain high-ranking Chinese lords.

Zoroastrians tell of Saena, a falcon who scattered the SEEDS from the TREE OF LIFE to all corners of the earth.

## Hawk

Many tribal peoples of North America believe the swift and keen-eyed hawk (above) to be the messenger of their ANCESTORS. Its cry is so sharp and shrill that it pierces the human mind, so that the ancestors' call can be heard.

Norse myths recount that a hawk sits on the brow of an EAGLE, which in turn sits at the top of the branches of the World Tree, YGGDRASIL. Both are beasts of the AIR and symbolize HEAVEN.

In Ancient Egypt the FALCON and the hawk also had very similar associations. A hawk-headed falcon with outspread WINGS represented the SUN gods HORUS and RA, as well as the MOON god KHONSU, PTAH, the funerary god Sokar, and Khebsenuf (one of the SONS OF HORUS). Hawks were also used as emblems of the MOTHER goddess Amenti, the goddess of the West and the UNDERWORLD.

In Japan, hunting with hawks is traditionally an aristocratic sport, just as it is in Europe.

## Owl

In many cultures the owl is a bird of ill omen, associated with DEATH. In Welsh it is called *aderyn y corff*, the 'corpse bird'. In China its hooting is thought to sound like the word for 'dig, dig', signifying that someone is about to die and will require a grave. Its image is used on funerary URNS. The Maori believe the owl to be an omen of death when seen in daylight, yet they represent it as a guardian in carvings. It is also a nocturnal protector of the Native American Pawnee tribes of Nebraska (above); and Ashozushta, the Zoroastrian sacred owl, frightens away evil SPIRITS by murmuring holy phrases.

Synonymous with wisdom and learning, the owl was sacred to the Greco-Roman goddess of wisdom, ATHENA/MINERVA. In alchemy it was considered the wisest of all the birds, and was a symbol of the true alchemist. In the form of the Hebrew LILITH it was associated with forbidden wisdom.

BIRDS

### Vulture

For Buddhists and Hindus, solitary predatory birds such as vultures inhabit 'twilight realms', acting as envoys of wrathful, dark gods. In Ancient Rome the vulture was sacred to APOLLO, and thereby had the power of prophecy. Its flight and habits were interpreted by augurs for omens.

Zoroastrians used to leave the bodies of the dead on the tops of high MOUNDS, to be eaten by vultures as a form of regeneration; this was called 'sky burial'. Tibetan Buddhists also dispose of their dead with sky burials.

The vulture was the heraldic symbol for Upper Egypt (above), its head placed next to the *uraeus* in the pharaoh's CROWN, representing the goddess of childbirth, Nekhbet. The vulture became associated with the FEMALE principle, in opposition to the MALE SCARAB. It was also the bird of the great MOTHER goddess MUT. Vultures with outspread WINGS were depicted on the underside of temple ceiling blocks to protect the way to sanctuary.

### Swan

The swan is significant in Hinduism and Buddhism. It is the vehicle of the Hindu god BRAHMA, the Lord of Creation, and of his consort SARASWATI. The swan represents discernment, and great Hindu yogis or saints are often referred to as *paramahamsa*, 'supreme swan'.

Swans were sacred to the Ancient Roman god APOLLO and the Celtic goddess BRIGID, both of whom were associated with music, poetry and divination. Because of the myth that a swan senses when its demise is near and sings to welcome it, the swan came to symbolize a happy DEATH. These beautiful creatures were also sacred to APHRODITE/VENUS, the Greco-Roman goddess of love and beauty; and because they are known for their fidelity to one partner for life, they became symbolic of faithful love.

In alchemy, the WHITE Swan refers to the appearance of white patches on the putrefying liquid during the blackening process of the NEGRIDO, and symbolizes spiritual purity.

### Crane

Symbols of long life in Japan (above) and in China, cranes are an attribute of Shouxing, the Chinese god of long life (FUKUROKUJU in Japan). Because they return once a year, cranes also symbolize SPRING and regeneration. In the Peace Memorial Park in Hiroshima, garlands of paper cranes commemorate the victims of the atomic bomb dropped on the city in 1945, and are peace symbols.

The THREE Cranes of Midir, were thought by the Celts to be a bad omen if seen before battle. Three cranes often appear with a BULL as symbols of the Gaulish god Esus, one of whose attributes was battle, and they were associated with DEATH. An Irish story tells of the FOUR cranes of death, which could regain their human form if sprinkled with a bull's BLOOD.

In medieval bestiaries cranes also symbolized duty, because they are said to take turns to keep watch while the others sleep.

## Stork

Storks have symbolized piety in cultures from Ancient Egypt onwards, because they were believed to look after their parents in old age. They also represent family harmony and filial obedience. Early Christians believed that storks killed SNAKES, and so were enemies of the DEVIL, and for this reason they are associated with CHRIST.

A migratory bird that returns to Northern Europe in the SPRING, the stork is often associated with regeneration. This is the source of the folk tale that storks deliver babies.

In West Africa marabou storks are associated with malevolence because of their diet of carrion. Their ability to move between the EARTH, the SKY and WATER means that they are accorded a transitional status, between the Otherworld and the realms of the living. In Benin, during the new YAM festival, a ritual in which men shoot at storks with RIFLES is associated with OGUN, god of war.

## Ibis

The wading ibis was sacred to the MOON deities THOTH and ISIS in Ancient Egypt. The curving shape of the beak (above) may have suggested the CRESCENT moon. The bird's BLACK and WHITE plumage represented LIGHT and dark, while its dark iridescent plumage was the hieroglyph for 'radiance'.

## Hornbill

The call of the hornbill, a bird of prophecy in Benin, is interpreted as a warning of disaster. One story tells how the Oba (KING) Esigie heard the bird's call while on a military expedition. He had the bird killed and the campaign was successful. Today, chiefs tap the beaks of special hornbill STAFFS once a year, to show that the Oba always has the last word.

## Peacock

In India the peacock symbolizes love and beauty, while its plaintive cry and tail-display before the rainy SEASON makes it the harbinger of the monsoon. The peacock-supported THRONE symbolizes royalty in India and for the deities of Buddhism, and this symbolism was absorbed into the Islamic traditions of Persia.

The peacock is also a sign of rank in China. Sacred to the Greco-Roman HERA/JUNO, the peacock became a symbol of the apotheosis and immortality of the Roman empresses. The EYES on its tail were likened to STARS, and associated with the HEAVENS.

In early Christian symbology the peacock represented immortality (because its body was thought not to decay), paradise (because of its exotic beauty), and resurrection (from the way it opens its WINGS, and the belief that it dwelled in paradise).

In alchemy an iridescent fan of colours called the peacock's tail appears after the NEGRIDO and *albedo* stages, marking a turning-point before the next process.

**199**

BIRDS

## Parrot

Parrots were prized by the Aztec for their powers of mimicry and their highly coloured FEATHERS. The Canaris tribe who inhabit an area near Quito in Ecuador believed the parrot to be their MOTHER-ANCESTRESS.

A story told by the Aborigines of Australia tells of a human CHILD born with twisted limbs, who yearned for release from pain. The elders of her clan prayed to the SPIRIT world all night, and in the morning she was transformed into a RAINBOW Lorikeet. Thus she became a vivid symbol of the human potential to transform pain and ugliness into beauty with the power of spirits.

The parrot's reputed powers of speech have made it a warning to unfaithful wives in some Chinese folk tales. In Buddhism parrots holding PEARLS in their beaks are attendants of the BODHISATTVA Guanyin (AVALOKITESHVARA). In Western art their beauty and exotic origins make them symbols of wealth.

## Bird of Paradise

In Malay myth, the bird of paradise lays its EGG in flight, and when the egg touches the EARTH, it cracks open to release a fully grown bird. When 16th-century Europeans first saw the dried, prepared skins of these birds – which had no legs – they thought that they were 'higher beings', and the myth of the FOOTless bird of paradise was born.

## Golden Oriole

In China, the Golden Oriole represents SPRING, WEDDINGS, joy and music. It is also a symbol of friendship. In paintings that depict the Chinese concept of the 'FIVE human relationships', the Golden Oriole is a symbol of friendship.

## Ostrich

In Ancient Egypt ostrich FEATHERS were associated with MAAT, the goddess of justice, and so they symbolized justice and truth.

In the Old Testament the ostrich appears as a symbol of neglect and cruelty: 'she leaveth her EGGS on the earth and warmeth them in the dust and forgetteth that the foot may crush them…she is hardened against her young ones' (Job 39: 14). However, this same myth was also interpreted by Christians as a symbol of CHRIST awakened by God, and of MARY's VIRGINAL MOTHERHOOD. Ostrich eggs are sometimes depicted in Renaissance religious paintings, although their precise meaning is the subject of debate.

The ostrich was also said to bury its head in the sand, symbolizing someone who is deliberately ignoring unpleasant events. Thus in Christian symbology it came to represent the deadly VICE of sloth, and – when appearing with a Synagogue – was also a symbol of Judaism.

B I R D S

## Emu

A Yuin creation story from Australia tells how Daramulan lived on earth with his MOTHER Ngalalbal, the emu. The land was barren until Daramulan placed TREES on the earth.

Eating emu flesh is said to give relief from many illnesses, but killing an emu brings bad luck.

## Pelican

The pelican is a Christian symbol of the crucifixion and resurrection, as the mother pelican is said to echo CHRIST'S SACRIFICE by pecking her breast and feeding her young on her own BLOOD (above); it also symbolizes charity. In alchemy, the end of the WHITENING stage of the Great Work, when the REDDENING begins, is symbolized by an image of the pelican.

## Heron

The wading heron is associated with WATER in Central America: the rain god Tlaloc of the Nahuatl culture wears a CROWN of heron FEATHERS. In Ancient Egypt, the heron's habit of migrating when the Nile FLOODED symbolized the transformation of the SOUL after DEATH, the rising SUN and the return of OSIRIS. The PHOENIX was sometimes depicted as a heron.

## Pigeon

In Polynesian mythology pigeons are linked with the first ANCESTRAL gods. In New Zealand, the pigeon is the SHADOW or double of the Maori god RU. In Tahiti, the GREEN MOUNTAIN pigeon is linked with the god Rupe or Ru, brother of Hina, and with the story of the origins of the first BANYAN TREE.

## Dove

Doves often symbolize peace. For Judeo-Christians, the dove that returned to Noah's ark carrying an OLIVE branch (above) symbolizes peace between God and mortals. The dove associated with HACHIMAN, the Japanese god of war, represents the peace that is sure to follow his exploits.

On Torah shrines, doves symbolize the SOULS of the dead. In Christianity, they represent the Holy SPIRIT. They have similar connotations in Arthurian legend – in which they were associated with the GRAIL – and in alchemy, where they were shown carrying an olive branch as a symbol of reconciliation, or a ROSE, signifying heavenly intervention.

In Ancient Egypt the dove was frequently depicted with the FRUIT on the TREE OF LIFE. A BLACK dove was a symbol of widowhood. In Ancient Rome the dove was sacred to VENUS, and was therefore often a symbol of erotic love. In China doves are said to pair for life and are symbols of fidelity, purity and meekness.

**201**

B I R D S

### Crow

The cawing of the BLACK CROW can be an omen of change. Native American tribes of the north-east Coast believe that the crow protects ancient records and keeps sacred laws. It may be a TRICKSTER and a SHAPE-SHIFTER, and it portends change. For example, in the alchemical text *The Chymical Wedding of Christian Rosenkreuz* (1616), CHRISTIAN ROSENKREUZ meets a black crow that pre-empts his selecting the correct PATH from a choice of THREE.

Crows have often been perceived as birds of ill-omen, war and DEATH, so they were sacred to the Greco-Roman war goddess ATHENA/MINERVA, although she would not allow them to land on the roofs of her temples because a crow on a roof foretold death.

In Chinese culture the crow is also a bird of prophecy. Its call is interpreted differently, depending on when it is heard. A THREE-legged crow symbolized the SUN, the dwelling place of this mythical creature. The Japanese also adopted the crow as a messenger of the sun goddess, AMATERASU OMIKAMI.

### Raven

In Judeo-Christian culture the raven is the dark counterpart of the DOVE. Both were sent out from the ARK by Noah when it reached Mount Ararat, but only the dove returned. However, in the lore of the Native American tribes of the north-west the raven is a significant figure, said to have brought LIGHT to the world when it was dark (above).

The raven was one of the THREE beasts of battle in Norse mythology. Two ravens called Huggin and Muggin ('Thought' and 'Memory') accompanied the battle god ODIN, symbolizing the search for wisdom. The Celts associated the raven with battle, DEATH and the MORRIGAN, the Irish war goddesses.

The name of the Ancient Welsh king BRÂN means 'raven'. Brân's HEAD – regarded as the guardian of Britain – is said to be buried on the WHITE MOUNT, the location of the Tower of London, where ravens are still kept today. It is said that their departure from the Tower would portend the fall of the country.

### Magpie

In the lore of the Australian Aborigines, the magpies are those who greet the dawn with enthusiasm and joy. It is said that when the world was first created, the SKY was so close to the EARTH that it shut out all the LIGHT, and life was very difficult. The magpies got together and searched for sticks, which they used to push up the sky. It suddenly split open, creating the first dawn.

The magpie, whose Chinese name means 'bird of joy' appears in the Chinese legend, the WEAVING Maid and the COW Herd, in which magpies form a BRIDGE across the MILKY WAY once a year so the two lovers can meet. Two magpies depicted with a Chinese COIN (round, with a SQUARE hole in the middle) symbolizes the wish 'great peace over the whole world'. In this context the coin is a representation of the world.

Magpies are traditionally associated with evil and ill omen in Europe. They are also considered to be thieves.

## Cuckoo

In classical antiquity the cuckoo was a common symbol for infidelity and the plight of the cuckold because of its habit of appropriating the nests of other birds for its young. It was one of HERA's attributes, because ZEUS changed himself into a cuckoo to ravish her.

In Japan the cuckoo is a popular subject for poetry. Its call is a symbol of early SUMMER and it has connotations of unrequited love. In the Chinese province of Sichuan the return of the cuckoo (above) after migration is associated with the beginning of certain agricultural tasks, and this link is expressed in its various local names, for example 'reap the WHEAT' and 'forcing us to plough'. Similarly in Northern Europe its appearance after the winter is taken as the first sign of SPRING.

The cuckoo was sacred to the followers of the Bon religion in Tibet because it is traditionally believed to have impregnated the female ANCESTOR of their founder.

## Chicken

Chickens (hens) are associated with WOMEN. The English expression 'to be hen-pecked' describes a MAN controlled by a nagging woman. In Western alchemy the pecking hen symbolized female sexuality, whereas the brooding hen sitting on her EGG represented love and constancy. This also referred to the need to watch the alchemical egg (or receptacle) closely and keep it at a constant, warm temperature.

In China and Japan much of the symbolism relating to chickens concerns the male birds (COCKERELS) rather than the hens. But a cockerel and a hen shown together symbolize a peaceful life in the country. A hen crowing instead of a cockerel was a sign of disruption to the established (male-dominated) family order.

It is the most popular SACRIFICE in African Voudon and the related Caribbean and American Voodoo; chicken's BLOOD is mixed with other potent ingredients and spread on sculptures to empower them. Chicken FEATHERS are also used in WITCHcraft.

## Cockerel

A herald of the rising SUN, the cockerel was the traditional sacrifice to the Celtic goddess BRIGID at the SPRING festival of Imbolc, and was associated with the Roman sun god APOLLO. One was kept at the Shinto shrine to the Japanese sun goddess, AMATERASU OMIKAMI, at Ise.

In Europe live cockerels were buried at the confluence of THREE streams, and built into the foundations and DOORWAYS of houses for luck. In Chinese culture a WHITE cockerel on a coffin kept ghosts away. Cockfights were often depicted on Ancient Roman sarcophagi as an allegory of the SOUL's ultimate victory over the powers of DEATH and darkness.

The cockerel is the TENTH sign of the Chinese ZODIAC; people born in the Year of the Cockerel are said to be confident, good with money, and argumentative.

A cockerel is an INSTRUMENT OF CHRIST's PASSION, a sign of ST PETER's faint-heartedness in denying Christ three times before the cock crowed.

BIRDS

### Waterbird

The inter-tribal Native American Church has incorporated many aspects of Christianity, and for them the waterbird (water turkey or snake bird, often called the 'peyote bird', above) has a symbolism similar to the Christian DOVE of the Holy Spirit.

Waterbirds are associated with Toshou, a WATER deity of the Fon people of Benin.

### Duck

The duck is a symbol of happiness in China and Japan. Mandarin ducks (so called because of their flamboyant plumage) are symbols of conjugal felicity and fidelity.

In the late Bronze Age ducks were depicted with SUN WHEELS, or on the prows of BOATS carrying the sun – a reference, perhaps, to their migratory habits.

### Goose

The Ancient Egyptians associated geese with the 'Great Cackler' that laid the EGG of creation. The Greeks and Romans believed that the goose was symbolically linked to Harpocrates, the CHILD HORUS. They were sacred to the Greco-Roman HERA/JUNO – associated with intelligence and vigilance – and to the fertility god Priapus.

The Chinese used flying geese – which are migrating birds – as an artistic convention for the coming of AUTUMN. They were often depicted with a full autumn MOON. Some Native American tribes thought that the snow goose, the herald of seasonal change, travelled beyond the NORTH WIND. The Celts believed the winter snows to be white goose FEATHERS strewn from the apron of the crone goddess CAILLEACH.

The Celts also associated the goose with war gods and with protection. Its image has been found carved over DOORWAYS and buried with WARRIORS. RHIANNON and EPONA were sometimes depicted riding geese.

### Albatross

The albatross plays an important role in the island culture of the South Pacific. One Hawaiian saying runs *ka manu ka'upu halo 'alo o ka moana* ('the albatross that observes the SEA'): the bird represents a careful observer.

The albatross is a sacred bird for the Ainu people of Northern Japan, who consider it a servant of the chief god of the sea. To see one foretells good fortune.

For the early Europeans the albatross was a legendary weather prophet, forecasting heavy winds and bad weather. It was supposed never to touch land, caring for its EGGS on a floating raft and SLEEPING while gliding on wind currents. It was held in awe by sailors, who believed that killing one would bring down a curse on their SHIP. This event is described in Samuel Taylor Coleridge's *Rime of the Ancient Mariner* (1797–98), in which the dead albatross is hung around the neck of the mariner who had shot it with his ARROW, its great weight a lasting reminder of his sin.

## Kingfisher

In China kingfisher FEATHERS adorn WEDDING chairs, symbolizing good luck, marital happiness and sexual enjoyment.

As its name suggests, it was associated with the FISHER KING.

The Australian Kookaburra is a species of kingfisher. The SKY SPIRITS asked it to use its laughter-like call to wake the people at sunrise, so that they would not miss the wonder of the dawn.

## Pheasant

In Chinese culture the pheasant (above) is one of the prototypes for the PHOENIX, a symbol of beauty and the empress. Like the phoenix it is connected with the SOUTH – the south entrance of a PALACE is called the Pheasant GATE. In Japan the common pheasant (*kiji*) was made the national bird after World War II.

## Plover

A design featuring plovers and waves is common in Japanese art because plovers beside the SEA are considered particularly beautiful. For the Hebrews, the plover (or partridge) was a symbol of pagan lust: Jeremiah referred to pagans who participated in orgiastic rites 'like a partridge which gathers into its nest EGGS which it has not laid' (Jeremiah 17: 11).

## Quail

The Chinese customarily held quail fights, and the bird became a symbol of courage. The Chinese for 'quail' is '*an*', which sounds like the word for 'peace', thus the bird is an emblem of peace. Its brown plumage resembles ragged clothes, and so it was sometimes regarded as a symbol of poverty.

The quail was sacred to the Phoenician sky god BAAL.

## Nightingale

Renowned for its sweet singing, the nightingale is a symbol of love (especially in Persia). Its habit of SINGING at dusk made it a romantic accompaniment to lovers. The mournfulness of its song has meant that in European folklore it has been associated with the SOULS of the damned. It may also prophesy a gentle death.

## Goldfinch

In Christian art the goldfinch symbolizes CHRIST's Passion. A legend describes how a goldfinch flew down to take a THORN out of Christ's brow as he hung on the CROSS and, in so doing, was splashed by the Saviour's BLOOD. It is sometimes held by the infant Christ in paintings of the VIRGIN and child, foretelling his destiny.

## Swallow

As migrating birds, swallows were associated with SPRING in Ancient Rome, China and Japan (above), and still are in Europe today. In Rome they were also associated with the domestic HEARTH because of their habit of nesting under the eaves of houses, so they were sacrificed to the Lares (household deities). Swallows returning to build their nests every spring were considered auspicious signs in China and Japan. (When they left again in autumn it was believed that they turned into mussels.)

The swallow was sacred to the Ancient Egyptian goddess ISIS, who flew around the pillar containing the body of OSIRIS in the form of a swallow. The dead hoped to be turned into swallows so that they could go through any of Osiris's GATES.

Among WARRIOR tribes of the Central American Great Plains the swallow is considered to be swift, agile and invulnerable to attack. The Lakota Sioux believe it to be *Heyoka*, the FOOL, possessing the powers of paradox and parody.

## Sparrow

Sparrows symbolize lust and lewdness in many cultures. They were sacred to APHRODITE in Ancient Greece, and the Chinese regard them as sensual birds and symbols of the PHALLUS. In the Psalms the sparrow symbolizes loneliness; in the New Testament it represents the humble.

## Woodpecker

The woodpecker was sacred to ARES/MARS and ZEUS/JUPITER, and was said to have brought food to Romulus and Remus, the founders of Rome. The Native American Lakota Sioux associate its pecking with THUNDER. The Akan of Ghana say: 'woodpeckers hope the silk cotton tree will die' (humans can do only small things but can hope the mighty will fall).

## Hummingbird

Hummingbirds appear in many stories of the Native American peoples as messengers or travellers between the worlds, representing hope and the yearning for beauty and exquisite joy. In Maya legend the hummingbird was the SUN in disguise, trying to court a lovely WOMAN (the MOON). According to Aztec beliefs, when the heroic WARRIOR Huitzilopochtli was killed in battle a hummingbird whirred up from the place where he had fallen, inspiring his followers to go on to victory. At his DEATH he became god of the sun and war, and so the Aztec came to believe that every warrior slain in battle became a hummingbird.

The Caribbean Arawacs (now extinct) believed that the hummingbird brought TOBACCO, and they called him the Doctor Bird. To many Pueblo people the hummingbird is also a tobacco bird, bringing SMOKE to the SHAMANS so that they can purify the earth.

## Wren

DRUIDS considered the wren to be a bird of prophecy: as a symbol of MIDWINTER it was said to fight the robin in the New Year. The Celtic hero BRÂN was said to have hidden in an IVY bush disguised as a wren. Hunted on St Stephen's Day (26 December), it was carried in a SACRIFICIAL procession in a 'Wren House'.

## Kiwi

The Maori word *kiwi* – now used worldwide as a nickname for New Zealanders – comes from the shrill 'kee-wee' cry of this small, flightless, tail-less, nearly blind, nocturnal bird. The national bird and emblem of New Zealand, it once formed part of the Maori staple diet, and kiwi FEATHERS were used in Maori cloaks.

## Lizard

In Greco-Roman culture the lizard symbolized evil, as it does in Christianity, but also resurrection from hibernation. Hence, it was also able to ward off evil. The Maori regard reptiles as symbols of evil, fearing them because they are believed to act as messengers for Whiro, the god of evil, disease and pestilence, or to serve as vehicles for harmful SPIRITS.

Native American tribes, particularly in the south-west, regard the lizard as a visionary, allying it to SHAMANIC powers and vision quests. The Plains Dakota associate it with strength (above).

Some Amazonian tribes believe that the lizard, associated with WATER, is a manifestation of Desana, lord of animals and fish. Similarly, the Aborigines of Australia consider the *kendi* or frill-necked lizard to be a powerful RAINmaker.

The Ashanti of Ghana associate the lizard with the EARTH, and depict it on funerary items. The Babanki of Cameroon equate it with household tranquillity.

## Crocodile ✳ Alligator ✳ Cayman

The Ancient Egyptian crocodile deity Sebek was first identified with SET and later with RA, when he was depicted wearing a SUN disc (above). The Nile was said to issue from his sweat, and his gaping jaws resembled the abyss.

Aborigines from Australia's Northern Territories believe that large crocodiles embody the SPIRITS of important people, and that old crocodiles are very wise. Madarrpa peoples of North-east Arnhem Land believe the Crocodile Man created FIRE, which spread to other clans, forging ritual links between them.

For the Caribbean Taino the MILKY WAY was a giant cayman floating in the nocturnal SEA. The Maya believed that the world was supported by four caymans floating on the primeval WATERS.

Some African tribes revere crocodiles as powerful intermediaries between the divine and human worlds and as oracles for WATER deities. They also symbolized the chief of the Venda of the Transvaal, who was called the 'crocodile of the pools'.

R
E
P
T
I
L
E
S

A
N
D

A
M
P
H
I
B
I
A
N
S

## Chameleon

Able to change skin colour at will, chameleons have long been associated with adaptability. In parts of Africa chameleons (above) are associated with SHAMANS because of this SHAPE-SHIFTING ability. In alchemy they symbolized the ever-changing mask of the persona. They are fertility symbols in Cameroon because they have many offspring.

## Gecko

The gecko is sometimes included in the Chinese group of 'FIVE noxious creatures' or 'five poisons'. It was also believed to guard WOMEN's virtue: RED ointment made from the pounded remains of a gecko that had been fed on CINNABAR powder for a year would not rub off the bodies of women who did not have SEX.

## Frog

Native Americans generally associate frogs with cleansing, and the frog was the WATER deity of the Maya and Aztec, connected with predicting and making RAIN.

To the Taino of the Caribbean the frog is the spirit of fertility. The Ancient Egyptian frog goddess Heket was associated with magic and childbirth. Frogs were linked with magic and WITCHcraft in medieval Europe because of their ugly appearance. In China they are traditionally ascribed magical powers called *ku*. Various folk tales describe people finding a frog beside a mysterious parcel containing riches. If they take the parcel they may be plagued by frogs or, if they are wise and virtuous, become very rich. The Israelite God sent frogs as one of the TEN plagues of Egypt.

In Chinese culture frogs were also associated with the MOON because frogspawn was believed to fall with the DEW, which was said to have come from the moon.

## Toad

The Native American Huron tribe tell how a divine WOMAN fell from the SKY into the primeval WATERS. The animals saved her from drowning, but only the toad could bring some EARTH up from below the waters for her to live on. This, placed on a TURTLE's back, was the beginning of the earth.

Alchemists believed toads to be creatures of the earth and matter. They are associated with WITCHcraft because of their ugly appearance, and because some have poisonous or hallucinogenic skins. Their skins were used by Aztec SHAMANS to take them on their SPIRIT journeys.

The distinction between FROGS and toads is not always clear in China and Japan. Like the frog, the toad is linked with the MOON. In Japan, the common toad was said to cause eclipses of the moon by swallowing it. Toads also symbolize money-making: a toad with a COIN in its mouth is a common Chinese symbol of good fortune. The idea of the toad with a jewel in its head (above), signifying happiness, is widespread.

A

B

C

## Tortoise ✳ Turtle

Many cultures interpret tortoises, who carry their homes on their backs and live to a great age, as symbols of strength and endurance and as bearers of the world (A).

The turtle is the oldest Native American symbol for the EARTH and the earth MOTHER. Many Native Americans call North America 'Turtle Island' (C). The creation stories of north-eastern tribes tell of a time when, because the world had fallen into disunity and disharmony, a great SPIRIT sent a mighty FLOOD that covered the land, and took all the humans away to a place in which they might learn the error of their ways. The animals became lonely without the humans, so the giant turtle offered his back to the animals, who built a place of earth in which the humans could dwell upon it.

The Maya also envisaged the earth as a huge turtle, and in Chinese culture the mythical ISLANDS of the Blessed, home to the Daoist EIGHT IMMORTALS, were said to be supported on the backs of huge tortoises. Some legends recounted that the entire world rested on a giant tortoise (called *ao* in Chinese). In a similar Hindu tradition, a tortoise supports EIGHT WHITE ELEPHANTS which hold up the terrestrial world and the HEAVENS.

In Ancient China a tortoise encircled by a SNAKE represented the NORTH and WINTER. This depiction embodied the belief that only female tortoises existed, and that these mated with snakes. (Illegitimate children were sometimes said to be the progeny of tortoises.) Said to live for a thousand years, the tortoise was an emblem of long life in China. In Ancient Greece tortoises also symbolized immortality – miniature terracotta models of tortoises are commonly found in Ancient Greek graves (B).

In Greco-Roman culture the tortoise was associated with the sun god HERMES/APOLLO. His LYRE, which had been invented by HERMES, was made from a tortoise shell. The tortoise is one of the ten incarnations of the Hindu god VISHNU who, while in this shape, helped with the churning of the SEA of MILK by the gods and DEMONS.

Among African tribes, turtles are often sacred to WATER deities because of their aquatic nature. The Aborigines of Australia also associate the turtle with the weather and with safety at SEA. In Polynesia the turtle embodies the incarnate power of the gods of the ocean.

Renaissance emblems make use of the legendary slowness of the tortoise to symbolize patience and wisdom (gained from its great experience). A tortoise mounted by a FLAG became an emblem of Cosimo il Vecchio de' Medici (1389–1464), accompanied by the motto *festina lente* (make haste slowly).

## Snake

Snakes are venerated as RIVER deities in Africa, Argentina and China where, like DRAGONS, they were believed to have an affinity for WATER. The sculpted figure of the 'Celtic APOLLO' on the Temple of Minerva in Bath is a snake-HAIRED water deity associated with healing. Snakes depicted biting their tails were associated with water encircling the LAND – for example the Dahomey RAINBOW python, which protected the capital city in the form of a moat. The Norse snake Jormungand lived in the sea, encircling the world. At the end of the world he tried to make his way on to land, causing the sea to boil, so he personified FLOODS and storms at sea.

As the OUROBOUROS, snakes biting their tails also symbolize eternity. Because they repeatedly shed their SKINS, they were venerated as creatures of eternal life in China. In Classical antiquity, the CADUCEI (herald's wands) of Asclepius, HERMES and Hygeia, made from two intertwined, copulating snakes, symbolized the opposing forces of DEATH and regeneration.

Snakes were associated with FEMALE deities, such as the Aztec MOTHER/earth goddess Coatlicue, who wore a skirt woven of snakes, or the snake-haired GORGONS of Greco-Roman mythology. Wadjet, the Ancient Egyptian snake goddess of Buto, personified the forces of growth. She came to be equated with the protective force of the *uraeus*, a FIRE-spitting cobra on the pharaoh's head-dress (A), and the EYE of RA. Snakes were related to female divination: female Pythia, their name recalling APOLLO's mythical defeat of the Delphic python, delivered his Delphic oracles. The African python Fo is the messenger-SPIRIT of the Senufo women's divination society of Sandogo, found in Mali and Côte d'Ivoire. In their Snake DANCE, the Native American Hopi of the south-west ask the snakes to carry their prayers for RAIN and fertile crops (B).

Snake worship is related to Hindu fertility rituals and snakes are often shown twined around the PHALLIC *linga* of SHIVA. They also symbolize the coiled kundalini or sexual energy present in every human. In China they were seen as sensual, metaphorically connected with the PENIS. In Christian representations of the VICE of Lust, they are shown biting a woman's BREASTS.

Snakes are connected to the UNDERWORLD. They represented its powers to the Inca, while in Greco-Roman culture they embodied the SPIRITS of the dead and guarded burial places. In India they are allied to tree-worship because they are believed to inhabit the UNDERWORLD, linked to the LIGHT by the tree's roots.

The snake is also the SIXTH sign of the Chinese ZODIAC (c). People born in the Year of the Snake are considered to be elegant, deep-thinking, curious and calculating. More generally, the snake symbolizes cleverness and treachery in China, where it is one of the 'Five Poisons' (with the SCORPION, CENTIPEDE, TOAD and SPIDER), creatures that could be toxic or – alternatively – ward off illness and evil.

## Fish

The Greek word for 'fish', ICHTHYS, was seen as an acrostic for the name of CHRIST: the letters form the initials of *Iesous Christos Theou Yios Soter*, 'Jesus Christ, Son of God, Saviour'. The fish is also a EUCHARISTIC symbol relating to the miraculous feeding of the 5,000 with BREAD and fish. The fish eaten at the Jewish *Pesach* (Passover) represents the food of paradise. Ancient Egyptians were forbidden to eat certain fish, possibly because one was said to have swallowed the PHALLUS of OSIRIS. It was also said that his phallus was a fish.

One of the Japanese SEVEN DEITIES OF GOOD FORTUNE, Ebisu, carries a *tai* fish – a sea bream or a red snapper – a symbol of plenty and good luck. A fish, or a pair of fishes (above), are said to have appeared on the BUDDHA'S FOOT, representing freedom from desire.

## Whale

The Old Testament story of Jonah and the whale is an allegory of DEATH and rebirth, originating from the Ancient Babylonian myth of the SEA monster that swallowed the SUN god Marduk: Jonah's THREE days and nights in the whale's belly (the UNDERWORLD) symbolize the dark night of the SOUL.

Japanese fishermen regarded the whale as a manifestation of Ebisu, one of the SEVEN DEITIES OF GOOD FORTUNE, worshipped as a god of fishing and food.

In New Zealand whales stranded on beaches provided the Maori with important sources of food and fat. As a result they use the whale to symbolize plenty and abundance. The mythical *pakake* figure, a stylized whale shape with large SPIRALS indicating its jaws, is found carved on the façade boards of Maori store-houses. With the DOLPHIN and the SALMON, the whale is one of Britain's THREE legendary sacred FISH.

## Dolphin

The dolphin is one of Britain's THREE sacred FISH, associated with healing WELLS and the SEA. It is linked with APOLLO and his gifts of prophecy and wisdom. It often appears in myths as a saviour and rescuer, originally from drowning. In Greco-Roman mythology the dolphin also carried the gods and human SOULS.

## Carp

In China the carp symbolizes strength and perseverance, and samurai fortitude in Japan (above). Carp swimming upstream in the Yellow RIVER were believed to turn into DRAGONS if they jumped with vigour – a transformation that became a metaphor for success in state examinations and more generally in life. The carp, like other FISH, signifies abundance. New Year RED 'lucky money' envelopes bear carp motifs.

### Salmon

The salmon, with the WHALE and the DOLPHIN, was one of the THREE sacred FISH of Britain. The Celts associated the salmon with deep wisdom, and to eat a salmon was to partake of that wisdom. In the tale of the hero CULHWCH AND OLWEN, the salmon was said to be the oldest animal in the world. The salmon of wisdom, Fintan, was said to be so old that he was a survivor of the great FLOOD. Able to live in saltwater and freshwater, the salmon was thought to be a special fish endowed with prodigious strength as it made its way upriver to the spawning grounds. Many famous DRUIDS, bards and magicians would eat or take on the form of a salmon to obtain wisdom, or for other reasons – for example TALIESIN may have taken a salmon's form to escape CERRIDWEN (perhaps symbolizing a stage of initiation).

The Native American Kathlamet of the North-west Coast tell how Salmon (above) honours all the plants that have fed the people in a time of famine as he travels upriver to spawn.

### Shark

Sharks are powerful symbols of the dangers of nature. The Maori use the highly prized TOOTH of the *mako* shark as an EAR pendant. On the face of a cliff at Chasm Island in Northern Australia there is a large RED stain, which is said to represent the tiger shark Bangudja who, unprovoked, attacked and murdered Amatuana, the DOLPHIN-man.

### Eel

In one of the Chinese FLOOD myths, an eel, Xiang-liu, helped the god Gong-gong submerge the world. The HEAD of an eel that had been saved from being eaten by a SNAKE was thought to bring good luck. In Japan the eel is considered to be one of the messengers of the gods.

### Mudfish

In Africa, mudfish are associated with WATER deities – the Yoruba of West Africa link them with their god OLOKUN (above). As a symbol of kingship, they signify power over water. Their succulence gives them shades of fertility and benevolence. The poisonous spines of some signify KINGLY strength as a WARRIOR.

### Octopus

Octopuses occasionally feature in Japanese folk tales as mischievous creatures that appear on land and frighten people. In other tales, the many ARMS of the octopus make it a talented creature. With their elongated HEADS, they are compared to the large-headed god of longevity, FUKUROKUJU.

## Squid

Aborigines in the Wessell Islands of Australia's Arnhem Land regard the squid as a healer. In their ancestral mythology, the female squid is believed to have created all the features of the landscape and the local family clans. The male squid then divided the land among the clans.

## Cowrie Shell

Cowrie shells were traditionally used as currency in Benin, so they appear on costumes and sacred artefacts, symbolizing wealth, prestige and royalty. Only KINGS and QUEEN MOTHERS had the right to use THRONES decorated with a cowrie motif. Their oval shape inspired their use in many cultures for the EYES of sculptures (above).

## Conch Shell

In Hinduism the conch symbolizes the origin of existence. It has the form of a multiple SPIRAL evolving from one point into ever-increasing spheres (above), and is associated with the primeval WATERS. The sound it makes when blown is associated with the primeval sound *om*, from which creation developed. The conch shell is also an emblem of the god VISHNU, who floats on the cosmic ocean.

In China and Japan, HORNS made from conch shells were originally used in Buddhist worship and became emblems of Buddhism, particularly of the BUDDHA preaching. They appear in the set of holy symbols on carvings representing the Buddha's FOOTPRINTS. The conch is also part of a related Buddhist set of motifs known in China as the EIGHT Lucky Emblems.

The Maya and Aztec used the conch as a ceremonial horn. The top of the shell has a STAR-like shape with a natural spiral in the centre, sometimes called a 'WIND jewel', a symbol of QUETZALCOATL as Lord of the Winds.

## Abalone

As Japanese Buddhist laws prohibit the eating of FISH when mourning, abalone signal a happy occasion. Flattened strips of dried abalone flesh used to be placed inside specially folded papers and attached to the wrappings of special gifts, such as those given at betrothals and weddings; in modern times they have been replaced by yellow strips of paper.

## Scallop Shell

For Christians the scallop or cockle shell symbolizes pilgrimage, associated with the pilgrim's patron saint ST JAMES THE GREATER. The scallop is also associated with birth or regeneration from WATER: VENUS is often shown emerging from a shell, and ST JOHN THE BAPTIST is sometimes shown BAPTIZING CHRIST with one.

A Q U A T I C   C R E A T U R E S

## Crab

Crabs periodically shed their shells and can regrow missing limbs, so to the Japanese they are a symbol of regeneration. They are sometimes described in stories as ghosts, because some species have patterns on their shells that look like human faces. A legend tells how the WARRIOR Yoshitsune and his retainer Benkei fought an army of these ghostly crabs.

In Chinese folk tales crabs are linked with WATER. They were traditionally believed to know where to find water, so they were also connected with drought. There was an ancient belief that crabs wax and wane with the MOON. In Sichuan province mythical JADE crabs were believed to bring plague.

In the Chinese provinces of Shanxi and Henan are found species of crabs that resemble TIGERS' heads when they are dried. Images of tigers' heads were thought to have protective powers, so these crabs were dried crabs and hung above the DOORWAYS of houses to repel evil.

## Coral

Its RED colour links coral with BLOOD, so for Christians coral symbolizes CHRIST'S PASSION. According to Ancient Greek myth, coral was formed from drops of the GORGON Medusa's blood. It was an important feature of Benin royal costume, because the association of coral with blood recalls the KING'S deadly power.

Coral's marine habitat links it to the protective qualities of CANCER. Coral necklaces have been worn by children and babies to ward off disease since Roman times.

There is an old Chinese belief that coral came from a tree growing at the bottom of the SEA. Coral trees were also said to grow in the Buddhist paradise. In Western alchemy coral was called the TREE OF LIFE, and was said to be filled with a blood-like substance. It represented the unification of the four elements, and so was compared to the PHILOSOPHER'S STONE.

Coral is associated with the red planet MARS on the NINE-gem jewels (*navratnas*) of India.

## Pearl

Pearls are highly esteemed as ornaments and are therefore used metaphorically to mean anything of great value, especially wisdom and the truth. In Christian imagery CHRIST is sometimes likened to a pearl, while the VIRGIN is the oyster shell.

Associated by the Ancient Greeks with WOMEN, the MOON, WATER, fecundity and purity, the pearl became a symbol of betrothal, love and the love goddess VENUS, so in Western portraiture, women are sometimes depicted wearing pearl necklaces.

In Chinese alchemy the WHITE Pearl represents Great YANG, which contains within itself the true alchemical MERCURY; the BLACK Pearl is Great YIN, containing the true LEAD.

The mysterious sacred CAULDRON of the Celts has been described as being bound with a rim of pearls. This could have represented the planets, with the cauldron representing the SKY, or it may have symbolized the SEA.

## Fly

Beelzebub, the Phoenician Lord of the Flies, was the agent of destruction and putrefaction, considered to be the god of the dunghill by the Hebrews. Flies were the third of the ten plagues of Egypt. In the Zoroastrian sacred text, the *Avesta*, the DEATH DEMON takes the shape of a fly. Consequently, images of flies are thought to ward off demons.

In the Ancient Egyptian New Kingdom (1550–1100 BC), flies were associated with persistence and bravery, and GOLD images of them decorated WARRIORS. Fly AMULETS have been found on magic wands (above) and, in a text from the New Kingdom a magician is described entering a body like a fly in order to see it on the inside.

The Norse TRICKSTER LOKI transformed himself into a fly in order to steal a gold necklace that belonged to the goddess FREYJA. In the Native American Navajo healing ceremony chant, the spiritual messenger Dontso (Big Fly) guides the heroes of the chant on their journey.

## Bee

Because of their industrious, collaborative labour in the hive, bees symbolize society, industry, and working for pleasure and the common good.

The Ancient Greeks believed that bees were born spontaneously from the carcasses of OXEN or CALVES – a belief that was related to Samson's famous riddle about the swarm of bees he found in the carcass of a LION he had killed: 'out of the strong came sweetness' (Judges 14:14).

Bees also symbolize the dangers of sweet love. In Renaissance emblems CUPID is sometimes stung by bees while tasting HONEY. In Hinduism, Kama, god of love, has a BOW-string of bees, and in Chinese art a bee (or a BUTTERFLY) hovering round or landing on a flower often symbolizes the courting of a woman by a man.

Bees were the tears of the Ancient Egyptian SUN god RA, while the ruler of Lower Egypt was known as 'He who belongs to the Bee'.

## Butterfly

Classical mythology associates butterflies with the SOUL, linked with Thanatos (DEATH) and Hypnos (SLEEP). PSYCHE is often represented as a butterfly. Sylphs, invisible female spirits of the AIR whose voices are heard in the WIND, are named from the Greek *silphe* ('butterfly' or 'MOTH'). The Aztec associated butterflies with WOMEN who died in childbirth and WARRIORS who died in battle. In some Chinese stories butterflies represent dead women's souls; but they also symbolize SUMMER, joy and longevity. For many Native American tribes butterflies symbolize the souls of the dead, but also transformation (because the insect emerges from the chrysalis) and beauty.

The butterfly signifies FIRE to the Aztec, while in Celtic SOLAR festivals the firebrand that rekindled the HEARTH fire after it had been extinguished was called the 'butterfly'.

In the Scottish borders and among the Kwele of Congo and Gabon, butterflies are associated with WITCHES.

## Moth

Moths symbolize idealism (because of their attraction to LIGHT), DEATH (they immolate themselves in FIRES), and madness (they fly toward lights when they emerge at night, yet the only visible light is the MOON, which they cannot possibly reach).

Some Native Americans associate moths with whirlwinds because of the whir of their wings and the swirled patterns of their cocoons.

## Firefly

The Ancient Chinese scholar Jiu Jin was said to be so poor that he studied by the light of glow-worms, signifying perseverance. In China and Japan fireflies were interpreted as the SPIRITS of the living or the SOULS of the dead (above). They were also symbols of passionate love.

## Scarab

The Ancient Egyptians believed that a scarab's offspring were born from a BALL of dung, which the parent rolled in front of itself. As Khepra, the scarab beetle (above) then became a symbol of the rising SUN, which it rolled up into the SKY like a dung ball. Scarab AMULETS made of steatite (soapstone) were laid with the dead to represent resurrection.

## Grasshopper

Grasshoppers are related to the MOON in Japanese culture. Their relatives, the locusts, are the insect mentioned most frequently in the Old Testament. Locusts were the eighth plague of Egypt, brought by the EAST WIND, and are symbols of destruction, wasting, drought, pestilence and calamity. They were blown away by the west wind, so they may also signify helplessness.

## Cicada

The longest-lived of all insects, cicadas can live for seventeen years or more. They periodically shed their skins as if being reborn. They were therefore believed by the Ancient Greeks to be immortal and sustained for eternity by DEW and AIR while they sang ecstatically – so they were regarded as intermediaries between the living and the dead. Similar beliefs were held in Ancient China, where pieces of JADE in the form of a cicada (above) were put in the MOUTHS of the dead from the late Zhou (1100–256 BC) to the Han (206 BC to AD 220) periods, to prevent their bodies from decaying.

Male cicadas sing all summer to attract females, so the species has become a symbol of happiness in China. In Japan during the Nara Period (AD 710–794) and the Heian Period (AD 794–1185), the cicada was described in literature as an AUTUMN insect, symbolizing solitude and melancholy.

## Mantis

In Ancient Egypt the mantis sometimes appeared as a psychopomp (a leader of SOULS) in place of ANUBIS or Wepawet. The Asmat people of south-west New Guinea use PHALLIC-shaped carved poles called *bis* to represent their ANCESTRAL SPIRITS; one of the most popular spirits is represented by the praying mantis.

## Silkworm

Silkworms represented purity and virtue in Ancient China and Japan, possibly because they were reared by WOMEN. In the SPRING, Chinese empresses would make ritual offerings of silkworms and the MULBERRY leaves on which they fed. The Japanese believed that silkworms and mulberries were created from the union of the FIRE god and EARTH goddess.

## Spider

Spiders are widely associated with WEAVING and with MOON goddesses, who are thought to control human destiny. In Ancient Egypt the spider was sacred to NEITH, the great weaver. In Ancient Greek mythology the mortal Arachne challenged ATHENA in the art of weaving and was turned into a spider for her impudence. In West Africa, the spider – associated with the Ashanti spider god ANANSI (above) – is said to have taught humans how to weave.

Native American peoples of the south-west relate how SPIDER brought the ALPHABET to humans, showing the shape of the letters in the angles of the web. As a result of its strength, near-invisibility and ability to withstand considerable damage without collapsing, the web was believed to bestow these qualities on WARRIORS, who decorated themselves with weblike designs.

In the Old Testament a spider's web denotes anything flimsy and perishable, and symbolizes the easy destruction of wicked designs and hypocrisy.

## Scorpion

In the Babylonian *Epic of Gilgamesh* (mid-7th century BC) Scorpion Men guarded the GATES of the UNDERWORLD, through which the SUN god Shamash departed and entered each day. In Tell Halaf, an Assyrian vassal city of the 9th century BC, sculptures of Scorpion Men guarded the municipal gateways. The Ancient Egyptian scorpion goddess SELKET, identified with the scorching heat of the sun, was one of the four goddesses who protected the dead OSIRIS. In the tomb she also protected the sarcophagus and the CANOPIC JARS holding the mummy's INTESTINES.

In the Old Testament scorpions, inhabitants of a waterless land of hard rocks, represent DESERT, drought, desolation and danger.

The scorpion is sometimes included in the traditional Chinese group of the FIVE Poisons (along with the SNAKE, the TOAD, the CENTIPEDE and the SPIDER). If these animals were put in a jar and left to devour each other, a potent poison was believed to remain in the last one left alive.

INSECTS • ANIMAL PRODUCTS

### Centipede

The Ancient Egyptian centipede god Sepa, associated with OSIRIS and the necropolis, protected against other animals and the enemies of the gods. The centipede is regarded by the Chinese as one of the FIVE Poisons (see entry for SCORPION). In Japan it is one of the attributes of Bishamonten, one of the SEVEN DEITIES OF GOOD FORTUNE.

### Fleece

In Ancient Greek myth, HERMES gave a GOLDEN RAM the ability to speak and FLY. It was SACRIFICED to ZEUS and its fleece hung in a GROVE (above). Jason and the Argonauts set out to retrieve it, and the many difficulties they met along the way symbolized a spiritual journey, akin to the quest for the Holy GRAIL.

### Animal Skins

In many cultures animal skins are thought to possess and reflect the qualities of the animal. For many African tribes the LEOPARD was the KING's beast, so kings wore leopard skins to denote their status. In Hinduism many deities and *sadhus* are depicted meditating on DEERskin mats, symbolizing the innocence and purity of a forest creature. The skins of powerful animals such as TIGERS (above) imply power and ferocity (as with the goddess of destruction, KALI). Other skins, such as RHINOCEROS hides, have protective qualities and have been used to make SHIELDS.

Early Egyptian priests who performed the ceremony of 'Opening the MOUTH' wore PANTHER or leopard skins, which were often portrayed on coffin lids. The protective household god BES also wore a leopard skin.

ADAM AND EVE's first clothes were animal skins, symbolizing their descent from divine grace into error and earthly existence.

During the Exodus, the Jews used tanned RAMS' skins as the CURTAINS of the Tabernacle.

### Feathers

In Ancient Egypt feathers were associated with MAAT, the goddess of truth, whose RED OSTRICH feather (above) was used as the balance for the HEART of the dead in the SCALES of the Hall of Judgment. As the consort of THOTH, who was thought to have invented writing, Maat's feather is also the instrument of script.

In Hawaii, feathers that represented the SPIRIT were traditionally tied to a wooden structure symbolizing the human world. In the Japanese folk tale *Hagoromo,* a feather robe is the magical apparel of a female WATER spirit. The feathered cloaks of the Celtic MORRIGAN and Norse FREYJA symbolize their ability to transform into BIRDS.

Feathers are used in spectacular HEAD-DRESSES by North, Central and South American peoples. The Aztec used GREEN Quetzal tail-feathers in making head-dresses for their high rulers. For Native Americans feathers contain the power of the bird. The gift of an EAGLE feather is a particular honour, and must be earned.

## Horn

Horned deities were common in Celtic cultures: the name of the horned god CERNUNNOS means 'Horned One', indicating his relationship to the SOLAR STAG.

Drinking horns had the same connotations of plenty and feasting as GOBLETS. The Norse VALKYRIES held them while greeting the dead in VALHALLA. The Ancient Greek god ZEUS turned the goat Amalthea's horn into the CORNUCOPIA.

In Ancient Egyptian hieroglyphs the horn represented respectful fear, and it appeared on the HEAD-DRESSES of many deities. The sky goddess HATHOR was said to have lifted the SUN god to HEAVEN on her horns.

God instructed the Israelites to make an ALTAR with its FOUR corners raised and pointed like horns. The LAMB of the Revelation has SEVEN horns, representing the seven gifts of the SPIRIT and also echoing the symbolism of the Menorah – the sacred CANDELABRUM used in Jewish worship – the design of which was given to MOSES by God.

## Ivory

Valued in Africa because of its relative permanence and its association with the ELEPHANT, a royal animal symbolizing strength and longevity, ivory is used in the regalia of African KINGS. Its WHITENESS symbolizes purity.

In the Bible ivory also carries connotations of kingship. The THRONE of Solomon was made of ivory; the PALACES of kings were panelled with it and the beds of the very rich inlaid with it.

The Ancient Greeks associated ivory with incorruptibility and purity. Two of their most celebrated cult statues, those of ZEUS at Olympus and ATHENA in the Parthenon in Athens, were made by Phidias (active *c.* 465–425 BC) from GOLD and ivory. Homer refers to the GATES of Dreams: a gate made of ivory signified false insights, while a gate of HORN symbolized true inspirations because of its relative opacity and translucence.

## Honey

As the sweetest food available to early cultures, honey symbolized bliss. From this arose its use as a libation for the gods and its association with immortality. The Greco-Roman god DIONYSUS/BACCHUS was said to have been fed on honey as an infant, and libations of MILK and honey were offered to him and drunk by his initiates at sacred festivals. Offerings of honey and WHEAT-cakes were also made to the MUSES and to the goddess of magic, HECATE. The Babylonian hero Gilgamesh offered a pot of honey and one of butter to the SUN god Shamash. The Maya used an ALCOHOLIC honey drink in rituals.

Honeyed words are persuasive and eloquent. BEES were said to have put honey in ST AMBROSE'S MOUTH as he slept in his cradle. The sweetness of honey has been compared to the sweetness of love. A poem celebrating the sacred marriage of the goddess INANNA (*c.* 2500 BC) describes her lover as a 'honey-man'. These annual rites may be the origin of the 'honey-MOON' (or 'honey-month').

A

B

C

## Egg

Eggs are symbols of birth and regeneration. In Ancient Egypt egg AMULETS were sometimes laid next to the mummy and the innermost coffin was referred to as an egg. Clay eggs have also been found in prehistoric tombs in Russia and Sweden. The eggs given at Easter to celebrate the resurrection of CHRIST have their origins in older pagan traditions related to SPRING and the rebirth of the fertility of the LAND (A).

Eggs are associated by many cultures with creation and with the cosmos. A belief of the Ancient Egyptians was that the primordial egg was laid by GEB (the earth) or AMUN (the primeval creator god) and was hidden in a swamp, or that it was created by PTAH, the creator god of Memphis, on his potter's WHEEL.

The Hindu myth of the Cosmic Egg states that the world developed from an egg, which had lain dormant for a while before splitting into two halves (HEAVEN and EARTH) (B). The veins of the egg became RIVERS, and the fluid inside it became the SEA.

A Chinese creation myth relates how the world initially resembled a CHICKEN's egg. After 18,000 years the lighter matter drifted up to form the SKY and the heavier part (or the yolk) sank down to make the earth. Followers of the *hun-tian* or 'ecliptical' theory, one of the competing astronomical theories in China during the 1st and 2nd centuries AD, believed that the earth was still contained within a huge egg, floating like a giant yolk, and that the white was the SKY. The ancient Chinese symbol for YIN AND YANG resembles an egg.

In traditional Chinese culture, eggs appear in many myths about divine or virgin births. The founder of the Shang Dynasty (*c.* 1700–1050 BC) was said to have been conceived after his mother ate an egg dropped by a divine BIRD. In addition to the mythical founders of Ancient Chinese dynasties, various humans and animals with supernatural powers were also said to have been born from eggs.

The Ancient Egyptian sun god RA emerged as a FALCON from the egg of creation. DRAGONS were also commonly thought to have hatched from eggs (C).

In Western alchemy the egg symbolizes the hermetically sealed alchemist's 'retort', within which the alchemist attempts to mimic creation. It also symbolizes of the *prima materia*: the YELLOW yolk is seen as MALE (SUN, GOLD), and the WHITE albumen FEMALE (MOON, SILVER); it is contained by a coiled SERPENT that represents time.

For Jews, the roasted egg and bone served at the *Seder*, the family meal preceding *Pesach* (Passover) symbolizes the animal offerings that were brought to the Temple in Jerusalem in ancient times.

## Milk

Milk is synonymous with
nurturing and so with compassion
and MOTHERHOOD. Myths abound
of abandoned infants who were
rescued by bountiful wet-nurses.
Romulus and Remus, legendary
founders of Ancient Rome, were
suckled by a she-WOLF. In
Ancient Egypt milk was the
nourishment of the gods: the
sun god HORUS is shown being
suckled by ISIS or by NUT in the
form of a celestial COW. Milk was
also left with the dead in the tomb,
and the pyramid texts (prayers,
hymns and spells inscribed on
the walls of burial chambers
inside the pyramids) say 'take
the BREAST of your mother Isis'.

The WHITENESS of milk also
symbolized purity. In Greco-
Roman culture, milk, WATER, OIL
and WINE were the FOUR standard
libations poured in honour of the
gods. For the Jews, milk, along
with HONEY and wine, symbolizes
good fortune and prosperity.
According to the Jewish
scriptures, Israel restored will
be 'a land flowing with milk
and honey' (Joshua 5: 6).

# MYTHICAL
# BEASTS

A

B

C

## Fairy Folk

Despite being closely allied to SPIRITS, European fairies usually appear in human form but in a much smaller size, often with insect-like semi-translucent wings (A). A few may nonetheless be of normal human proportions or even as large as GIANTS. They are in fact very far from being human and may be held responsible for anything regarded by humans as outside ordinary experience or expectation.

In modern Western culture, fairies are generally considered benign. Other cultures present and past have perceived them differently. Fairies in the Celtic world, for example, have always been regarded with a good deal more circumspection. Celtic fairies may own 'fairy cattle', ride WHITE HORSES, and be accompanied by GREEN or white DOGS with RED EARS. Their notion of time is altogether different – a day for them may be as long as a hundred years for us. Their food may be tempting for humans, but if a human was to eat any, he or she would never return from

fairyland. An extension of this is the common theme of human abduction by fairies: Celtic fairies are particularly fond of abducting CHILDREN. The Tylwyth Teg ('beautiful kinsfolk') of Wales tended to steal newborn babies and swap them for sickly changelings. Children in Scotland might be stolen away as part of the tribute paid to HELL every SEVEN years. It was not just children who might be taken, however, for in Celtic lore fairies also regularly spirited away musicians and poets for their own entertainment, and young women to act as wet-nurses.

Abduction also features in fairy lore elsewhere. The Apicilnic folk of Northern Canada are similarly held to kidnap children. Other fairies less than helpful to humans are exemplified by the Lawalawa of the North-west Coast of North America, who are visible only at night, when they have a fondness for throwing ROCKS at humans' houses.

Fairies beneficial to humans include the Djigaahehwa folk revered by Native American tribes

of the north-east. These tend the medicinal plants used by the tribespeople for healing. The Deetkatoo of the Tillamook people of north-western North America, who embody the essence of the balanced natural world, bring good fortune to those who treat them with courtesy and show respect for their environment. In Brazil, the forest-dwelling Curupira – who is short like a boy, but has reversed FEET so that his toes point backwards (B) – leads humans astray who may damage his forest.

There are groups of mythological peoples who have long been classified by Western commentators as fairies, although this may be a poor reflection of the qualities that are actually attributed to them. The Chinese *xian nü* ('sacred maidens'), for example, were not necessarily small and have also been considered as goddesses. They included XI-WANG-MU (C), the Queen Mother of the West. Irish Tuatha Dé Dannan were probably earlier deities; they became known as the Sidhe, the fairy folk, after they retired beneath the HILLS and LAKES.

## Djinn

Djinn (a plural word) are half-human, half-DEMONIC creatures whose origins lie in pre-Islamic Arabian mythology, where they were spirits of nature and the DESERT, symbolizing the dark side of nature over which man had no control. In Islamic folklore they are formed of AIR and FIRE (as opposed to the CLAY and LIGHT of which humans and angels are formed).

Even so, they share much with humans – they have the same bodily needs, they reproduce, and they die (although their life span is much longer). Moreover, like humans they can choose to serve Allah or follow the path of evil. Evil djinn take pleasure in wreaking havoc among humans. There are five orders of djinn: in descending order of powerfulness, the Marid, the Afrit, the Shaitan, the Jinn and the Jann.

The djinn are by tradition subject to human control through the use of spells or esoteric incantations. This is the origin of the notion of the 'genie' in the LAMP or bottle.

## Giant

The two main characteristics of giants are their enormous size and the fact that they belong to an extremely primitive age. Giants existed at the beginning of the world, sometimes creating it. They are named after the ancient Greek *gigantes*, who fought the Olympian gods and lost. The Chinese tell how the earth's features such as trees and RIVERS appeared from the dying body of the giant Pan Gu. There is a similar story about the Norse frost-giant Ymir (above). In Japan, giants (*kyojin*) were believed to have created natural features such as MOUNTAINS and LAKES.

Giants are usually cruel, eating humans, such as the Greco-Roman ONE-EYED Cyclops. Often evil, they can be outwitted by men and gods, as in the biblical contest of David and Goliath, or that between the frost-giants and deities of Norse mythology. But giants could also be benign, using their strength to help people: the Iroquois Dehotgohsgayeh protects humans against malice.

## Dwarf

Dwarfs are like people, but much smaller. European dwarfs inhabit CAVES, HOLES beneath the ground, or hollow trees – in Norse lore, these are the places where the dark dwarves and elves (often interchangeable) could be found, the light elves living in Alfheim, in the HEAVENS. Such supposed closeness with the EARTH often means that dwarfs are said to live by mining METALS and JEWELS (above), and to be skilled in metal-working – they made magical objects such as the Brisings' necklace for which FREYJA allowed its four dwarf makers to sleep with her.

In other cultures, dwarfs are associated more generally with nature-SPIRITS. Desana, the master of animals and fish in the Amazonian region, is represented as a dwarf bathed in the juices of magical plants. He dominates the forests and RIVERS. The dwarf Wanagemeswak of the Penobscot people of north-eastern North America are unusual in being aquatic: they live in small pools and rivers, and are so thin as to be visible only when seen in profile.

M Y T H I C A L  B E A S T S

### Wild Man

Wild men are human in form, but with features symbolizing their animal natures – for example, excessive HAIR (above), HORNS or large TEETH. Essentially a representation of the forces of nature – like the GREEN MAN with whom they were allied – they were also known as woodwose during the Middle Ages.

In New South Wales there was a large, hairy male SPIRIT called Dul(v)ga(w), and a bush APE-man known as Guna:m(v)ldajn. Other stories from the area tell of the frightening Yowie or Yahoo that raided settlements during the night. But it is unclear whether these creatures were known before the Europeans arrived.

However, the North American Big Foot or Sasquatch (its name probably deriving from a Salish word for 'wild man of the woods' or 'GIANT'), was known to Native Americans long before the arrival of Europeans; it was greatly respected as a supernatural, spiritual being. The Tibetan Yeti, or Abominable Snowman, myth is similar to that of the Sasquatch.

### Sphinx

The best-known form of sphinx had a human HEAD and a LION's body, although variations could be found around the eastern Mediterranean, Asia Minor and Mesopotamia; for example, Assyrian and Greek sphinxes had EAGLES' WINGS. They sometimes included parts of other animals as well; it has been suggested that the sphinx originated as an amalgam of the FOUR LIVING CREATURES – human, lion, BULL, and EAGLE – to be seen in Assyrian deity-figures such as LAMASSU.

Most sphinxes were FEMALE, as was the Assyrian sphinx with its eagle's wings (it was the female counterpart of the winged bull), but the Great Sphinx of Egypt (above) is MALE, and was known as 'HORUS on the Horizon', or Harmachis. Sphinxes were enigmatic and ambivalent, both wise and cruel. The sphinx that lay in wait outside Thebes required passers-by to answer a riddle; if they gave the wrong solution, they were devoured. Only Oedipus answered correctly, and the sphinx killed itself (or was killed by Oedipus).

### Centaur

In Greco-Roman mythology, a centaur had a human head and torso on top of a horse's body (above). They were lecherous and brutish, becoming inebriated at the merest whiff of WINE: at the MARRIAGE FEAST of the Lapith KING, the centaurs tried to abduct the bride, raped the female guests and bludgeoned their hosts with stone slabs and tree trunks. The battle of the Lapiths and centaurs, and the Lapith victory, can be interpreted symbolically as Greek civilization (Lapiths, the intellect and reason of APOLLO) versus barbarous chaos (centaurs, the instinct and animal passion of DIONYSUS).

However, Chiron, the only immortal centaur, was exceptionally wise and gentle, tutored by ARTEMIS and Apollo and in turn mentor to several heroes including ACHILLES. Wounded by HERAKLES, Chiron chose to exchange his immortality for PROMETHEUS's mortality rather than exist in terrible pain. ZEUS eventually placed him in the night sky as the constellation SAGITTARIUS.

## Satyr

Like PAN, the chief of satyrs, a satyr had the head and torso of a MAN, and the HORNS and hindquarters of a GOAT (above). Satyrs inhabited the woods and MOUNTAINS, drinking WINE and chasing nymphs. Representing man's carnal, instinctive drives, they were mischievous and libidinous – but generally benign, promoting the health and fertility of flocks and the GRAPE harvest.

## Bird People

Make Make was the creator god of the people of Easter Island; he is represented as a man with a BIRD'S HEAD, often holding the EGG from which the universe was formed.

A common symbol in Maori carvings is the Manaia (above), a human body with a stylized head with a pointed beak; it seems to have some magical potency.

## Merpeople

Mermaids and mermen are marine creatures with the HEAD and upper body of a human and the tail of a FISH (above). Similar beings appear in ancient mythologies (for example, the Chaldean SEA god Ea), and they are included among the denizens of POSEIDON's underwater kingdom. In European folklore, merpeople were natural beings who, like FAIRIES, had magical and prophetic powers and loved music, often SINGING (like SIRENS). They were usually dangerous to humans, and to see one on a voyage portended shipwreck. They sometimes lured mortals to death by drowning – for example, the Lorelei of the Rhine and the Scottish Kelpie. Aquatic mammals that suckle their young above water in human fashion, such as seals and manatees, are considered by some to lie behind these legends.

The Inuit believe in a 'Sea Woman', who lives deep in the ocean and has mastery over all the mammals of the sea.

## Siren

The siren is a winged beast with the HEAD and BREASTS of a WOMAN, and the body of a SNAKE or a BIRD. Its appearance is the same as that of LILITH, when she is depicted as the night monster (who originated as a Babylonian female DEMON).

Sirens were traditionally found on the Italian coast near Naples. Known for the beauty of their singing, which they used to lure sailors to their deaths on the rocks, they were said to be the daughters of one of the Muses. Odysseus escaped them by being lashed to his mast and stopping up his crew's EARS.

Amazonian manatees have been mistaken for – and described as – sirens or MERMAIDS by Europeans since the time of Christopher Columbus. The *Iara* (also known as *mãe d'água*, 'mother of the waters') is a Brazilian siren-figure, whose identity and name were finally established in the 18th century. Originally, she was the water SNAKE, *boiúna* or *mboiaçu*.

MYTHICAL BEASTS

MYTHICAL BEASTS

## Harpy

Terrifying hags with the bodies of BIRDS and with sharp talons, the Ancient Greek harpies ('snatchers') were originally beautiful winged maidens. Called Aello, Celaeno and Ocypete, they were identified with storm WINDS, and were said to snatch the SOULS of those who died prematurely and to carry them to the UNDERWORLD, where they inflicted torments on the dead.

## Gorgon

In Ancient Greek myth, there were three Gorgons – monstrous women with scaly skin, fangs and SNAKES for HAIR, whose gaze could turn a human to STONE. They became powerful apotropaic talismans: *gorgoneia*, carved stylized gorgons' heads, were placed on buildings, ARMOUR and weapons.

## Minotaur

The Minotaur was a MAN with a BULL's head and tail. It symbolized a joining of the natural and supernatural worlds, of human rationality and animal instincts. According to the Ancient Greeks, POSEIDON sent the Cretan KING Minos a snow-WHITE BULL from the SEA. However, the covetous king failed to SACRIFICE this magnificent animal to the god. In revenge, Poseidon caused Minos's wife, Pasiphaë, to desire the bull. The master artificer Daedalus made her a wooden heifer, in which she hid as the bull sired a child upon her – the Minotaur. Daedalus was punished with imprisonment (with his son ICARUS) in the LABYRINTH, a series of maze-like passages and chambers which he had created. The Cretans, afraid of the Minotaur, also imprisoned it in the Labyrinth, where each year it devoured SEVEN maidens and seven youths sent as a tribute from Athens – until Theseus found his way to the heart of the Labyrinth, assisted by Ariadne's THREAD, and killed the monster.

## Kappa

Japanese kappa (also called *suiko*, 'water TIGERS') are child-sized RIVER creatures with tiger-like snouts, lank HAIR, and a hollow in the top of their HEADS that contains a liquid said to be the source of their supernatural powers. They are dangerous to any who enter the water, but are also polite and partial to cucumbers.

## Tengu

Tengu live in the Japanese MOUNTAINS and forests. *Karasu tengu* have MEN's bodies but BIRDS' beaks, WINGS and claws, whereas the more human *konoha tengu* have long NOSES and bright RED faces (above) with WHITE HAIR and BEARDS. Some are malevolent, occasionally abducting CHILDREN; others protect and pass useful skills to chosen persons.

## Basilisk

A LIZARD-like combination of a COCKEREL and a SNAKE, the basilisk can kill with a glance, and is killed if it can be made to see itself in a MIRROR; its poisonous BREATH is also deadly. In the Old Testament, 'basilisk' describes a SNAKE with supernatural powers; it is reminiscent of the viper, the most poisonous snake known in the Middle East.

## Chimera

As described by Homer, a chimera had a LION'S HEAD, a GOAT'S body, and a SERPENT'S tail. It breathed FLAMES. To the Ancient Greeks it was the embodiment of tempestuous storm CLOUDS. By the Middle Ages, it was associated in Western Europe with lustfulness.

## Griffon

Popular among the Babylonians, Assyrians and Persians, the mythical griffon combined a LION'S body, an EAGLE'S HEAD, a SERPENT'S or SCORPION'S tail and sometimes WINGS. Griffons were considered to be good guardians: attentive, swift, brave and tenacious.

## Gargoyle

A gargoyle is a carved rain-spout, used to drain water from the gutters of high church parapets. Medieval gargoyles are mostly grotesque, frowning BIRDS sitting on their haunches. They were considered to be wild scavenging beasts, beyond human control. They may have originated from the dragon-like Gargouille, which was said to have lived in the river Seine and to have ravaged the local area until it was killed by St Romain.

## Naga

To Indian Hindus and Buddhists, the mythical nagas are the sacred SERPENTS of the UNDERWORLD. They have more than one HEAD, and are the chief enemies of the mythical bird GARUDA. They are symbols of fertility and WATER, as they are believed to inhabit the world's subterranean waters, and to have the power to bring forth (or to withhold) RAIN.

*Nagadevas* and *naginis* are SNAKE deities worshipped throughout India, where the cult of the snake is ancient. There are either SEVEN or EIGHT *nagarajas* ('serpent rulers'), so the naga symbolizes the numbers seven or eight.

The nagas' cobra-like hoods are protective symbols, often depicted as a sort of CANOPY over the heads of deities. The *nagamudra* or 'snake-pose' is a related HAND GESTURE in which the fingers of both hands are held in a cupped attitude resembling a cobra's hood.

A

B

C

## Dragon

The word 'dragon' stems from the Ancient Greek for 'SERPENT'. Found in the mythologies of many cultures, in East Asia dragons are usually described as beneficent. In the West they often symbolize evil, and are frequently represented as enormous FIRE-breathing BAT-WINGED serpents (A and C) with barbed tails, and sometimes with a number of identical HEADS. They often live in dark CAVES, guarding chests of TREASURE like the Norse dragon Fafnir, who began life as a DWARF, but spent day and night guarding the hidden hoard of GOLD he received as his reward for killing OTTER on behalf of the gods. His greed slowly changed him into a dragon – as a result of which he was eventually killed. A dragon that owned a great PEARL is said also to have lived once in Mount Kinabalu in Borneo. According to the Ancient Greeks, a dragon called Ladon guarded the Golden Apples of the Hesperides.

The original belief in dragons may have been inspired by the sight of meteorites streaking through the night sky and appearing to come down somewhere far out to sea. This would explain why dragons, although fire-breathing, are often associated with WATER. In China they were believed to control and live in water, and to be RAIN-makers. Celtic dragons are also associated with watery places. The Native American Seneca tribe tell how their fire dragons (the Gaasyendietha) live in deep water so that they do not set the world on fire.

The link between dragons and meteors would seem to be affirmed by the Celtic story in which King ARTHUR's father Uther took the surname Pen Dragon ('head of the dragon') after he sighted a dragon-shaped COMET. It would also explain why not all dragons have wings, and yet all fly. In East Asia, this capacity for flight is said to derive from magic, or through the powers of a special lump on their CAMEL-like heads. Dragons in China (B) are often depicted flying through CLOUDS when they are not playing with pearls that may variously represent good fortune, THUNDER, or wisdom; different-coloured dragons are associated with each of the DIRECTIONS and SEASONS. The dragon is the FIFTH sign of the Chinese ZODIAC – people born within its year are held to be honest and energetic, but short-tempered.

Dragons take up residence near human settlements and demand human SACRIFICES – often falling victim to celebrated dragon-slayers. Perhaps the most famous of these is ST GEORGE, who rescued a Cappadocian princess. The Dausi people of West Africa tell how a dragon called Bida laid siege to the CITY of Wagadoo, and demanded the annual sacrifice of a young girl in return for spewing gold over the city. The practice went on until the lover of the girl next to be sacrificed decapitated it, and the head then bounced all the way to the Gold Coast – which is why gold is so plentiful there.

## Serpent

Serpents are often associated with evil: for example, in China. Christians believe that the treacherous serpent that tempted Eve was responsible for humanity's expulsion from Paradise. Serpents are also associated with healing: for example Moses' brazen serpent, or the serpent on the STAFF of Asclepius, the Greco-Roman god of healing.

For the Ancient Egyptians, serpents could be forces for evil (Apep) or good (Khematef). Australian Aborigines tell how the Rainbow Serpent created MOUNTAINS, RIVERS and LAKES and made the land fertile.

The Celts seem to have related HORNED serpents to the Horned God (Cernunnos – above), while in Central America the Aztec FEATHERED serpent was a symbol and manifestation of Quetzalcoatl. In North America, the Uktena of the Cherokee nation was a great horned serpent with a dazzling JEWEL in its forehead. The Doonongaes of the Seneca tribe lived in WATER and was able to SHAPE-SHIFT into human form.

## Ourobouros

The Ourobouros, a great SNAKE curled around on itself with its tail in its mouth so that it forms a continuous CIRCLE, is a symbol of infinity. It was central to the Ancient Greek Orphic creation myth, encircling the cosmic EGG that gave birth to the universe. It also played a part in the Greek Eleusian mysteries and the cults of Isis and Mithras.

According to the mythology of Dahomey, West Africa, Aido Hwedo is the RAINBOW SERPENT that encircles and protects the country's capital Abomey in the form of a moat. Part of the Fon people's creation myth, he is said to be coiled up underneath the world, supporting it. The SEA was created around him to keep him cool. He eats IRON bars, and when these run out he will eat his own tail, which will cause the world to collapse into the sea.

## Hydra

This swamp-creature had the body of a SNAKE and numerous HEADS – from SEVEN to ONE HUNDRED, according to different accounts. Any head that was cut off regrew instantly (and sometimes in multiple fashion). It terrorized the Ancient Greek city of Lerna, and was killed with considerable difficulty by Herakles as one of his Twelve Labours.

## Salamander

The mythological salamander is a lizard-like animal that was said by the Ancient Greeks to be impervious to FIRE, living in hearths, furnaces and even volcanic vents. Indeed, salamanders feed on fire, and can even extinguish it by walking in it. They are also conceived of as elemental fire SPIRITS.

MYTHICAL BEASTS

## Cerberus

Cerberus was the hell-HOUND who guarded the gates to HADES. He is variously described as having THREE HEADS or fifty, bristling with SNAKES and slobbering BLACK venom. However, he was calmed by PSYCHE with cakes of flour and HONEY; by Orpheus with music; and by HERMES with his CADUCEUS.

## Leviathan

The Leviathan is a primordial sea-monster, possibly based upon the CROCODILE, which originated in Mesopotamian folklore. It is found in the Bible (Job 41: 1–34). Associating it with the WHALE, medieval Jews considered it to be the counterpart of the BEHEMOTH, the primordial land monster (which was associated with the HIPPOPOTAMUS).

## Unicorn

In medieval bestiaries, unicorns are depicted as HORSES or large GOATS with a single, central HORN on their foreheads. Fierce creatures, they could only be caught by VIRGINS, laying them open to being killed by hunters. In medieval Europe, they thus came to symbolize CHRIST, resting in the VIRGIN MARY's lap and laying himself open to suffering and death.

In the Old Testament, Daniel saw a 'he-goat coming from the WEST with a prominent horn between its eyes', which defeated the two-horned RAM (Daniel 8: 5–7). Jewish scholars relate its single horn to the unity of the SPIRIT.

The *qilin* (Japanese *kirin*), one of the Chinese FOUR supernatural creatures, was depicted with a DEER's body, WHITE or YELLOW fur, and a single horn on its head. It was believed to be a good and gentle creature, which would step on no living thing, not even grass; it would appear in times of peace and prosperity, and symbolized the wise rule of an emperor.

## Thunderbird

The Thunderbird is generally portrayed as a colossal EAGLE-like bird, with LIGHTNING flashing from its WINGS. Of all the SPIRITS of the LAND celebrated in North America, the Thunderbird may well be the most revered.

In Nootka (Vancouver Island) lore, the Thunderbird rules the HEAVENLY realm. WINDS blow when he ruffles his FEATHERS; the SUN shines when he opens his EYES; when he moves his wings, the bright colours of his feathers flash and emit lightning; and when he claps his wings together, thunder is heard – although some say that it is the flashing of his eyes that causes lightning.

Tribes around the Great Lakes believe the Thunderbird to be in continual conflict with the Underwater PANTHER. Their tremendous battles cause the squalls which threaten the lives of people out on the lakes in canoes.

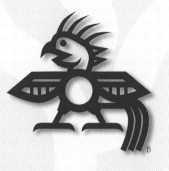

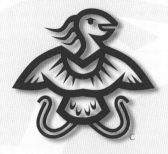

## Phoenix

A BIRD of different form according to different cultures – but probably originally EAGLE-like – the phoenix is associated with FIRE and SUN worship. Its RED and GOLD WINGS were meant to suggest the rising sun – as it renews itself eternally, like the sun rising from the WATER. Hence it was represented in Ancient Egyptian hieroglyphs by THREE parallel wavy lines, emphasizing its connection with water. The most celebrated myth relating to the phoenix's rejuvenation tells of it cremating itself on a bed of spices and aromatic wood, before rising from the ASHES as a young bird again (A). It is a rare bird: only one exists at any one time.

In Egypt it was called the *bennu* or *beno* (the Ancient Greek for which has become the English *phoenix*, B), and was said to return once every Sothic year (approximately every 1,460 years) to sit on the *ben ben* stone at Heliopolis (Greek for the 'city of the sun'). Rather than an eagle, though, here it was generally considered to be a HERON or a wagtail, and was regarded as the SOUL (*ba*) of the god RA, and a manifestation of OSIRIS, a deity particularly associated with reincarnation.

The Jewish Talmud says that after 1,000 years, the bird shrivels to the size of (or turns into) an EGG, then re-emerges.

An obvious symbol of eternal life, for Christians it came to represent the Resurrection of CHRIST and life after death.

The Persian phoenix (C), central to Persian mythology and symbolizing the divine, is called the *si-murg*, which additionally means 'thirty birds'. A 13th-century work by Farid od-Din 'Attar (the *Conference of the Birds*) describes the journey of a group of birds that symbolizes the mystical journey of the soul towards the godhead. After many trials, only thirty birds reached their destination – the *simurg's* PALACE – to find an empty THRONE and a MIRROR in which they saw themselves reflected.

For the Chinese, the phoenix (*feng huang*) is one of the FOUR supernatural creatures, along with the DRAGON (*lung*), the UNICORN (*qilin*) and the TORTOISE (*gui*). It is the chief of the 'feathered creatures', represents the SOUTH and the SUMMER, and is associated with the colour RED. Phoenixes were believed to appear during periods of peaceful and just rule, and were thought to alight only on the drysandra (*wutong*) or paulownia tree – for which reason families planted these trees in their courtyards to attract phoenixes and good fortune.

In Japan the phoenix (*ho-o*) appeared – with other aspects of Chinese culture – in the 6th and 7th centuries AD. It became a popular symbol in the art and architecture of Pure Land Buddhism, which focused on reverence for Amida BUDDHA and emphasized the reincarnation of the spirit. Phoenixes also became popular motifs on the tops of portable Shinto shrines (*mikoshi*). Like the DRAGON, the phoenix became a symbol of imperial authority in Japan.

# FLOWERS PLANTS AND TREES

**6**

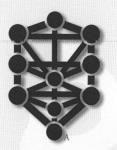

TREES AND BUSHES

## Tree of Life

The Tree of Life appears in some aspect in all creation mythologies of the Near East. It originates in a belief that the earth was flat and CIRCULAR, and above it were the HEAVENS, supported by a tree. This tree is sometimes depicted as the world's axis, with its roots deep in the EARTH and its branches high in the heavens above. It has variously been associated with the OLIVE, the FIG, the date PALM and the GRAPE vine, and their FRUIT.

The Babylonians (C) envisaged the Tree of Life in the context of a GARDEN of Paradise, surrounded by the Apsu, the SEA of creation. In Zoroastrian belief the first tree, home of the *simurg* (PHOENIX), grew in the primordial sea. From it sprang all the varied SEEDS that flourished as the earth's abundant vegetation. In Mesopotamian reliefs of the Sacred Tree, the KING is depicted as its guardian and as the dispenser of its benefits – its fruits and liquids, the symbolic quintessence of life itself.

In Egypt the Tree of Life was symbolized by the SYCAMORE or the date palm (B). It was said

that, if one drank of the WATER of life and ate of the tree's fruit, one lived for ever. In the Classical world the OAK was said to be the Tree of Life, as its branches penetrated the SKY (the heavens), and its roots penetrated the UNDERWORLD.

The biblical Tree of Life in the Garden of Eden (which is different from the TREE OF THE KNOWLEDGE OF GOOD AND EVIL, the fruit of which was eaten by ADAM and EVE) was said to confer immortality.

The Tree of Life is also the Western name given to the diagrammatic representation of the Kabbalah (A) , which was at first envisioned as the branches on a tree. The Kabbalah ('ancient lore' or 'received wisdom') is a system of Jewish mystical thought. Its origin is disputed, although connections have been claimed with Zoroaster, the Zohar, *Sepher Yetzirah* and *Ma'aseh Merkabah* (*The Work of the* CHARIOT). It was later taken up by the Western hermetic tradition (based upon alchemy and the writings ascribed to HERMES TRISMEGISTUS) as a basis upon

which to systematize and structure their own system of beliefs. In its diagrammatic form, the Tree of Life contains three pillars: two on the left and right correspond to the Jachin and Boaz columns on the façade of Solomon's Temple, and an additional central pillar. These represent form, force and consciousness. There are TEN sephiroth (circular points), representing emanations of the divine, and covering all of creation. All of action and reaction is symbolized by the twenty-two PATHS which connect the sephiroth.

The *Kayu Abilau is* the Tree of Life for the Dyak tribes of Borneo. Its trunk is ascended by the dream-wanderers when they are entranced (asleep or awake), to enable them to talk to Aping, the forest god.

The Makuxi (indigenous Amazonians of Brazil and Guyana) believe that Waxacá, the Tree of Life, is the origin of all the plants on which their lives depend, while some Native American tribes regard the CEDAR as the Tree of Life.

## Tree of Heaven

Chinese myths mention huge trees at the centre of the world, which join HEAVEN and EARTH; these include the 'Building Tree' (*Jian Mu*), and the 'Giant PEACH Tree' (*Da Tao Mu*), up which mortals may climb to paradise – provided they succeed in passing the guardian deities at its apex. The 'Leaning Mulberry' (*Fu Sang*) is a world tree, situated in the EAST, where the SUN rises each morning. Legends describe how, in a time of terrible drought, the tree harboured TEN SUNS. A mythical hero, Yu the Archer, shot down NINE of the suns to save the earth.

Pre-Columbian cultures perceived the earth as a flat disc pierced at the centre by a mysterious hole or conduit. A supernatural ceiba tree (silk cotton or kapok tree) filled this space and connected the heavens to the WATERY depths of the UNDERWORLD. The Maya believed that the SOULS of the dead ascended through its roots and climbed the ceiba tree to reach heaven above.

Irish mythology calls the YEW 'the tree that is in paradise'.

## Tree of the Knowledge of Good and Evil

The Tree of the Knowledge of Good and Evil – said to have been a FIG or an APPLE tree – is the tree in the GARDEN of Eden whose fruit Eve was tempted to eat by the SERPENT. A Gnostic legend relates that the wise serpent advised ADAM AND EVE to eat from this tree so that they should acquire knowledge of good and evil. Thus they would see through the illusion of their unthinking enjoyment of Paradise to perceive how different they were from the transcendental divinity of God.

The Kabbalistic TREE OF LIFE is also known as the Tree of the Knowledge of Good and Evil. It is said to exist in two dimensions – one that leads to an understanding of God's goodness; and another (the Qliphoth, 'empty shells', 'negative reflections') that leads to evil. They are in fact one and the same: it is impossible to take the path of good without knowing and understanding the nature of evil.

## Camphor Tree

In Imperial China camphor was believed to have aphrodisiac qualities (so a 9th-century emperor took it daily). Camphor wood protects against insect attack, so it was used to make document-chests. In Japan camphor trees were worshipped along with other evergreen trees and believed to be temporary residences for the gods on earth. Camphor trees can grow to an impressive size, which may explain why they attracted veneration.

T R E E S   A N D   B U S H E S

### Yggdrasil

In Norse mythology Yggdrasil was the mighty ash tree at the centre of the world, with its roots deep in the UNDERWORLD (where the DRAGON Nidhogg lived, tearing human corpses apart). Other roots curled into Asgard, the home of the Norse gods, under which was the WELL of Urd, where the Norns lived. Another root curled under Jotunheim, the land of the frost GIANTS, where a SPRING was guarded by the wise Mimir.

Yggdrasil's trunk was in Midgard, the world of men. Along it ran the squirrel Ratatösk, communicating insults from the dragon Nidhogg, up to the EAGLE and HAWK who lived in its branches in the heavens.

The fearsome ODIN hanged himself upside-down on Yggdrasil for NINE nights pierced with a SPEAR in order to learn the runes and gain understanding. *Ygg* means 'terrible one', and *drasil* means 'HORSE'. Thus Yggdrasil was 'Odin's horse' or 'gallows' – and the Norse poets often spoke of the gallows as a horse.

### Oak Tree

In Greco-Roman culture oaks were synonymous with strength and power. They were sacred to ARTEMIS, Cybele, HECATE and ZEUS (they were believed to attract LIGHTNING), and so also to Romano-Celtic deities associated with Jupiter, like TARANIS. In some accounts, HERAKLES' CLUB was made of oak.

Although Jews associated the oak with forbidden heathen worship, they retained a belief in its connection with the supernatural. An ANGEL appeared to Gideon sitting under an oak tree; prophets prophesied while sitting beneath oaks.

The word 'oak' shares its etymological origin with 'DRUID', and was the tree associated with the druids' sacred GROVES. In European folk tradition, the Oak KING was killed at midsummer (just as the HOLLY King was killed at midwinter).

In Japan the oak symbolizes good fortune and protective powers. Oak branches are placed at house GATES to attract the gods during the Japanese New Year.

### Grove

Egyptian towns usually had a sacred grove where the god's *ba* (SOUL) rested. In Greco-Roman mythology groves were sacred places, protected by different gods: the GOLDEN FLEECE hung in a grove dedicated to MARS; and LAUREL copses were sacred to APOLLO, OAK copses to JUPITER, and OLIVE groves to MINERVA. Groves were also places of refreshment and sanctuary: the unfortunate Oedipus eventually found solace in a grove at Colonus, near Athens.

Groves, especially of oak trees, were DRUIDIC places of worship. Later, early Celtic churches were found on MOUNDS surrounded by a circle of YEW TREES.

In the Old Testament, groves used for heathen worship were called *asherot* and they represented a goddess of the same name. Specifically, the *asherah* was a pillar by the ALTAR, or a tree in these groves. It was therefore forbidden to raise a pole or tree by the altar in the Temple. In Daoist illustrations, a grove or a wood represents the element of wood, SPRING and the LIVER.

## Cedar Tree

The long-lived evergreen cedar tree was sacred to the Phoenician Goddess ASHTART, and the Sumerian TAMMUZ. Because its wood was believed indestructible it was associated with fertility and immortality. Cedar OIL was used in embalming: the Egyptians used it to dissolve the organs and purify the mummy. The Celts used cedar oil to preserve the HEADS of enemies taken in battle.

As a sacred and expensive wood, cedar was used for cult statues and images of ANCESTORS in the Classical world. The Temple of SOLOMON had a cedarwood roof and King David had a house that was built entirely of cedarwood.

Native Americans of the north-eastern USA and Canada have also long held the cedar in high esteem, using the wood and shredded bark to make ceremonial MASKS, FLUTES and DRUMS.

The Japanese cedar (*Cryptomeria*), regarded as auspicious in Japan since ancient times, is linked with Shinto religious observances.

## Chestnut

The Chinese word for chestnut resembles words meaning 'good manners', 'fearful' and 'sons', and the chestnut may be symbolic of any of these. The evergreen Japanese chestnut is used in New Year decorations, placed at house-GATES as temporary homes for the gods, attracting good fortune for the coming year.

## Christmas Tree

Christmas trees are traditionally fir trees: their GREEN needles in midwinter suggest immortality. Bringing evergreens into the house at midwinter was common in pre-Christian European cultures. Now, trees are usually put up from Christmas Eve until Epiphany.

## Pine Tree

The pine was sacred to DIONYSUS, PAN, APHRODITE and the great mother goddess Cybele and her son/lover Attis. Its evergreen nature and the curative properties of its resin led to associations with fertility and resurrection, so Dionysus is depicted holding a pine cone, or with his THYRSUS tipped with a pine cone.

In China the evergreen pine symbolizes WINTER and longevity. It is one of the group (also adopted in Japan) called the 'THREE Friends of WINTER', which symbolize hope and good fortune. In Japan the pine, the CEDAR, the CHESTNUT and other evergreen trees are revered as temporary dwelling places for the gods while on EARTH. Pine branches are included in *kadomatsu*, the Japanese New Year decorations. They are placed outside the GATES of houses as temporary homes for the gods, to attract good fortune for the coming year. In Ancient China pines were planted on graves because they were thought to be disliked by a monster who ate the brains of the dead.

TREES AND BUSHES

### Cypress Tree

The evergreen cypress, like the CEDAR, was sacred to the goddess ASHTART in ancient Phoenicia and signified fertility and resurrection. It was also sacred to the Greek ARTEMIS, the cult of ADONIS, and HADES. Associated with the UNDERWORLD, the cypress was commonly planted in cemeteries, and it is often linked with death in alchemical depictions.

In China, where cypresses are also planted beside graves, they symbolize longevity. In Japan cypresses, in common with other evergreen tress, were worshiped as the supposed dwelling places of the gods. The cypress is called the 'FIRE tree' because its twigs were once used to kindle fires, including the sacred fires at Shinto shrines.

The smooth, scented wood of the cypress was also prized as a building material, for example in the construction of Buddhist temples and Shinto shrines. Noah's ARK was also made with 'ribs of cypress' and then covered with REEDS.

### Palm Tree

The palm was the TREE OF LIFE in Assyrian art. As its LEAVES never fell it symbolized everlasting life and eternity for the Akan people of Ghana. In Ancient Egypt it was sacred to ISHTAR and ASHTART, and HATHOR and NUT, who nourished the dead from a palm tree before the tribunal of gods decided their destiny. A date-palm CROWN was sacred to the SUN god RA. The cabbage palm belongs to the Wala-undaya (LIGHTNING Man) of the Aborigines of Arnhem Land.

A BLOOD-like mixture of palm OIL and precious RED camwood empowers African ritual objects.

Palm fronds were a Classical symbol of victory. They were thrown in the path of returning heroes, and in the path of CHRIST when he entered Jerusalem, hence they also represent pilgrims who JOURNEY to the Holy Land. As symbols of victory over death they can represent the martyrdom of saints. Branches of palm are one of the 'FOUR spices' carried in procession as symbols of the earth's fruitfulness at *Succoth*, the Jewish Feast of Tabernacles.

### Banana Tree

Banana leaves are one of the 'Fourteen Precious Things' of the Chinese scholar, symbolizing self-discipline. This may relate to the story of a student who used banana leaves to write on. B*asho* means 'banana' in Japanese, and was the nickname of a famous 17th-century haiku poet. In later haiku, the WIND rustling in banana LEAVES symbolized autumn.

### Banyan Tree

In India the banyan is worshipped for its sturdiness. It keeps growing after repeated cutting of its branches, which are deemed uncountable, so it also symbolizes immortality and vastness, referring to those great people who acquire metaphysical knowledge. The Balinese believe this giant tree links HEAVEN and EARTH.

## Bodhi Tree

The bodhi, bo or pipal tree, *Ficus religiosa*, is a species of FIG. It has great significance for Hindus and Buddhists as the tree of wisdom: 'BODHI' means 'perfect knowledge', 'wisdom' or 'enlightenment', and Shakyamuni BUDDHA is said to have achieved enlightenment when meditating beneath a bodhi tree (above). Buddhist ROSARIES are sometimes made from its nuts.

## Sycamore Tree

The Egyptians believed that two TURQUOISE sycamores stood each side of the entrance to HEAVEN, in the EAST where the SUN god RA rose. Sycamores were associated with the sky goddess, NUT; with HATHOR, also called 'Lady of the Sycamore', and with the CROCODILE god Suchos, who was also called the 'House of Sycamore'.

## Olive Tree

In Ancient Greece the olive tree was sacred to ATHENA who, competing with POSEIDON for hegemony over Attica, caused an olive tree to sprout on the Acropolis (Poseidon produced a SPRING or a HORSE – accounts differ). The gods decided in Athena's favour. The olive was also sacred to ZEUS/JUPITER, and the Romans held it in high esteem, for it symbolized victory, wealth and peace. WREATHS of olive leaves were worn in the Classical world to celebrate military and sporting victories.

Olive OIL was used universally around the Mediterranean as a sacred ANOINTING oil, a LAMP oil, and food. It had medicinal and cosmetic applications. The Israelites imagined it flowing freely in the Promised Land – like WINE, MILK and HONEY, olive oil symbolizes abundance in Jewish culture. Wild olive branches were used with PALM and MYRTLE to make *succah* at the Feast of Tabernacles, *Succoth*.

The olive branch in the beak of Noah's DOVE means peace.

## Fig Tree

For the Ancient Greeks the fig was an emblem of the PHALLUS and, if the fruit was cut open, of the VULVA. It therefore symbolized erotic ecstasy and so it was sacred both to VENUS, the goddess of love, and to DIONYSUS, the god of erotic revelry.

For Jews and later for Christians, if the TREE OF THE KNOWLEDGE OF GOOD AND EVIL was not an APPLE tree, it was a fig tree. It produced the fourth fruit, which represented the material world. It also symbolized lust and desire, and so, appropriately enough, it was believed that Adam and Eve covered their nakedness, and thus their sexuality, with fig leaves, which are phallic in shape.

Presumably as a result of its phallic associations, and perhaps because of the practice of caprifying (artificially fertilizing) fig trees – an ancient custom formerly accompanied by pagan fertility rites – the fig tree was also used as a fertility symbol by Jews.

The BODHI TREE under which the BUDDHA gained enlightenment was a species of fig.

TREES AND BUSHES

**241**

A

B

C

## Willow Tree

The willow was sacred to the Egyptian god OSIRIS. It encompassed his coffin, and his SOUL – as the PHOENIX – sat in its branches. The Celtic god Esus (associated with MERCURY and MARS) is shown cutting down a willow tree containing THREE CRANES or three egrets and the head of a BULL: egrets live on the lice on bulls' backs and nest in willow trees. The Romans called the tree *bellicum*, the adjective from *bellum* ('war').

In Western art the willow was associated with WATER (C), mourning and death. Its affinity for water has led to its use by those who divine for sources of water. The drooping 'weeping' willow was a popular image on TOMBstones and other funerary artefacts (B). During the Jews' Babylonian exile, when they wept for Zion they hung their HARPS on willow trees (Psalms 137: 1–2).

The Jews also used willow branches for their THYRSI, which they carried in procession at the Feast of Tabernacles (*Succoth*).

The Great Day of this festival was called the 'day of willows'.

In China the willow is a symbol of SPRING, and in art it is often depicted with another emblem of spring, the SWALLOW. It is also strongly linked with prostitution: the phrase 'looking for flowers and buying willows' means buying the services of a prostitute. The red-light districts of Chinese cities are called 'willow quarters'. Similarly Yoshiwara, the licensed pleasure district in the Japanese capital, Edo (modern Tokyo), was planted with willow trees to symbolize the prostitution in the quarter.

At the Chinese *Qingming* (or Clear and Bright Festival), held on the fourth or fifth of April (105 or 106 days after the Winter Solstice), branches of willow are used to sweep the tombs of family members. Traditionally people wore pieces of willow on this day to repel evil. According to one saying, those who did not wear it on the festival would be reborn as YELLOW DOGS in their next lives.

In China the supposed power of the willow over SPIRITS meant

that willow wood or branches were used by mediums in contacting the spirit world. Some believe that the word 'Wicca', used for the European tradition of witchcraft, came from the word 'wicker', meaning 'willow', which had its roots in the ancient Scandinavian word for 'to bend'. One of the SEVEN Sacred Trees of the Irish, it is still considered unlucky in Ireland.

In China the RED Willow was linked to the BODHISATTVA and goddess of mercy, Guanyin (AVALOKITESHVARA). Senju Kannon ('Thousand-Armed Kannon'), a Japanese form of the bodhisattva, has a willow branch as his attribute. He was said to use it to sprinkle life-giving WATER from a VASE. Chinese Buddhists also believed that water sprinkled with a willow twig had purifying properties.

The suppleness of the willow made it a sign of friendship. In China branches of willow (A) were given to those leaving on a trip or moving away. The willow tree is also a Buddhist symbol of meekness, and of strength in weakness for Daoists.

## Almond Tree

The Jewish menorah or SEVEN-branched CANDELABRUM, is said to be shaped like the branch of an almond tree, the cups for OIL or candles resembling the blossom. The almond branch shown to Jeremiah in a vision symbolized the prophetic wisdom he was to be granted by God; hence the almond is said to be the tree of Wisdom (SOPHIA) herself.

Aaron's STAFF was made from the WOOD of the almond tree. When placed before the Lord it sprouted blossom and ripe almonds, indicating that Aaron and his sons were to become the Jewish priesthood. (The staff of Joseph, husband of the VIRGIN MARY, also sprouted blossom, symbolizing God's divine favour and Mary's purity.)

Ground almonds are an ingredient in *haroset*, a sweet paste eaten at *Seder* (Passover), which symbolizes the mortar and CLAY of the bricks made by the Jews during their imprisonment in Egypt.

## Alder Tree

This tree grows near watercourses and has WATER-resistant properties, so it is thought to be imbued with FIRE energy. It name is related to the Anglo-Saxon *ealdor,* or 'chief'. In Celtic lore it is associated with BRÂN and his powers of protection. FLUTES of alder were used to summon the North WIND.

## Birch Tree

Birch was called 'the lady of the woods'. Its twigs were used to make clean-sweeping BROOMSTICKS and to define boundaries by beating the bounds. Its wood was often used for maypoles and yule logs. A protector against FAIRY mischief, it was also used in cribs to protect babies. Wearing it protected the bearer from kidnap. It was used by some Native American SHAMANS as a 'SKY LADDER'.

## Elder Tree

Linked with the crone in British folklore, the elder can protect from WITCHES and their spells, but is also used by them. An elder branch was carried during the Celtic Beltane procession, perhaps as a precaution – to honour the crone while honouring the MAID. Its flowers reveal the WHITE of the maid in SPRING; the juice of its berries the colour of BLOOD in AUTUMN.

## Yew Tree

The poisonous, evergreen yew renews itself by putting down shoots which form its trunk, so it represents everlasting life, death and resurrection. Hence it is found in churchyards, and was sacred to the DRUIDS. Yew STAFFS measured corpses and graves; yew branches were used for Easter celebrations.

TREES AND BUSHES

## Rowan Tree

In Celtic druidic rites WANDS of SILVER rowan were used to represent the goddess. Rowan was planted near new homes to protect them from LIGHTNING and bring luck, and in cemeteries to protect from haunting; while its wood protected BOATS from storms. As a 'FAIRY tree' whose seeds first came from fairyland, **it was linked to the Irish Sidhe.**

## Hazel Tree

For druids the hazel was the tree of the WELL of Wisdom. Its nuts floated downstream to be eaten by SALMON, poets and wise people. The hazel was one of THREE trees that demarcated the Otherworld. It grows by holy wells. Its GOLD POLLEN falls at Imbolc, festival of BRIGID, who bestows poetic inspiration and the GOLDEN BOUGH.

## Magnolia Tree

In China the magnolia (*mu-lan*) symbolizes female beauty. In ancient times the emperor had exclusive rights to the tree and might give it to his favourites.

A magnolia was said to grow on CONFUCIUS's TOMB. The 'Magnolia Festival' may be so named because the flowers resemble LANTERNS lit to attract the SPIRITS of the dead.

## Acacia

The burning bush in which God appeared to Moses was an acacia. Acacia is a 'thorny, jealous and self-sufficient tree' whose roots strangle other trees nearby, so it has been said to symbolize the coming victory of monotheism. Acacia WOOD was used to make the ARK OF THE COVENANT, while for the Hebrews a flowering acacia branch symbolized God's word.

## Mulberry Tree

Early Chinese myths describe various world trees that stand at the centre of the world, joining HEAVEN and EARTH. The most important of these is the great 'Leaning Mulberry' (*Fu Sang*). According to one myth, TEN SUNS rose from this tree, causing a terrible drought. The world was saved by the archer Yu, who shot down NINE of the suns.

Silkworms feed on the leaves of the mulberry. As the raising of silkworms and the spinning of silk THREAD was always performed by WOMEN, the mulberry became a symbol of female industry. Mulberry LEAVES were used as offerings by Chinese empresses in annual rites of sericulture, while mulberry-wood STAFFS were carried at the funeral of one's MOTHER, as part of mourning. In Japan, the mulberry is associated with the Chinese tale of the WEAVING Girl and the Cow Herd, and is linked to the *Tanabata* festival, which celebrates this story.

## Holly

The DRUIDS considered holly to be sacred and to protect against LIGHTNING. In the Arthurian tale of *Sir Gawayn and the Grene Knight* it was carried by the GREEN Knight, symbolizing the WINTER KING'S SACRIFICE and the spark of increase in daylight which it ignited.

In Northern Europe holly is one of the evergreens traditionally brought into homes at Christmas, representing life at the darkest point of the year. It was also formed into a 'KISSING BALL' with evergreens and MISTLETOE. Holly was held by a girl while orchards were being wassailed or sung to and having their health drunk, to ensure a good crop. A dead WREN was hung within it.

Holly was considered MALE, and IVY FEMALE; whichever dominated indicated where the power lay in the household.

The Japanese believed that holly drives away evil, so it was hung at the entrances of houses at New Year. Likewise, holly with dried sardine-heads and dried beans were also believed to protect from evil at New Year.

## Thorn Bush

Thorn bushes have religious associations. The burning bush into which God transformed himself when he spoke to MOSES was a thorny ACACIA. The Essenes grew acacia hedges in order to keep out worldly temptation and corruption.

CHRIST had a CROWN of thorns put upon his HEAD when he was mocked by the Roman soldiers before his crucifixion, and it is one of the INSTRUMENTS OF THE PASSION. In European literature thorns are often associated with ROSES, symbolizing the pain that is a by-product of love. Christ's crown of thorns thus inverts associations of rose garlands with love or joy. Significantly, rose bushes in the Christian paradise have no thorns. Temptation is a 'thorn in the flesh', according to St Paul.

The Holy Thorn of English folklore was a bush that grew from Joseph of Arimathea's STAFF when he struck it into the ground at Glastonbury. It traditionally flowers at Christmas, in celebration of Christ's birth.

## Blackthorn

In the Celtic tradition the blackthorn was said to represent the dark aspect of the goddess. It was the first tree to flower, in late WINTER. Its THORNS are also very poisonous. They are small, so they can pierce the skin without being noticed and can work deep into the flesh.

## Hawthorn

In Ancient Greece the hawthorn was sacred to ARTEMIS and to Hymen, the god of MARRIAGE, so Athenian brides wore CROWNS of hawthorn. In Celtic tradition the hawthorn or 'May tree', which flowers around the time of the Beltane festival in May, was associated with chastity, but it was considered unlucky to bring hawthorn into the house.

## Laurel Bush

In ancient Greece and Rome, the laurel was held to be sacred to the god APOLLO. The poet Ovid related how Apollo ardently pursued the resolutely VIRGINAL Daphne, only to see her change into a laurel tree as he finally grasped her. Apollo was also said to have purified himself of the Delphic PYTHON'S BLOOD in a laurel GROVE. The prophetic priestesses (the 'Pythia') who pronounced the oracles at Apollo's sanctuary at Delphi chewed laurel leaves and also burnt them in order to experience their visions. If the seer's pronouncements were favourable, the seeker returned home CROWNED with laurel. As a consequence, laurel came to symbolize triumphant victory and heroic poetry, and WREATHS of laurel were given to the winning contestants in Classical sporting games, and oratory and poetry contests (above). The laurel tree was also considered to provide protection against LIGHTNING.

## Myrtle

THREE sprigs of myrtle (in Hebrew, *haddasah*) are carried in the procession of *Succoth*, the Jewish Feast of the Tabernacles, a HARVEST festival. It was one of the Jewish 'FOUR Spices' with CITRON, PALM and WILLOW, thought to have been symbols of the earth's fruitfulness, which accompanied prayers for RAIN. Its branches were also used to make the canopy (*succah*) that commemorated the Israelites' flight through the DESERT from the land of Egypt.

The Jews also associated myrtle with the joy of brides. In Classical antiquity myrtle – with ROSES – commonly made a bridal WREATH, because it was sacred to APHRODITE, the goddess of love. It is still used in bridal bouquets today; but it is risky to plant myrtle in a newly-married couple's garden as, if the plant fails, the marriage will, too.

The Ancient Greeks used it to mark out the victors of the Athenian games, who wore CROWNS of myrtle. They also associated it with prophecy and justice: Athenian judges and suppliants wore myrtle wreaths.

## Ivy

Ivy was wound around the THYRSUS of the vigorous Greek pastoral deity, DIONYSUS. It was also sacred to Attis, the beautiful youth dear to Cybele who castrated himself and thereby died – but whose corpse did not decay after ZEUS intervened. Consequently ivy has a strong association with fertility and resurrection. The Ancient Greeks valued ivy for both provoking and curing altered states of mind: if it were chewed it would produce a narcotic high (and it was also a good cure for a hangover). As a result, ivy was an attribute of lyric poetry.

Ivy was also associated with resurrection in the Celtic tradition. Along with HOLLY it is associated with BRÂN, whose festival is held at midWINTER. He was said to have hidden in an ivy bush disguised as a WREN to escape capture. Ivy was traditionally the FEMALE counterpart to the MALE HOLLY.

## Bamboo

An evergreen, bamboo is known in China as one of the 'THREE Friends of WINTER', along with the PLUM and PINE. It is also known as one of 'The FOUR Gentlemen' (together with the plum, orchid and CHRYSANTHEMUM), a group that alludes to the ideal characteristics of a CONFUCIAN gentleman.

Chinese people believed that the mythical and auspicious bird, the PHOENIX, fed exclusively on bamboo. The empty core of a bamboo branch makes it a symbol for Daoists of the Dao or Way: the hollowness of the stem is considered a virtue. The Chinese word for bamboo is a homonym of 'to wish' or 'to pray', so an image of a VASE (a visual pun for 'peace') with bamboo branches means 'We wish for peace'.

A bamboo branch is an attribute of Guanyin (the Indian bodhisattva AVALOKITESHVARA) the goddess of mercy. In Japan's Noh theatre female characters carry a bamboo twig as a sign of madness. This arose from the use of bamboo WANDS (and other objects) by mediums to attract divine powers.

## Golden and Silver Bough

In the DRUIDIC religion the GOLDEN and SILVER Bough was associated with poets. The *ollamh*, or chief poet, carried a gold branch hung with gold BELLS (above), while the lesser poets, known as the *anruth*, carried a silver bough.

Both MANNANAN MacLir and LUGH were said to have possessed a silver bough. It was supposed to be a branch of an APPLE tree dangling with apples, which tinkled with enchanting music and produced food for those who lived in the Otherworld.

The Irish KING Cormac MacAirt was so enchanted by such a silver bough that he was willing to exchange it for his family. It later led him back to them in the otherworld. The story indicates that the silver bough helped mortals to gain access to the otherworld.

## Wood

In Chinese cosmology, wood was one of the FIVE Elements, associated with flexibility. It was thought to come from WATER and to be destroyed by METAL; and to produce FIRE and destroy EARTH. It corresponded to the EAST and to SPRING. At the most important Shinto shrine, at Ise in Japan, the sacred fire is made by rubbing sticks of CYPRESS wood together. Japanese Buddhist monks who practice extreme asceticism are described as *Mokujiki*, 'ones who eat wood'.

The solidity of the wood used to carve representations of Maori ANCESTORS in the *Wharenui* ('great' or 'meeting houses') expresses the durability and substance of the ancestors through whom the Maori trace their descent.

Wood is the most common material used for African religious sculpture, and the choice of the right wood or branch is important for empowering the sculpture. The guidance of the SPIRITS in dreams is important in making these choices.

TREES AND BUSHES

**669** **670** **671**

T R E E S   A N D   B U S H E S

### Sandalwood

Sandalwood is highly prized in India, where it is used for carving religious statuary. Smoke from burning sandalwood and sandalwood paste daubed on the body are important aspects of Hindu ceremonies. It was imported from India to Egypt, where it was used in ritual and was burned to venerate the gods. Zoroastrian rituals also used FIRES that were kindled by sandalwood.

### Ebony

Ebony comes from *eben,* the Greek word for stone. It is the dense, BLACK hardwood of a tropical tree. It was considered exotic and mysterious, but its colour gave it associations with death, sleep and melancholy. The Greeks therefore associated ebony with the UNDERWORLD, where it was believed PLUTO sat upon an ebony THRONE.

### Leaf

ADAM AND EVE made loincloths of FIG leaves when they became aware of their nakedness. These became a symbol of modesty and shame, and were later used to hide the genitalia of naked statues.

Leaves play a significant part at Maori funerals. Traditionally the *kawakawa* leaf formed the *Parekawakawa* (funerary WREATH) worn by elderly female mourners, although other kinds of leaf, including WILLOW, are used today. Mourners also hold single leaves, waving them from left to right in an action believed to create a current or PATHWAY for the dead SPIRIT to pass along on its journey to the SPIRIT world.

Leaves appear in many Japanese family crests, generally carrying the symbolism of the original plant or tree: HOLLY leaves, therefore, symbolize the repulsion of evil influences. Leaves – for example OAK or MULBERRY – were also used as receptacles for offerings to Shinto gods.

### Seed

In India, as in many other cultures, the word 'seed' (*bija* in Sanskrit) refers to semen. It is the name of a syllable or a letter that forms part of a mantra or prayer: the *bijamantra,* whose repetition conjures up the form of a deity – related to the seed as a starting point. *Bija* is also the name for the *reliquiae* inside a STUPA.

In the Bible the word 'seed' is associated with and interchangeable with: semen, sons, CHILDREN and family, and descendants. In China seeds are also linked with familial fertility and abundance. The many seeds of the POMEGRANATE fruit and the LOTUS pod make them emblems of a wish for many children. In traditional Chinese WEDDINGS, the bride sometimes presented her new parents-in-law with a BASKET of seeds (representing children) and dates (JUJUBES, the word for which forms a homonym with the word for 'soon') on the day after the marriage ceremony, symbolizing her wish to furnish the family with new children without delay.

## Bitter Herbs

*Maror* or bitter herbs are traditionally eaten at *Seder,* the Jewish feast of Passover, where they remind those present of the bitterness of the Israelites' slavery in Egypt. They are dipped twice into the *haroset,* a mixture of nuts, FRUIT, WINE and spices, which sweetens them before the main meal is eaten. Bitter herbs and WORMWOOD also represent God's punishment of Zion.

## Tulsi

This is a variety of basil sacred to the Hindu deity VISHNU. It is deified as Tulsidevi or Vrinda, a virtuous woman who was however seduced by Vishnu, and whose symbolic marriage to him in Kartik (November–December) inaugurates the Hindu wedding season.

## Mandrake

The bifurcated end of the mandrake's root looks like MAN's legs below a torso formed by the upper part of the root, and this appearance gave the mandrake its symbolism as a man-plant in European folklore. It was said to grow around gallows, where the semen or urine of hanged men would fall. Mandrake was also said to scream when pulled out of the ground, and because it was dangerous to hear the scream, the approved method of harvesting it was to get a DOG to pull it up in one's absence; on returning one would find the root attached to a dead dog. Its lethal properties led to the mandrake's association with WITCHcraft and potent spells.

For Jews the mandrake has entirely different connotations. It is associated with fertility and is believed to be an aphrodisiac – its Hebrew name means 'love-plant': 'I will give you my love when the mandrakes give their perfume' (Song of Songs 7: 12–13).

## Artemisia ✳ Wormwood

Artemisia (wormwood) was sacred to ARTEMIS, from whom it takes its name. In the Old Testament gall and wormwood symbolize bitterness and poison, while in Revelations a STAR called Wormwood fell from HEAVEN, 'and the THIRD part of the WATERS became wormwood; and many men died of the waters, because they were made bitter' (Revelations 8: 11).

In both China and Japan artemisia was believed to repel evil and increase longevity. The Daoist Immortals are sometimes shown clothed in its leaves. A single artemisia LEAF is included in the Chinese 'EIGHT TREASURES'.

White sage, a member of the genus *Artemisia*, is also burnt by Native Americans to heal, purify and cleanse a person, an object or a place.

HERBS, SPICES AND INCENSE

**249**

## Saffron

The saffron is a species of crocus, *Crocus sativus*, prized because a deep YELLOW dye was made from its stamens. It colours the saffron robes of Buddhist monks – the colour is related to the Buddhist paradise (sometimes described as 'GOLDEN'). Because of the number of dried stamens needed to make the dye, saffron was expensive. In Europe, therefore, it was a colour associated with royalty, the SUN and gold.

## Rosemary

The name of this plant means 'DEW of the SEA', and it was sacred to DIONYSUS and APHRODITE. As an evergreen it signified fertility and longevity. It was also associated with fidelity and remembrance between lovers, and was a symbol of immortality in funeral rites.

## Rue

Because rue was associated with the VIRGIN MARY it was called the 'herb of grace' in medieval herbals. But it was also connected with the planet SATURN and shared the planet's connections with death. It was called the 'death herb' because it was laid in WREATHS around the necks of corpses to protect them.

## Sage

Associated with healing since antiquity, sage takes its name from the Latin word *salvere*, ('to save'). In European herbals it was described as a panacea (a cure-all). Because of its redemptive properties it was used as an attribute of the VIRGIN MARY in medieval Christian art. Native Americans also consider it to be a healing herb.

## Hyssop

The Jews associated hyssop with purification, using bunches of hyssop dipped into BLOOD (with SCARLET THREAD and CEDARWOOD) to purify houses where there had been disease or a death. Most famously, hyssop was used on the eve of the flight from Egypt to daub LAMBS' blood on the lintels of Jewish houses so the ANGEL of DEATH would pass over them.

## Clove

In China and Japan cloves are prized for their aroma and are believed to have medicinal properties, so they can represent sweetness and health. In Japanese art cloves were one of the Myriad TREASURES (*takaramono*), the SACK of precious objects carried by the SEVEN DEITIES OF GOOD FORTUNE.

## Garlic

In antiquity garlic was associated with the MOON and magic. It was considered a powerful protector against the evil EYE. Pliny noted that it was effective against SNAKES and SCORPIONS, although he also warned that it was an exceptionally potent aphrodisiac. Garlic has continued to be seen as a powerful protector against evil, SPIRITS, magic and illness – hence the various folklore beliefs that garlic wards off vampires and werewolves.

In China garlic has long been regarded as lucky, as an antidote to poison, and as having the power to keep away evil spirits. It was also used as an emblem for 'CHILDREN and grandchildren', and was one of the gifts sent to married women who were yet to have children. In the *Nihongi,* an early Japanese chronicle (AD 720), a stick of garlic (or wild chive, *Allium odorum*) was used by the legendary prince Yamatodake no Mikoto to strike in the eye and kill a MOUNTAIN god who was bothering him in the form of a WHITE DEER.

## Tobacco

The Native Americans are said to have been the first peoples to use tobacco, a plant indigenous to North America, up to 8,000 years ago. For many generations tobacco has been considered sacred by many tribes, used as an offering to SPIRIT, for prayers, healings and ceremonies. Roasted tobacco LEAVES are also used to make *seri*, which is inhaled as an integral part of ritual by the Machiguenga of Peru, whose term for a SHAMAN is *seripegari*, 'he who uses tobacco'.

The Caribbean Arawaks, now extinct, believed that the HUMMINGBIRD brought tobacco, and they called him the Doctor Bird. To many Pueblo people the hummingbird is a tobacco bird, bringing SMOKE to the shamans so they can purify the EARTH.

In 17th-century Netherlandish art the smoking of tobacco is associated with dissolute young men and soldiers, who are commonly seen drinking in brothels and gambling.

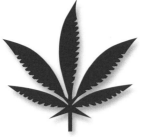

## Cannabis

The cannabis LEAF has become a symbol of Rastafarianism, whose followers believe that their use of cannabis, or ganja, is grounded in the Bible. Also known as the 'holy herb', ganja took on the role of a religious sacrament, producing an altered state of consciousness. It also represented a protest against the oppressive 'White Babylon' which had deemed its use illegal.

## Frankincense

The Magi brought frankincense, a symbol of divinity, to the infant CHRIST. It was the usual offering on the incense ALTAR in the Jewish Temple, and was scattered on grain and BREAD offerings. It is also used figuratively to represent incense generally, or, as in the Song of Songs, a sweet smell.

HERBS, SPICES AND INCENSE

**251**

## Myrrh

In the Bible myrrh is associated with sex and death. In the Song of Songs, drops of liquid myrrh signify female arousal, and Esther prepared for her seduction of Ahasuerus by anointing herself with OIL and myrrh. A gift of the Magi to the infant CHRIST, myrrh symbolized his later crucifixion because of its use in ANOINTING and embalming the dead.

## Alcohol

Alchemists called alcohol WATER that BURNS. It was an emblem of the reconciliation of opposites. Central American *curanderos* or healers spray aguardiente, a cane alcohol, from their MOUTHS to purify ALTARS, and a bottle may be offered to the gods on an altar. Alcohol is used similarly in African and Voodoo religions.

## Maize

Maize figures in Maya creation stories. One tells how, after trying unsuccessfully to create people from mud and then from WOOD, the gods mixed their own BLOOD with maize flour to create human beings, so that one famous Maya image depicts an earth god sprouting from a stalk of maize (above). For most of the great cultures of ancient Central America, to eat maize was to eat the flesh of the gods, and this belief may account for the practice of human SACRIFICE as a gift to the gods in return.

For Native Americans maize was one of the 'three sisters' (maize, BEANS and squash), which formed the staple diet for many tribes. It also has ritual uses. Despite the arid desert conditions of Northern Arizona, the Hopi grow maize of many different colours, from YELLOW through to PURPLE. They use maize in healing ceremonies or as a blessing, and corn husks are used in many traditions to make ceremonial MASKS and DOLLS.

## Wheat

In many cultures wheat symbolizes fertility and the cyclical death and rebirth of vegetation. Ears of wheat were attributes of the goddess Cybele, and of Tammuz and DEMETER. The Nepri, the 'One who Lives who has Perished', was the personification of wheat for the Ancient Egyptians. Wheat-shaped mummies made of linen and filled with sprouting wheat were a part of the mysteries of OSIRIS. They were also left with the deceased to manifest Osiris's power of fertility and immortality. Wheat was also associated with life and resurrection in alchemy.

In China an ear of wheat is a symbol for the clitoris, while in Japanese mythology the first wheat grains were said to have come from the VAGINA of the food goddess Oketsuhime no Kami, after she was killed by Susano o no Mikoto.

In Christian art wheat and WINE when shown together symbolize the BREAD and wine of the EUCHARISTIC host.

## Sheaf

Corn and sheaves of corn have a similar meaning. (Although often used of WHEAT, corn can mean any cereal, including MAIZE.) Sheaves of corn have been common in European art since antiquity, when they were related to fertility goddesses such as DEMETER. In Renaissance art they symbolized HARVEST and SUMMER, particularly the month of July (related to the LABOURS OF THE MONTHS). Since the 19th century they have been associated in Britain with harvest festivals celebrated in the Christian Church.

Earlier in the British Isles, the last sheaf of corn to be cut used to be thrown into the neighbour's field. It was called the 'Kern Baby', 'Old Woman' or CAILLEACH, and was passed from neighbour to neighbour until the last person to harvest was left with the Cailleach to keep through the winter. Although performed in fun, this might be the vestige of a more ancient and serious rite. Later, the corn for the corn doll was taken from the last sheaf.

## Bread

Ancient Egyptian priests made bread sacred by blessing it. It was offered to the gods, and, according to *The Book of the Dead*, it was considered the stuff of life, and loaves were frequently left as grave goods in tombs.

Bread is one of the most potent symbols in the Bible. Unleavened bread is eaten at *Pesach* (Passover) in memory of the Israelites' flight from Egypt, when they had no time to wait for the bread to rise. Esoterically, the leaven in the bread symbolizes material development and multiplicity, which must be determined by divine rather than human will.

Taken ritually at the Jewish Sabbath, bread and WINE symbolize the duality of the physical world becoming unity. CHRIST allied himself with this symbolism, declaring the bread of the Last Supper (and thus the EUCHARIST) to be his body, the WINE his BLOOD. The name of his birthplace, Bethlehem, means 'the house of bread'.

## Millet

As far back as the Neolithic Yangshao culture (*c.* 5000–3000 BC) millet was the major crop of northern China. One Chinese myth said that the farmer god, Shen-nong, taught people how to sow millet; another that the grain god Hou Ji ('Sovereign Millet') had passed the skill of cultivating millet and other grains to humans, teaching them how to give offerings of millet to the gods. Hou Ji was believed to have founded the Zhou dynasty (1100–256 BC), and millet is one of the TWELVE Ornaments that were embroidered on the robes of the Chinese imperial household (only the Emperor could wear all twelve).

In Japanese mythology millet grain is said to have come from the EARS of the food goddess Oketsuhime no Kami when she was killed by Susano o no Mikoto. Millet is consumed with RICE and rice WINE by the Japanese emperors in their (Shinto) enthronement ceremonies (*Daijosai*).

GRAINS • FRUIT, VEGETABLES AND NUTS

### Rice

Rice is one of the dietary staples of people in China and Japan. However, it was once the food of the rich, so to have rice constitutes good fortune. Ears of rice are an attribute of the farmer god Shen-nong (the Japanese Shinno), who was thought to have taught Chinese people the rudiments of agriculture. In Japanese mythology, rice SEED is said to have originated from the EYES of the food goddess Oketsuhime no Kami when she had been killed by Susano o no Mikoto.

The Japanese consider rice sacred and in their enthronement ceremonies (*Daijosai*) Japanese emperors eat it, along with MILLET, and drink rice WINE. A bale of rice is the attribute of the god of prosperity, Daikokuten; while INARI, the deity of cereals, is closely connected with rice cultivation (and wealth). Some scholars believe that his name is a contraction of the words for 'rice opening'. He is sometimes depicted carrying a SHEAF of rice.

### Fruit

Fruit is redolent of ripeness, abundance and fertility. In Greco-Roman art, therefore, a WOMAN with a HEAD-DRESS of fruit (above) or a CORNUCOPIA overflowing with fruit symbolized SUMMER.

For Jews, the 'first fruits' were offered for sacrifice – including children (until the time of ABRAHAM), then animals, grain, and so on.

### Grapes

In classical imagery grapes symbolized WINE, intoxication and uninhibited physical excess, so they became sacred to DIONYSUS, protector of the grape harvest.

In the Bible, grapes and vines symbolize the Israelites; for Christians, the EUCHARISTIC WINE.

### Wine

For the Jews wine was an important liquid offering, usually given with other substances. GRAPE juice or wine was called the BLOOD of the grape in the Bible, probably in the sense that vineyards and wine formed the lifeblood of the nation. Wine was associated with the blood of DIONYSUS, for whom the grape was sacred, and of CHRIST, symbolizing sacrifice, the EUCHARIST and communion with Christ and God.

RICE wine (*sake*) is included in offerings made to the gods at Shinto festivals, then it is consumed by the worshippers in special banquets (*naorai*) so they may commune with the gods. It has a similar role in the enthronement ceremonies (*Daijosai*) of the Japanese imperial family, in which new emperors demonstrate their communion with the deities by consuming rice wine, RICE and MILLET.

The ancient Japanese also worshipped several wine deities, one of the most famous being Omiwa no kami.

A

B

C

## Apple

In Celtic legends apples appear as the FRUIT of the Otherworld. More specifically, they are associated with the mythical Avalon, the 'Island of Apples'. The otherworldly apple tree was also said to have been the source of the SILVER BOUGH. In Norse tradition the tree bearing the golden apples of immortality was protected by the goddess Idun, whence they were stolen by LOKI. The gods began to age, but they recovered the apples just before they were overcome by senility and death. In alchemy, when the alchemist is represented eating an apple at the end of the Great Work, he enjoys the fruit of immortality.

The golden Apples of the Hesperides were a wedding gift to ZEUS and HERA from Gaia, the primordial earth goddess. The precious fruit was guarded by a SNAKE or a DRAGON. HERAKLES' eleventh labour was to steal the apples, and although he was successful he followed ATHENA's instructions and returned them. Eris, 'Discord', proffered an apple as a prize for the fairest among Hera, ATHENA and APHRODITE, asking the SHEPHERD Paris to act as judge. Paris chose Aphrodite, bribed by her promise of Helen of Troy as his reward. The Trojan War was the consequence, and so in Greek myth apples are associated with temptation, transgression and the acquisition of success and power.

Jews and Christians also consider that apples symbolize temptation, as well as forbidden wisdom. They are central to the story of ADAM AND EVE's temptation by the SERPENT and expulsion from the GARDEN of Eden (B). Since the apple is a pagan emblem of immortality and the serpent a symbol of ancient wisdom, and both were associated with goddesses, this story – which blames WOMAN for the Fall after she was tempted by the serpent with an apple (also a symbol of love, A) – may have been an attempt to demonize powerful symbols of the old religions which the Jews were struggling to replace. (The TREE OF THE KNOWLEDGE OF GOOD AND EVIL, from which Adam and Eve ate the fruit, is sometimes considered to have been a FIG TREE – but both trees are symbols of knowledge.)

In Christian art, when CHRIST or the VIRGIN hold an apple (C), they are overcoming evil, redeeming mankind from the first sin symbolized by the apple.

But the Old Testament also compares wise words to GOLDEN apples, and apples are an ingredient of *charoseth*, eaten at Passover, representing the CLAY from which the Israelite slaves made bricks in Egypt.

In China apple blossom represents feminine beauty. In northern China the apple is a symbol of SPRING. Apples are a good gift, as the word for apple (*ping*) sounds similar to the word meaning peace. However, apples should not be given to someone who is unwell, as their name also sounds similar to the word for illness (*bing*).

## Pomegranate

A symbol of fertility and carnal passion, the pomegranate was sacred to ASHTART and later to APHRODITE. Its multiple SEEDS and RED juice commemorated the BLOOD of DIONYSUS and of ADONIS. The myth of PERSEPHONE indicates a link with MARRIAGE and SEXUAL UNION: HADES offered her a pomegranate in the UNDERWORLD. When she ate some of its seeds she was bound to her husband for one-third of every year.

In Christian art the many seeds of the pomegranate, bound by its red juice (the BLOOD of CHRIST) and flesh (the body of Christ), symbolize the unity of the Church, found within the tradition of the Eucharist. For the Chinese the seeds symbolize plentiful offspring and fertility; with the PEACH and the CITRON it makes up the 'THREE Fortunate FRUITS'.

In the Jewish Temple pomegranates decorate the HEM of the high priest's robe and the menorahs and Torah scrolls of Jews in Morocco, symbolic of incorruptibility.

## Jujube

The plum-like fruit of the jujube tree (*Ziziphus jujuba*) is often incorrectly translated from the Chinese as 'date'. Its name in Chinese (*zao*) forms a homonym with the word for 'early' or 'soon', so an image of a jujube tree symbolizes the wish, 'May you soon have sons.' For the same reason, jujubes figure in traditional Chinese WEDDING ceremonies. A sweet jujube soup may be served at the banquet; and the bride may present her new parents-in-law with a BOWL of jujubes and SEEDS on the day after the wedding to represent the descendants with which she intends to provide them. Eating the unripe fruit was believed to bring on premature labour in pregnant women.

In various Chinese stories, characters chew on jujube stones, which magically remove hunger and thirst and cause them to fall into a deep sleep.

## Peach

The peach is a very important symbol in Chinese culture. Its blossom is associated with the New Year and with the SPRING, symbolizing fertility, and it is one of the Chinese group called the 'THREE Fortunate FRUITS'. It is also an emblem of MARRIAGE, and the season when peach trees blossom is thought to be a good time to marry. Dao Hua Hsiennui (above), the SPIRIT of the peach blossom, was worshipped during the second month of spring.

In Chinese art, literature and alchemy the fruit is a symbol of immortality. Magic peach trees grow in the GARDENS of the mythical QUEEN MOTHER of the WEST, fruiting only once every THOUSAND years, and eaten by the EIGHT IMMORTALS. The God of Longevity is therefore depicted emerging from a peach or carrying one. The expression 'peach-blossom SPRING' refers to a mythical stream flowing from a CAVE through which paradise may be reached. The same phrase is also used to refer to the VAGINA.

## Apricot

In China the apricot was a symbol for a beautiful woman, whose EYES might be described as apricot kernels. A branch of apricot fruit, also called 'WHITE fruit' or 'a hundred-fruit branch', symbolized the wish to have many sons. The Japanese PLUM (*ume*) is sometimes called an apricot.

## Pineapple

To Europeans the pineapple was an exotic fruit, associated with feasting. It was the centrepiece of FRUIT decoration for the Christmas table – and so expensive it was often hired for the occasion. It became a popular architectural motif on 18th-century GATEposts, symbolizing wealth and welcome.

## Plum

Along with the PINE and BAMBOO, plum blossom is one of the Chinese 'THREE Friends of WINTER', representing good fortune and longevity (pine and bamboo are evergreen, plum blossom appears from branches which appear dead). Plum blossom is also one of the 'FOUR Gentlemen': plum, orchid, CHRYSANTHEMUM and bamboo, each representing a SEASON; the plum symbolizes the spring.

The FIVE petals of the plum blossom represent the FIVE GODS OF GOOD LUCK. As the national flower of the Republic of China (1912–49), each of the five petals represented one of the main population groups that fell under China's jurisdiction: the Chinese, Manchus, Mongolians, Muslims and Tibetans.

In Japan plum blossom has much the same symbolism as in China, and so is used in New Year decorations. A pickled plum (*umeboshi*) placed in the middle of a square container of boiled RICE represents the rising SUN – the emblem on the Japanese FLAG.

## Citron

The Citron or *Ethrog* is one of the FOUR Spices (with PALM, WILLOW and MYRTLE), the four plants used ritually during the Jewish Feast of the Tabernacles (*Succoth*). They were thought to have been symbols of the earth's fruitfulness and accompanied prayers for RAIN.

The 'Buddha's hand' citron (*Citrus sarkodactilius* or *Citrus medica*) is thought to resemble the HAND of the BUDDHA with its little finger and index finger pointing upwards. Objects shaped in the form of the Buddha's hand citron were popular with Chinese and Japanese literati and Japanese tea masters. This citron is also a symbol of wealth because it is thought to resemble a hand holding money; and with the PEACH and the POMEGRANATE it is part of the Chinese group called 'The THREE Fortunate FRUITS'. It was traditionally offered to the household gods at New Year and other festivals.

## Orange

In China oranges were eaten on the second day of the New Year to bring good luck, as their name is phonetically close to the word meaning 'to wish (or pray) for good luck'. They are also sometimes included in New Year decorations (*kadomatsu*) in Japan. In addition, in Chinese the bitter orange (*yuan*) forms a homonym with the word for fate.

## Walnut

In the *haroset* eaten by Jews at Passover, walnuts symbolize the mortar and CLAY they made during captivity in Egypt. It represents fertility and long life and was served at Roman and Greek marriage feasts. In China the walnut (*hu tao*) symbolizes flirting after Qin-hu, who did not recognize his own wife and flirted (*tao*) with her.

## Coconut

The coconut has great significance in the practice of many Hindu rituals. In part because the fibrous tuft at its top can be seen to represent a lock of human HAIR, a coconut serves as a replica for the human HEAD in SACRIFICIAL rituals. The coconut is also seen as a magnified *bindu* or 'drop'. For Hindus, the *bindu* represents a metaphysical point beyond normal dimension, and it is a sacred symbol of the universe. As the *bindu* is manifest in the human body in semen, the coconut has come to be associated with fertility.

The coconut is closely associated with the god SHIVA, because its THREE 'EYES' symbolize the three eyes of Shiva.

In Polynesia, the first coconut tree is said to have sprouted from the head of an EEL called Tuna who was killed by the TRICKSTER, Maui.

## Gourd

On classical sarcophagi, Endymion was shown enjoying his eternal slumbers under a gourd vine. This imagery was directly transferred by the early Christians to the narrative of Jonah resting outside the city of Nineveh under the shade of a gourd plant, which became emblematic of a peaceful afterlife, and then of resurrection.

The Maya in the south of Mexico thought of the SKY as the inside of a great shining BLUE gourd.

The double-lobed bottle-gourd encapsulates Daoist beliefs, symbolizing the union of HEAVEN and EARTH, YIN AND YANG. A bottle-gourd is an attribute of Li Tie-guai, one of the Daoist EIGHT IMMORTALS. CLOUDS issuing from gourds were charms against evil, effective in catching DEMONS. The Japanese carried objects shaped like bottle-gourds as charms.

Sufi dervishes were identifiable by the gourds they carried to use as begging bowls.

## Pumpkin

These fruits – a form of gourd – are associated with the European and North American festival of Halloween (31 October), when WITCHES and the SPIRITS of the dead roam the night. Pumpkin LANTERNS (once made from turnips), were put out at night to scare them away. They are called Jack O'Lanterns from an Irish tale, in which Jack tricked the DEVIL out of seizing his SOUL, but was prevented from entering HEAVEN because of his dissolute life. He was thereafter doomed to wander in darkness, carrying a lantern lit with a coal given to him by the Devil from the embers of HELL. The custom was believed to have travelled to America with Irish immigrants, who used the native pumpkin instead of the turnip to make their lanterns.

Pumpkin pie is also part of the traditional meal that is eaten in America at Thanksgiving (November), in remembrance of the pumpkins which the Native Americans taught the first European settlers to grow, thereby avoiding starvation.

## Beans

With MAIZE and squash, beans are one of the Native American 'THREE Sisters', a staple diet for north-eastern tribes.

In Japanese mythology, the first RED and broad beans came from the nostrils and anus of the food goddess Oketsuhime no Kami as she was dying. Dried soya beans are scattered at the Japanese ceremony of *Setsubun* (February, in the lunar New Year) to dispel DEMONS. Red is an auspicious colour in China, so red bean paste is used in various seasonal cakes.

The Bean KING and Pea QUEEN are figures associated with the festival of TWELFTH Night (Epiphany, 6 January) in the Netherlands and elsewhere in Northern Europe. They are so called because they are selected by finding a bean and a pea in a twelfth-night cake. Those who are chosen become Queen and King of the night's festivities in a celebration that retains vestiges of the old Roman festival of Saturnalia.

## Yam

The New Yam Festival, which is a popular holiday in Ghana and Nigeria, marks the beginning of the new year. Yams are the first crops to be harvested, and are offered to gods and ANCESTORS before being distributed to the villagers. Usually held at the end of the rainy season, early in August, the festival is associated with the Yoruba EARTH god, known as ODUDUA.

## Iris

An iris sometimes replaced the VIRGIN MARY'S lily, especially in German art. It was also associated with the Greek goddess IRIS, a messenger of the gods who was associated with death: she was sent by HERA to release Dido's SOUL on the pyre. In Japan irises symbolize early SUMMER.

## Lotus

As it closes its flowers in the evening and does not open them up again until the first light of dawn, the lotus is an old symbol of LIGHT and the SUN. The Indian sun god Surya holds a lotus in each hand: the lotus in the West from which he arises, and the Eastern lotus of his setting. In Egypt the RED WATERLILY or the lotus was said to have emerged from the watery CHAOS of the NUN at the dawn of creation, and to have brought forth RA, the SUN (C). The fragrance from the BLUE lotus (A) was revered as sacred to NEFERTUM and was thought to be rejuvenating.

For Hindus and Buddhists the lotus is a symbol of purity. Although it grows in the mire it is rooted in neither mud nor WATER, so its beauty represents the triumph of purity. The lotus THRONES of Hindu and Buddhist deities attest to this enduring theme; they are particularly associated with AMITABHA, the compassionate Buddha of the Pure Land sect of Buddhism. The lotus is also one of the

Buddhist group known as the 'EIGHT Precious Things'.

The lotus's SEED grows in the water rather than the EARTH, thus symbolizing divine or spontaneous generation. BRAHMA is said to have been born of a golden lotus sprouting from VISHNU'S NAVEL, thereby asserting the supremacy of Vishnu even though Brahma is the god of creation. Padmasambhava, the founder of *Vajrayana* Buddhism, which is practised in Tibet, was also said to be lotus-born. The lotus is also an attribute of one of the Daoist EIGHT IMMORTALS, He Xian-gu.

The lotus is also a divine womb, and its Sanskrit names, *padma* or *kamala*, are synonyms for the VAGINA; lotus blossom also symbolizes the vagina in China. The lotus is a significant sexual metaphor in Tantra, having to be joined with the male 'force' to release or harness the power of the universe.

A lotus is soft and open while the *vajra* or THUNDERBOLT is hard and penetrative. Their union is also the union of compassion and wisdom.

In India, the EIGHT-petalled lotus (B) symbolizes the eight cardinal DIRECTIONS, and is thus a symbol of cosmic harmony. The thousand-petalled lotus is a symbol of the entirety of all spiritual revelation. In the system of psychic energy believed to lie within the body, it represents the CROWN CHAKRA, which is located above the HEAD.

Lotuses grow in different colours, each of which signifies different things. The BLUE lotus or *utpala* is especially venerated, and held by the GREEN TARA and AVALOKITESHVARA. The WHITE lotus or *pundarika* is held by the White Tara; and the pink lotus is usually a seat for deities such as the goddess LAKSHMI.

The Chinese make much of homophones for lotus, which include 'to bind' or 'to connect' (marriage), 'uninterrupted', 'to love', 'modesty', and 'concord' or 'unison'; the lotus can therefore symbolize any of these things.

## Rose

Throughout the Classical world and in the ancient Near East roses were synonymous with beauty, fertility and purity: They were sacred to APHRODITE, the MUSES, AURORA and DIONYSUS. The nymph Chloris (the Roman Flora) created the first rose from the body of another beautiful nymph.

Zoroastrians associated the rose with innocence. Its thorns appeared when evil first entered the world. In Sufi thought the rose symbolizes life's pleasures, the thorns its pains. In Islam roses are associated with GARDENS and therefore with paradise. In China, they symbolize youth and the FOUR SEASONS.

In the Bible, the rose (which is sometimes called the asphodel) is beauty personified. It is associated with the VIRGIN MARY's beauty and purity. The thorns indicate her suffering at the death of her son. In Western culture a RED rose symbolizes love and a WHITE rose martyrdom. In alchemy, the rose symbolizes the blossoming of the SPIRIT.

## Chrysanthemum

The chrysanthemum is a symbol of AUTUMN in China and Japan. The Chinese name for this flower is almost a homonym with the word meaning 'to remain'; and it is linked to the number NINE, which forms a homonym with the word meaning 'long time'. For these reasons, the chrysanthemum flower is a symbol of long life.

Along with the PLUM, orchid and BAMBOO, the chrysanthemum is included in the Chinese and Japanese group of plants called the 'FOUR Gentlemen', which were believed to represent the virtues of a CONFUCIAN gentleman.

In Japan the Chrysanthemum Festival (*Kiku no Sekku*), which draws on the Chinese seasonal celebrations for the HARVEST, fell on the ninth day of the ninth lunar month. A chrysanthemum flower is also the emblem of the Japanese imperial family.

In Western art the chrysanthemum, which looks increasingly sensuous as it dies, represents decadence and death.

## Lily

In the Classical world the Madonna lily (*Lilium candidum*) was associated with HERA's MILK and signified purity and chastity. It took on a similar symbolism in Christianity, where it was associated with the VIRGIN MARY, particularly in scenes of the Annunciation, where the lily is often held by the ARCHANGEL Gabriel. It also represented purity in alchemy.

The Australian gymea lily is associated with the story of the steadfast courage and perseverance of a young Aboriginal man from the mountains of south-east Australia: it took on these qualities when it received its strength from his HAND as he lay dying.

In both China and Japan the day-lily (*Hemerocallis*) was believed to act as a drug capable of dispelling grief. Women wore the flowers in their BELTS in order to forget the sorrow of a lover's departure; and an alternative name for the lily in Japanese is 'the plant of forgetfulness'.

F
L
O
W
E
R
S

## Poppy

The poppy, which often springs up in CORN fields, is an attribute of DEMETER, the goddess of corn. It is a symbol of SLEEP, and some myths associate the season of WINTER with Demeter drinking poppy juice and sinking into a slumber until spring. In Greco-Roman funerary art the poppy came to symbolize the sleep of death, and is an attribute of Hypnos, the Greek god of sleep. It was taken up in Renaissance allegory as a symbol of Nyx (the night) and Morpheus, the god of sleep and dreams.

Later, after World War I, the RED poppies that flowered in the battlegrounds of the fields of Flanders came to represent the individual SOULS of the soldiers who had died, so that in Britain artificial poppies are sold and worn in the lapels of those remembering the sacrifice of soldiers in all wars.

## Narcissus

According to Greek myth, Narcissus was a beautiful youth who fell in love with his own reflection in a pool. He was unable to tear his gaze away from this intangible idol, despite the attentions of the nymph Echo, and eventually he metamorphosed into the flower that bears his name. He symbolizes the deadly cost of excessive self-absorption (and so, according to some accounts, PERSEPHONE was abducted by HADES when she was gathering narcissi).

In China and Japan, narcissi are symbols of New Year and of good fortune for the coming twelve months. In Chinese and Japanese, the second character used in the word for narcissus (*shui-xian, suisen*) means 'Daoist Immortal', therefore the flower can stand for the EIGHT IMMORTALS. The narcissus is also one of a Chinese group called the 'FOUR Nobilities' (PLUM, cinnamon, CHRYSANTHEMUM and narcissus).

## Tulip

In the Turkish script of the Ottoman Empire, the word for tulip, *lale*, is spelled using the same letters as those that form the word 'Allah'; therefore, the tulip was often used as a symbol of the divine. Persian poetry extolled the tulip as one of the flowers to be found in the GARDENS of Paradise.

Introduced into Europe from Turkey shortly after 1550, tulips are often depicted in 17th-century Netherlandish still-life paintings, because their exotic and delicate flowers were highly prized. They became symbols of wealth and beauty and were imported in great numbers, resulting in the 'Tulip Mania', when vast sums of money were invested in tulip bulbs in the belief that it would be recouped after cultivating the exotic flowers. The bubble burst in the Netherlandish economic disaster of 1637, after doubts arose as to whether tulip prices would continue to increase.

## Cherry Blossom

Cherry blossom is particularly admired in Japan, where cherry blossom-viewing parties began to be held by aristocrats during the Heian period (794–1185). These are still an important springtime custom and the blossom thus symbolizes SPRING. Because the blossom is in flower only briefly before dropping, the cherry tree is also a symbol of purity and short-lived beauty. The fallen blossom is sometimes used to symbolize WARRIORS (*samurai*) who have died young. Cherry blossom is one of a Japanese trio known as the 'THREE Beauties of Nature' (*setsugekka*) which represent the transience of life – together with the MOON (sometimes represented by a RABBIT) and snow. It has become associated with Japan itself, being used by poets to encapsulate the nation's spirit.

In China, cherry blossom is a much less important symbol than PLUM blossom, although as one of a group of flowers representing the TWELVE months of the year, it may be used to represent the FOURTH month.

## Anemone

In Greco-Roman mythology the anemone sprang from the BLOOD of the dying ADONIS. Its name stems from the Greek word for WIND (*anemos*), as its beauty is as brief and welcome as a passing breeze. Revered as the first flower of SPRING, it came to be associated with youth, beauty, love and, most especially, with the pain of the loss of these transient blessings.

## Acanthus

Used as a motif on Greek funerary architecture, the acanthus may have symbolized death's conquest of the sufferings of life, represented by its spiky LEAVES and thorny stems. It became a common decorative motif in Greco-Roman architecture, on the capitals of certain COLUMNS, for example.

## Carnation

These flowers were said to have grown where the VIRGIN MARY's tears fell on the way to Calvary. They have become a symbol of love, held by the betrothed in Renaissance portraiture. They are also associated with MARRIAGE in China. In the Victorian language of flowers, RED carnations symbolize marital love; pink, compassionate, maternal love; WHITE, pure spiritual love; and YELLOW, rejection.

## Columbine

The columbine's name comes from *columbus*, meaning DOVE. Christians associate it with the Holy SPIRIT. It symbolizes purity and constancy. SEVEN columbine flowers represent the seven gifts of the Holy Spirit, or the seven sorrows of the VIRGIN; THREE, the TRINITY.

## Daisy

The daisy is said to have been sacred to the Norse goddess FREYA. It is a Christian symbol of innocence and was associated with the VIRGIN MARY and the infant CHRIST. It is found in some Italian Renaissance paintings of the Adoration of the infant Christ, where it sometimes replaces **the Virgin's LILY.**

## Violet

Participants in DIONYSIAN festivals bedecked themselves and sometimes their THYRSI with violets, perhaps to guard against the ill-effects of ALCOHOL. Later, violets became a symbol of FEMALE modesty and frailty (hence the term 'shrinking violet'). They also symbolize remembrance and death – in *Hamlet*, Shakespeare associates them with Ophelia.

## Marigold

Associated with APOLLO in antiquity, the marigold was said to be the Nereid Clytie who, having been spurned in love by the SUN god, was transformed into a marigold and ever after turned her head to face the sun. Mexicans associate marigolds (*Cempazu-chiles*) with the dead and use them as decorations during the Day of the Dead.

## Peony

In Chinese the peony is called the KING (or QUEEN) of flowers. It is a symbol of good fortune, riches and female beauty, and is associated with erotic love and the VAGINA. Peonies are also symbols of spring and may be depicted with the LOTUS, CHRYSANTHEMUM and PLUM, representing the other SEASONS.

## Sunflower

When this YELLOW flower arrived in Europe from the New World the Spanish called it *girasol,* 'turn to the SUN' because it always turns its ray-like petals to the light. Hence it became associated with the faithful love of God and, in portraiture, with loyalty and devotion.

## Waterweed

A design based upon waterweed is one of the 'TWELVE ORNAMENTS' embroidered onto the robes of the Chinese Imperial household. Together they represented the power of the emperor. The waterweed design represented the element of WATER, and the FEMALE principle, YIN.

## Reed

To avoid the amorous attentions of the god PAN, the Greek nymph Syrinx was turned into marsh reeds. In Egypt, reeds are associated with the reed-beds of the river of HEAVEN. Temple COLUMNS imitate bundles of these reeds. In the Bible, reeds are associated with the baby MOSES hidden in reeds beside the Nile.

## Fern

In Maori culture, the *koru* (named from the word for folded/coiled) is a common decorative motif. It symbolizes the unfolding of new life, renewal, and hope for the future. Today, the motif is used by New Zealanders in the symbols of national organizations such as the Silver Ferns netball team and the All Blacks rugby team.

## Mistletoe

Mistletoe means 'all heal'. Its peculiar nature, as neither tree nor shrub, but a parasite that lives on OAK TREES, means that it has become a powerful symbol in European cultures. The ancient Celts believed that it possessed miraculous healing powers and held the SOUL of the tree on which it grew. The Norse belief in the power of mistletoe comes from the myth of the death and resurrection of BALDER, the god of the SUMMER SUN, who was killed by an ARROW poisoned with mistletoe, thrown at him by his BLIND brother Hoder, who had been tricked by LOKI. The TEARS shed for Balder by his MOTHER were said to have turned into the mistletoe's WHITE berries. In her joy at Balder's resurrection, she reversed the mistletoe's poisonous reputation and kissed everyone who passed beneath it. This is the origin of kissing under the mistletoe at Christmas, despite its reputation as the wood used to make the CROSS on which CHRIST was crucified. Because of this, it was banned from Christian ALTARS.

## Mushroom ✳ Fungus

Daoist Immortals are often depicted with the magic 'fungus of immortality' (*lingchi*), which was believed to grow on the mythical ISLANDS of the Blessed where the Immortals lived. It conferred everlasting life to those who ate it. In European folklore toadstools are associated with the FAIRIES.

## Teve

The Samoans considered teve, a bitter root-plant, to be sacred, as a form of the TREE OF LIFE. In the Samoan creation legend, the god Tagaloa first created a ROCK, which he then broke apart, causing the EARTH, SKY, SEAS and a freshwater SPRING to be made. He then propped up the sky, Tu'ite'elagi, with the first plant, a teve.

MISCELLANEOUS

# OBJECTS AND ARTEFACTS

7

BUILDINGS

### Dome

Curved, domes often represent the HEAVENS. This symbolism is evident in several Roman buildings, most notably the Pantheon (above), built in Rome in the 2nd century AD, and in many Byzantine buildings, such as the church of Hagia Sophia in Constantinople. Mosaics of CHRIST Pantocrator ('Ruler of All') decorate the interiors of the domes of some Orthodox churches emphasizing this connection.

Domes were also used in the construction of TOMBS, such as Theodoric's tomb in Ravenna, and of Christian *martyria* – domed memorials on sites linked with Christ's life or with holy martyrs. They appear in Islamic mausolea called *qubba* (the Arabic for 'dome'), and they are central features in mosques, such as the Dome of the Rock in Jerusalem.

In some Chinese creation myths, the SKY or HEAVEN was described as a dome-shaped CANOPY positioned over the flat, SQUARE earth. It was also compared with the dome of a TORTOISE's shell.

### Arch

TRIUMPHAL arches – sometimes single (above), sometimes with two small arches flanking a large central one – were erected in cities and on major BRIDGES all over the Roman empire to express civic pride and to commemorate important military victories. When marching to and returning from war, the emperor, his retinue and army would pass ceremonially through this arch. This tradition was resurrected in Europe during the Renaissance, and temporary and permanent arches have since been erected at moments of national celebration. Examples include London's Marble Arch and the Arc de Triomphe in Paris.

Arches are employed to create large open spaces in mosques and to enclose the community at prayer in the sacred space. These large arched areas emphasize the connection between God and the community in Islam. The shape of an arch often marks the MIHRAB, the niche in the *qibla* wall that indicates the direction of Mecca for the faithful.

### House-post

The WOODEN posts that support meeting houses throughout Oceania are often carved with intricate and beautiful designs representing ANCESTOR figures (above). They invoke the ancestors' *mana* (prestige) and provide a sense of collective continuity passed down through the generations.

In a similar way, Native American tribes of the North-west Coast carved totemic figures on house-posts to ensure the protection and guidance of TOTEM animals and ancestors.

In Bwiti, a modern religion formed from Catholicism and the Fang culture of Gabon, the temple's central post is believed to be the centre of all Bwiti power, symbolizing the HEART and BREAST of God, and everlasting life. It reflects elements of earlier ancestor worship, in that it is also the point of contact between the living and the dead. It is often carved with a representation of the VIRGIN MARY, whose image balances the innate MALENESS of the post's form.

A

B

C

# Column

The STONE columns in the early temples of Ancient Egypt were carved to resemble bundles of REEDS, symbolizing the reed-beds of the celestial HEAVENS. PALM columns were associated with RA, the SUN god, and papyrus capitals with his path across the SKY – the papyrus closes at night and unfurls in daylight.

The classical system of building with columns and beams is said to derive from the wooden architecture that preceded it. The columns took the place originally occupied by tree trunks, supporting the roofs. Columns were associated with temporal and spiritual authority, so they expressed grandeur and order; hence the Romans' use of single columns as monuments to imperial exploits, for example Trajan's Column, Rome.

God, the spiritual authority, appeared to the Israelites in the wilderness as a pillar of FIRE, the SHEKHINAH as a pillar of CLOUD. The TWELVE pillars built at the foot of Mount Sinai represented the twelve tribes of Israel; the SEVEN pillars of wisdom represented by the menorah are identified with the planets, the days of the week, and the seven days of creation.

In esoteric Jewish lore, the TWO columns on the façade of King Solomon's temple are sacred symbols. The LEFT-hand column, of BLACK stone, was called Jachin, meaning 'it shall stand', and corresponded to the MOON, decay, the waning year, and cursing. The RIGHT-hand column, of WHITE stone, was called Boaz, meaning 'in strength', and corresponded to the sun, growth, the waxing year, and blessing. (This symbolism became confused when the Jewish New Year moved to autumn.) The two columns retained their meaning in the Kabbalah, the mystical Jewish system of theology and metaphysics dating from the 11th century, in which they form the two outer columns on the TREE OF LIFE, with a third, central column that represents balance. The secrets of Freemasonry were said to have been hidden in these columns so that they would survive the FLOOD. Two often appear outside Masonic temples, representing force and form; the initiate himself embodies the third.

Later in Freemasonry the three main Greek orders of columns, Doric (A), Ionic (B) and Corinthian (C), represented Strength, Wisdom and Beauty. Antique and Renaissance texts associated the three orders with MEN and WARRIORS, matrons and scholars, maidens and VIRGINS, respectively (in Christian churches, specifically with male and female saints of each type). The column to which CHRIST was tied when flogged by the soldiers has become a symbol of his PASSION.

Japanese Shinto shrines may consist of a simple stone pillar or a rock. Two pillars or columns with a cross-bar on top forms a Shinto GATEWAY (torii), marking a shrine's entrance or a sacred area. In a Buddhist PAGODA, the central pillar is particularly significant as it houses the relics of the BUDDHA.

As objects of support, pillars often embody the basic tenets of a faith: for example, the 'FIVE Pillars of Islam' (profession of faith, prayer, pilgrimage, fasting, charity).

B U I L D I N G S

### Canopy

Canopies protect the sacred or the important from the elements. They protected KINGS of the Ancient Near East and the THRONES of Roman and Persian rulers. They still provide symbolic protection for rulers in many cultures, and are symbols of their status. They have a symbolic role at Jewish WEDDINGS, when a canopy called a *chuppah* or *huppa* is held over the bridal couple – 'king and QUEEN of this day' – by MALE relatives. Similar canopies are also used at Islamic weddings (above).

In the temples of Ancient Mesopotamia, Greece and Rome canopies protected cult statues. They came to denote sacred spaces, evolving into the Christian ciborium (or baldachin), an architectural canopy supported over the ALTAR on slim COLUMNS.

The Hebrew *succah*, a booth of PALM LEAVES (or tree branches, through which STARS are visible) is set up for the SEVEN days of *Succoth* or Feast of the Tabernacles to commemorate the Israelites' DESERT life during the Exodus.

### Stair

At the entrances to churches and temples there is often a stairway, which symbolizes a means of transition between the sacred and the mundane. The Israelites stood on the steps of the Temple for their ceremonies. The great stairways leading to temples on top of the ziggurats of Mesopotamia symbolized the mediating position of the temple between HEAVEN and EARTH (above). Stairways similarly lead to the summits of Aztec and Maya PYRAMID temples.

A flight of steps leads up to the platform of a *minbar*, or Islamic pulpit. The prayer-leader delivers his Friday address from the step beneath the topmost one, which is reserved symbolically for the Prophet Muhammad.

In China and Japan, one steps up from dirt towards cleanliness. Stairs also embody social hierarchy. Steps lead up to Chinese imperial PALACES, indicating the power of the emperor.

For Freemasons the winding staircase symbolizes the levels on the road of life. It is CIRCULAR because life is a SPIRAL.

### Threshold

Thresholds are places of change and transition. Roman households were thought to be protected from malevolent SPIRITS that congregated near entrances by the minor god Limentinus; and the attendants of a Roman bride protected her by carrying her over the threshold, a familiar tradition today (above). A Chinese bride would sometimes pretend to be weak the first time she crossed her husband's threshold to symbolize her willingness to obey the rules of the household.

Temple DOORS often mark the junction between the temporal and spiritual worlds. Early Hindus and Buddhists carved protective tree spirits or RIVER goddesses at the entrance, and *mithuna* images of copulating couples are carved above the threshold in a Hindu temple to strengthen these junctions with energy. Early Judaic priests would wash, robe and disrobe at the threshold of the Temple, and animal SACRIFICES would also take place there so that BLOOD was not shed in the Temple.

A

B

C

## Entrance ✳ Door

Several cultures consider
doorways and other entrances
to provide opportunities for good
and evil influences to enter, and
special deities may be assigned
to oversee them.

Lamassu carvings (C) guarded
the entrances of Assyrian and
Babylonian palaces, while certain
*numina* (minor deities) guarded
Roman doors. The god Forculus
oversaw the door panels, while
the goddess Cardea oversaw the
hinges. A cave in Chalcatzingo,
Mexico, has a monster's face
carved around the entrance,
symbolizing the protection
of the entrance and the
transition from one state of
being to another.

Portals are often associated with
the transition from life to death.
On Ancient Roman tombs the dead
were often depicted in front of
half-open doors, while some
tombs in Ancient Egypt had a
very small false door to allow
the *ba*, or soul, to fly in and out.
The Hebrew for door, *daleth*,
has the same structure as the
word for birth.

Entrances and doorways also
symbolize the transition from one
year to the next. Janus, the Roman
god who oversaw all entrances and
departures through doors, was
associated with New Year. This
association remains in the name
of the first month of the year in
the Gregorian calendar, January.

On the eve of the Chinese New
Year, families lock the doors while
waiting for midnight, and paste
up images of the Door Gods to
help guard against evil spirits.
Another New Year decoration is
a red paper banner bearing the
words 'May the five blessings
approach the door'; the blessings
are old age, wealth, health, love of
virtue and a natural death. For the
Japanese New Year, decorations
made from the boughs of evergreen
trees, called *kadomatsu*, are placed
at the entrances to houses to
attract the gods and good luck.

In temples and churches
doorways often carry specific
meanings. A Shinto *torii* gateway
(B) marks the entrance to a shrine
and the point at which a visitor
passes from the profane to the

sacred. The absence of doors on
a *torii* has been interpreted as a
sign of the perpetual openness
of the shrine.

In Hebrew temples, different
offerings were brought to different
doors: grain to the north door;
animals to the south door; and
incense was burned at the east
door. Christian churches usually
have their everyday entrance on
the south side, while the larger
western portal (A) is for
ceremonial use and is often
surrounded by carvings of the
hierarchy of the heavens, with
Christ and God over the central
door. The doors of Native
American dwelling places and
ceremonial structures always face
east, towards the rising sun.

Ancient Chinese texts described
a closed door as yin, the passive
principle, and an open door as
yang, or active. The opening and
shutting of a door was held to
symbolize the alternation of
yin and yang in the universe.

BUILDINGS

## Hearth

As the source of LIGHT, heat and cooked food, the hearth was historically central to the well-being of any household. It was the sacred place of Ometecuhtli, the TWO-LORD of the Aztecs, who was MALE and FEMALE and believed to live at the heart of the universe and so in the heart of all people.

In Japan and China the hearth gods attracted good fortune and plenty to the household. The Chinese CAOZHUN ('Hearth God' or 'Kitchen God') resided in the kitchen, while the Japanese god of the hearth lived in the hook on which the COOKING POT was suspended.

The Vestal VIRGINS, priestesses of Vesta, the Roman goddess of the hearth and the domestic fire, tended the sacred FLAME that symbolized the security of all Roman hearths and the prosperity of Roman homes. Her Celtic counterpart, BRIGID, was associated with the SUN and the hearth. The fire was put out every year at Imbolc in February, to be relit as Brigid was called back into the house.

## Mihrab

The niche or mihrab (above) in the *qibla* wall of a mosque (see KA'BAH) indicates the direction of Mecca for the praying faithful. It is usually decorated with geometric motifs and text from the Qu'ran. In large mosques a space just in front of the mihrab, the *maqsura*, was reserved for the Caliph or ruling prince and his leading attendants.

## Cornerstone

In the Judeo-Christian tradition, a cornerstone symbolizes strength and stability: 'Look, I am laying a stone in Zion, a precious cornerstone for a firm foundation' (Isaiah 28: 16). Thus, PAUL described the APOSTLES and prophets as the foundation of God's household, 'Jesus CHRIST himself being the chief cornerstone' (Ephesians 2: 20).

## Keystone

The last stone of an ARCH, placed in its centre, is the keystone. It locks all the others in their places, ensuring firmness and stability. CHRIST is described as a keystone, ensuring the integrity of the self. Freemasons aspire to be unique keystones, playing essential supportive roles in society.

## Black-and-white Flooring

The black-and-white carpet is a basic symbol of Freemasonry. Its FOUR sides represent the world of solid matter; the BLACK and WHITE SQUARES represent the polarities of, for example, LIGHT and dark, good and bad, MALE and FEMALE, and are the grid upon which the universe is built. Those who step on the carpet accept the ups and downs that life brings, and that wisdom is the gift of experience.

# Wheel

As simple, versatile, useful and widespread tools, wheels have accumulated many meanings, often linked with their continuous, circular motion. The wheel or CHAKRA is an important Hindu symbol, representing perfect completeness and unifying time and space. In ancient Indian medical texts it represents critical junctions inside the body that unify the physical and the metaphysical.

The SIX-spoked wheel is a symbol of VISHNU, the second deity in the Hindu Trimurti or Trinity, while the EIGHT-spoked wheel symbolizes the eight cardinal DIRECTIONS, each ruled by a deity and with a unique quality or property. The wheel is also used to symbolize the SUN, when it may be depicted as a CIRCLE of FIRE with FOUR darting points of flame (C).

The wheel is a fundamental Buddhist symbol (A). As the *dharmachakra*, the Wheel of the Law (also called the GOLDEN Wheel and the Wheel of Truth), it symbolizes the ability of Buddhist teaching and enlightenment to roll over and crush falsehood. Its spokes (usually EIGHT) relate to BUDDHA's first sermon at Sarnath, and the eightfold PATH that leads to perfection. Its hub represents the moral anchor, and its rim, contemplative discipline.

The Wheel of the Law (B) is one of the Chinese Eight Buddhist Symbols, and one of the thirty-two signs in carvings representing the FOOTPRINTS of the Buddha. In Japan the Wheel of the Law is an attribute of the BODHISATTVA Senju Kannon ('Thousand-Armed Kannon', a manifestation of AVALOKITESHVARA) and the 'Great Sun' Buddha, Dainichi Nyorai (Mahavairocana).

In Jewish Merkaba mysticism – which focuses on the CHARIOT or THRONE of God, as described in Ezekiel's vision (Ezekiel 1), as a subject for contemplation – the wheel is related to the chariot/throne. In Ezekiel's vision, the chariot was associated with the CHERUBIM. Its wheels were said to be the FOUR LIVING CREATURES, who represent the SEASONS, so that in the Bible the wheel may represent the earthly life cycle.

A wheel motif is often found on depictions of Celtic SKY gods and Romano-Celtic gods associated with JUPITER. It is probably linked with the SUN, and possibly the cycle of the year.

The concept of the Wheel of Life is also central to Native American beliefs. Human spiritual, physical, emotional and psychological experiences of life, and their connections with the elements and with the other worlds of the earth, plants, animals and minerals, are reflected and described within the many interrelated medicine wheels, which in their totality form the complex Wheel or Hoop of Life.

In antiquity the wheel was an attribute of TYCHE (Fortuna), illustrating the ever-changing nature of man's fortunes. In alchemy, the *rota philosophica* (philosophical wheel) is a representation of the SOUL's ascent through various spheres until, released from the wheel, it ascends towards union with god.

A  B  C

## Chariot

As symbols, chariots are the carriers of rulers and gods. Assyrian chariots (A) conveyed the KING and the battle standards of the gods into war, so they symbolized the THRONE and the temple. The Assyrian king also hunted LIONS from his chariot, thereby fulfilling his sacred duty to protect his people from predators. The chariot therefore symbolized the king's power to lead and to vanquish.

In all the cultures of the Ancient Near East, Greece and Rome chariots continued to be associated with gods. Herodotus recounts how the Achaemenids (Ancient Persians) went into battle accompanied by the chariot of AHURA MAZDA drawn by EIGHT WHITE HORSES, and left empty (driven by a charioteer from behind the chariot), to indicate the god's presence among his warriors. APOLLO, Greek god of the sun, drove the FIERY chariot that conveyed the SUN across the SKY each day.

Jews also related their chariots to God's chariot or throne. In Ezekiel's vision, interpreted in an esoteric text called the *Ma'aseh Merkabah (The Work of the Chariot)*, the chariot had four WHEELS representing the turning year. The wheels, 'all alike, like a wheel within a wheel', represent the four SEASONS. The eternal charioteer is the God of Israel, identifying Jehovah as the SUN.

In Renaissance art, chariots or triumphal cars are also depicted carrying various classical deities, such as VENUS, MARS or JUPITER (B). These might be portrayed in a purely astrological context, carrying the planetary deities. In illustrations depicting Petrarch's TRIUMPHS (1351–74) one allegorical figure is shown triumphing over another. For example, Fame's triumphal chariot follows, and triumphs over, the chariot bearing DEATH. Alternatively, chariots might appear as 'cars' carrying allegorical figures in festivals.

The various deities of the Indian subcontinent use chariots, or *rathas*, drawn by different creatures: for example, HORSES for AGNI and Surya, GEESE for BRAHMA. *Rathas* can also be LOTUS-shaped. The *Pushpaka* is a mythical chariot of Indra and Kubera. The English word 'juggernaut' is derived from the massive chariot of the god Jagganath. As processional cars, chariots are found in many shrines all over the region. They are TOWER-shaped, like the shrines, so the word *ratha* has also become the popular name for a shrine. Temple *rathayatras* (car festivals) are famous in India.

Chariots have been discovered at Celtic burial sites, but it is not clear whether this tradition was a mark of wealth or rank, or to provide a vehicle with which the deceased could reach the Otherworld. A few chariots have been found in the graves of high-ranking Celtic WOMEN, and it has been suggested that they may have been priestesses associated with war cults. In battle, chariots were used mainly by those of high rank, who would have had a charioteer to drive them at high speed in and out of the fray.

## Boat × Ship × Canoe

As means by which humans can travel over WATER (A), boats are linked in many cultures with water deities. In southern China, for example, races held on the 5th day of the 5th LUNAR month between long boats decorated with DRAGONS' heads had their roots in ceremonies to propitiate the water god (sometimes conceived of as a dragon) at the start of the rainy SEASON.

In Ancient Mesopotamian mythology the SUN god crossed the SKY in a celestial boat, while the Ancient Egyptian sun god RA travelled through the UNDERWORLD and the sky in the 'boat of a million years'. Other Egyptian gods also crossed the HEAVENS in boats. The Dogon of Mali make pendants depicting the 'world boat': FOUR rods of IRON (the four elements) are joined together at both ends, carrying a firestone BALL in the ovoid space between the rods representing the sun (the yolk of Amma, the Creator's EGG).

Boats can symbolize DEATH and transformation. The Ancient Greeks and Romans believed that Charon ferried the dead across the River Styx to the Underworld in a boat, and Egyptian barques also bore the dead to the afterworld. Norse ship graves – or burial MOUNDS in the shape of ships – often point out to SEA or to a body of water, indicating the journey to the afterlife.

In China and Japan, paper boats are used as conveyances for SPIRITS. At the end of the Japanese Buddhist festival of Bon, miniature boats containing LANTERNS were floated downstream or out to SEA to symbolize the departure of the ANCESTORS' spirits. Hindus, too, use miniature boats carrying FLAMES to symbolize solar energy or prayers.

Impossibly small boats such as coracles are central to Celtic tales, called *Imrams*, of remarkable sea journeys to fantastic ISLANDS. Such tales were probably symbolic, instructional accounts of journeys to the Otherworld. KING ARTHUR and his men took such a journey to the Underworld in a boat called *Pridwen*. The theme of heroes travelling on a quest in a boat is a common one:

for example, the Ancient Greek tale of Jason and the Argonauts' search for the GOLDEN FLEECE in the ship called the *Argos*, which has similar connotations to the search for the Holy GRAIL.

Sea transport is vital to island peoples, so boats are central to Oceanic cultures (C). Maori war canoes (*wak a taua*) are said to possess *mana* (prestige) for all those who own and sail in them. In many Hawaiian proverbs and sayings, canoes are used to describe warnings and observations on life: for example, 'the canoe has come ashore' means that hunger is satisfied or desire fulfilled.

Ships are symbolic containers. The 15th-century Christian Ship of FOOLS (B) holds representative members of humanity. The nave of a church (from the Latin *navis*, 'ship') carries the congregation. The Japanese SEVEN DEITIES OF GOOD FORTUNE are sometimes depicted aboard a *takarabune* or Treasure Ship, which is said to sail in to land at New Year, symbolizing good fortune, long life and prosperity.

F O R M S   O F   T R A N S P O R T

## Ark

In Judeo-Christian belief, the ark was the BOAT created by Noah on God's instructions, in which Noah, his family, and one breeding pair of each living creature survived the FLOOD (Genesis: 5–10). A form of transport that provides salvation for one or more peoples or species is now often called an ark. It was a symbolic device for carrying the word of God (*teba* is the Hebrew word for 'ark' and for 'word').

The BASKET of bulrushes that carried the infant MOSES down the Nile is sometimes translated as an ark. He was saved from the water by the pharaoh's daughter, to carry the word of God. As a device for carrying the word of God, Noah's ark is also related to the ARK OF THE COVENANT. For Freemasons, Noah's Ark is a symbol of Sacred Architecture, as detailed instructions for building it were given to Noah by God.

In alchemy the ark represents the vessel containing the CHAOS created in the alchemical work, keeping the contents firmly secured by the grace of God and the faith of the alchemist.

## Sail

Sails were an Ancient Egyptian symbol for WIND and BREATH. As they have to follow the wind, they symbolize fickleness and inconstancy. Their colour may be symbolic: in Greek legend, Theseus, returning home after defeating the MINOTAUR, forgot to replace his BLACK sail (above) with a WHITE one to signal his survival.

## Rudder

The rudder was an Ancient Roman attribute of FORTUNA, the goddess of fate, who guided the course of people's destinies. It was also adopted by the Greeks and Romans as a symbol of their version of the Egyptian goddess ISIS, with the same meaning. In Renaissance allegory it became a symbol of luck, fate and chance.

## Anchor

Symbols of steadfastness, anchors were used in Roman art of the era of Augustus (27 BC–AD 14), to allude to his naval victory at Actium. They suggested that his reign augured a new period of stability.

For Christians, anchors symbolize hope, 'the anchor of our soul' (Hebrews 6: 19). Freemasons place an anchor on Jacob's LADDER as a goal to be attained.

## God-stick

A god-stick, a carved peg used by Maori priests to summon up and hold the essence of a SPIRIT or god, would be held by the priest, or thrust into the ground. To make a request, sacred strings or THREADS were attached to the sticks and pulled to get the attention of the spirit in the stick.

A

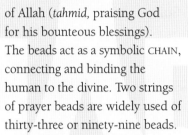
B

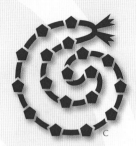
C

## Prayer Beads

These sets of beads symbolize the prayer and meditation for which they are used. Chinese and Japanese Buddhists use bead rosaries to count the repetitions of the BUDDHA's name in prayer. Most rosaries consist of 108 beads, ensuring that the Buddha's name is repeated at least ONE HUNDRED times (A). Each bead can also represent a base human passion. Buddhist rosaries are attributes of believers and deities, such as the BODHISATTVA Guanyin (AVALOKITESHVARA) and the Buddha of Immeasurable LIGHT, AMITABHA (called Omi to fo in Chinese and Amida in Japanese).

Muslims use prayer beads (*misbaha* or *subha*) to help in the recitation of the ninety-nine names of Allah (the hundredth being known only to Allah himself) and his attributes, to remind believers of the litanies (*wird*) of Islam and as an aid to memorizing and repeating important prayers, ranging from contemplating the unity of the divine (*shahada,* expressing the unity of God), to giving thanks for the blessings

of Allah (*tahmid,* praising God for his bounteous blessings). The beads act as a symbolic CHAIN, connecting and binding the human to the divine. Two strings of prayer beads are widely used of thirty-three or ninety-nine beads.

Hindus also use prayer beads (*malas*) as an aid in the recitation of mantras – sacred passages used as prayers or incantations. *Malas* are of various kinds and materials, depending on whether they are to be used for peaceful rites, rites of prosperity, rites for power, or wrathful rites. The most famous *mala* is the *rudraksha mala,* made from the dried SEEDS of a tree (*Eliocarpus ganitus*) (C). Named after the Vedic deity Rudra, from whom SHIVA, third deity of the Hindu Trimurti, is said to have evolved, they are especially sacred to Shiva. *Rudraksha* means the 'EYE of Rudra', symbolizing Shiva's third eye; it also refers to Shiva's TEARS (the Sanskrit root *rud* means 'to cry').

The *rudraksha* seed is naturally grooved, with indentations thought of as *mukhas* or faces. The significance and sacredness of a bead varies according to

how many *mukhas* it has. A ONE-faced bead (*ekhamukha*) is particularly sacred.

Prayer beads are also used extensively by Roman Catholics while reflecting on events in the life of CHRIST or the fifteen Mysteries of the VIRGIN MARY (B), which relate to her various virtues and sorrows. They originated in the 13th century to aid with the recitation of certain series of prayers. These prayers were usually addressed to the Virgin Mary, and the prayer beads came to be called rosaries because of her association with the ROSE. They usually have 165 beads, divided into fifteen sets, each consisting of TEN small beads and one large one. Each small bead represents an *Ave Maria* ('Hail Mary', the ARCHANGEL Gabriel's words to Mary when he announced to her that she had conceived Christ), and each large bead represents a Paternoster ('Our Father', the Lord's Prayer). On occasion, particular sets of beads are offered by their owners to shrines in thanks for favours received as a result of prayer.

SYMBOLIC AND RITUAL OBJECTS

## Prayer Wheel

One revolution of a Tibetan Buddhist prayer WHEEL is considered equivalent to a spoken prayer or prayers. A prayer wheel is a rotating drum inscribed with or containing prayers. It is rotated clockwise as prayers are recited. Large prayer wheels are found outside Buddhist shrines, and are rotated by pilgrims as they walk clockwise around the shrine.

## Prayer Stick

Native American prayer sticks, made of painted WOOD OR REEDS and decorated with FEATHERS, THREAD and other objects, embody prayers and carry them to SPIRIT. Sticks may be placed, according to custom, around a ceremonial site or they may be bundled together and placed upon it.

## Amulet

Small objects or pieces of jewelry imbued with magical or protective powers are usually worn about the body as a charm or amulet. Their form often relates to the protector they call upon, or the evil against which they protect. The Ancient Egyptians and Romans used deities or symbols, such as RA or a CORNUCOPIA. Popular Hindu amulets include the Vishnupada (VISHNU'S FOOTPRINT) and the plaque of HANUMAN, whose bravery overcomes obstacles. In the Middle East, a HAND-shaped amulet carrying a BLUE STONE representing an EYE wards off the evil eye. The Chinese used many types of amulet, such as padlock-shaped charms which 'locked CHILDREN to life'.

Amulets such as Indonesian *anting-anting* charms can imbue their carriers with special powers; Native American animal amulets embody the SPIRIT of the animal represented. Amulets also protect the dead, and were often buried with corpses. In Egypt different amulets were laid on specific parts of a mummy.

## Talisman

A charm inscribed onto an object is called a talisman, from the Greek *telesma*, meaning 'ritual'. Chinese talismans were sometimes written on paper in 'ghost script', thought to be understood by the spirits. In Japan *gofu* – talismans designed to bring good fortune – are sold or given away at Shinto shrines. These are usually pieces of paper bearing the name of the shrine's deity.

A common Islamic talisman is a *tawiz*, a STONE or METAL plaque bearing a quotation from the Qu'ran. Another type carries a 'magic SQUARE', composed of a word or a sum that can be read in any direction (above). Talismans of this type influenced the Jewish Kabbalah and the European alchemical and hermetic traditions.

Hindus use a wide variety of objects, such as STONES, AMULETS, charms and figures, as lay talismanic symbols. It is not uncommon for one person to own several talismans, each with its special quality and power.

A

B

C

## Altar

From the Latin word *altus,* meaning 'high', an altar is generally a raised area that forms the focus for the worship of a divinity to which it is dedicated. It is often, but not necessarily, found within a building or area that is considered sacred.

An altar is usually dedicated to a particular deity, which is often indicated by placing an image or a symbol related to that deity above the altar.

The items assembled on an altar provide a connection between people and the SPIRIT to which the altar is dedicated. For example, altars to the African goddess MAMA WATA are covered with personal items that are considered beautiful, such as perfumes, flowers, sweets and beauty aids. Impermanent items which have to be replaced, such as incense and CANDLES, are often placed on altars to ensure that they are tended continuously.

Altars also have the role of carrying prayers up to the gods in the form of FIRE and SMOKE. This relates to the use of altars as sites for SACRIFICES to the gods. In the Philippines, PALM LEAF books of prayers are offered by fire on *batong buhay,* or stone altars.

Altars also act as TABLES for the gods, who are believed to eat and drink the offerings left for them. *Chac mools* (B), found in temples at Chichén Itzá and Tula in the Yucatán, Mexico, are large reclining figures with flat, circular stones like dishes on the STOMACH on which offerings were placed. This idea developed in Christianity into the use of the altar as a table for the Communion (A).

The Jewish Temple contained more than one altar, placed according to their role. The altar in the NORTH received BREAD and grain offerings; the SOUTHERN altar held the menorah and received burnt animal offerings; the altar in the EAST received incense; and in the WEST the ARK OF THE COVENANT was covered with RED RAM SKINS, and guarded by two CHERUBIM looking east towards Eden.

Christian altars are shaped like a Roman TOMB (which took its own form from the Roman altar).

They are sometimes inscribed with FIVE CROSSES (one in each corner, one at the centre) which symbolize CHRIST's five wounds, so that the altar table recalls Christ's body inside the tomb. They are often placed at the east end of the church on a raised platform, like the high table in a great medieval hall, and they symbolize the table used at the Last Supper, over which Christ broke the Eucharistic bread.

Many religions also use personal altars and household shrines (C). Traditional Chinese and Japanese homes contained small shrines or altars honouring deities and the family's ANCESTORS.

An altar need not be fixed. Native American altars may be constructed afresh according to the ceremonial intention of those who set them, or to tribal traditions and practices.

### Altar Light

The custom of keeping LIGHTS burning before ALTARS was prefigured by the FIRES used to consume the SACRIFICES made upon them. Such fires came to symbolize the eternal or divine fire, so it became important that these fires should never go out. Examples are the fires tended on the fire altars of the Zoroastrians, or the eternal flame of the Vestal VIRGINS of Roman antiquity. Thus in many religions, such as Buddhism, CANDLES are placed on or near the altar to symbolize the eternal light or fire.

The altar or sanctuary LAMP of Christian churches also represents continual vigilance and prayer, and symbolizes CHRIST, 'the light of the world'. Jewish tabernacle lamps were lit only at night, although incense was burnt morning and evening. God's divinity would thus be visible as fire at night and a CLOUD of incense during the day, reflecting the form in which God and the SHEKHINAH appeared to the Israelites during the Exodus.

### Tomb

Since Neolithic times, tombs have represented for many cultures a home beyond the grave. As such they are often filled with the requirements of daily life. Their size and richness reflected their occupants' status when alive.

Egyptian tombs were the vehicles by which the body was reborn into the afterlife. The magical symbols painted on the sarcophagus enabled its occupant to continue to live in this world and in the Otherworld.

Roman tombs were sacred places, shaped like ALTARS and dedicated to the SPIRITS of the departed. Christian altars in turn recall CHRIST's tomb, which itself is a symbol of DEATH and resurrection.

The tomb is the alchemist's oven, while the great Rosicrucian mystery of CHRISTIAN ROSENKREUZ is symbolized by his rebirth from a SEVEN-sided tomb. In the Masonic legend of Hiram Abiff, the tomb is a place of darkness through which man must pass to be resurrected in the knowledge of the LIGHT.

### Flag

In most ancient cultures people carried totems, and to elevate their significance they would place them on long poles. From these developed the standard and the flag. These would be held above the heads of soldiers in battle or placed on buildings and planted in the ground to indicate self-assertion and identity, nationhood and allegiance.

Flags (*dhvaja* in Sanskrit) also have religious significance: a TRIANGULAR banner or flag on a tall pole (*sthamba*) is always placed in front of the main shrine of the temple. The flagpole represents the axis of the universe, and the ORANGE or RED banner the life-giving FIRE of the SUN and the victory of the eternal values of Hinduism (*sanatana dharma*).

Buddhist prayers are carried on the WIND by fluttering flags hung on trees, which thus become *parijata* or wish-fulfilling trees.

The *Agnus Dei* (LAMB of God) is often shown holding the banner of CHRIST's resurrection (and TRIUMPH over DEATH): a red CROSS on a WHITE ground.

A

B

C

## Throne

Modern monarchs use their thrones mainly on ceremonial occasions. A throne is a special seat symbolizing the authority of a god or a sovereign – the authority represented by a throne may be temporal or spiritual, so the rulers of the Greek pantheon, ZEUS and his consort HERA, were sometimes shown enthroned. In Byzantine Christian art an empty throne is a symbol of God or of the Second Coming. Depicted with a DOVE and a CRUCIFIX, it represents the TRINITY.

A throne is often positioned on a raised platform (A). In the Bible, Solomon's IVORY throne was at the top of SIX steps, with a pair of GOLDEN LIONS flanking each step, so that the KING was symbolically raised above his subjects. Ezekiel (1: 26 & 10: 1) describes the throne of God as being of SAPPHIRE or LAPIS LAZULI 'above the vault over the heads of the CHERUBIM', representing the HEAVENS.

In the Judeo-Christian tradition the word 'throne' has a secondary meaning, since thrones are one of the NINE orders of ANGELS enumerated by the 6th-century Neoplatonic writer, Pseudo-Dionysius the Areopagite.

The VIRGIN MARY is associated with the throne: she is depicted seated on one holding the infant CHRIST, so that she becomes the throne of Christ. Earlier Egyptian images show ISIS in a similar position, seated on a throne suckling the infant HORUS (C). The name of Isis, Aset, is derived from the Egyptian word *set*, meaning 'throne', and a throne was depicted on her HEAD-DRESS. Like Mary, she may have embodied the power of the throne and the concept of sovereignty.

In Buddhist art a 'DIAMOND throne' under a BODHI TREE or a CANOPY symbolizes the person of the Shakyamuni BUDDHA. Other Buddhist deities are often shown on a LOTUS throne, which symbolizes their divinity, purity and enlightenment.

The decoration of thrones indicates local traditions and myths regarding kingship. The highly decorated beadwork thrones of the Bamum Kingdom in Cameroon incorporate two figures into their decoration: a MALE offering a drinking HORN and a FEMALE offering a calabash BOWL. These represent the court TWINS, both a symbol of the fertility of kingship and a permanent representation of the ceremonial practice of making offerings. The two figures stand on either side of the king, visually recalling the tradition that the king never appeared outside alone.

A carved stone relief set above a throne in the palace at Palenque in Mexico shows Zac Kuk, MOTHER of the Maya ruler Pacal, presenting the crown to him as he sits on a double-headed JAGUAR throne, possibly indicating the importance of matrilineal inheritance in the culture.

In Imperial China, the legitimacy of the emperor was not embodied in one particular throne. Nevertheless, ornate thrones and seats (B) acted as powerful symbols of the emperor's might and his special powers. They were frequently decorated with the DRAGONS from which emperors were believed to be descended.

A

B

C

## Crown

The crown, a form of head-dress reserved for sovereigns (A) – who may be divine like ZEUS/JUPITER, ruler of the Greco-Roman pantheon, or mortal KINGS and QUEENS – is often the most important part of their regalia. In the case of mortals, it is associated with the bestowal of divine right upon a sovereign during a coronation ceremony. In the Bible, flinging the crown of an anointed KING to the ground symbolically broke the king's covenant with God.

The *mukut* or crown of kings of the Indian subcontinent is conical. The *Kiritamukuta* embodies the concept of divine kingship for Hindus, and male and female Hindu deities are usually depicted wearing a crown. The crown of the Nigerian Yoruba king (B) is also conical, with a beaded fringe to obscure his identity and protect the viewer from the power of his direct gaze. The Pope also wears a conical tiara, its THREE coronets symbolizing the TRINITY. The height of these crowns lifts the wearer symbolically above others and indicates contact with HEAVEN.

The *Muktadharin,* or crowned BUDDHA, usually wears a crown having FIVE LEAVES, symbolizing the five *dhyani* or meditating Buddhas. The crowns worn by BODHISATTVAS symbolize their princely status and indicate the wearer as a future Buddha.

The Ancient Egyptian pharaoh had a number of crowns, and commonly wore the BLUE and GOLD *Nemes,* the WHITE crown of Upper Egypt (*Hedjet*), or the RED crown of Lower Egypt (*Deshret*). The white and red crowns combined represented the uniting of the two lands. As the living OSIRIS, he also wore the WHITE *Atef* crown of Osiris (C), and in war the BLUE *Kephresh*. All crowns bore the uraeus, symbolizing the gods' protection and power.

In China one single crown did not represent imperial authority, although Chinese emperors wore crown-like head-dresses as symbols of their authority. These were topped with flat, SQUARE boards from which hung strings of JEWELS. The mythical QUEEN MOTHER of the WEST (XI-WANG-MU) is pictured wearing a similar crown. Yan-huo, Lord of the UNDERWORLD, is also depicted wearing a crown, symbolizing his dominion over hell.

In the medieval European conventions of courtly love, the coronation of a lover with a coronet symbolized the consummation of love. In Christian iconography, the Virgin is shown being crowned as Queen of HEAVEN by CHRIST. In contrast to the personification of ECCLESIA, who represents the Christian Church, 'Synagogue', representing Judaism, wears a toppling crown in some medieval representations of the crucifixion. This symbolizes Christianity superseding Judaism.

Sassanian and Byzantine crowns were similarly rendered in mosaic on the walls of the Mosque of the Dome of the Rock in Jerusalem (AD 691), symbolizing the Muslim belief that Islam had incorporated and completed the monotheistic traditions of Christianity and Zoroastrianism.

In Western alchemy the crown symbolizes completion and also the perfection of a METAL.

## Orb

The standard form of imperial orb is a GOLDEN globe, surmounted with a CROSS (above), encircled by two JEWEL-encrusted bands: one runs horizontally around the middle, the other runs over the top and joins the first to create a tri-partite division, symbolizing the TRINITY or the THREE continents of the pre-Columbian globe. It originated in the globe held by Urania, MUSE of astronomy. In Greco-Roman art, personifications of VICTORY show her balanced on a globe and holding out a WREATH, symbolizing the victor's success in territorial conquest.

The orb was first used as part of a monarch's regalia by the Roman emperors, as a symbol of their rule over their Empire. It later became one of the insignia of the Holy Roman Emperors, when it was Christianized by being surmounted with a cross. In some instances CHRIST is depicted holding an orb, symbolizing his dominion over the world.

## Sceptre

The sceptre – from the Greek word *skeptron*, meaning STAFF – symbolizes authority and rulership. The Egyptian sceptre, with a forked bottom and a stylized animal HEAD, was held by gods, symbolizing happiness and well-being. It was placed in TOMBS of the Middle Kingdom because it was believed to bring wealth and prosperity in the afterlife.

In the Ancient Near East a sceptre was often depicted as a STAFF of life, sprouting buds and jets of WATER, symbolizing the ruler's responsibility to provide sustenance for his people. In the Old Testament the sceptre symbolizes royal power. To 'stretch out the GOLDEN sceptre' can mean life or DEATH, favour or disfavour for subjects.

As part of the insignia of Roman consuls, the sceptre was tipped with an EAGLE, a symbol of the emperor's authority.

Several Japanese characters carry sceptres: Bishamonten, Guardian of the NORTH; the BODHISATTVA 'HORSE-headed Kannon'; and the HERMIT Moki.

## Baton

In the West, the short stick called a baton (above) has been a symbol of military command since at least classical antiquity.

In China, baton-like objects were used as *tan zhu* (talk-sticks). Students would pick up an object ranging from a twig to a RU-YI to signal their desire to start a discussion with their masters.

## Wand

In Greek mythology, as well as the CADUCEUS the magician HERMES had a GOLDEN wand with which he could raise the dead. Roman augurs possessed a *littus*, a curved wand symbolizing their office. Early depictions of CHRIST show him as a *thaumaturgos* (miracle worker), turning WATER into WINE or raising the dead Lazarus with a touch from his wand.

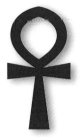

<div style="writing-mode: vertical">SYMBOLIC AND RITUAL OBJECTS</div>

### Treasure

Treasure signifies a collection of precious objects. In China and Japan auspicious, symbolic groups of objects are called 'treasures':

✳ EIGHT BUDDHIST TREASURES: an UMBRELLA, a pair of FISH, a VASE, a LOTUS, a CONCH SHELL, an endless KNOT, a CANOPY, the WHEEL of the law – refer to aspects of Buddhism.

✳ Chinese Eight Treasures: a BOOK, an ARTEMISIA leaf, a pair of RHINOCEROS HORNS, a LOZENGE, a COIN, a MIRROR, a PEARL, a STONE chime, each adorned with a RED ribbon – refer to the Chinese scholar or a wish for prosperity.

✳ Chinese Eight Treasures of Daoism: a FAN, a SWORD, a bottle-GOURD, CASTANETS, a FLOWER BASKET, a BAMBOO cane, a FLUTE, a LOTUS – attributes of the EIGHT IMMORTALS.

✳ Japanese Myriad Treasures (*takaramono*): related to the SEVEN DEITIES OF GOOD FORTUNE, who carry them in a SACK or as cargo on the Treasure SHIP (*takarabune*).

Celtic tales describe forays into the Otherworld to find treasures. Hidden treasure guarded by a monster, a DRAGON or a sleeping WARRIOR is a prize in later tales.

### Coins

The designs stamped on the earliest coins once served as symbols guaranteeing the quality and weight of the precious metal they contained. As the value of coins diverged from their intrinsic worth, coins came to symbolize specific sums of money. The designs upon them often signified the authority of the body that minted them, as they still do.

As money, coins symbolize wealth and riches. BRONZE 'money trees' from which 'coins' hang have been found in Chinese TOMBS from the late Han dynasty (206 BC–AD 220). Charms made of TWO coins hung in Chinese shops represent the God of Riches and a wish for financial success.

Many Chinese coins were round with a SQUARE hole in the middle (above): the circumference symbolized the CIRCLE of HEAVEN, the square represented the EARTH.

Coins often accompanied the dead as payment for their journey to the next world. Since Roman times, they have been tossed into bodies of WATER, such as fountains, to secure good luck.

### Ankh

This Ancient Egyptian hieroglyph came to symbolize life and divine immortality. Held by gods to the pharaoh's MOUTH, it imbued him with life, BREATH or immortality. It was later Christianized by the Coptic church as the *ansate* ('having a handle'), the CROSS of life, a symbol of life after death.

### Canopic Jars

Named by Egyptologists for their resemblance to 'Osiris Canopus', OSIRIS-headed jars found at Canopus. Several canopic jars were placed in Ancient Egyptian tombs close to the sarcophagus containing the mummy. They contained the HEART, STOMACH and other viscera of the deceased, and were sealed with the heads of the FOUR SONS OF HORUS.

## Ushabti

Small figurines, often mummy-shaped, ushabti were placed with the dead in Ancient Egyptian tombs to perform the tasks expected of the deceased in the afterlife. The name traditionally means 'answerer': they were often inscribed with the deceased's name and were supposed to answer 'here am I' when the name was called.

## Menat

The Ancient Egyptian menat or 'Great Menat' was a necklace worn by the priestesses of HATHOR. It was believed to have healing powers, especially in restoring the function of the LUNGS. It was placed on mummies as an AMULET and was also used as a percussion instrument in rituals.

## Ark of the Covenant

This was a sacred chest made by the Israelites to hold the Tablets of the Law, Aaron's STAFF, and a pot of MANNA. A portable ALTAR, it was made to precise instructions from ACACIA wood, with two CHERUBIM set upon its GOLDEN lid, protecting it with outstretched WINGS. The Ark of the Covenant was the vehicle through which God spoke to MOSES and the priests. The Israelites carried it through the DESERT until they reached Jerusalem and built the first Temple.

The Ark had strong powers, and its journey was dotted with miracles. When the Philistines stole it they were plagued with boils and RATS until they returned it to the Israelites with additional gifts. Uzzah was struck dead on touching it with unconsecrated HANDS, although he was trying to prevent it from tipping over.

The VIRGIN MARY has been referred to as the Ark of the New Covenant, because she carried God as CHRIST.

## Tet

In Ancient Egyptian mythology the tet KNOT, or BLOOD of ISIS, represents the womb. Its RED colour symbolizes menstruation and the BLOOD that was shed by Isis in order to obtain RA's secret name. It was placed over the sexual organs of mummies as an AMULET. It is feminine to the djed's masculine.

## Tefillin

These are small boxes containing passages from the Torah written on parchment. Orthodox Jewish men bind them to their LEFT ARMS near the HEART and on their brows for morning prayers (*tefillin* means 'prayers' in Hebrew), but they are also called phylacteries (from the Greek *phylakterion*, 'protection'). Putting on *tefillin* is an elaborate process designed to clear the mind.

SYMBOLIC AND RITUAL OBJECTS

### Mezuzah

In Hebrew *mezuzah* means 'DOORPOST'. On the night before the Exodus, the BLOOD of the sacrificial LAMB was daubed with a bunch of marjoram or HYSSOP on the lintels and doorposts of the houses of the Israelites, so that the ANGEL of DEATH would pass over them when he came to kill all the first-born in Egypt (Exodus 12: 3–13).

In a practice related to the Muslim writing of 'Allah' over DOORS and windows, and the Egyptian writing of lucky words over entrances, the doorposts of Jewish houses used to have sacred words written upon them. In modern Jewish homes, the mezuzah has come to mean a parchment SCROLL inscribed with text from the Pentateuch (the first five books of the Old Testament) and kept in a container that is attached to every doorway (above). According to the Shema Yisrael, the Jewish confession of faith, 'these words shall be upon thy HEART, and thou shalt write them upon the doorposts of thy house and upon thy GATES'.

### Urim and Thummim

Meaning 'The Shining' and 'The Perfect', the urim and thummim were carried by the High Priest of the Ancient Hebrews in the BREASTPLATE, an embroidered pouch worn over the sacerdotal heart when entering the Lord's presence. They comprised TWO stones or tablets, and were used to divine God's decisions.

### Herm

A rectangular pillar surmounted with the head and torso of the god HERMES. The figure often had an erect PHALLUS, a protective symbol. The Ancient Greeks used it to mark territorial boundaries, reflecting the role of Hermes as guardian of merchants, travellers and channels of communication.

### Thyrsus

Thyrsi were the attribute of the hedonistic Ancient Greek god DIONYSUS. They were WANDS, tipped with PINE cones and wreathed in IVY or GRAPE vines, suggesting fecundity and uninhibited pleasure. The tip of a thyrsus was reputed to be poisonous, alluding to the headache induced by the excessive consumption of WINE.

### Fasces

A bundle of BIRCH or elm rods bound by a RED cord, sometimes wrapped round a projecting AXE. Carried by *lictors* in procession before the chief magistrate in Ancient Rome, it symbolized justice, scourging and decapitation. Used as a badge by Mussolini, it gave its name to Fascism.

## Wreath

Since classical times wreaths have symbolized victory and have been held by personifications of VICTORY. OSIRIS received a wreath from ATUM as a token of victory. LAUREL wreaths (above), sacred to APOLLO, were conferred upon the winners of musical and sporting contests.

A symbol of imperial majesty, the *corona civica* (OAK wreath) was worn only by the emperor from the time of Augustus (27 BC–AD 14).

In Ancient Egypt, 'wreaths of justification' made of OLIVE leaves were associated with the dead and with OSIRIS – the ruler of the next world – symbolizing the proven innocence of the deceased in the Hall of Judgment.

In Ancient Roman funeral processions, the wreaths that a man had been awarded during his life were carried before his body. The association with the dead continues to the present day, as wreaths of flowers are commonly placed upon coffins at funerals as a token of respect and of memorial.

## Caduceus

The caduceus is an attribute of HERMES, herald of the Greek gods, who used it to give SLEEP to whomsoever he chose. It is a BATON with two WINGS, around which two SNAKES intertwine. The wings may relate to the swift passage of Hermes as messenger of the gods. Some interpret the snakes as an allusion to his role as *psychopompos* or guide of SOULS to the UNDERWORLD. The caduceus may also indicate his ability to mediate between the opposing poles of HEAVEN and hell.

Roman heralds and ambassadors used the caduceus as a STAFF of office, and carried it when treating for peace or a diplomatic truce.

In Freemasonry, its form indicates the risen kundalini, and its shape reflects the two-way flow of energy sited in the spine.

In alchemy, the caduceus symbolizes Hermes and the THREE levels of conjunction.

Its similarity to the staff of Asclepius (which has only one snake) means that the caduceus has come to symbolize the medical profession.

## Instruments of the Passion

These are a series of objects linked to the events leading up to and following CHRIST's crucifixion. They include the CROWN of THORNS, the COLUMN to which Christ was bound, the scourge with which he was whipped, the HAMMER and the NAILS which pinioned him to the cross, the CROSS, the SPEAR with which his side was pierced, the sponge soaked with vinegar from which he drank while on the cross, the dice cast by soldiers for his cloak, the pincers used at his deposition and the LADDER with which he was lowered from the cross.

These objects became the focus of intense devotion from the 14th century, developed to facilitate an emotional response to the passion of Christ, in contrast with the intellectually symbolized and allegorized interpretations of it that were current at the time.

## Crucifix

The crucifix – a CROSS carrying the image of CHRIST crucified – is Christianity's principal symbol. As such it is used devotionally, commemoratively, ritually, for healing and purifying and to dispel evil SPIRITS. Since the Middle Ages Catholics have held a crucifix before the EYES of the dying, so that their last sight is of Christ.

## Eucharistic Symbols

The Eucharist – the communion partaken in the Christian Church – is represented by BREAD and WINE, recalling the Last Supper. Consuming them symbolizes taking CHRIST's body within one. In some churches these are believed to be miraculously transformed on consecration into the flesh and BLOOD of Christ.

## Grail

In medieval legend – but never accepted by the Church – the Holy Grail was believed to be the CUP used by CHRIST at the Last Supper, in which Joseph of Arimathea is said to have caught Christ's BLOOD as it fell at the Crucifixion (thereby constituting the first Eucharist). The first surviving text containing such a vessel is the unfinished *Perceval* of Chrétien de Troyes, written in the late 12th century. The Grail legends are particularly associated with the courtly romance of the late medieval era.

The Grail is especially linked to the Arthurian Grail which, appearing to PARSIVAL, ARTHUR and the knights of the Round Table, started the mystical Grail quest. Its actual nature remains an enigma: it seems to represent the self, giving the hero a question and initiating the quest to find it. Like its Celtic prototype, the CAULDRON, it serves anything one desires. Like the cauldron, it, too, is connected to the fertility and stability of the LAND.

## Vernicle ✳ Mandylion

According to legend, Veronica passed a towel to CHRIST as he carried his CROSS to Golgotha, so that he might wipe the sweat from his face. When he returned it to her, it bore a miraculous image of his face. It came to be known as the Vernicle (related to the Latin *vera icon*, 'true image').

A similar legend appears in connection with an apocryphal correspondence between Christ and King Abgar of Edessa, which seems to date from the 4th century. The ailing KING asked Christ to come to Edessa to heal him. Christ declined, but gave the messenger a towel on which he had wiped his face, and upon which an image of it had miraculously been impressed. Upon receiving the towel, the king was healed. This became known as the Mandylion.

The two images grew to be cult objects in the Western and Eastern Churches respectively, both signifying divine approval of the cult of images.

## Font

A font is a container for BAPTISMAL WATER. Christian baptisms originally involved whole-body immersion in RIVERS or natural pools. As the church became established, fonts large enough for the whole body came to be used. These were replaced by smaller 'infusion' fonts, as infants formed an increasing proportion of the baptized; these were often octagonal, symbolizing renewal.

## Crozier

Croziers are the STAFFS held by, or carried in front of, bishops, abbots and abbesses. They originally terminated in a CROSS, as popes' and archbishops' croziers still do, but subsequently came to resemble SHEPHERDS' crooks, symbolizing the clergy's role as shepherds of Christ's flock, the congregation.

## Ka'bah

Islam's most holy structure, the Ka'bah, stands in the courtyard of the Great Mosque in Mecca. According to tradition it was built by ABRAHAM and Ishmael and represents the *qibla*, the earthly focus of all prayers, symbolizing the divine presence.

## Maypole

A relic from pre-Christian times, the maypole is PHALLIC in form and related to summer courtship. It is cut from a tree around May Eve, and hung with garlands and coloured ribbons attached to a flower CROWN. Young women and men DANCE around it in opposite directions, holding the ribbons to braid it.

## Gohei

These are WANDS topped with either individual zigzag streamers of WHITE paper or cloth, or with bunches of streamers. Used in Shinto rituals, gohei represent the offerings of cloth made to the gods in ancient times, and serve as vessels or conductors for deities – a symbolism that may be reinforced by the fact that the Japanese for paper, *kami*, sounds very similar to the word for deity.

Shinto priests wave gohei over participants in ceremonies and festivals in gestures of purification. They are also used in a number of other ways: at the New Year festival; to encourage the gods to end droughts; on the ridges of new dwellings in house-raising ceremonies (*muneage*); and hung from the rope BELTS of sumo wrestlers (above).

In Japanese mythology, gohei numbered among the offerings made by the goddess Ama no Uzume no Mikoto to entice AMATERASU OMIKAMI out of her CAVE.

## Shimenawa

These are sacred ropes of straw hung in Shinto shrines and elsewhere to mark them as holy places. Shimenawa can incorporate natural features, such as trees and ROCKS, which are thought to be the homes of deities. The ropes are twisted to the LEFT, which is considered a fortunate direction. They are hung with tufts of straw, GOHEI and other symbolic offerings. In Shinto legend, a shimenawa was placed behind the sun goddess AMATERASU OMIKAMI to prevent her from re-entering the Rock CAVE of HEAVEN.

Hung at the entrances to Japanese houses at New Year, once they have been cleaned in readiness for the New Year deity, shimenawa mark a clean or sacred area and are thought to ward off misfortune. Huge shimenawa in the GATEWAYS (torii) to Shinto shrines are burned at New Year and replaced by new ones in a ritual of purification. Sumo wrestlers wear WHITE cloth versions of shimenawa round their waists.

## Mon

These designs or symbols are used by Japanese families and individuals as identifying crests. Placed on kimonos, ARMOUR and other accessories, mon denote allegiance to a particular group. From their origins as decorations on courtiers' belongings as early as the 8th century, by the 19th century mon were being used by people as diverse as actors and courtesans, and even by commercial companies.

Most mon designs are now CIRCULAR in shape. They are formed from a large range of symbols, in particular plants, trees and flowers, often with auspicious meanings, such as OAK LEAVES and ORANGES. Other auspicious symbols are also used, such as DRAGONS, animals, and symbolic objects, such as the endless KNOT or the WHEEL of life. In addition, some motifs play on a family's name while others are chosen because of the aesthetic qualities of the objects depicted.

## Ru-yi

A ru-yi (also ju-i, 'what one wants', and in Japanese a nyoi) is a Chinese WOODEN, JADE or IVORY STAFF or SCEPTRE with a head shaped as a CLOUD or lingchi. It is an attribute of Daoist figures such as LAOZI. A ru-yi may be a gift expressing the hope that the recipient's wishes be fulfilled. With a WRITING BRUSH, it is a desire for promotion; as a wedding gift, it is a wish for a happy MARRIAGE. It is also a symbol of Buddhist monks' authority.

## Totem Pole

Tall, carved CEDAR totem poles are made and erected by Native American tribes of the North-west Coast. The creatures or totems represented on each pole give form to a body of stories, legends and beliefs sacred to the tribe.

## Wampum

Native Americans wove strings of beads called wampums, which they sometimes formed into BELTS, necklaces or ornaments. They also served as money from the 17th to the 19th century. The north-eastern tribes used them as gifts, objects of tribute, and to seal and commemorate treaties.

## Medicine Bundle ＊ Medicine Pouch

A Native American medicine bundle may contain objects of sacred and spiritual significance, herbs, or healing and ceremonial tools, depending on its purpose. It may be made by an individual for personal use, by a healer, a SHAMAN or a medicine man, or as a collective representation of the spiritual power and cohesiveness of a tribe or a society.

## Quipu

Quipu were made by the Inca of Peru and are mnemonic devices made by tying knots in lengths of STRING. The precise size, position and colour of each knot on the string represented a piece of information according to a decimal mathematical system. This allowed demographic, economic and administrative data, and possibly histories and poems, to be represented and recorded.

## Kara

An unadorned IRON bangle worn on the wrist, the kara symbolizes self-control in action, and thus also represents mental strength. It is one of the five 'ka-things' (pancha-ka-kara) integral to Sikhism, each of which is a signifier of adherence to its ideals.

## Axe ＊ Tomahawk

The Myceneans made many votive offerings of BRONZE double axe-heads to a war deity (possibly ATHENA), to seek success in battle or to give thanks for a victory secured. Throughout the Ancient Near East and the Greco-Roman world, axes were used in the SACRIFICIAL slaughter of large beasts, while a *hacha* or STONE axe carved in the form of a SKULL, found at Chichén Itzá in Yucatán, Mexico, was possibly used in sacrificial ceremony. SHIVA is often depicted holding an axe.

Fine GREENSTONE axes carried in ceremonial processions by chiefs of New Caledonia in the South Pacific were said to indicate the tribe's fruitfulness and SPIRIT. Priests struck the ground with them during RAIN-making ceremonies.

The tomahawk (above) was an axe or hatchet used as a throwing weapon by Native Americans. The PIPE tomahawk combined a hatchet blade (symbolizing war) and a pipe bowl (symbolizing peace) on the same head.

A  B  C

## Sword

With their symbolic power over life and DEATH, swords are considered in many cultures to be conductors of divine will. In the swords of the Kongo people of Central Africa the quillons or cross-guards are bent so that one side points up, the other down, representing the power to link EARTH and SKY and the transition from life to death.

Ancient Iranian cults worshipped the divine in the form of a sword placed in the ground. In Hinduism and Buddhism the sword is one of the SEVEN precious possessions of the Universal Ruler. It is one of the THREE imperial regalia of Japan, given by Susano o no Mikoto to AMATERASU OMIKAMI, and thence to the imperial family's ancestors.

As conductors of divine will, swords also symbolize divine might, rightful vengeance, and justice. In the Ancient Near East the gods struck down their enemies with swords. God used a FLAMING sword to bar ADAM AND EVE from the GARDEN of Eden; and it is one of the weapons of the ARCHANGEL Michael (who takes much of his symbolism, including SCALES and sword, from the Roman goddess of justice, Themis). Ada swords in Benin were carried before the Oba (the KING) only. Although they signified the right to take human life, these swords had no cutting edge.

Arthurian legends also show swords representing the power and just rule of a king: ARTHUR's kingship is confirmed when he pulls a sword from a stone. He receives the invincible Excalibur (its name perhaps derived from the Latin for 'from steel') from the Lady of the LAKE (A); before dying he returned the sword to her.

The Celts seem to have associated swords with bodies of WATER. Many swords have been found in lakes and RIVERS, perhaps intended as offerings to the Otherworld, or thrown into the water on the DEATH of their owners. The Japanese once gave swords as votive offerings at shrines. Still preserved among the treasures of the shrines, they are considered *shintai* – objects that help to summon deities and act as vessels for them.

Magic swords are often associated with heroes, such as the Nordic Sigismund, or Zhong-li Quan (Shoriken in Japanese) one of the Chinese Daoist EIGHT IMMORTALS. Their powers may include the ability to scare off evil, especially in the form of DEMONS, which they are particularly suited to killing.

After the invention of gunpowder, when swords were replaced in combat by firearms, in Europe swords came to symbolize male honour, virtue, courage and courtesy (B and C). They were worn by nobles into the 19th century. Japanese swords – masterpieces of the SMITHS who created them with semi-religious rituals – were very highly valued, serving as symbols of the WARRIOR class. From 1588 until the wearing and making of swords were banned in 1868, only samurai were allowed to wear two swords.

With their sharp blades, swords can cut and discriminate: in Buddhist belief they represent the power of Buddhism to cut through wrong thinking.

## Knife

In the many cultures in which SACRIFICE was practised, ritual knives were essential for the sacrificial slaughter of animals. In depictions of the *taurobolium*, the Ancient Roman god MITHRAS is portrayed using a knife to slit the BULL's throat. In Christian art, a knife is an attribute of ABRAHAM, who is sometimes shown on the point of sacrificing his son, Isaac.

A knife was also associated with APOLLO, who flayed Marsyas, the SATYR, for presuming to compete, by playing his FLUTE, with the god's LYRE-playing. St Bartholomew is also represented holding the knife with which he was flayed.

Knives are also used for the Jewish practice of CIRCUMCISION. Aztec priests used stone knives for cutting out the HEARTS of sacrificed prisoners. The extensive decoration of the knives they used indicates their importance and their ritual significance.

The knives placed with other weapons in early Chinese and Japanese TOMBS represented the martial skills of the WARRIORS who had died.

## Dagger

A Sikh dagger, or *kirpan*, symbolizes bravery, fortitude and dignity, and is one of the five 'ka-things' meant to be carried by every Sikh at all times, even if only in a symbolic form.

Buddhist Vajrayana deities wield daggers to cut through obstacles such as hatred and DEMONS. The blade of the dagger represents skill or technique while the handle represents wisdom. A dagger called a *phurba* is one of the ritual weapons of Tibetan monks, who use it in ceremonies to protect sacred buildings and MANDALAS, while staking out building sites.

A dagger was described in the Bible as a two-edged weapon of a cubit (about fifteen inches/thirty-eight centimetres) long (Judges 3:16).

Daggers are designed as stabbing weapons. They are easily concealed under a garment, and so were commonly used for – and have become associated with – acts of treachery, by contrast with SWORDS, which were worn openly and wielded with honour.

## Spear

Magical spears are associated with Celtic SOLAR heroes and gods such as LUGH and Llew. In Japanese mythology IZANAGI AND IZANAMI used a spear to create the first land. Spears were weapons used to combat evil. HORUS used a spear to defeat SET, and the ARCHANGEL Michael killed the DRAGON or SERPENT of evil with a spear.

Spears are also associated with wisdom. In classical mythology ATHENA carries one. A spear is the attribute of St Longinus, the soldier who used one to pierce CHRIST's side at the Crucifixion, and suddenly realized Christ's true nature. The Norse god ODIN was killed with a spear when he hung upon the WORLD TREE to gain the wisdom represented by the runes.

In Japan spears symbolized the might of armies and WARRIORS, and they are the attributes of various Buddhist martial deities. They were one of the symbols of samurai status, carried by the samurai's retainers. They were also used in Roman and Norse declarations of war.

WEAPONS

### Trident

A weapon of power and authority, the trident – a THREE-pronged SPEAR – is one of the key attributes of POSEIDON, the Greco-Roman god of WATERS, SEAS and storms, and a symbol of his authority. It is sometimes depicted with LIGHTNING flashing from its tines.

Hindus call the trident the *trishul*; it is associated with SHIVA, and is a symbolic weapon against evil. Its three prongs symbolize the three *gunas* or qualities of nature: creation, preservation and destruction (also desire, action and wisdom). In Tantrism it is a SHAMANIC WAND invested with power against DEMONS.

In the Ancient Middle East the trident denoted lightning, and Buddhists link the *trishul* with the *vajra* or thunderbolt, and with the *triratna*, or three JEWELS of Buddhism, which represent the BUDDHA, the *Dharma* (Law) and the *Sangha* (Community). It also symbolizes right knowledge, right belief and right conduct. The *trishul* is also the mark on the hood that identifies the sacred SERPENT.

### Club

A symbol of fortitude, strength and MASCULINITY, the club vanquishes all adversaries. BAAL, the Canaanite fertility god, had a mighty THUNDER-club which he wielded against the enemies of his devotees. The DAGDA owned a club, its PHALLIC shape alluding to his fertility and his enthusiasm for the opposite sex. This may also be linked to the Hebridean tradition of laying the bride DOLL to bed with a club in the FIRE at Imbolc.

When the Greek mythological hero HERAKLES was temporarily enslaved by Omphale, Queen of Lydia, she disarmed him of his club and LION SKIN. This symbolized the power of FEMALE charms to erode the hero's combative drive, the root of his masculinity.

The wooden club or *meres* was the most common weapon used by the Maori in battle. Since so few of these often highly carved objects have been preserved, the Maori regard them as important symbolic survivals of their WARRIOR culture.

### Mace

Originally a club with a metal head, the mace was used in warfare throughout the Ancient Near East, and its use spread even wider later on. In the hands of gods or KINGS it became a symbol of power and retribution. The Ancient Egyptian god HORUS was known as the Lord of the Mace so that he might smite down his enemies, and the pharaoh was frequently depicted striking his enemies with one.

In China and Japan the DIAMOND mace is a form of the Indian *vajra* (THUNDERBOLT), an auspicious sign on carvings of the BUDDHA's FOOTPRINTS and a symbol of resolution. Called a *kongo* in Japan, it can also symbolize the Buddha, karma, or wisdom. Like the SWORD it strikes at untruths, while esoteric Japanese Buddhist sects believe it can drive out earthly desires and evil. It is carried by various figures, such as the sculpted *ni-o*, who guard the compounds of Japanese Buddhist temples.

In the West the mace is used as a staff of office by mayors, and in the English Parliament by the Speaker of the House of Commons.

## Bow and Arrow

Long associated with HUNTERS and WARRIORS, a bow and arrows are carried by deities such as ARTEMIS/ DIANA, Greco-Roman goddess of the hunt, and the Assyrian god of war, Assur. They are attributes of APOLLO, embodying the SUN's rays.

The bow and arrows signify communication with deities or SPIRITS who entered the bodies of Japanese *miko* (female SHAMANS) through bows. M*iko* and ascetics would similarly loose off arrows to contact spirits. The bow and arrows can therefore transform. The Greek god of love, EROS, fired arrows to induce love or passion in his target.

In China, they were connected with childbirth. A bow hung at the DOOR marked the birth of a boy, while arrows scared off evil. They were shot into the air shortly after a child's birth. Japanese amulets to stave off evil during an ECLIPSE were shaped like bows and arrows.

The Arrow of Truth enables the leader of some Native American tribes to make reliable decisions, and the Bow of Beauty endows supple strength.

## Quiver

Containers slung over the shoulder to hold ARROWS, quivers were linked with many deities associated with HUNTING or fighting and with weapons, such as the Mesopotamian INANNA, who had a quiver full of arrows when she appeared as a war goddess.

Japanese designs with quivers and flowering PLUM symbolize the 12th-century battles between the Minamoto and Taira clans.

## Sling

Far-reaching, accurate weapons, slings were used by SHEPHERDS to drive off wild beasts. In the Bible the sling is associated with David, the shepherd boy who brought down the GIANT Goliath, champion of the Philistines, using a sling. It symbolized the power of good over evil and right over might.

## Musket ✳ Rifle

Flintlock muskets are symbols of power among the West African Ashanti. But the musket and the later rifle often symbolize colonial power. Indigenous artists in Latin America painted ANGELS in Spanish dress holding rifles, revealing complex links between military power, the conquered, and the religion of the conqueror.

## Armour

Greco-Roman victors erected a *tropaion* (trophy, above) at a place of victory. The weapons and armour of the vanquished were hung from an OAK post, symbolizing ZEUS, god of victory. In medieval Europe armour embodied knightly virtues: strength, courage, honour, protection and righteousness. In China and Japan it symbolized the WARRIOR classes.

A

B

C

## Shield

Shields symbolize protection and deliverance. In Greco-Roman mythology the aegis of ATHENA/MINERVA (either a BREASTPLATE or a shield) was formed from hide and fringed with SNAKES, and afforded protection to those she favoured.

Shields may bear symbols intended to turn away evil. Those decorated with an EAGLE and a DRAGON, insignia of Woden, the Norse god of war and of the dead, indicated allegiance to him and may have elicited his protection. KING ARTHUR is supposed to have owned a shield with the VIRGIN MARY depicted on the interior, eliciting her protection (C).

In Renaissance allegories, the shield is a symbolic protector of VIRGINITY, and is held by personifications of chastity. It is also held by, and associated with, the protective qualities of a number of Indian deities, such as DURGA and KARTIKEYA.

By the Hellenistic period (*c.* 320–30 BC) honourific shields, inscribed with a recipient's merits and achievements, were awarded

to courageous WARRIORS. The Romans continued this tradition, and the Senate awarded such shields (the *clipeus virtutis*) to citizens who demonstrated exceptional military prowess and moral rectitude (A).

Raising the emperor on a shield appears to have been an element of the early Byzantine coronation ritual, confirming his status as a military leader. In late Renaissance art, therefore, personifications of history and victory were depicted recording important events and victories on shields. Even today, shields are used as trophies, inscribed with the names of those who won them. In the Bible shields also appear as symbolic trophies, proclaiming victory, whereas a tarnished shield is a sign of defeat (2 Samuel 1: 21). Biblical shields also represent defence: God is the shield of his chosen people (Deuteronomy 33: 29).

In Africa shields are used to declare ethnic affinities. The shields of Masai warriors of Kenya and Tanzania bear symbols denoting their geographical origin

and age. The Zulus of South Africa use shields to indicate a warrior's status (B). In the Zulu battle formation, which imitates a COW's horns, the youngest and swiftest warriors, who make up the HORNS, carry BLACK shields; they surround the enemy, drawing him into the chest where the elite warriors, bearing WHITE shields, destroy him.

The shield is also the one essential part of a heraldic achievement (a 'coat of arms'). Its design identifies and symbolizes an individual and that individual's family and followers.

In Aboriginal myth, shields are associated with the MOON. A Central Australian story tells how, in the Dreamtime, an OPOSSUM man carried the moon around in his shield. Another man discovered this and stole the shield, but the opossum man shouted and the moon went up into the SKY, where it has remained to this day.

## Breastplate

A piece of ARMOUR that covers the breast and protects the HEART, the breastplate was a Judeo-Christian symbol of love, courage and faith: 'put on righteousness as a breastplate' (Ephesians 6: 14).

Jewish priests wore a ritual garment called a breastplate, an embroidered pouch containing the URIM AND THUMMIM; these were originally placed in Aaron's breastplate, 'so that they will be over Aaron's heart when he enters the presence of the Lord' (Exodus 28: 30).

ATHENA's aegis (a tasselled breastplate or a SHIELD) was emblazoned with the gorgoneia, the GORGON'S HEAD, cut off by Perseus and presented to his divine protectress. The gorgoneia became a common motif in the centre of Greco-Roman breastplates, intended to turn away evil.

Breastplates made with mother-of-pearl or sperm-WHALE ivory were among the most significant items of male decoration in Fiji, worn only by those of high rank.

## Helmet

A helmet was a vital part of a warrior's equipment. The martial goddess ATHENA/MINERVA was often shown wearing a WARRIOR'S HELMET. Helmets frequently carry other symbols: those of Celtic and Norse warriors might be decorated with a BOAR, a totem of warrior cults and war deities, such as FREYR. Japanese warriors carried various auspicious symbols.

## Castanets

Castanets made by HEPHAESTUS/VULCAN were used by HERAKLES/HERCULES to scare the Stymphalian BIRDS, suggesting that, like other percussive instruments they had an apotropaic function in the ancient world. They are one of Daoism's EIGHT TREASURES.

## Rattle

The noise from percussive instruments such as rattles disturbs the natural silence and is said to scare aware DEMONS and evil SPIRITS. Rattles are common ritual instruments across the Americas. Statues of the Aztec Lord of Flowers, Xochipilli, show him SINGING, accompanying himself with a rattle in each hand. Japanese Buddhists use rattles to mark out religious time during the ritual day and in ceremonies.

Each Native American rattle (above) has its own sound with a particular significance and ceremonial use. For example, the *locv-saukv*, leg-rattles used by tribes of the south-east, are worn by WOMEN who make the rattles speak for ceremonial dances. The Hopi *Aya Kachina*, or Rattle Runners, wear rattles on their legs that imitate the sound of WATER while they are running. The Rattle Runners appear during the SPRING dances, challenging the men of a village to a race so that the water will run in the arroyos.

MUSICAL INSTRUMENTS

### Sistrum

An early Egyptian form of RATTLE, the sistrum consists of a handle attached to a metal frame with a number of cross-bars (usually FOUR), along which are groups of jangling discs (above). Used in Ancient Egyptian rituals, sistrums were often decorated with an evil-deflecting image of the uraeus, and were used to scare away negative forces.

The Greek biographer and author Plutarch (c. AD 46–120) explains that the metal loops represent the world encircled by the MOON's orbit, while the four bars represent the four elements. He describes a sistrum with an image of BASTET on the top, and images of NEPHTHYS and ISIS – representing the forces of life and DEATH – on either side of the base. Sistra were thus associated with various deities, although they were most commonly considered sacred to HATHOR, the Ancient Egyptian MOTHER goddess. They were also used by Bastet, and found their way to Rome as attributes of Isis.

### Drum

In Western antiquity, drums and drumming were associated with the Greek god of war, ARES, and have since had military associations. In Japan, conversely, a drum shown overgrown with weeds with a COCKEREL on top symbolizes peace.

In Africa the rhythmic sounds of drums provide the energy required to bring the MASKS used in ritual dramas to life. Among Native Americans, drums are widely used in ceremonies and empower prayers, sending them to SPIRIT. Through the drumming the heartbeat of GRANDMOTHER EARTH is given a voice.

BLIND Chinese fortune-tellers play a 'FISH drum' (above), a pipe of BAMBOO with SNAKESKIN covering one end and an attribute of one of the Daoist EIGHT IMMORTALS, Zhang Guo-lao.

From the sound they make, drums have come to symbolize THUNDER. Several drums are an attribute of the Japanese thunder god Raijin.

All over Africa, the sound of drums is associated with the presence of a KING or chief, whose command they symbolize.

### Gong

Gongs, metallic discs with upturned rims, which give a resonant sound when struck, are essential to Chinese and Japanese religious rituals. They are beaten in Chinese temples to gain the attention of the SPIRITS, while in Japanese Buddhist life they mark out religious time during daily rituals and in major ceremonies. Zen Buddhists use *umban*, gongs in the form of stylized CLOUDS, to accompany liturgical chants.

A gong is an attribute of the itinerant Japanese Buddhist monk, Kuya Shonin (AD 903–972), known for popularizing Pure Land Buddhism. While on a pilgrimage he struck a gong after every TEN prayers.

The noise of a gong can drive evil spirits away, such as the **evil Celestial DOG**, who the Chinese believed to cause ECLIPSES.

Gongs may mark arrivals or departures. The Chinese sounded a gong on the departure of a SHIP or the arrival of an official. A small gong summons guests for the Japanese tea ceremony.

## Tambourine

Tambourines were sacred instruments in Mesopotamia, and their use continued into the Greco-Roman period. They were usually played by WOMEN. Female devotees of the cult of DIONYSUS were frequently depicted shaking tambourines in a state of physical and religious ecstasy.

## Cymbals

In Mesopotamia cymbals were played with TAMBOURINES in temple precincts during sacred rituals. Bacchantes, the frenzied devotees of DIONYSUS, clashed cymbals during their rites. Jews used cymbals in processions and praise. They were played with LUTES and HARPS by the Levites accompanying the ARK OF THE COVENANT, and at the foundation of the Temple in Jerusalem.

## Bell

In Ancient Israel, golden bells ringed the Jewish High Priest's *ephod* (vestment) signalling his presence in the Temple in Jerusalem. Similarly, Shinto worshippers ring a bell and clap to inform deities of their presence.

In Christian churches bells signal the devotions held at different times of day, and mark times of crisis and celebration. A bell signals the transformation of the BREAD and WINE into CHRIST's body and BLOOD during some Eucharistic services. In Shinto shrines, bells also serve as vessels for the deities. They are similarly used during Buddhist, Daoist and Confucian worship and rituals.

Bells repel evil SPIRITS in a Christian exorcism, and in China. Western magicians also used them to summon good spirits.

TWO bells joined with a loop of rope symbolize royal authority in many African kingdoms. They are rung continuously during royal ceremonies to signify a continuous spiritual presence.

In China a picture of a bell can mean hope for a successful result.

## Horn

The RAM's HORN was one of the earliest musical instruments played in the Near East. It was sounded to summon the people to sacred rituals. Called the *shofar* by Jews, a horn was sounded by a priest processing to the Temple in Jerusalem, and in battle (above). Horns are still sounded ritually on Yom Kippur, the Day of Atonement.

Horns made from CONCH SHELLS were used by Maya priests to summon gods and people to ceremonial occasions. The Central African Kongo people also use horns made of ELEPHANT tusks at royal ceremonies. They are said to symbolize the KING's omniscience, and they summon important royal ANCESTORS.

Celts used horns surmounted by BOARS (the symbol of many war deities) to create a cacophony to scare off the enemy in battle. Horns are also associated with the ritualized practice of HUNTING with HOUNDS, when they are used to call the hounds and direct the hunt.

MUSICAL INSTRUMENTS

**299**

MUSICAL INSTRUMENTS

### Flute * Pipes

In classical legend HERMES/ MERCURY invented the flute and gave it to APOLLO, god of music, prophecy and reason. It is an attribute of Euterpe, the MUSE of lyric poetry and music. The *aulos* (double flute, above) was played during Greco-Roman religious processions and ceremonies. Flutes also had obvious PHALLIC associations, and flute-girls were synonymous with boisterous revelry and low morals at classical symposia.

Pan pipes (named after PAN, the Greek god of woods and fields ) were played by SATYRS and SHEPHERDS. Pan pipes and flutes were associated with nature and a bucolic lifestyle. In Native American legend the hump-backed KOKOPELLI plays the flute.

BAMBOO flutes called *shakuhachi* are associated with Japanese itinerant mendicant Zen Buddhist monks, *komuso*. In China, the transverse flute or *xiao* is an attribute of the Daoist EIGHT IMMORTALS Lan Cai-he and Han Xiang-zi, and thus one of the EIGHT TREASURES of Daoism.

### Trumpet

Throughout the ancient Near East and during the classical period the straight trumpet (the Roman *tuba*, above) was associated with military excursions and state occasions. Its impressive sound would announce the presence of a ruler or other important state dignitary. As an object of war it was intended to strike terror into the hearts of the enemy. This role is described in the biblical story of the collapse of the walls of Jericho, brought down by the sound of SEVEN Israelite priests blowing RAM'S-HORN trumpets.

In Renaissance art a trumpet appears as the attribute of the personification of fame, and in the hands of ANGELS announcing the Last Judgment.

When they appear in alchemical texts, trumpets refer to the announcement of the coming of a being from a higher level.

### Bagpipes

Associated with European folk culture, bagpipes are sometimes depicted being played by SHEPHERDS. In 17th-century Flemish and Dutch art, they are used as humorous allusions to the PHALLUS. The famous piper family of Scottish folklore, the MacCrimmons, were said to own a SILVER pipe or chanter given to Iain MacOg by a FAIRY woman.

### Bull-roarer

A bull-roarer makes an other-worldly wailing sound when whirled in the air at the end of a cord. Said to be the voice of SPIRIT, it is used by Native American SHAMANS and Australian Aborigines to communicate with the spirit world and the ANCESTORS.

## Lyre

The most ancient of all stringed instruments, there is evidence of the lyre's use in Mesopotamia in the first Dynasty of Ur (*c.* 2500-2350 BC), when it was often decorated with a BULL's head, implying a connection with some form of animistic worship.

The Ancient Greeks believed that the lyre was an invention of the god HERMES, who strung bull sinews across a TORTOISE shell and then gave it to APOLLO in exchange for a GOLDEN BATON or the CADUCEUS. Hence the lyre became an attribute of Apollo, the god of music, reason and the higher senses. Its sound restored order and inspired prophecy. Orpheus was taught to play the lyre by Apollo, and he used his music to soothe the wild beasts and create harmony among them. The lyre was also an attribute of two of the MUSES: Terpsichore, the muse of dance, and Erato, the muse of lyric (love) poetry. The number of strings varies from THREE (the Olympian lyre) to TWELVE – corresponding to the signs of the ZODIAC.

## Harp

Played throughout the Ancient Near East and the classical worlds, the harp was associated with Terpsichore, the MUSE of dancing and song. The principal musical instrument in Ancient Egypt, its THREE strings were linked to the three SEASONS of deluge, growth and dryness.

The harp was also considered the pre-eminent Celtic instrument (above). The DAGDA possessed a magical harp that played music appropriate to every event and was able to send his enemies to sleep, a quality also associated with FAIRY harps.

In the Bible the harp was played during sacred processions. David played it for Saul to chase away the evil SPIRITS. Harps were associated with Jewish nationhood, and for harps to be silenced meant the defeat of a nation: 'there on the WILLOW TREES, we hung up our harps ... for how could we sing our song in a strange land?' (Psalm 137: 2, 4).

The form of harp familiar today in orchestras emerged in early medieval Europe.

## Lute

Introduced to Europe from the Middle East at the time of the Crusades, the lute became an attribute of personifications of music, and of lovers. It was also one of the attributes of the Chinese Moli-Hai, the Celestial KING guarding the WEST, and of the Japanese Benten, one of the SEVEN DEITIES OF GOOD FORTUNE.

## Zither

The form of Chinese zithers (*qin*) echoes the form of the universe. Their DOMED tops represent the SKY and their flat bases the EARTH. Playing the *qin* was an important accomplishment for educated men and, with chess, literature and painting, is one of the 'FOUR Signs of the Scholar'. Its music revealed truths to its players and represented marital happiness.

T O O L S

## Mill

The function of the mill, grinding WHEAT to make flour, has often been used as a metaphor for the grinding processes of life, and of interpretation, that is, the transformation of esoteric mysteries and divine revelations into a form that can be understood and received by ordinary people.

In Celtic legends, mills often appear with an old crone, and seem to symbolize fate and the grinding of the SOUL back into its original constituents on the WHEEL of life.

In Christian iconography the mill is connected to the metaphorical depiction of the prophet Isaiah (in 15th-century German art, sometimes the FOUR Evangelists) grinding the flour of the Old Testament, which is received by ST PAUL to make the BREAD of the New Testament.

The millstone was the instrument of martyrdom for a number of Christian saints, including Vincent of Saragossa, Florian, and Christina of Tyre.

## Forge

Deities related to SMITHING, such as the Greek god HEPHAESTUS, are associated with the forge. The magical transformative fire of the forge was also sacred to BRIGID, the Celtic goddess of FIRE. In Christian art, the forge is one of the attributes of St Eligius, the patron saint of metalworkers and of farriers.

## Furnace

The transformation and refining of METALS, with which the furnace is associated becomes, in Western alchemy, a metaphor for refining the SOUL in the alchemical furnace or *athenor*. In the Bible 'furnace' is sometimes translated as 'crucible', suggesting the refining of precious metals. The deliverance of the Israelites from Egypt was described as escape from a smelting furnace.

## Anvil

SMITHS, such as HEPHAESTUS/ VULCAN, the Greek and Roman gods of fire and metalworking, and St Eligius, the Christian patron saint of metalworkers and farriers, are associated with anvils.

In Norse and Germanic folklore the process of metalworking was associated with elves. The natural ringing sounds heard in the MOUNTAINS were believed to be the sounds made by elves at work over their anvils.

In Scottish folklore, anvils were linked with the ancient magical powers of the smith, whose role as the forger of indissoluble bonds has remained in the tradition of getting MARRIED over the anvil at Gretna Green in southern Scotland.

In Polynesian culture anvils are associated with WOMEN. The sound produced by the process of making bark cloth using a MALLET on a WOODEN anvil was sometimes used by women to send messages. It was also said that one could learn all about a woman from hearing her beating bark cloth.

## Hammer

In classical mythology a hammer was one of the attributes of HEPHAESTUS/VULCAN, blacksmith of the gods. Norse culture associated it with THOR, whose great AXE-hammer represented the power of LIGHTNING. Symbolic hammers had many uses in various rituals and, depicted on tombstones, represented resurrection. Thor's hammer was believed to have life-giving powers because of a tale in which Thor returned his GOATS to life after they had been eaten.

The Celtic WINTER hag, the CAILLEACH, had a magic hammer with which she struck the ground to crack it with frost and ice. A hammer was also an attribute of the Celtic thunder god.

In Ancient Chinese mythology, Pan Gu used a hammer and chisel to fashion the world from rock. A mallet that can grant wishes is the attribute of Daikokuten, one of the Japanese SEVEN DEITIES OF GOOD FORTUNE.

In the Communist emblem of hammer and SICKLE, the hammer stands for industry.

## Nails

The nails used to nail CHRIST to the CROSS are one of the INSTRUMENTS OF THE PASSION, emblems of his crucifixion and torment on the cross. The very earliest images of the crucifixion show Christ with nails through his HANDS alone. These were gradually replaced by depictions showing FOUR nails, one through each hand and FOOT, although later medieval art began to represent THREE (one nail through both feet), reflecting certain ancient texts.

St Helena, who was mother of Constantine the Great and who rediscovered the True Cross, is said to have made a BRIDLE for her son's HORSE from one of the nails and an imperial CROWN from another.

In China, the act of HAMMERING a nail into something, such as a GATEWAY, could ward off illness (or bring sons). For this reason iron nails used to seal coffins were sometimes beaten into protective BRACELETS for CHILDREN.

The Ancient Romans drove a nail into the temple of Jupiter every 13 September, to ward off disasters.

## Adze

An axe-like tool with a curved blade, used to cut away the surface of wood, the adze was prized by Maori chieftains as a ceremonial weapon because it possessed *mana* (spiritual power) and was an effective weapon. The blade, which was typically long and slender, was made from *pounamu* or greenstone (JADE) a sacred material. The handles were usually made from WOOD and often carved in the shape of a figure (above). Adzes were also used by Maori chiefs to execute important prisoners, such as a captive chief from a rival tribe. It would be thought a mark of honour to be struck down by a famed weapon.

In Ancient Egypt the adze was said to echo the shape of the constellation of the PLOUGH (or Big Dipper). It was one of a number of instruments used in the ritual of the Opening of the MOUTH to allow the deceased to breathe and eat in the next world.

TOOLS

### Plough

According to Ancient Chinese mythology, the plough was invented by the farmer god, Shen Nong, who is depicted with a forked WOODEN plough. In Imperial China, every SPRING the emperor would plough THREE or EIGHT furrows of EARTH in a sacred field using a ceremonial OX-drawn plough (above), to set an example to his subjects. Parts of old ploughshares were sometimes used as AMULETS to ward off evil SPIRITS, who were frightened by sharp pieces of IRON.

On Roman COINS, images of a plough or a team of oxen ploughing, commemorated the founding of colonies by veterans of the Roman legions. The Roman New Year purification festival of *Compitalia* (which fell in late December or January) was celebrated in the countryside by erecting small shrines on the boundaries of farms. A plough and sufficient DOLLS to represent each member of the household were placed on these temporary ALTARS.

### Scythe

The scythe is an attribute of Saturn, originally the Roman god of agriculture, who used it to reap crops. Saturn was gradually conflated with the Greek god CRONUS, who personified time, then with Old Father Time, the Grim Reaper, and the Christian ANGEL of DEATH, who used the scythe to cut short the lives of mortals and HARVEST their SOULS.

### Sickle

Sickles are associated with the HARVEST and DEMETER/CERES. CRONUS used a sickle to castrate Uranus, and APHRODITE/VENUS was born from the foam as his genitals fell in the SEA. DRUIDS harvested the sacred MISTLETOE with GOLDEN sickles. The sickle in the Communist emblem (see also HAMMER) represents agriculture.

### Shears

In classical legend shears were the attribute of Atropos, one of the three FATES; her task was to snip the THREAD of mortal life.

The COMB and shears were associated with the Welsh Twrch Trwyth, the great BOAR, and were sought after by CULHWCH as part of his marriage gift for OLWEN so that her father, the GIANT, could groom his HAIR and BEARD.

### Digging Stick

Aboriginal women used long WOODEN digging sticks to gather roots and root vegetables. One was used symbolically to create SPRING WATERS in a story about the Djan'kawu Sisters, ANCESTRAL SPIRITS who founded the clans of the Arnhem area of Northern Australia. In contemporary art, digging sticks have been used to represent ancestral beings.

## Trowel

A trowel is used to mix the mortar that binds the STONES of a building together, then to lay it on the stones. The idea of binding has been adopted in modern Freemasonry, where a trowel is given to the Master who rules the lodge, and it is his job to bind his members together in brotherhood.

## Chisel

The Chinese CREATOR GOD Pan Gu shaped the universe with a MALLET and chisel. The chisel is used to carve and shape ASHLAR, which symbolizes the self. It is therefore one of the first tools given by Freemasons to an Entered Apprentice to use to perfect his character, and it symbolizes the actions of discipline and of education upon the self.

## Plumb Rule

The plumb or plummet is a small weight hanging from a string, used to check the accuracy of vertical lines. Freemasons adopted this 'absolute' standard of uprightness as a symbol of emotion, morality, and mercy. It is a guide against which to measure one's conduct and qualities in public life and while building one's metaphorical temple.

## Level

A level ensures that surfaces are horizontal, that TWO points are at the same height. Freemasons use it as a symbol of fraternal equality, of all people recognizing the fatherhood of God, and, as a corollary, the brotherhood of Man, so that all men are subject to the same immutable laws.

## Lewis

This is a system of ropes and metal pivots that enables large STONES to be raised securely. Freemasons see the lewis as a symbol of strength and of the mason's son, whose duty is to relieve his parents' burden in their old age.

## Set Square

An instrument used to test the accuracy of angles and the precision with which STONES are cut. For Freemasons the set square symbolizes the universal morality against which one must measure oneself. It rests with the COMPASSES upon the Lodge's ALTAR; the combination of compasses and set square has come to symbolize Masonry.

The Chinese depict the god Fu Xi, credited with a great many inventions, with a carpenter's square.

TOOLS

**305**

TOOLS

## Bridle

The Greek goddess ATHENA, mistress of the domestic crafts of peace as well as the arts of war, was reputed to have invented the bridle. As a symbol, it represents the bridling of the passions, particularly in Renaissance allegorical personifications of Temperance, Nemesis and fortune.

## Horseshoe

In Celtic countries, SILVER HORSEshoes were traditionally given to the bride and groom at WEDDINGS for good luck. Horseshoes were generally kept over the door for the same reason, but should never be tipped upside down, in case the luck should fall out. This tradition may derive from the cults of earlier HORSE GODDESSES, such as Rhiannon and Epona.

## Whip

Whips symbolize punishment. In Greek art EROS used one to chastise the gods, while HECATE and the FURIES used whips to punish the SOULS of the dead, especially those who had committed crimes of BLOOD-guilt.

A whip or a many-tailed scourge, a type of whip, was one of the INSTRUMENTS OF THE PASSION, used to flagellate CHRIST just before he was led to Golgotha. Flagellation has subsequently been used as a form of self-punishment, penance and mortification by monks and fanatical laymen – who mortified themselves publicly in processions in anticipation of the end of the world. Flagellation is also associated with the penitent Mary MAGDALENE, and with ST AMBROSE who holds a scourge with THREE KNOTS, representing the TRINITY.

A whip is also an attribute of HELIOS, the Greek sun god, later called Apollo, symbolizing his control of his HORSE-drawn CHARIOT as it carries the SUN across the SKY.

## Yoke

A wooden bar placed across the shoulders of OXEN to harness them to the PLOUGH, a yoke is a symbol of obedience. Associated in the Bible with slavery, it can also represent piety and devotion to God. In late Renaissance emblem books, a yoke placed over the shoulders of a husband and wife represents MARRIAGE.

## Crook

A short crook (*hkz*) was carried by Ancient Egyptian gods, pharaohs and high officials as a symbol of their beneficent power, a meaning probably derived from SHEPHERDS' crooks. A similar meaning is attached to the very elaborate crooks called CROZIERS, carried by bishops as a symbol of their leadership and care of their congregation or 'flock'.

TOOLS

## Fish-hook

One Maori tribe believes that Maui hauled up the North Island of New Zealand with a fish-hook (above) fashioned from his GRANDMOTHER's enchanted jawbone.

In Japanese mythology, a fish-hook represents the 'luck of the SEA'; Hoori no Mikoto, great-grandson of AMATERASU OMIKAMI, discovered the sea god's PALACE when searching for his brother's lost fish-hook.

## Spindle

Spindles are tools for spinning THREAD. They are often associated with unmarried WOMEN, who used them to earn money by spinning (hence 'spinster'). Lachesis, one of the three FATES, uses a spindle to spin out the thread of life.

In the procession to their new marital home, Roman brides carried a DISTAFF and a spindle, symbolizing the domestic sphere of their authority.

## Ukhurhe

Originally a STAFF for pounding YAMS, the ukhurhe is part of the royal regalia of Benin (Nigeria). Made of BRASS, WOOD or IVORY, it is used to annul curses and resolve conflicts. It is essential when establishing ancestral ALTARS and performing consecrations during PALACE ceremonies.

## Distaff

An attribute of ATHENA/MINERVA, who invented the domestic crafts of spinning and WEAVING, the distaff is the rod on which yarn is wound. Klotho, first of the THREE FATES, held the distaff on which the stuff of life was kept ready to be spun into THREAD by her companion, Lachesis.

## Flail

A flail is a jointed wooden pole used for threshing. Called *nhzhz* in Ancient Egypt, it was carried by the pharaoh as a symbol of authority. It was said to have originated from the SHEPHERD's flail carried by the shepherd god Anedjti, and may originally have been a FLY WHISK.

## Crutch

Symbols of infirmity and old age, crutches are often left at Roman Catholic shrines as material proof of miraculous healing. The lame god HEPHAESTUS/VULCAN is often shown leaning on a crutch, as is SATURN and his later incarnation Old Father Time.

More generally, crutches symbolize the inessential phenomena – particularly beliefs – on which people grow to depend.

**307**

TOOLS

### Staff

For Polynesian islanders WOODEN staffs symbolize the physical dimension of the core principles of life held by their gods, while in Japan staffs may be used to contain deities. In Africa a staff is a sign of supernatural powers. Diviners, healers, court linguists, chiefs and KINGS carry staffs, which often bear an image of the ANCESTOR or deity from whom their power derives.

When associated with SNAKES, staffs may heal. Asclepius, the classical god of healing, is shown with a staff encircled by a SNAKE, while the staffs of MOSES and Aaron turned into snakes when miracles were required (above).

Staffs indicate travellers and symbolize pilgrimage. Mendicant Buddhist monks carried 'alarm-staffs', whose jangling sounds announced their arrival and repelled evil. Staffs are carried by the destitute, the lame and the elderly. In Japan they are attributes of Fukurokuju and Jurojin, the elder SEVEN DEITIES OF GOOD FORTUNE, and in China of Shouxing, one of the THREE STAR GODS OF HAPPINESS.

### Net

A net is a symbol of the APOSTLE and fisherman St Andrew. Several of the apostles were fishermen, and when they cast their nets as CHRIST instructed, their catch, symbolizing converts to Christianity, was great.

In Maori mythology a net is associated with the TRICKSTER hero Maui, who caught the SUN in his great net, making the day as long as it now is. He also used his net to drag great FISH up from the SEAS. These became ISLANDS, including the one that today bears his name.

A net was also an attribute of the classical smith god HEPHAESTUS/VULCAN, who forged a fine but strong METAL net to entrap his wife, APHRODITE/VENUS, while she was making love to ARES/MARS.

In Ancient Greece and medieval Russia nets were invested with protective powers against sorcerers – so they were brought to WEDDINGS.

### Chain

GOLD chains signify honour, status and favour. Yet chains restrain, so they also symbolize captivity and loss of freedom. ZEUS bound CRONUS in chains when he overthrew him as ruler of the HEAVENS, so his victim's cult statue had chains around its FEET. These were undone at the WINTER feast of Saturnalia, when the social order was reversed and mayhem allowed. An ANGEL broke the chains binding St Peter, freeing him from prison.

### Knot

In Ancient Egypt knots held magical power, sometimes representing binding and releasing. Labyrinthine Celtic knot-work designs appear to have no beginning or end, perhaps reflecting an endless cycle of birth and DEATH, like the Buddhists' endless, mystic knot.

TOOLS

## Noose

Freemasons hang a noose around an initiate's neck to represent the cords that bind one to life, and the cord with which an initiate is born into a new life in Freemasonry, and which, worn by new babies, signifies unconsciousness. The SILVER cord that binds the astral form to the body symbolizes the beginning of understanding.

## Sieve

When doubt was cast upon her chastity, the Roman Vestal VIRGIN Tuccia proved her VIRGINITY by carrying WATER from the Tiber in a sieve which, miraculously, did not leak, so the sieve became a symbol of chastity.

A sieve that does not leak suggests disruption to the natural order, however, and in European folk tales, frightening old WOMEN or WITCHES use sieves as BOATS.

## Broom

A broom cleans and purifies. Ancient Roman houses were swept after funerals to cleanse them. Chinese families would sweep the house at the end of one year to banish bad luck for the next. But standing a broom behind someone in a game of chance could sweep away that person's good luck.

The Aztec Feast of the Brooms saw the distribution of honours to WARRIORS. Brooms can be PHALLIC ritual objects (above). In Europe, a couple who jumped over a broomstick together were considered to be MARRIED for a year and a day. This phallic symbolism also accounts for the association between brooms and WITCHES. Coupled with beliefs expressed by witches that they FLEW – apparently while in a trance-like state – this has led to the familiar image of witches flying on broomsticks.

Followers of Jainism, an ancient Indian religion, consider *Ahimsa* (non-violence) the highest good, so they sweep the ground before them with brooms as they walk in order not to not step on insects.

## Ladder

Ladders are used for ascent and descent, measured out by the regular rungs. The Biblical account of Jacob's vision of a ladder (above) on which ANGELS were ascending and descending has influenced sacred systems throughout the West. Byzantine depictions of the 6th-century John Climachus's *Ladder of Divine Ascent* show monks toiling heavenwards up a ladder while impeded by DEVILS.

Ladders were used in Ancient Masonic initiation ceremonies. Their rungs (between THREE and SEVEN in number) represented different stages in the process of spiritual transformation, each represented by a symbol such as a METAL or one of the three Theological VIRTUES. In alchemical illustrations ladders also represent ascent through the various stages of the Work.

The ladder of DEATH is a common symbol for the inevitability of death, used by the Akan people of southern Ghana, and embroidered on their mourning clothes.

## Scales

Scales weigh quantities to determine which dominates. When the Ancient Egyptian dead were taken to the Halls of Judgment, their HEARTS were weighed against a FEATHER in the scales of the goddess MAAT. If they were heavier than the feather, the hearts – the vessels that hold the SOUL – would be thrown to a monster and devoured; if lighter, the deceased would live eternally in the Afterlife.

Scales were also an attribute of Themis, Greek goddess of justice, and of personifications of the Roman Cardinal VIRTUE of Justice. They were also taken up by Christians as an attribute of the ARCHANGEL Michael, depicted holding a set of scales in representations of the Last Judgment; a DEVIL is often shown attempting to pull one of the pans down unfairly, to gain another soul for HELL.

The scales are also the symbol of LIBRA, tenth sign of the ZODIAC.

## Compasses

Compasses or dividers are essential to the study of geometry, and they identify personifications of this Liberal Art. In depictions dating from the 13th century, God in his role as creator of the harmoniously (geometrically) ordered universe is sometimes shown holding dividers.

Architects use compasses to draw up plans, so these instruments symbolize their profession, appearing as an attribute of personifications of architecture in Renaissance art. In the art of the 18th and early 19th century they may symbolize the rational mind, which is sometimes associated with enlightened thought.

For Freemasons, compasses represent the need to keep the passions circumscribed. For some Masons compasses represent the SUN; it is symbolized by a CIRCLE, its diverging rays are the points of the compass. Since the fundamental metaphor of modern Freemasonry is the building of a temple, compasses are highly significant symbols and, together with the SET SQUARE, represent Freemasonry.

## Gavel

The gavel is a miniature representation of a setting maul, a large wooden HAMMER used by stonemasons to knock heavy STONES gently into their proper positions. For Freemasons, the stones represent the spiritualized members of the lodge. The gavel is given to the master as a symbol of his authority, to be used to keep the brethren in order whenever this may be necessary.

## Palette

An important tool of the artist's trade, the palette has become a symbol of painters. It sometimes appears as an attribute of the evangelist St Luke, who was said to have painted a portrait of the VIRGIN MARY, and is sometimes depicted doing so. He thus became the patron saint of artists.

## Key

Keys unlock DOORS, revealing the secrets and TREASURES within. The Key to the Storehouse of the Gods is one of the Myriad TREASURES of the Japanese SEVEN DEITIES OF GOOD FORTUNE. In West Africa, miniature bunches of GOLD keys on a ring are worn with court regalia to symbolize the wealth of a state.

ST PETER is represented with the keys to HEAVEN and earth, conferred on him by CHRIST, which embody the power to bind and loose in heaven and on earth. These symbols of religious authority were soon adopted by the Church – in particular because of the connection with St Peter and the papacy.

In Europe, important individuals are given keys symbolizing the 'freedom' of particular cities – originally the power to come and go without hindrance at all times.

JANUS was often depicted holding two keys, representing his role in opening and closing the GATES to the WINTER and SUMMER solstices.

## Hourglass

Hourglasses measure the passing of time and, like their successor the CLOCK, have come to symbolize the transience of life. They often appear in *vanitas* still-life paintings, and as an attribute of Old Father Time and as personifications of DEATH.

The hourglass is also said to represent the scalp to the Navajo of the south-west United States.

## Clock

Like the HOURGLASS, the clock is found in *vanitas* paintings as a symbol of the transience of life. Stopped clocks represent DEATH and are placed on graves in South American countries to mark the point between life and death. As a symbol of a well-ordered life, the clock is an attribute of the Cardinal VIRTUE of Temperance.

## Wine Press

Isaiah (63: 3–4) refers to the future redeemer, whose garments are RED from the GRAPES trodden in the wine press, or from the BLOOD of the people. This has been taken as an allusion to CHRIST's Passion, and to the CROSS, the mystical wine press that yields the WINE at the EUCHARIST.

## Beehive

Awareness of the structured social organization of BEES has led to the hive becoming an emblem of industry, wisdom and obedience. In Ancient Egyptian times it was a symbol of the pharaoh of Lower Egypt because, according to Horapollo, 'of all insects, the bee alone has a KING'. The hive was associated with the ordered structure of Christian monasteries.

TOOLS • CONTAINERS

## Fly Whisk

Fly whisks, made of anything from the bushy tail of the yak to fine strands of IVORY, are the insignia of royalty in many cultures, associated with power and authority. In Mesopotamia, Egypt, Phoenicia, Afghanistan and other countries of the Ancient Near and Middle East, fly whisks were carried by attendants who preceded the KING. In the Austral and Society Islands of Polynesia fly whisks were also a mark of rank. Fly whisks used by African kings signify the monarch's role in chasing away bad SPIRITS that may threaten the kingdom.

In the Indian subcontinent, fly whisks or *chauris* are usually shown being held by FEMALE attendants of the deities. Sikhs use *chauris* during readings from the Guru Granth Sahib to keep insects or FLIES from alighting on the holy BOOK. For Buddhists, they symbolize royal compassion and obedience to the first Buddhist commandment, 'thou shalt not kill', so they are attributes of several Buddhist deities and BODHISATTVAS.

## Sack

Archetypal containers, sacks are used in many mythologies to hold things that sometimes prove hard to restrain – like the WIND, which was kept in a sack by the Greek wind god Aeolus, the Chinese god Fei Lian, and the Japanese gods Fujin and Futen.

Because they can hold myriad objects, sacks often symbolize gifts and prosperity. They are associated with ST NICHOLAS, FATHER CHRISTMAS, the equally fat and jolly Chinese MAITREYA BUDDHA, and Japanese gods of wealth, contentment and goodness, such as the SEVEN DEITIES OF GOOD FORTUNE, who are often accompanied by the sack that holds the Myriad TREASURES (*takaramono*).

In many cultures bags are used in ritual as sacred containers. Leather bags containing 'THUNDER STONES' (meteorite fragments) are associated with the African thunder god SHANGO. In Papua New Guinea, special *bilum* (string bags) serve as part of ceremonial clothing, and are seen as carriers of ANCESTRAL power.

## Vessel ✳ Urn ✳ Vase ✳ Jar

In many cultures, rigid vessels have been used to store the ASHES or bones of the dead and have thus come to symbolize DEATH. The vases used for the ritual nuptial BATH in Ancient Greece also marked the graves of the young and unmarried. An urn with a FLAME rising from it symbolized resurrection, and urns often appear on 18th-century European funerary monuments. In South American countries a broken vessel is sometimes placed on a grave, marking the point of transition between life and death.

Mesopotamian goddesses such as ISHTAR carry urns containing the WATERS of life, symbolizing fertility. In classical art, RIVER gods often hold or lean against an overturned urn from which the river SPRINGS.

A vase is a basic Buddhist altar furnishing, an emblem on the BUDDHA'S FOOTPRINTS, an attribute of MAITREYA, one of the 'EIGHT TREASURES of Buddhism', an attribute of the BODHISATTVA Senju Kannon, and sometimes a symbol of the Buddha's STOMACH.

## Bowl

The Ancient Greeks and Romans used bowls to contain offerings and to catch BLOOD as it fell from sacrificial victims. In Western art, therefore, bowls have come to symbolize ritual SACRIFICE. In the Jewish Temple GOLDEN bowls – a metaphor for vessels containing life – were used to pour libations.

Native American medicine bowls, BLACKENED inside and filled with WATER to make a reflective surface, are used for divination and to ask for guidance in matters such as healing. Begging bowls are one of the few objects owned by mendicant Buddhist priests and monks in China and Japan.

The Shona of Zimbabwe associate pottery bowls with WOMEN, and some are shaped like parts of a woman's body. Both carry similar patterns, those on the body made by SCARIFICATION. A husband must treat his wife with respect because, by inverting the bowl, she can symbolically cut off his access to her sexuality.

In the Japanese tea ceremony the tea-bowl represents the MOON and the yin essence.

## Cauldron

In Celtic legend, cauldrons are sacred vessels. The DAGDA's cauldron provided sufficient food for all, BRÂN's revived dead WARRIORS, while CERRIDWEN made TALIESIN stir hers for a year and a day to create THREE drops of inspiration. Thus the cauldron can bestow life, DEATH and rebirth. It retained these associations in later European folklore, becoming linked to WITCHcraft and the brewing of magic potions.

The ancient Chinese deity and hero, Yu, fashioned NINE sacred BRONZE cauldrons, which signified the legitimacy of subsequent rulers' reigns: if their rule was corrupt, the cauldrons would FLY away.

Boiling cauldrons symbolize ordeals. The SEA nymph of Ancient Greece, Thetis, threw most of her children by Peleus into boiling WATER to determine whether they were immortal; unfortunately they were not. Saints are sometimes depicted being boiled in a cauldron: ST GEORGE in molten LEAD, ST JOHN THE EVANGELIST in hot OIL – like sinners in the seventh Buddhist HELL.

## Retort

A sealed vessel used in alchemy, the retort can symbolize the womb, where the growth of the various processes takes place sealed off from the outside world. They come in a variety of shapes, which are symbolic of the processes taking place inside them. The double retort, for example, is said to be like a couple engaged in lovemaking.

## Cornucopia ✳ Horn of Plenty

The cornucopia is a HORN abundantly filled with flowers and FRUIT. Some myths say ZEUS/JUPITER created it from the broken horn of the nanny-GOAT Amalthea, in gratitude for her having nurtured him; others say it was a BULL's horn. In both cases it symbolizes inexhaustible fecundity.

### Cup ✳ Chalice

Cups are often connected with WINE. In classical mythology, the *kantharos*, a two-handled wine-cup, was an attribute of DIONYSUS/BACCHUS, and was carried by the devotees of the god in ritual processions and feasts.

The chalice is a ritual cup, usually made of SILVER or GOLD, used in the Christian Eucharist to hold the wine, which either symbolizes or is transformed into the BLOOD of CHRIST. It recalls the cup of wine given to his disciples by Christ at the Last Supper, when he stated that the wine was his blood. (In medieval chivalric literature this cup was associated with the Holy GRAIL.)

Christian art represents its role as the container for Christ's blood in depictions of the crucifixion, where one or more chalices are held up to Christ's wounds by an ANGEL or angels as he hangs from the CROSS. It is sometimes shown as an attribute of the personification of the Theological VIRTUE of Faith.

### Basket

Baskets are often used to carry offerings of FRUIT, BREAD and grain. These were offered in the Temple in Jerusalem as the first fruits produced by the land. In classical mythology the *cista mystica,* a sacred basket containing a SNAKE, was carried in procession during Dionysiac festivals and Eleusinian mysteries.

The canon of Buddhist writings is called the 'Great Scripture of the THREE Baskets' in China and Japan. Each basket is one section of the canon (i.e. sutras; rules for monks and nuns; commentaries).

In the Americas, legends about baskets and basket-making are related to WOMEN. For example, in the lore of the Pawnee people of the North American Central Plains, Basket Woman is the MOTHER of the MOON and the STARS, who gives permission for the creation of the earth. A Mexican legend describes how a grateful HUMMINGBIRD taught a Taroscan Indian woman who had saved its life how to weave beautiful baskets.

The Japanese identify MOUNTAIN ascetics by baskets that they carry.

### Flower Basket

A basket of flowers is the attribute of one of the Chinese EIGHT IMMORTALS, Lan Cai-he. Its contents symbolize riches. Other Daoist deities also carry flower baskets, one of the 'EIGHT TREASURES of Daoism'.

PERSEPHONE/PROSERPINE (Queen of the UNDERWORLD) was picking flowers when seized by PLUTO. A flower basket is the attribute of Persephone and of Flora, Roman personification of SPRING.

### Stool

The Roman magistrates' stool of office embodied judicial authority and power, so Roman emperors sat upon stools, and THRONES were reserved for the gods. Today, stools are the symbols of office for several African KINGS. The GOLDEN stool of the Ashanti of Ghana enshrines the nation's SOUL.

## Footstool

In the ancient Near East KINGS were usually depicted enthroned, with their FEET resting on a footSTOOL while their subordinates stood. Hence the footstool could signify the privileges of ease and comfort reserved for the ruler alone – a meaning it still carries in the East. This connotation became integrated into Western ceremony, and footstools are used by European monarchs today.

Jews described worship before the ARK OF THE COVENANT, or any ALTAR, as worship at God's footstool, the most sacred terrestrial location being the lowliest place in HEAVEN and worthy only of God's feet.

In Celtic legend, Math had a royal foot-holder who had to be a female VIRGIN. She acted as his footstool and was forbidden to let his foot fall to the ground. Math's foot in the royal foot-holder's lap probably had sexual connotations. The foot-holder may also have represented the KINGDOM and sovereignty.

## Chair

A person sitting in a chair is raised in comfort above the floor, so gaining a privileged position. A chair therefore symbolizes status. Elevated status is most clearly embodied in a THRONE. The form of the chair – whether it has arms or a back – can vary according to the status of the sitter. Any person with whom one sits can also indicate one's status.

The chair of power of the Swahili people of Zanzibar is used only for visiting guests and the most important members of the family. The Welsh Eisteddfod, a national and DRUIDIC cultural festival, includes the CROWNING of the bard who creates the best poetry. The winner is honoured by being seated in and given a specially crafted Bardic chair.

In Latin, a bishop's chair was called a *cathedrum*, from the Greek *kathedra,* meaning 'chair', so churches presided over by bishops were called 'cathedrals'.

In Japan, where it is customary to sit on matting on the floor, chairs can indicate a Chinese or Western influence.

## Tripod

In antiquity the tripod, a THREE-legged CAULDRON, was sacred to APOLLO. At his shrine at Delphi his priestess sat upon a tripod placed over the *omphalos* (navel-stone) to deliver her oracles. BRONZE and GOLDEN tripods were dedicated to Apollo to seek favour and advice. In Imperial China the three legs on the NINE sacred CAULDRONS represented three senior officials who supported the emperor.

## Table

As the Jewish home symbolizes a temple, so the table at which meals are taken symbolizes the ALTAR. On sabbath and feast days, the ceremony of the family meal has replaced the ritual of animal SACRIFICE – not practised since the Temple's destruction by the Romans in AD 70.

A       B       C

## Candle

The FLAMES of candles are small LIGHTS, and the light they give is an important part of religious ritual all over the world (A). Candles are associated with the Jewish winter festival of lights, Hanukkah, which commemorates the purification and rededication of the Temple in Jerusalem in 165 BC, following the ravages of the Syrians. During Hanukkah, each of the candles in the EIGHT-branched menorah is lit in succession over the eight days of the festival as a symbol of the survival of the Jewish people against all odds. Sometimes each candle is lit from a NINTH, central candle called the *shammes*. The ceremony of lighting each candle symbolizes the giving of love and light to others without losing any part of oneself.

On the anniversary of the **death** of a member of a Jewish household, a candle called a *yortzeit* (or *yahrzeit*) is lit for twenty-four hours; it is compared to the SOUL. When a Jewish WOMAN lights a sabbath candle on Friday, saying a blessing out loud and silently asking God to preserve her family's peace, health and honour, she momentarily becomes a priestess.

Since early Christian times, the ritual extinction and lighting of a paschal candle on the eve of Easter has symbolized the death and resurrection of CHRIST. From the 11th century the Presentation of Christ in the Temple was marked with the blessing and procession of candles, symbolizing his entry into the Church. Celebrated as Candlemas on 2 February, this festival coincided with the feast of the Purification of the VIRGIN MARY, when the congregation offered candles to be burned in front of an image of the Virgin. These festivals also coincide with St Bridget's day and the Celtic Imbolc (associated with BRIGID).

Candles are also associated with the Swedish festival of St Lucy, whose name means 'light'. On 13 December each year the 'Lucia Queen' wears a WHITE gown and a CROWN of lit candles (B).

Many ancient customs associated with the Yuletide festival were assimilated into its celebration. In Christingle services held during Advent, which originated in the Moravian Church, one lighted candle represents CHRIST as the light of the world (the ORANGE that holds it represents the world; a RED ribbon tied around it, the BLOOD of Christ, C; and the raisins and FRUIT stuffed inside the orange represent the people of the world).

More generally, candles are also lit before ALTARS to symbolize the continuity of prayers offered or to provide cleansing and protection.

The Chinese associate candles with WEDDINGS: a pair of large red candles symbolizes the idea that YANG (the active principle) will operate during the marriage, while the behaviour of a pair of candles lit in the bridal chamber prefigures the fates of the married couple. Related to this is the 'lighting of the wax candles' as a metaphor for deflowering a VIRGIN.

In the Japanese Bon festival, candles are used to welcome the SPIRITS of the ANCESTORS and send them back on their way.

As a symbol of the light of faith, the candle is an attribute of faith personified.

FURNITURE

## Candelabrum

Candelabra were used to illuminate Greek and Roman temples and the rites carried out within them; thus candelabra were often used in classical art to represent piety and sacred ritual.

Candle-holders are one of the THREE main implements of Buddhist rituals, and they are used on Christian ALTARS.

The menorah (above) is a SEVEN-branched candelabrum used in Jewish ritual. Supposedly shaped like an ALMOND branch, it commemorates Aaron's STAFF of almond wood (Exodus 37: 17–24). The seven branches also symbolize the seven pillars of wisdom, and the seven days of creation. An EIGHT-branched menorah is used only at the eight-day winter festival of Hanukkah, celebrating the renewal of the LIGHT.

The decorations of Mexican TREE-OF-LIFE candelabra combine pre-Christian symbolism with ADAM AND EVE and the SERPENT of Knowledge, referring to the essence of life – but sometimes DEATH appears in the branches, in the form of SKELETONS.

## Torch

Torches banish darkness and therefore the malevolent evil that lurks in the shadows. In classical mythology DEMETER/CERES, the Greek corn goddess, is often represented holding a torch in her search for her daughter PERSEPHONE. Torches are also one of the attributes of the goddess HECATE who, like Demeter, used a torch to find her way through the darkness of the UNDERWORLD.

In the Greco-Roman world torches were associated with processions to temple gatherings, and to escort a bride to her new home, and other processions. The torch was the attribute of Hymen, Greek god of MARRIAGE. The Olympic torch holds the FLAME that symbolizes the SPIRIT of the modern games.

In Roman funerary art, especially on CHILDREN'S TOMBS, CUPIDS were depicted holding down-turned torches to indicate the extinguished life of the departed, a motif which was later used in Renaissance allegories and funerary monuments.

## Lantern

In China and Japan, the LIGHT of lanterns symbolizes the BUDDHA'S wisdom and knowledge. During the Chinese Lantern Festival and the Japanese Bon Festival, lanterns attract the SOULS of dead ANCESTORS – and then send them on their way again. In Britain and the United States, turnip and PUMPKIN lanterns are lit on Halloween, All Hallows' (or All Saints') Eve (31 October).

In China, lanterns (above) are connected with fertility. The Chinese word for lantern (*deng*) sounds very similar to *ding*, the word for a young MAN suitable for military service. Thus, walking under a lantern was believed to make WOMEN more fertile, while a pair of lanterns to hang at the GATE are an auspicious WEDDING gift.

In some European paintings the Cynic philosopher Diogenes (4th century BC) is shown holding up a lantern as he seeks an honest person among a crowd. He and his lantern thus symbolize the search for truth and virtue. CHRIST is also sometimes shown holding a lantern as 'the LIGHT of the world'.

A

B

C

FURNITURE

## Lamp

Lamps signify both literal and metaphysical illumination. In classical mythology PSYCHE realised the true identity of her lover, EROS/CUPID, when she lit a lamp in the depths of night and finally gazed upon his face. In China and Japan, the LIGHT of lanterns symbolizes the BUDDHA's wisdom and knowledge.

An integral feature of Islamic mosques (B) are lanterns suspended from chains which light the MIHRAB, the niche in the wall indicating the direction of Mecca. They symbolize the incandescent grace of God, described in the twenty-fourth sura of the Qur'an, 'Allah is the Light of the HEAVENS and the earth. The parable of His light is as if there were a Niche and within it a lamp.'

The Deepak or EARTHEN lamp (C) forms an essential feature of Hindu ritual, symbolizing as it does the light of knowledge piercing the darkness of ignorance. The earth of which the lamp is made denotes the human body, born of the earth.

The burning OIL is the essence of life. Each lamp represents the contribution each individual can make to the spread of knowledge. These lamps are related to the Hindu festival of lights, Diwali (from the Sanskrit *dipavali*, meaning 'row of lights'), celebrated in October or November to commemorate the return of Rama (an incarnation of VISHNU) after fourteen years in exile. Lighted oil lamps are placed outside houses or in windows, and floated on WATER.

In Jewish tradition a sabbath lamp (A) was lit in every Jewish home on Friday night, and to this day the WOMAN of the house lights a CANDLE for the sabbath. In the Temple in Jerusalem, lamps were lit from dusk to dawn, and kept trimmed, by the priests. Before the use of candles, lamps and TORCHES were lit in the Temple courts at the winter festival of lights, Hanukkah. This commemorated Judas Maccabeus's victory, in 165 BC, in regaining the Temple for Jewish rites from the Peleucid forces attempting to impose

Hellenic religion upon the Jews, when one day's oil miraculously lasted for EIGHT days.

In Christ's parable of the wise and foolish VIRGINS, the wise virgins, who had enough oil for their lamps, symbolize those who are spiritually prepared for their DEATHS and the Last Judgment; the foolish virgins, those without oil, represent the prodigal and negligent (Matthew 25: 1–13).

Since the graves or mausolea of ancestors or saints are regarded as sanctuaries in Islam, lamps are placed before them.

In Chinese tradition, lamps are symbols of fertility. In Yunnan Province, for example, a lamp placed under the bridal bed was called the 'CHILDREN and Grandchildren' lamp. Lamps were also hung under the beds of pregnant women. 'All night long lamps' were lit in the bridal chamber, one for the bride and one for her groom. If both lamps went out at same time, it was considered an auspicious sign for a long married life, since the lamps embodied the couple.

A

B

C

# Mirror

The Ancient Egyptians associated the mirror with the SUN's disc – the god Aten. Similarly, the Japanese tell how the sun goddess AMATERASU OMIKAMI was enticed from her CAVE using a sacred mirror, which she later gave – with a SWORD and some curved STONE JEWELS – to her grandson when she sent him to pacify the ISLANDS of Japan. These were supposedly handed down to the first emperor, and have become the three imperial regalia of Japan, embodying imperial authority and the legitimacy of the succession. The mirror (B), called the Yata mirror (*Yata no Kagami*), is said to be kept at Amaterasu's main shrine at Ise, where it symbolizes her, and therefore the sun. A replica is said to have been made in the 9th century for the emperor to keep with him.

As a symbol mirrors have a wide-ranging and complex significance. They are sometimes seen as reflecting the truth – in classical mythology, for example, the chief GORGON, Medusa, was transfixed and petrified when she saw her evil visage reflected in Perseus's SHIELD. By contrast, in Christian symbolism, the *speculum sine macula* ('flawless mirror' – c) is associated with the VIRGIN MARY, who reflects God's flawless nature.

The god Tezcatlipoca ('SMOKING Mirror') of the Aztec of Central America is related to the mirrors made of polished BLACK OBSIDIAN, used by their scryers, or diviners, when seeking visions.

Chinese and Japanese Buddhists believed that mirrors were used at the court of YAN-LUO and EMMA-O, respectively, to reveal the transgressions of the dead to them, while Buddhist priests used them to show people the form they would take in their next life. Followers of Shinto used mirrors as hosts for the SPIRITS of the gods.

In the West mirrors were used to trap SOULS, and might also draw the souls of the weak from their bodies. They are also associated with vanity. Western depictions of 'DEATH and the MAIDEN' show a SKELETAL figure of death about to embrace a beautiful young woman, who cannot see her fate because she is gazing at herself in a mirror.

The Chinese count a round mirror among the EIGHT TREASURES. They used small mirrors, often of BRASS, to frighten off evil spirits who, seeing their own reflections, would scare themselves away (A). These were particularly used near beds or worn by brides. Mirrors could also cure those who had been rendered insane by seeing a spirit.

Given as gifts at the Chinese MOON Festival, mirrors symbolize brightness and intelligence. People used mirrors to flash rays of LIGHT on a bride, to bring her good luck, while a man who dreamed of finding a mirror might expect, shortly, to find a good wife. Similarly, the state of a mirror may reflect the state of a MARRIAGE: a break symbolizes an unhappy marriage; or the separation of husband and wife – when 'the broken mirror is round again', the partners have been reunited.

In the West, a broken mirror causes seven years of bad luck for the breaker.

F U R N I T U R E · T O Y S , A N D G A M E S

## Carpet

In the Middle East carpets are associated with the home and the mosque. They delineate and beautify domestic and holy spaces.

Muslim prayer rugs commonly incorporate the image of a LAMP set in a niche, recalling the holy light burning in the *qibla* at Mecca. Floral and vegetal designs on such carpets recall the GARDENS of paradise. Carpets woven for trousseaux include motifs to ward off the evil EYE, TREES OF LIFE, ears of grain and BIRDS in flight, all tokens of good news.

In Europe carpets have symbolized status. They appear in portraits from the 16th and 17th centuries, adorning tables as was customary at that time. Carpets might be hung outside during processions, or laid flat so that the FEET of an honoured individual need never touch the bare ground. RED carpets, particularly, are often used for royalty and statesmen.

## Curtain

Curtains provide temporary and portable concealment. The curtain in the Temple in Jerusalem was drawn in front of the Holy of Holies containing the ARK OF THE COVENANT and the SCROLLS of the Torah. Only the high priest could go beyond it, and only on Yom Kippur, the Day of Atonement. In the Armenian Church the sacraments are consecrated behind a curtain temporarily drawn across the sanctuary.

In certain Muslim societies, curtains (together with screens and VEILS) are central to the practice of *purdah* (from the Urdu and Persian words for 'curtain'), which involves the seclusion of WOMEN by concealing them from the public. This practice came to India with the advent of Muslim power, where it was also adopted by some Hindus, mainly the upper classes.

In Greco-Roman funerary art a half-drawn curtain suggested the new realm into which the deceased had stepped, beyond human sight and understanding.

## Games

Playing-pieces have been found among grave goods in high-status Norse burials. Often included in lists of royal or divine TREASURES, they represent the KING's power, skill and luck. Irish legends tell of a chess-like game called *fidchell* (above), 'WOODEN wisdom'. When the king played, the game was sometimes said to reflect events in the KINGDOM. In China, chess was one of the FOUR Arts of the Scholar.

## Ball

Depicted as a child, the Hindu deity KRISHNA holds a spherical butterball, symbolizing his playful childhood among cowherds.

Balls held by male LIONS in Chinese Buddhist temples may represent BUDDHA (above). In lion DANCES they represent the SUN, the YIN/YANG symbol, or a JEWEL.

A

B

C

# Doll

AS CHILDREN'S toys, dolls are associated with childhood. On her WEDDING day a bride in Ancient Rome left her dolls and *bulla* (BRACELET or TORC) at the shrine to the household gods, symbolically leaving her childhood behind her.

Generally, in religion, ritual and sympathetic magic, dolls act as surrogates for the individual they represent. Female figurines found in Palestine indicate that dolls were once made to represent Asherah (a Canaanite goddess and possibly the local form of ASHTART) in Jewish households, despite Judaism's official prohibition against idolatry.

In Ancient Rome each May saw the *argei* paraded around the city; these were bundles of REEDS bound into human shapes. After the procession, the Vestal VIRGINS threw them from the Sublicius BRIDGE into the RIVER Tiber, presumably as substitutes for what had originally been human SACRIFICES. In Imperial Japan, courtiers' impurities used to be transferred to paper dolls, which were then thrown away. Small dolls and other objects (*katashiro*) are still rubbed against the body to absorb evil influences, then floated away on a river. SILVER figurines dressed with cloth and FEATHERS were used by the Inca of the South American Andes as votive offerings to the gods.

From the Middle Ages, some Europeans used dolls in malevolent magic as surrogates for a particular person whom they were intended to represent. By sticking pins in them or burying them, injury and death was believed to be caused magically to the people they represented. Such dolls were also used as surrogates in some fertility magic.

Central African 'power sculptures' (*nkisi* images) often have hollowed-out STOMACHS containing substances specific to the SPIRIT that the sculpture embodies. Other sharp objects are sometimes driven into them to empower or awaken the spirit within them.

Corn-husk dolls (B) are made by Native American tribes of the north-east for ceremonial use. Their faces are usually left blank, leaving them free to be inhabited by the spirits. Hopi WOODEN Kachina dolls (A) embody the spirits of the many different Hopi Kachinas (spirit beings), and also serve to educate the children about the Kachinas.

Dolls representing the CHRIST Child are sometimes paraded in festival processions around southern European cities and shrines. They are often associated with miracle-working and are believed by some women pilgrims to facilitate conception.

Miniature models of limbs and organs may be offered at Catholic shrines as representations of prayers asking for the part of the body represented to be healed; as *ex votos*, they embody thanks for divine assistance received.

Japanese Daruma dolls (C), with large bodies and no limbs, represent the late 6th-century priest Bodhidharma, who meditated for so long that he lost the use of his limbs. They represent endurance and are used to help achieve specific ventures.

Celtic corn dollies, made from the year's last gleanings, were hung up to bring fertility.

## Cards

Playing cards originated in Central Asia, then spread to India, and to Europe during the 15th century as a game to amuse courtiers, for whom exquisitely hand-painted and gilded cards were made. Their imagery was varied, but often incorporated allegorical groupings and symbolic figures such as the SEVEN planets, or the FOOL. Tarot cards derive from some of these decks.

In the East, decks of playing-cards still contain various suits and different numbers of cards, but in the West they were standardized, and disseminated by printing. Their use for gaming and gambling was condemned by the Church. In the 16th–17th centuries they are usually shown being played by disreputable characters, and symbolize a dissolute lifestyle.

When used to tell fortunes, each playing or tarot card carries a specific meaning, as does its relation to the other cards selected.

## Kite

The Venetian traveller Marco Polo (1254–1324), described people being lifted on kites in China to divine the likely ease of a SEA-journey. The Japanese originally flew kites to secure good health or rich HARVESTS. They later used them to determine the intentions of the deities. Chinese kites decorated with BUTTERFLIES represented prayers for the SOULS of the living and the dead.

## Writing Implement

The Qur'an calls the pen the symbolic agent of divine revelation. In Christian iconography a quill pen is sometimes an attribute of each of the FOUR Evangelists, symbolizing their part in writing the gospels. In classical mythology the stylus and tablet are attributes of Calliope, MUSE of Epic Poetry.

## Brush

The Chinese include the writing brush, which is used in calligraphy and ink drawings, among the 'FOUR TREASURES of the Study', as a sign of the scholar, and of the literati class who ruled China from the 2nd century BC to the early 20th century. The word for writing brush sounds the same as that for 'certain' (*bi*), so a brush may symbolize certainty.

## Ink and Inkstone

The Chinese use solid ink, which must be ground with WATER on an inkSTONE before it can be used. The ink and inkstone are two of the 'FOUR TREASURES of the Study'. Calligraphy's high status ensured that its tools were accorded special powers: ink was said to prevent convulsions if rubbed on the lips and TONGUE.

A

B

C

# Book

A book may be a large-scale piece of writing in any form (including SCROLLS); or a codex, composed of pages stitched together along one edge and usually encased in covers (A). It is often depicted in the form of a codex, although codices seem to have emerged only in the 4th century AD. For the three 'religions of the book' – Judaism, Christianity and Islam – a codex therefore often symbolizes their respective holy books.

The Jewish Torah or Pentateuch (the first FIVE books of the Bible) was given to MOSES by God on Mount Sinai; Moses gave it to the Levites to keep beside the ARK OF THE COVENANT. It is forbidden to destroy anything that contains the name of God, so the Torah and Talmud (the collection of Jewish law and moral doctrine, which are based on scripture), are stored in perpetuity in a room in the synagogue called a *genizah*.

The Christian Bible (B) consists of the Old Testament of the Jews and the New Testament, with the lives of CHRIST written by the FOUR Evangelists, and the teachings of his followers and disciples. It symbolizes the holy word of God and is often used ritually in courts of law in Christian countries.

Muslims believe that the holy Qur'an is the word of God revealed to his messenger, the Prophet Muhammad. It symbolizes divine miracle, authority and blessing. It is the keystone of all Islamic theology and jurisprudence and forms the context within which all believers conduct their lives.

The SIBYLLINE Books, written in Greek and said to prophesy Rome's destiny, were sold by the Cumaean Sibyl, a priestess of APOLLO, to the Roman KING Tarquinius Superbus. Kept in the temple of Capitoline JUPITER in Rome, they were consulted by the Senate at times of crisis.

In Europe books were believed to have divinatory powers. If a book were opened at random and a grain of WHEAT dropped onto it, the text on which the grain landed would indicate the course of future events, answer a question, or provide apposite advice (C). Words from books have also been eaten as auspicious TALISMANS.

Copies of Chinese literary classics such as the *Yi jing (I Ching)* were believed to have the power to repel evil SPIRITS, and so were sometimes put under pillows at night. Even reciting passages from these books could be effective.

These phenomena indicate the status accorded to books in China. They were included in the Chinese EIGHT Symbols of the Scholar, symbolizing the learning of the scholars who governed China for much of the last two millennia. Two books together are one of the Eight TREASURES, while books shown with a spray of ALMOND blossom symbolize the wish, 'May you pass your examination and achieve high rank'. A book is an attribute of the sage LAOZI, the Chinese god of literature, Kui-xing, and several Daoist EIGHT IMMORTALS.

Books were important to the pre-Hispanic civilizations of Central America. The *Popol Vuh,* the Maya *Book of Time,* recounts how the ancestral gods Tepek and Gucumatz created the EARTH from a celestial SEA and endowed it with animals and plants.

W
R
I
T
I
N
G

•

C
L
O
T
H
E
S

A
N
D

J
E
W
E
L
R
Y

## Scroll

Scrolls – rolls of paper or parchment that carry writing – symbolize holy works. The Torah, the Jewish holy BOOK, and the biblical passages in MEZUZAHS are still printed on scrolls. The SIBYLS are sometimes shown holding the scrolls on which their prophecies were recorded (these sometimes appear, anachronistically, as bound books).

Scrolls embody learning and wisdom, and identify philosophers and scholars. A scroll is the attribute of Clio, the MUSE of history. Early images of CHRIST occasionally show him in the role of teacher and sage holding a scroll, flanked by his attentive disciples and followers.

In China scrolls are attributes of LAOZI, the founder of Daoism. In Japan they are attributes of Hitomaru, the god of poetry, and of Fukurokuju and Jurojin, the gods of longevity and of learning, two of the SEVEN DEITIES OF GOOD FORTUNE. They are also one of the Deities' Myriad TREASURES.

## Seal

Seals appeared in Mesopotamia as early as 5000 BC, and their use spread to the Near East, China, the Roman Empire and Japan.

Seals secure objects so that they cannot be opened undetected, implying secrecy and security. Still sometimes used as signatures, they signify the author's or issuer's authority on contracts, accounts and other documents. The SILVER or WOODEN seals of office used by imperial Chinese officials denoted the authority of the imperial bureaucracy and thus of the emperor. A great seal can still represent the authority of a ruler or of a state.

Seal RINGS were occasionally inscribed with the names or images of deities, or inscriptions from holy BOOKS. This, together with the perceived magical properties of the stones into which they were carved, led to their use as TALISMANS.

In China as late as the 19th century seals were remedies. Even the impressions of seals could cure, if torn from documents and rubbed against affected parts.

## Veil

Veils (and HIJAABS) conceal the divine, powerful or dangerous from mortal sight. ISIS, principal goddess of Ancient Egypt, was sometimes described as veiled, and to lift her veil was to discover a powerful mystery. Alchemically, she personified nature and its secrets; unveiling her revealed the secret knowledge of the laws of nature. MOSES veiled his face when he entered the Tent of the Presence, and Roman priests veiled their heads with their togas.

Veils conceal WOMEN'S attractions and so signify modesty and virtue. Ancient Roman brides wore a *flammeum*, a 'FLAME'-coloured veil, over their HAIR but not over their faces; Chinese brides wore a RED veil over their faces. Western brides are still veiled, usually in WHITE (with connotations of VIRGINITY and modesty). The veil is lifted from the bride's face by her husband, once she is officially MARRIED. Nuns' head-dresses or veils recall medieval DRESS, and indicate that the nuns are brides of CHRIST.

A

B

C

## Head-dress

HEADgear combines practicality with symbolism, so like other clothes, it can identify deities, social groups or individuals. In classical iconography HERMES/MERCURY is depicted wearing a traveller's sun-hat (*petasus*). HERAKLES/HERCULES wears the head of the Nemean LION'S SKIN on his head, and this same image appeared as a symbol of heroism and divinity on COINS minted during the reign of Alexander the Great, who is depicted wearing the Nemean Lion's skin and the ram's horns of ZEUS, expressing his aspirations to heroic and divine status. In the cultures of the Middle East, the Phrygian cap (A) was worn by deities with eastern origins or influences, such as MITHRAS and Orpheus. The Three Magi were also often depicted wearing Phrygian caps, denoting their Eastern origins.

Hats might also have magical powers. The cap or HELMET worn by HADES/PLUTO was said to make him invisible. Some head-dresses of Central and South American cultures are resplendent with brightly coloured FEATHERS, which sometimes symbolize the brilliance of the SUN.

The *pileus*, a felt cap worn by citizens of Ancient Rome, was a symbol of pride for those released from slavery into the classes of freedmen. This symbolism was revived by 18th-century French revolutionaries.

In the Indian subcontinent until fairly recently, head-dress has been a part of traditional male attire, denoting caste, community, status and religion. It might vary from a simple cotton bandanna to the complex, BEJEWELLED turbans of royal families. It is compulsory for Sikhs to wear turbans (B). They are an integral aspect of their identity as part of the tradition handed down by Guru Gobind Singh, the tenth Sikh guru. Turbans of distinctive colours are worn on different religious occasions, and the way they are shaped and tied varies among the communities.

In early Semitic culture, the turban signified honour and status. When Aaron was made high priest he was given a turban marked with a GOLD ROSETTE fixed with VIOLET braid. This has been replaced by the *yarmulka* (skull cap) worn by Jewish men when at prayer (or always if they are Orthodox). It is disrespectful to say the name of God with one's head uncovered. To preserve their modesty, modern Orthodox Jewish women must not show their HAIR in public. They shave their heads and wear a *shaytl* (wig), or cover their own hair with a snood.

The head-dresses of Native American men (C) indicate their tribe and status. To wear a head-dress made from or resembling an animal is to seek to express and call upon the SPIRIT of that animal or the medicine associated with it. For example, Pueblo Deer-Dancers wear head-dresses bearing the HORNS of the DEER they seek to embody in the DANCE.

More generally, as important and recognizable components of uniforms and other characteristic forms of dress, hats often symbolize belonging to a particular group, trade or profession. For this reason, caps, helmets and other insignia have often been buried with their owners.

CLOTHES AND JEWELRY

A

B

C

## Mask

Masks allow their wearers to assume another identity, sometimes to the point of relinquishing their own personality. SHAMANS sometimes use masks associated with the totem animals with which they are connected to take on the personality and powers of that animal, enabling them to see as it sees and to use its medicine.

In Africa, being able to wear a mask and take part in masquerade rituals demonstrates skills in performance and status in society (C). Masking is often associated with MALE initiation societies, in which wearing particular masks indicates the transition from adolescence to manhood, and may endow status. However, many local traditions indicate that masquerades once belonged to WOMEN and were subsequently taken over by men.

Masquerades are used not only for entertainment but also to bring the powers of nature (such as wild beasts, nature SPIRITS, or the dead), into a town or village. The masks therefore tend to be made of natural materials. They may be passed on from one generation to another, and may embody a tribal spirit. Some are considered so powerful that they cannot be worn, but are used to protect the masks that are worn.

Masks are also important in Native American ceremonial. The tribes of the North-west Coast make carved WOODEN masks representing totemic animals, SPIRITS of the forest (A) and the SEA, ANCESTORS, and mythical beings. These are worn in ceremonial DANCES. Rituals performed while a mask is made imbue it with power or spirit. Thus a False Face mask for the False Face Society of the Iroquois was traditionally carved on a living tree. The process would be carried out ceremonially, and offerings made to ensure that the tree continued in good health and that its energy would remain in the wood of the mask as it was cut free.

Masks were a fundamental part of the Ancient Greek theatre, emphasizing the actors' scripted personalities. The tragic mask was an attribute of Melpomene, the MUSE of tragic theatre, and the comic mask was an attribute of Thalia, Muse of comedy or pastoral poetry. These two masks (B) still represent the theatre. Masks are still used in the classic Japanese Noh theatre. The main character and his companions (all actors are male) wear masks that fall into stock types, but the main characters have second masks that reveal their true nature. For example, a beautiful woman might also wear a DEMON mask.

In Ancient Rome, wax death masks of the deceased were made. These would represent a family's ANCESTORS and be carried in procession before the bier of the deceased family member. Similarly the rope and basketwork mask costumes used in the festivals of the Asmat of Western Papua New Guinea enable the SPIRITS of the recently dead to visit briefly the world of the living.

Rulers of the pre-Columbian Olmec culture were buried wearing the masks they wore in life. Most Ancient civilizations of Central and South America appear to have buried their high-ranking dead with funeral masks.

## Hijaab

In Muslim tradition, 'hijaab' is something that separates two things. The term has a social and a spiritual dimension. God's countenance is said to be concealed by 70,000 VEILS, to make it endurable for humans to view his splendour. Consequently the higher truth is hidden from all men except saints, and divine secrets can be satisfied or revealed only by reflection and devotion. The greater the obstruction that stands in the path to attainment, the more intense the resulting devotion.

A reference in the Qur'an to speaking to the Prophet's wives from behind a CURTAIN has been interpreted in various ways over the centuries. From this, the Hijaab has evolved into a code of modest behaviour or dress for WOMEN. This ranges from a veil to a covering that conceals the body completely, the wearing of which is compulsory in some Muslim countries, but not in others. To be veiled in public is to display modesty and virtue.

## Comb

The Maori regard the HEAD as the most sacred part of the body, and combs as *tapu* – sacred and protected. From the early Middle Ages, a Roman Catholic priest celebrating the Eucharist combed his HAIR beforehand, symbolically clarifying his mind and stilling his thoughts.

## Blindfold

Personifications of both Justice and Fortune may be blindfolded, because justice takes no account of status or appearance, while Fortune's blindfold indicates that the future is unforeseeable.

Blindfolds symbolize ignorance or lack of reason. EROS wears one because love is irrational, whereas Masonic initiates are blindfolded to symbolize their ignorance.

## Apron

The FIG LEAVES with which ADAM AND EVE first covered their nakedness were the first aprons, and symbolized their shame, modesty and loss of innocence. For Jews, CIRCUMCISION symbolizes the removal of this covering – the foreskin is regarded as the VEIL between spiritual wisdom and the material world.

In Freemasonry the apron (above) is the symbol of work and also, echoing the Biblical meaning, of innocence and honour. Its rectangular shape represents the material world, and the CIRCULAR waistband the OUROBOUROS, the binding energy of the universe. The various symbols decorating these aprons indicate each wearer's membership of a particular lodge and status within it.

Aprons made of DEER or buckSKIN were worn by the ceremonial DANCERS in some Native American tribes. The different designs and materials in the decorations had a special significance in the ceremony for which they were worn.

### Belt ✳ Girdle

A belt or girdle encircles, protects and withholds, delineating the attainable and the inaccessible. APHRODITE's GOLDEN girdle incited infatuation in the beholder. The complex KNOTS in the girdles of Ancient Roman brides presumably symbolized their VIRGINITY and tested their new husbands' patience. Chinese MOTHERS attached a cloth to their daughters' girdles for their WEDDING. The cloth was removed in the nuptial bed and returned for WASHING. Touching the girdle symbolized the consummation of a marriage. Ainu women of Japan traced their descent through matrilineal lines, symbolized by a hereditary chastity belt.

Christians associate the girdle with the VIRGIN MARY. A symbol of her virginity, it also proved her bodily ascension to HEAVEN by dropping as she rose, eradicating ST THOMAS's doubts about what he was witnessing.

The THREE monastic vows of poverty, chastity and obedience are represented by the three knots tied in a monk's girdle.

### Sash

In Hawaii the *malo* (sash) worn round the waist symbolizes sovereignty. Rulers in the Society Islands wear long FEATHER girdles or sashes to represent their mortal genealogy and divine descent from a particular god.

The Brahmanic *yajnopavita* (sash), originally a DEER SKIN worn diagonally over the LEFT shoulder by high-caste Hindus, symbolizes a spiritual THREAD attaching them to the divine (above). It is worn by several Hindu deities, such as AGNI, BRAHMA, VISHNU and SHIVA. Chinese and Japanese images often represent BODHISATTVAS wearing a sash.

In Europe, sashes may be worn on very formal occasions as symbols of chivalric honour and civic prestige. Their status now extends as far as beauty queens.

A Japanese WOMAN's status used to be indicated by how she tied the sash (*obi*) worn with her kimono: girls and unmarried women tied theirs at the back, married women at the front. Today, most are tied at the back.

### Glove

In medieval chivalry, it was forbidden to deliver a challenge by striking a blow with the hand, so a glove or a gauntlet was thrown down as a representative act. This insult required a riposte in the form of a duel. A knight (and later a cavalier) wore the glove of the woman he loved on his HELMET, an emblem of his devotion.

WHITE gloves, worn by Catholic bishops, symbolize purity.

### Garter

In folklore garters are associated with WITCHcraft. A 16th-century woodcut shows a witch putting on a garter before FLYING up a chimney on a BROOM. In Scotland, the witch's garter called the 'Mettye Belt' was used to cure the sick.

The Order of the Garter, which Edward III founded in 1348, is the senior English order of chivalry.

## Sandals

Lavishly decorated sandals with TALISMANS against evil on the soles are part of the regalia of African KINGS, such as the Dahomey of Benin and the Ashanti of Ghana.

The WHITE sandals worn by the dead in the Egyptian Hall of Judgment symbolize their purity. .

The WINGED sandals worn by HERMES and by the Daoist EIGHT IMMORTALS enabled them to fly.

## Tassels

Jewish men are commanded in the Bible to 'make twisted tassels on FOUR corners of the cloak' (Numbers 15: 38); the Hebrew for tassel, *tzitzit*, means 'fringe.' The fringed biblical cloak evolved into the *tallis*, the shawl worn by adult males when praying (above). The tasselled undergarment worn by Orthodox Jewish MALES reminds them of God's law.

## Jewels

Chinese and Japanese Buddhist iconography includes a 'wish-granting gem', often depicted as a FLAMING PEARL, symbolizing the possibility of release from human desire. An attribute of the BODHISATTVAS Guanyin (AVALOKITESHVARA) and Di-zang (Jizo), it is sometimes identified with the BALL under the paw of Buddhist LION figures.

## Hem

Kissing or touching a hem – the most peripheral part of a garment – signifies deference or submission. The haemorrhaging woman of Cana (Matthew 9: 18–21) proved her humility by touching Christ's hem, eliciting an instant cure.

The hem of the *ephod*, a Jewish priest's overgarment, was highly decorated and embroidered.

## Tobacco Pipe

Native Americans formulate prayers to the SPIRITS with each pinch of TOBACCO, gather them in the pipe and offer them as they smoke. The bowl represents the FEMALE, the stem the MALE, and assembling the pipe signifies unity and healing.

In Bamum and the Cameroon grasslands, the king smoked a pipe as a symbolic act of fertilization.

## Torc

The torc was a precious METAL neck ornament with large end stops worn to signify the wearer's power, status and wealth. Worn particularly by Celts, torcs have been found in MALE and FEMALE graves and may have religious significance. Celtic deities linked with wealth and fertility, such as CERNUNNOS, are shown with torcs.

CLOTHES AND JEWELRY

**329**

## Bracelet

The BRASS anklets worn by the Igbo women of Nigeria indicate their husband's status: their great size prevents the wearer from taking on domestic chores.

*Bullae*, which could either be bracelets or take the form of a necklace like a TORC, were worn by Etruscan CHILDREN until they reached adulthood.

## Ring

Rings, with no beginning or end, symbolize eternity: hence their association with enduring love and MARRIAGE since the Ancient Romans; their wedding rings took the form of two HANDS holding a CROWNED HEART. Large rings signify a ruler's authority. Those worn by the Christian priesthood show their sanctified status.

## Parasol ✳ Umbrella

In Ancient India the parasol (*chatha*) symbolized wealth. THIRTEEN umbrellas on a pole, representing the protection of the SUN and the TWELVE signs of the ZODIAC, became an attribute of deities and royalty. Thirteen umbrellas decorate the spires of Buddhist STUPAS, and umbrellas appear on carvings of the BUDDHA's FOOTPRINTS. In China and Japan, umbrellas are one of Buddhism's EIGHT TREASURES, symbolically connecting HEAVEN and earth (above).

Rulers and gods in the Ancient Near East were depicted with attendants behind them holding parasols, signifying status and power.

In East Asia generally, umbrellas protect from evil, often being held over brides or others at transitional points in their life. Roman Catholics protect the Host with an *umbrellino* as it is processed through a church.

Umbrellas are part of the regalia of an Ashanti KING, symbolizing respect and shelter from the SUN.

## Thread

A long, thin thread signifies something enduring but frail. In classical antiquity it symbolized the progress of human life, spun and finally cut by the FATES.

Threads also hold things together. In Hindu religious ceremonies they symbolize binding together, protection and preservation. Among the Brahmins, threads symbolize coming of age and the gaining of access to Vedic knowledge. Buddhists use thread-CROSSES (above) made by tying pieces of WOOD together with a thread, to create temporary homes for deities who then trap and destroy evil SPIRITS; they are destroyed at a CROSSROADS when they have served their purpose.

Jews used RED threads in SACRIFICES, burning them with red heifers, CEDAR WOOD and HYSSOP as offerings to atone for sins, and with BIRDS in thanks for healing and to purify a house after illness.

Even a slight thread may mark a trail. Ariadne's thread helped Theseus escape from the LABYRINTH after killing the MINOTAUR.

## Fan

The Chinese word for 'fan' (*shan*) sounds similar to 'good', so fans symbolize goodness. They are attributes of one of the EIGHT IMMORTALS Zhong-li Quan, who uses his to revive the dead, and of Hotei, one of the Japanese SEVEN DEITIES OF GOOD FORTUNE. Japanese FEATHER fans are attributes of more important TENGU; the deity Bimbogami, said to bring poverty, has a tattered fan.

## Philosopher's Stone

The Philosopher's STONE, or the 'Stone of the Wise', is a crucial symbol to Western alchemists because it is the goal of the Work, and it can transmute base METAL into GOLD, or, according to some, give eternal life. Some people believe it is a stone that must be found, not made; for others it is the culmination of a process of spiritual development.

## Vitriol

Chemical vitriol is sulphate of various METALS, or 'OIL of vitriol' (SULPHURIC acid), which burns and destroys. According to Valentinus the word 'vitriol' spells out the initials of: *Visita Interiora Terrae Rectificando Invenies Occultem Lapidem* (visit the earth's interior through purification and you will find the hidden STONE), a reference to the first stages of alchemy.

## Manna

Manna, a thin WHITE flake, shaped like wafers of BREAD and tasting like HONEY, was the food given by God to the Israelites in the DESERT; it signifies God's bounteousness.

JESUS spoke of himself as the 'true bread from HEAVEN' (John 6: 32), and hence, manna is a symbol for the EUCHARIST.

## Golden Elixir

Chinese and Japanese alchemists were more concerned with finding an elixir of immortality than making GOLD. The Chinese Elixir of life or 'Golden Flower' is similar to the Western alchemists' Golden Elixir – a liquid equivalent of the PHILOSOPHER'S STONE; it can cure disease and restore vitality.

## Bubble

Since Roman times bubbles have symbolized transience and brevity: 'man is but a bubble', in Varro's proverb. They sometimes appear in allegories of time and DEATH, being blown by small CHILDREN or putti, and in *vanitas* still-life paintings. They also symbolize the transience of dreams.

# ABSTRACTS

SHAPES

—

COLOURS

—

LETTERS AND WORDS

—

NUMBERS

8

## Circle

As it has neither beginning nor end, the circle has come to signify eternity (A). It is also used to indicate perfection, HEAVEN and the cosmos; in short, all that is.

Tibetan Buddhist depictions of the cosmos, subsequently taken up in China and Japan, often take the form of a SQUARE WITHIN A CIRCLE. This symbolism is related to the most common Chinese COINS, called 'cash', which were circular with a square hole in the middle: the circle symbolized the shape of heaven, while the square represented the EARTH.

As perhaps the most important shape in Native American beliefs, the circle is related to the Medicine WHEEL or Sacred Hoop. It symbolizes the cycles of life, and teachings on this and on all aspects of human existence: the Wheel encompasses SPIRIT, body, emotions, mind, and relationships to all aspects of life.

As a symbol of heaven, the circle is also important in Christian symbology. Dante's *Divine Comedy* (c. 1310–14) described heaven, purgatory and HELL as being divided into different circles or levels. The different hierarchies of ANGELS are sometimes shown arranged in circles around God and CHRIST. The circle was also the basis of the ground plan of early martyries, some Renaissance churches (shrines to miraculous MARIAN images or to martyrs), and several baroque churches.

The circle's endless nature means that, in many civilizations, it represents the continuing cycle of the SEASONS, and of the SUN's endless progression through the heavens. The circle is widely used as a symbol for the sun, itself a symbol of perfection and the origin of life in many cultures, and also the (full) moon. In Ancient Egyptian iconography the sun god, Horus, is often represented as a winged circle. In Japan the sun is depicted by a red circle, the moon by a white one. In the Chinese 'Twelve Ornaments', depicted on official robes, two circular designs represent the sun and the moon: the sun's contains a three-legged crow,

the moon's a hare pounding a pestle and mortar (b).

In Christian art, the EARTH is sometimes represented by a circle (or an ORB) divided into three unequal compartments (c). The three-fold division represents the TRINITY's dominion over the earth, and the three pre-Columbian continents of Asia, Europe and Africa.

Circles also represent PEARLS and other JEWELS in religious art in East Asian cultures: for example, a motif of interlocking circles, given the Buddhist name of 'SEVEN Jewels', is considered auspicious in Japanese and Chinese art.

Zen Buddhists use drawings of concentric circles to symbolize the different stages of inner perfection; the Rosicrucians and other, esoteric Christian sects used similar diagrams in their teachings.

For Australian Aborigines, concentric circles in bark or ground paintings indicate a place where ancestral power can come to the surface from within the earth, and return again.

334

## Triangle

Usually represented as an equilateral triangle with sides of equal length, it is a Christian symbol for the TRINITY.

The ancient Hittite people used an upward-pointing triangle as a symbol of the KING and of health; the Sumerians (and others) used the downward-pointing triangle to represent WOMAN.

Alchemists represent the four elements of FIRE, EARTH, AIR and WATER with triangles: one pointing upwards symbolizes fire or, with a horizontal line through it, air; one pointing downwards symbolizes water, or, with a horizontal line through it, earth.

Artists of the Pueblo peoples of the south-western United States used a downward-pointing triangle to symbolize CLOUDS, and an upward-pointing one to represent a sacred MOUNTAIN.

A triangle with sides in the proportion 3:4:5 always contains a right-angle, enabling buildings to be constructed accurately; like the SET SQUARE, such a triangle symbolizes construction and development to Freemasons.

## Square

In contrast to the CIRCLE of the HEAVENS or SKY, the square often symbolizes the EARTH, matter and stability. In the Chinese system of correspondences, a square is related to the earth and the colour YELLOW.

The FOUR sides of the square have been related to other groups of four, such as the cardinal DIRECTIONS; the Pythagoreans associated them with the four elements and seasons.

In Islam, the square is said to represent the HEART of a normal person, open to four possible sources of inspiration: the divine, ANGELIC, human and DIABOLIC. Prophets' hearts are therefore said to be TRIANGULAR, as they are immune to the devil's influences.

In Christian art, a person depicted with a square HALO is, obviously, holy – but they may also have still been alive when the image was made.

Some Chinese stories say that Daoist EIGHT IMMORTALS can be identified by their **eyes**' square pupils.

## Pentagon

The pentagon's FIVE equal sides relate it to Geburah, the fifth sephira on the Kabbalistic TREE OF LIFE, which is associated with severity, justice, war and the planet MARS.

In Islamic mysticism, the pentagon is considered a static symbol of the five elements, FIRE, AIR, EARTH, WATER and ether, and of the five senses.

## Hexagon

In Islamic symbolism, the hexagon's six equal sides are associated with the positions of bodies at the macrocosmic level (over, under, before, behind, RIGHT, LEFT), and with the six DIRECTIONS of movement at the microcosmic level (up, down, forwards, backwards, right, left). The hexagram is its active equivalent.

## Point Within a Circle

Astrologers use a point within a CIRCLE to represent the sun, and, by symbolic inference, the divine. The point also represents the creator in relation to his creation, bounded by the circle.

For Freemasons, the point within a circle symbolizes the point from which a Master Mason cannot err.

## Square Within a Circle

Buddhist depictions of the cosmos, also used widely in China and Japan, usually take the form of a SQUARE within a CIRCLE; each side of the square represents one of the FOUR cardinal DIRECTIONS.

The most common COINS in China AD 62–c.1900, called 'cash', were round with a square hole in the middle: the circle symbolized HEAVEN; the square, the EARTH.

## Circle Touched by Two Straight Lines

In Freemasonry, when placed outside the CIRCLE, the two LINES are invariably parallel (above), representing MOSES and King SOLOMON, respectively embodying the law, and wisdom.

Two parallel lines placed within a circle represent Jacob's LADDER, stretching from EARTH to HEAVEN.

## Triple Circle

The triple circle is shown as THREE inter-linked CIRCLES of the same size. It may be enclosed by a larger circle, or a TRIANGLE, usually pointing downwards. Mainly a Christian symbol, it represents the three aspects of the TRINITY. It is thus found in churches as the geometric and architectural basis of stained-glass windows (above).

## Triskele

The Triskele, derived from the Greek for 'THREE legs', comprises three ARMS, legs or spokes radiating from a common centre; in folk art, especially Celtic (above), the legs become stylized into flowing, geometric forms. Occasionally a human face is placed at the conjunction of the thighs. It is a symbol of movement and, like the SWASTIKA, a SOLAR symbol.

## Tau

Tau is the Greek and Hebrew letter T. It has come to symbolize safety, being the sign which the righteous people of Jerusalem marked upon their foreheads to save them from slaughter (Ezekiel 9: 4); and acquittal. It thus came to symbolize salvation, and was later adopted by Egyptian Christians as the CROSS of CHRIST.

A

B

C

## Cross

The cross, particularly the Latin cross (the top and side arms of equal length, the bottom arm longer – A), is one of Christianity's seminal cult objects, representing the cross on which CHRIST was crucified, and consequently his sacrifice and mankind's resulting redemption.

The earliest cross associated with Christianity was the *chi-rho* CHRIST'S MONOGRAM (B). The Latin cross appears on Roman artefacts dating from the 4th century AD, once Christians were able to worship freely. It also forms the ground plan of many churches.

The Greek cross, with all FOUR arms of equal length, similarly forms the basis of the ground plan of many early Greek churches. It, too, has earlier antecedents, and was once widely used as a symbol for the four elements (FIRE, EARTH, AIR, WATER) of classical antiquity, as well as being associated with the ancient Middle Eastern four cardinal DIRECTIONS and the four WINDS. Hence it symbolized gods associated with the SKY, such

as the Mesopotamian sun god, Shamash, or sky god, Anu. A Buddhist ritual implement in the form of an equal-armed cross, called the *visra vajra* in Sanskrit, represents two crossed THUNDERBOLTS and the power of the BUDDHA's doctrine. An equilateral cross also symbolizes a CROSSROADS or a meeting place, and was therefore sacred to the god Yacatecutli ('Lord NOSE'), the Aztec patron of merchants.

Placed diagonally, a Greek cross becomes a saltire, associated with ST ANDREW, who was said to have asked to be martyred on a cross shaped differently from that on which Christ was crucified, as he was unworthy of imitating Christ; ST PETER, too, was said to have been crucified upon an inverted cross, to differentiate himself from Christ.

The double cross, or cross of Lorraine, is formed by a single vertical crossed by two horizontals, the upper shorter than the lower (C). This is believed to represent the normal crucifix with the addition of the *titulus,* or inscription 'INRI', fixed

by the order of Pontius Pilate above the crucified Christ. The cross of Lorraine is associated with the patriarchs, the bishops of the five principal sees of medieval Christendom. With the addition of another, third, smaller horizontal at the top, it becomes a 'triple' cross, associated with the Papacy. The cupolas of Russian Orthodox churches are often topped by a similar cross, but with the third, smaller horizontal added below the centre horizontal (and sometimes slanted). This cross reproduces the *titulus,* the cross-piece and the board to which Christ's feet were nailed. The Coptic (Egyptian) church uses the TAU cross to represent the cross on which Christ was crucified. Another Egyptian form of cross is the ANKH.

Western heraldry, based on the Christian knightly ideal, uses many different forms of cross; in addition to those already mentioned are types such as the cross patée (the ends of the arms splayed to represent animals' paws) and the cross flory (the arms terminating in stylized LEAVES).

S H A P E S

## Swastika

The swastika (Sanskrit *svastika*, 'good health') is formed like an equal-armed cross, with a right-angled extension added to each arm, often indicating clockwise movement like the sun's. It was used by the Maya, Navajo, Jains and Buddhists. It represents THOR'S HAMMER in Scandinavia, while as an ancient sun-symbol, Hindus ally it with VISHNU. In China and Japan it appears on images that represent the BUDDHA. The Chinese also associate it with Daoism and LAOZI.

In Western traditions, the swastika's arms each represent one of the FOUR elements, and the extension symbolizes that element in motion; thus representing life and movement.

The Nazi Party seem to have considered the anticlockwise swastika as a symbol of anti-Semitism and thus adopted it for their emblem so thoroughly that a positive symbol has become associated with evil.

'Anticlockwise' swastikas are also found in Buddhism, Daoism and in Native American cultures.

## Pentagram

The pentagram is a FIVE-pointed STAR, its lines dividing each other in the ratio known as the 'golden proportion' (above), often used in art and classical architecture, and found occurring widely in nature.

In Pythagorean theory, the pentagram was considered to be upright when the single point was to the top. This also symbolized man, with the upright point as the HEAD, and the four other points the limbs. The symbol for cosmic (or universal) man, a human figure depicted within a CIRCLE with ARMS and legs spread, echoes the pentagram.

When 'inverted', with two points upward, the pentagram is said to be a symbol of the DEVIL – the two points being his HORNS – and thus of evil.

Sometimes called SOLOMON'S SEAL in the western hermetic tradition, in both hermetic and and Islamic mysticism, the pentagram is related to the PENTAGON, as a dynamic symbol, on the MACROCOSMIC level, of the five elements and, on the MICROCOSMIC level, the five senses.

## Star of David

The Star of David, or Magen David, is a form of HEXAGRAM, a SIX-pointed STAR produced from two overlapping equilateral TRIANGLES. It has been the symbol of Judaism for centuries, although its exact relationship to King David is unclear.

A similar hexagram appears in Hindu iconography, representing the joining of the *linga* (the MALE triangle that points upwards) and the *yoni* (the FEMALE triangle that points downwards). It is also a symbol of conjunction in alchemy, relating to the union of the FOUR elements, symbolized by their respective triangles.

In Islam, the same hexagram is considered the dynamic version of the energies associated with the number six (as opposed to the static HEXAGON), and is associated with the positions of bodies at the macrocosmic level (over, under, before, behind, right and left), and with the six possible DIRECTIONS of movement at the microcosmic level (up, down, forwards, backwards, to the right and to the left).

## Yantra

In Hinduism and Buddhism, a yantra (Sanskrit for 'instrument') is a complex geometrical figure which forms a visual expression of a *mantra* or prayer. Yantras symbolize the forces, powers and qualities of various deities, who in turn represent the creative forces in the universe. Those who use yantras believe that basic geometric elements symbolize certain cosmic concepts, and these can be combined into complex diagrams to symbolize the universe. Although drawn on flat surfaces they are meant to be visualized as three-dimensional. The true inner meaning of yantras is only accessible through yoga.

A yantra is also the geometric basis on which a MANDALA is constructed: the crossing points of the lines forming the yantra delineate the position of figures in the mandala. These points also indicate specific points on the body, such as the third EYE in the centre of the forehead or the centres of the palms.

## Mandala

A mandala (Sanskrit for 'CIRCLE') is a magic circle enclosing symbolic diagrams, used in Hinduism, Buddhism, Daoism and Shinto as a contemplative tool for meditation. It is a deeply philosophical figuration devised to make sense of the universe, the abstract and everything that is not manifest, forming a model of the cosmos. The *shunya* (Absolute Void) and the *bindu* (Cosmic SEED) at the centre of every mandala represent both the void and the creative energy at the heart of the universe, while the geometric shapes, mystic patterns and astrological symbols it contains each have symbolic implications. The framework of the mandala is the YANTRA. Meditators are meant to visualize themselves inside the diagram, gradually working their way towards the most sacred area at the centre.

The Maya eight-fold mandala formed of a single spiral line is said to represent the Hunab Ku, the 'One Giver of Movement and Measure' and 'Centre of the Universe'.

## Vesica

If TWO CIRCLES are drawn, the centre of the second being placed on the circumference of the first, the area where they overlap forms a vesica, similar in shape to a MANDORLA. Also called the *vesica piscis* (Latin for 'fish's bladder', the shape of which it resembles), the vesica symbolizes the interactions and interdependence of opposing worlds and forces, and unity becoming duality.

Thus, the two circles from which the vesica is constructed may be taken to represent SPIRIT and matter, or HEAVEN and EARTH. The relationship created between these two circles can be used to construct all regular polygons, but most importantly it is part of the geometric solution for SQUARING the circle, which is the most elegant geometric analogy of the infinite becoming manifest.

The word also refers to the ovoid frame that is painted around figures of Christ and the Virgin Mary in early medieval Christian art.

A variant of the vesica appears in the ZODIAC as PISCES.

**339**

## Mandorla

A mandorla (the Italian word for almond) is the almond-shaped VESICA or aura which surrounds the bodies of CHRIST, the VIRGIN and SAINTS in medieval Christian art, and of deities in Buddhist depictions. Encompassing the entire figure, it symbolizes wholeness and healing.

## Crescent

The crescent is the foremost symbol of Islam.

As the shape of the MOON in its first and last quarters, it is also the conventional symbol for the moon in astronomy and astrology. As the moon increases from its first quarter to the full moon, so the crescent stands for growth, increase and fertility.

## Fleur-de-lis

A frequent motif in European heraldry, where it represents a LILY and is particularly associated with the French royal family (above). Having THREE petals, it can also represent the Christian TRINITY. It was adopted by Navajo silversmiths as a variant of their corn-plant design, representing fertility.

## Lozenge

The lozenge, a rhombus or diamond-shaped figure, appears as one of the Chinese 'EIGHT TREASURES', representing good fortune and victory. In Japan, a lozenge sometimes occurs among the 'Myriad TREASURES' (*takaramono*).

Two lozenges with a central dot form part of a traditional Navajo rug design, and represent a SHAMAN's all-seeing EYE.

## Spiral

A symbol reflecting the growth-patterns found in nature, such as shells or FERNS. Widely used in Oceanic art (carved into door handles, canoe prows and so on) for the Maori it represents the act of creation. For Polynesians, it is the key to immortality. Spirals are also found in the West, carved upon STONES associated with megalithic burial MOUNDS.

## Rosette

Rosettes are stylized ROSES. Mesopotamian cylinder SEALS depict them with images of the goddess INANNA, and they may be associated with another of her symbols, the EIGHT-pointed STAR. In Greco-Roman culture, they are associated with APHRODITE, and with the VIRGIN MARY by Christians. A rosette set on a CROSS is the symbol of Rosicrucianism.

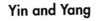

S
H
A
P
E
S

## Trigram

Trigrams are figures used in the Chinese system of divination based on the *Yi jing* (*I Ching/Book of Changes*). Composed of THREE parallel lines, broken or unbroken, each trigram presents a different combination, there being EIGHT in all, each having a specific meaning. Each line of the trigram is either YIN (broken) or YANG (unbroken).

## Hexagram

In the Chinese system of divination based on the *Yi jing* (*I Ching*), each of the 64 hexagrams comprises SIX lines, formed by combining two TRIGRAMS; each has a different basic meaning such as 'youth', 'hope' or 'wealth'.

More generally, a hexagram is a six-sided figure also known as the STAR OF DAVID.

## Yin and Yang

Yin and yang are the two inseparable aspects of the universal force (*qi*) of Daoist philosophy. Yin stands for the FEMALE principle: shade, the MOON and passivity. Yang denotes the male principle: LIGHT, the SUN and vigorous activity. All matter, phenomena and individuals are believed to include yin and yang elements, the proportions of which ebb and flow, creating the possibility of change. Harmony is achieved when the two are perfectly balanced.

The dualism of yin and yang is symbolically expressed by the *tai-ji* circle, the best known depiction of yin and yang. The BLACK section is yin, the WHITE yang, but a white dot in the black part and a black dot in the white part are reminders of their interdependence. The *tai-ji* represents the 'primeval one', the first principle out of which came yin and yang, followed by the five elements (EARTH, METAL, WOOD, FIRE, WATER) which created the 'TEN THOUSAND things'.

## Cube

A cube (more properly a regular hexahedron) is a SIX-sided solid figure; as one of the regular geometric solids described by Plato (the 'Platonic solids'), it represents the three-dimensional, physical manifest world with its SIX directions. In Japanese *gorinto* STUPAS, it symbolizes the element EARTH – a meaning derived from India. It also represents perfection: the smooth cube of ASHLAR is the masonic symbol of the perfected person.

In Kabbalism, the Cube of Space is used as a teaching diagram: the twenty-two paths of the TREE OF LIFE are placed upon and within it, so that the student can consider their meanings as if placed at the central point of the cube, surrounded by the created universe as described by the paths of the tree.

The cube is also a hidden Christian symbol, as it can be opened out to form the traditional Latin CROSS.

S H A P E S

### Tetrahedron

The tetrahedron, a solid figure with FOUR triangular faces, is most easily conceived of as a PYRAMID with a triangular base. In Platonic philosophy, its upward-pointing TRIANGULAR faces make it a symbol of FIRE.

As the most stable regular solid, the tetrahedron symbolizes form and structure.

### Dodecahedron

One of the FIVE regular geometric solids, the dodecahedron has TWELVE pentagonal faces. In Platonic philosophy, as a representation of an idealized form of divine thought, to contemplate its facets and symmetries was to contemplate the divine.

Considered the most perfect of the Platonic solids, its twelve sides make it a symbol of completion.

### Pyramid

Although most commonly associated with the monumental TOMBS of the Pharaohs, pyramids commonly appear in many cultures as sites of worship.

In the western hermetic tradition, the traditional SQUARE base represents EARTH, matter, form and manifestation; the apex, HEAVEN.

In Japanese *gorinto* STUPAS flattened pyramids represent FIRE.

### Octahedron

The octahedron is one of the FIVE regular geometric solids described by Plato; it has EIGHT triangular faces, and is associated with AIR.

The earliest cut DIAMONDS were made in the form of an octahedron; the flattened version, the LOZENGE, is still called the diamond in British and American playing CARDS.

### Icosahedron

The icosahedron is a regular solid figure with TWENTY faces, each an equilateral TRIANGLE; FIVE faces meet at each of the figure's points. One of the five Platonic solids, it is associated with the element of WATER. For Gnostics, it is also a symbol of perfected man, (imperfect man being represented by the DODECAHEDRON).

### Double Cube

In the Western hermetic tradition, the double cube represents the perfection of the CUBE reproduced, or made manifest, on earth; it is therefore a symbol of the manifestation of the divine and so has become the traditional shape of an ALTAR, whether arranged horizontally or vertically.

C O L O U R S

## Red

Red is the colour of FIRE and BLOOD, hence its association with anger and aggression, and war deities such as ARES and OGUN.

It is associated with blood and the life force by Australian Aborigines and the Navajo. In the Roman Catholic liturgy, red is associated with the feast of Pentecost, CHRIST's passion, APOSTLES and martyrs, symbolizing FLAME, blood, SACRIFICE and love. In Japan and China it is associated with prosperity, celebration and happy occasions, like WEDDINGS, when it is worn by brides. Red is associated with the SUN, particularly in Japan and Korea, and hence symbolizes life; in China, it represents the SOUTH, SUMMER, YANG and the PHOENIX (the empress).

Hermetically, red is associated with the south and with fire. The final phase of the alchemical work is associated with the red-PURPLE colour of royalty.

In India, red is the colour of the root CHAKRA (above), and the TRIANGLE *tattva* (meditational shape) associated with fire.

## Yellow

Yellow, the colour of the SUN, symbolizes life, heat and FIRE. In India it is the colour of the solar CHAKRA (above). It is often used to represent GOLD, for example in heraldry, where it signifies glory, faith, constancy and wisdom.

In Chinese mythology, yellow is strongly associated with the 'Middle Kingdom', or China itself. One creation myth describes the CREATOR GODDESS Nii Gua making the first humans out of yellow CLAY. In China, yellow relates to the centre, earth, YIN and the yellow DRAGON. The dragon is historically related to the emperor, and yellow was his colour. (This is not the case in Japan.)

The Hindus' SQUARE *tattva* (meditational shape), which is associated with earth, is yellow.

Aborigines use yellow ochre in rituals associated with the dead, to symbolize death and the deceased's body. For the Navajo, it is associated with the Pollen PATH of harmony, and the WEST.

In the western hermetic tradition, yellow is associated with the EAST and AIR.

## Green

Green is the colour of nature, life, renewal and earth. In Ancient Egyptian mythology, OSIRIS, as the vegetation god, is coloured green. It is also associated with APHRODITE and the medieval European GREEN MAN.

As one of the five traditional liturgical colours of the Roman Catholic church, green symbolizes regeneration and eternal life.

In China and Japan, green relates to SPRING. However, green and BLUE are not differentiated from each other as clearly as in the West. In China, green is used as a complement to RED; together, they form an auspicious combination. Green or blue correspond to the EAST, wood and the blue-green DRAGON.

Green is the most important colour in Islam: Muhammad's cloak was said to be green, and it is the colour associated with paradise, spiritual refreshment, renewal and knowledge. It is also the colour worn by saints and martyrs in paradise.

In India, the heart CHAKRA is green (above).

**343**

C O L O U R S

## Blue

Blue is the colour of the SKY, and thus often symbolizes divinity: Ancient Egyptian deities such as AMUN were often painted blue, alluding to their divine aspect, as are the Hindu gods SHIVA and KRISHNA. Blue has also come to symbolize purity: Christians associate it with the VIRGIN MARY, and it is the Roman Catholic liturgical colour used on her feast days.

Blue is the colour of the SEA, and is associated with sea-deities such as POSEIDON/NEPTUNE; hermeticists associate it with WATER and the WEST.

In China and Japan, GREEN and blue are not differentiated from each other as clearly as in the West. In China, they correspond to the EAST, wood and the blue-green DRAGON. Blue is also the Navajo colour of the SOUTH, associated with RAIN, fertility and the SUN's heat.

In India, the throat CHAKRA is blue (above), as is the CIRCLE *tattva* (meditational shape) which represents AIR.

## Orange

As a blend of RED and YELLOW, orange blends their associations, symbolizing stimulation, success and attraction. Orange is obviously also associated with the ORANGE fruit, thus symbolizing fruitfulness and fecundity.

It is one of the colours frequently used to depict the SUN, and in India is the colour of the sacral CHAKRA (above).

## Indigo

In India, indigo is the colour of the brow CHAKRA (above), which is associated with the third EYE. It is also the colour of the oval *tattva* (meditational shape) which represents the element of SPIRIT; it is therefore a symbol of intuition and psychic power.

## Violet

Violet is one of the five Roman Catholic liturgical colours, specifically used during Advent and Lent to mitigate the BLACK of mourning, and symbolize gravity, reflection, meditation and affliction. In 19th-century western Europe, violet clothing was associated with 'half mourning'.

In India, violet is associated with the crown CHAKRA (above).

## Grey

Grey, a blend of WHITE and BLACK, is associated with the grey hair of old age, the planet SATURN, and Chokmah, the sephira of WISDOM on the Kabbalistic TREE OF LIFE.

It is also linked with anonymity and invisibility: magical cloaks are often said to be grey.

## Purple

In Europe and Japan, purple was historically an extremely rare dye; in the West it was made from the murex and purpura molluscs, and in the East from the root of one species of plant (gromwell). Its costliness meant that it was only worn by the exceedingly rich, and over time it came to be the preserve of nobles and rulers, such as the Roman and Byzantine emperors. At certain times those of lesser rank were even forbidden from wearing it. In China, the imperial PALACE compound at Beijing was known as the Purple Forbidden City.

Considered a sacred colour in Buddhism, purple is used in the robes of Indian priests (above). Buddhist sutras were sometimes written in GOLD on special purple paper, a style also used in a few, very high-status Western manuscripts.

Indians associate purple with the throat chakra; Chinese alchemists, with the HEART or 'purple PALACE'.

## Black

The colour of night and darkness in European folklore, it is related to evil and witchcraft, and in Japan to unlucky or evil deities. To the Navajo, it is the colour of the NORTH, night, old age and death; as the colour of evil and destruction, it can also protect against them.

In ancient mythologies it is associated with the UNDERWORLD and related gods, such as PLUTO and ANUBIS. Europeans associate black with DEATH; it is used on days of mourning, fasting and penitence in the Roman Catholic church. Used in Christian priests' robes (above), black suggests sombre, upright morality but, as an expensive colour to dye, it could also indicate wealth.

Black has also been associated with the FEMALE principle: in Daoist philosophy it is the colour of YIN. Hermeticists link black to matter, EARTH, and the north. The alchemical Work includes a black stage, putrefaction.

In China, black corresponds to the north, WATER and WINTER.

## White

Widely associated with purity, white is the Roman Catholic liturgical colour used on all feasts of the Lord, confessors and VIRGINS. In Buddhism it is related to the pure white LOTUS, and in Shinto to the white paper streamers (GOHEI) which mark off sacred places in their shrines.

In the West, white is traditionally used for baptism robes and WEDDING dresses, in both cases denoting innocence and purity. Japanese brides also traditionally wear white kimonos when leaving for their husbands' houses, but these signify their 'deaths' to their parents, as white is associated in Asian and Slavonic cultures with DEATH, old age and mourning.

In China, white corresponds to the WEST, METAL, AUTUMN, the 'White TIGER' and YANG (LIGHT and masculinity).

For the majority of Native Americans, white (and particularly white or albino animals) have strong connections with SPIRIT.

A

B

C

## Alphabets

In ancient times, alphabets and writing had a strong association with magic. The ability to produce marks that few could understand was of great commercial and military value. In more open societies and peaceful times writing was essential for the wider dissemination of knowledge and information.

Humankind's first physical representation of information or of a desired objective was by drawing or painting. CAVE paintings are now accepted as depictions of what the artist desired to bring about (a successful HUNT) and are thus at least partially magical. Information in pictorial form could be produced on bark to be carried to the intended recipient.

Hieroglyphs and ideograms are simplifications of drawings. Those of Egypt (B) and China are well known, but Hebrew (C) script and runes are also hieroglyphic in origin. Like letters, different hieroglyphs can be joined to produce the sounds of whole words. Maya script, for example, used images and glyphs together.

As letters convey sounds, so the number of letters varies between alphabets, in relation to the number of sounds in particular languages: the runic and Greek alphabets consist of twenty-four letters, the Hebrew twenty-two. Even the number of letters of the Roman alphabet (A) used in many countries is not standard.

Certain civilizations assigned numerical values to letters: a practice still evident in the West in the use of Roman numerals when recording dates on a monument or listing chapter numbers in a BOOK.

By adding the numerical value of the letters of a word a total value of that word can be obtained. The Kabbalah makes much of the significance of words and phrases having the same numerical value. In numerology, a modern system of character analysis and prediction, NUMBERS are allocated to each letter of the alphabet, and significant NUMBERS are then produced by reducing a person's first and family names to numbers. Some traditions also give significance to the order of the letters within their alphabet.

The letters of the Roman alphabet have no intrinsic meanings in themselves. However, certain alphabets (such as the Hebrew and runic) are a sequence of specific words, not sounds; and those words are not variable. For example, the Hebrew alphabet begins *aleph* (OX), *beth* (house), *gimel* (CAMEL), and not A, B, G. Mystics use this as the basis for their contemplation of these objects.

The compilation of Hsu Shen's lexicon in the 2nd century AD enabled the Chinese to pay close attention to the etymological roots of their written characters. So in classic literature, the etymology of a character (rather than just the word) held a deeper significance for the discerning reader. For instance, two different words were used in the *Dao De Jing* which mean 'mysterious'; one used the character containing the etymological roots for 'WOMAN', the other contained a character which represented a cocoon under the roof of a house. Both are similar on the surface but with very different nuances.

## Tetragrammaton

Tetragrammaton, from the Greek for 'FOUR letters', is specifically a euphemism for the four-lettered Hebrew name of God (above) which no devout Jew would ever pronounce, using instead the word 'Adonai', generally given in the Bible as 'Lord'. Many Jewish scholars consider that the exact pronunciation has been lost; that widely used today by Christians – 'Jehovah' – is composed of the vowels of the Hebrew for 'Lord', combined with the four consonants of the Tetragrammaton: *Yod, Heh, Vau, Heh* – J H V H.

The seventy-two powers of the Great Name of God are alleged by certain Jewish and Christian mystics to be derived from various arrangements of the four letters of the Tetragrammaton.

In the Kabbalah, each letter of the Tetragrammaton is said to represent one of the four elements (FIRE, WATER, AIR and EARTH), the four DIRECTIONS, FOUR LIVING CREATURES, the four worlds (the archetypal, the creative, the formative and the material worlds), and many other groups of four.

## Christ's Monogram

One form of CHRIST's monogram, the *chi-rho*, is formed by placing the Greek letter *chi* (X) over the letter *rho* (P) (above): the first two letters of the Greek spelling of Christ's name – the combination also signified *chrestos* in Greek, meaning 'auspicious'. Prior to its adoption by the early Christians, the *chi-rho* had earlier served as the symbol of a Chaldean SUN god, and was used on military banners. It was adopted by the Christian Emperor Constantine the Great (died AD 337) for his military standard. The symbol appears in Roman catacombs of the 4th century, often in combination with the LETTERS alpha and omega (A and Ω).

IHS, a contraction of Christ's name, Jesus, in Greek, was a common decoration in Greek and Latin churches. Promulgated as an object of devotion in the 15th century by Saint Bernardino of Siena, its use as a decoration for TOMBS and churches then became widespread. In the 16th century it was adopted as a device by the Jesuits.

## Fu

In China fu is a geometric sign forming one of the traditional 'TWELVE Ornaments', an ancient set of symbols representing the universe that decorated clothing worn by the Chinese imperial court. It represents the power of judgment, the ability to tell right from wrong and good from evil.

A different fu character, meaning blessings or good fortune, is commonly used on TALISMANS.

## Shou

The Chinese character for long life, shou is an auspicious symbol used in the decoration of ceramics, textiles and other objects and written on paper as a TALISMAN. Associated with Daoist beliefs that promoted immortality as an ideal, the character is shown in many different styles.

**347**

## Numbers

* Zero: devised by Ancient Hindus and introduced to Europe by the Arabs, the concept was also formulated by the Mayas. It represents the complete cycle, and the CIRCLE of all that is. Zero is very important in the Kabbalah, where it represents what existed before creation; it is therefore allied with divinity, yet represents 'no-thing' and infinity.

* One (A): the beginning and the first being, one represents primal beginnings and creation. In monotheistic religions it is related to the one supreme deity, to unity and totality, expressed in Christian terms as God the Father. The Chinese character is a horizontal line, representing unity and the source of everything. In the Native American Earth Count, it represents FIRE, the spark of life, and Grandfather SUN.

* Two (B): the binary, represents pairs and polarities; EARTH and SKY, MALE and FEMALE, good and evil, LEFT AND RIGHT. In Pythagorean theory, two represents the female principle, as opposed to the male nature

of one. Sets of two, such as TWINS, are especially lucky in many cultures. In the Native American Earth Count two represents the body, earth, death, introspection and GRANDMOTHER Earth.

* Three (C): three reflects the TRIANGLE. In Pythagorean theory it represents perfect harmony, the union of unity and diversity. In many cultures it represents divine triumvirates: for example, in Christian religion it is the TRINITY of Father, Son and Holy Ghost, in Hinduism it is the Trimurti, BRAHMA (the creator), VISHNU (the preserver) and SHIVA (the destroyer), and in Ancient Egyptian mythology it was ISIS, OSIRIS and HORUS. In Chinese philosophy it suggests HEAVEN, EARTH and humanity. In Islam the number three represents the SOUL, and for Native Americans it signifies the emotions and WATER.

* Four (D): In Pythagorean theory, as the first square (2 x 2), four represents perfection. Related to the SQUARE, four represents matter, solidity and stability. It is echoed in the FOUR SEASONS, the four cardinal DIRECTIONS and the

four elements of the Greco-Roman tradition. In Islam, it relates to matter and the four HUMOURS. In Christianity it represents the four evangelists. In the Native American Earth Count it symbolizes balance and harmony. For the Japanese and some Chinese, four is a taboo number, as the word for it is a homonym for 'death'.

* Five (E): the Pythagorean perfect number of man, with his five senses, fingers and toes in fives and whose body, with four limbs and a HEAD, can be placed inside a PENTAGRAM. In Christian symbolism five represents the five wounds of the crucified CHRIST, one in each HAND and FOOT and one in His side. In Islam it signifies the five pillars of Islamic piety. In India and China, five represents the five elements; in China, therefore, it represents the many things that correspond with the elements, such as the senses, the body, the SEASONS, the tastes, the planets and so on. In the hermetic mystery the Quintessence (fifth essence or element) is associated with the SPIRIT. In the Native American

4 <sub>D</sub>

5 <sub>E</sub>

6 <sub>F</sub>

Earth Count, five represents the sacred human who makes the BRIDGE between EARTH and SKY, past and future, and the material and SPIRIT worlds.

✳ Six (F): as the basis of the HEXAGRAM, six signifies harmony and balance. Related to the dimensions of the CUBE it reflects matter, the three-dimensional. In Pythagorean theory it represents justice. In Judeo-Christian belief it suggests the six days of creation. Tripled, it becomes the number of the beast of the apocalypse (666). There are several groupings of six in Buddhism, such as the six realms of existence and six perfections. In the Native American Earth Count six signifies the ANCESTORS.

✳ Seven (G): seven has widespread significance. It is the number of days in a week, the seventh being the day of rest and worship in the Judeo-Christian tradition; and of the traditional planets of astrology (MERCURY, VENUS, MARS, JUPITER, SATURN, MOON, SUN). For Christians it is the number of VIRTUES, of deadly sins, sacraments, joys and sorrows of the VIRGIN, among others. Seven is important in Judaism; the sacred CANDELABRUM, the Menorah, has seven branches, representing the creation and planets, as well as the seven heavens. Buddhists, too, believe in seven HEAVENS; for the Chinese, it represents the seven STARS of Ursa Major. Native Americans associate seven with the Dream of Life.

✳ Eight (H): in Buddhism eight suggests the eight-spoked WHEEL of the *dharmachakra*, the auspicious symbols and the number of petals of the lotus, representing the paths to spiritual perfection. In Chinese belief eight is an auspicious number and relates to the eight DIRECTIONS, the EIGHT IMMORTALS and Eight Precious Things.

It is also the number of the Beatitudes, or blessings, made by JESUS in his Sermon on the Mount (Matthew 5: 3-11). In ancient mythology the eight-rayed STAR is an attribute of INANNA (the Babylonian goddess of love and war) and APHRODITE (the Ancient Greek goddess of love). For Native Americans eight is the number for all Natural Laws.

✳ Nine (I): the tripling of the triple, nine represents the powerful multiplication of the symbolism of THREE. In China, it is YANG, very auspicious, and connected to the Nine Places, represented in geomancy by the eight DIRECTIONS and the centre. In the Native American Earth Count, it signifies the MOON, movement, rhythms, cycles and change.

✳ Ten: As the basis of decimal systems, ten represents completion and the return to unity. As it is the sum of ONE, TWO, THREE and FOUR, Pythagoreans considered ten to be a numerical version of the quintessence, with divine power; it was sometimes represented as a TRIANGLE of dots (four to each side and one in the middle) called the *Tetrakys*. It is the number of commandments comprising the Law given to MOSES by God. The Chinese character is an equal-armed CROSS, a symbol of extension, the centre and FOUR cardinal DIRECTIONS. In Native American thought it represents the collective mind, the intellect.

# 7

<sub>G</sub>

# 8

<sub>H</sub>

# 9

<sub>I</sub>

* Eleven: For Christians, it is the number of faithful APOSTLES. In the Native American Earth Count eleven represents the STARS, or 'Star Nations', and the ability to travel to them; by extension, it means altered states of consciousness.

* Twelve: generally associated with the twelve months of the solar year and the signs of the zodiac, it is also, in Judeo-Christian religion, the number of Christ's disciples and, in imperial Chinese symbolism, the number of ornaments on the Emperor's robes. In the Native American Earth Count it represents the twelve planets and the twelve WINDS.

* Thirteen: the widespread Christian belief that thirteen is unlucky stems from the Last Supper, where thirteen were present, including JUDAS the betrayer. Traditionally, it is the number of WITCHES in a coven. Thirteen also represents the months of the LUNAR year, and, in Maya culture, the base unity governing the sacred calendar of 260 units. In the Native

American Earth Count it signifies the Goddess, MOTHER of all.

* Forty: In Ancient Mesopotamia, forty was associated with the new year, celebrated forty days after the Pleiades had disappeared under the horizon. In the Bible it is associated with preparation and expectation; the waters of the FLOOD covered the earth for forty days and nights; MOSES waited on Mount Sinai for forty days and nights before receiving the Ten Commandments; the Exodus lasted forty years; CHRIST fasted in the DESERT for forty days and appeared to his disciples forty days after his resurrection.

* Fifty-two: the number of weeks in a year and of years in a complete Maya calendrical cycle. It is also the number of CARDS in a standard deck of playing cards.

* One hundred: TEN multiplied by itself, hence a symbol of completion.

* One hundred and eight: of great significance in Eastern cultures, this is the number of beads on Buddhist and Hindu PRAYER BEADS, ensuring that the

deity's name is said at least ONE HUNDRED times.

* Three hundred and sixty: as the number of degrees in a CIRCLE, this suggests completion of a cycle and perfection.

* Ten thousand: the Japanese cry 'banzai' means 'ten thousand years', wishing the emperor a long life. In the *Dao De Jing*, ten thousand means 'all'.

* One hundred thousand: in early cultures this symbolized a high number, considered beyond reckoning; it became a standard term for infinity.

# FURTHER READING

## General

Becker, U., *The Continuum Encyclopaedia of Symbols,* New York, Continuum, 1994

Cooper, J. C., *An Illustrated Encyclopaedia of Traditional Symbols*, London, Thames & Hudson, 1979

Cooper, J. C., *Symbolic & Mythological Animals*, London, Aquarian Press, 1992

Hall, J., *Hall's Dictionary of Subjects and Symbols in Art*, London, John Murray, 1987 (revised edn)

Hall, J., *Hall's Illustrated Dictionary of Symbols in Eastern and Western Art*, London, John Murray, 1994

Willis, R. (ed.), *Dictionary of World Myth,* London, Duncan Baird Publishers, 2000

*Native Web – Resources for Indigenous Cultures Around the World*, www.nativeweb/org/

## Astrology

Walters, D., *Chinese Astrology*, London, Aquarian Press, 1992

Hinckley Allen, R., *Star Names, Their Lore and Meaning*, New York, Dover Publications, 1963

## Alchemy

Kohn, L. (ed.), *Taoist Meditation and Longevity Techniques*, Ann Arbor, University of Michigan, 1989

*The Alchemy Website and Virtual Library*, www.levity.com/alchemy/

## The Judeo-Christian, Islamic and Western Mystery Traditions

*The Bible* (New Testament, Old Testament, and Apocrypha): available in many editions and translations

Case, P. F., *The Tarot*, Los Angeles, Builders of the Adytum, 1990 (revised edn)

Chebel, M., *Symbols of Islam*, Paris, Assouline, 1997

Cohn-Sherbok, D., *A Concise Encyclopaedia of Judaism*, Oxford, Oneworld Publications, 1998

Jones, B. E., *The Freemasons' Guide and Compendium*, London, Harrap, 1956

*New Catholic Encyclopedia*, Washington, Catholic University of America, 1967

Wind, E., *Pagan Mysteries in the Renaissance*, London, Faber, 1968

Unterman, A., *Dictionary of Jewish Lore and Legend*, London, Thames & Hudson, 1997

## Norse

Crossley-Holland, K., *The Norse Myths*, New York, Pantheon, 1980

Davidson, H. E., *The Lost Beliefs of Northern Europe*, London, Routledge, 1993

## Celtic and Arthurian

Adkinson, R., *Sacred Symbols: The Celts*, London, Thames & Hudson, 1995

Green, M., *Dictionary of Celtic Myth and Legend*, London, Thames & Hudson, 1997

*The Mabinogion*, tr. G. Jones & T. Jones, London, J. M. Dent & Son (Everyman's Library), 1949

Ross, A., *Pagan Celtic Britain: Studies in Iconography and Tradition*, London, Routledge, 1967

## Ancient Egyptian

Adkinson, R., *Sacred Symbols: Ancient Egypt*, London, Thames & Hudson, 1995

Lurker, M., *The Gods and Symbols of Ancient Egypt*, London, Thames & Hudson, 1974

Lurker, M., *An Illustrated Dictionary of the Gods and Symbols of Ancient Egypt*, London, Thames & Hudson, 1982

Quirke, S., *The Cult of Ra*, London, Thames & Hudson, 2001

Silverman, D. P., (ed.), *Ancient Egypt*, London, Piatkus, 1997

Wilkinson, R. H., *Symbol and Magic in Egyptian Art*, London, Thames & Hudson, 1999

## Classical Antiquity

Hornblower, S. & Spawforth, A., (ed.), *The Oxford Classical Dictionary*, 3rd ed., Oxford & New York, Oxford University Press, 1996

Kerényi, C., *The Gods of the Greeks*, London, Thames & Hudson, 1976

Original sources are available with English translations in the Loeb Classical Library (Cambridge MA: Harvard University Press): Homer, *Iliad & Odyssey*; Hesiod, *Theogony* (in the volume *Homeric hymns ...*); Pliny, *Natural History*; Ovid, *Metamorphoses & Fasti*

## Africa

Hackett, R. I. J., *Art and Religion in Africa*, London, Cassell, 1999

Preston Blier, S., *Royal Arts of Africa: The Majesty of Form*, London, Laurence King, 1998

## India

Adkinson, R., *Sacred Symbols: The Buddha*, London, Thames & Hudson, 1996

Liebert, G., *Iconographic Dictionary of the Indian Religions – Hinduism – Buddhism – Jainism*, Leiden, Brill, 1976

Shearer, A., *The Hindu Vision*, London, Thames & Hudson, 1994

Singh, H., (ed.), *The Encyclopaedia of Sikhism*, Patiala, Punjabi University, 1998

Walker, B., *Hindu World*, London, George Allen & Unwin, 1968

Zwalf, W., *Buddhism, Art and Faith*, London, British Museum Publications, 1985

## China

Eberhard, W., *A Dictionary of Chinese Symbols: Hidden Symbols in Chinese Life and Thought*, London & New York, Routledge and Kegan Paul, 2000

Williams, C. A. S., *Outlines of Chinese Symbolism & Art Motifs*, New York, Dover Publications, 1976 (revised edn)

## Japan

Baird, M., *Symbols of Japan*, New York, Rizzoli International Publications, 2001

*Nihongi: Chronicles of Japan from the Earliest Times to AD 697*, tr. W. G. Aston, Rutland VT & Tokyo, Charles E. Tuttle Company, 1988 (revised edn)

## The Pacific

Ellis, J. A., *This is the Dreaming: Australian Aboriginal Legends*, Victoria, Australia, Collins Dove, 1994

Stafford, D. M., *Introducing Maori Culture*, Auckland, Reed, 1997

Thomas, N., *Oceanic Art*, London, Thames & Hudson, 1995

## The Americas

Coe, M. D., *The Maya*, New York, Thames & Hudson, 1987 (4th edn)

Gill, S.D. & Sullivan, I. F., *Dictionary of Native American Mythology*, California, ABC-CLIO, 1992

Miller, E. and Taube, K., *An Illustrated Dictionary of the Gods and Symbols of Ancient Mexico and the Maya*, London, Thames & Hudson, 1997

Stierlin, H., *The Pre-Colombian Civilizations*, New York, Sunflower Books, 1979

*Native American Myths of Creation*, www.crystalinks.com